ON THE VERY EDGE

MODERNISM AND MODERNITY IN THE
ARTS AND ARCHITECTURE OF INTERWAR SERBIA
(1918-1941)

D1360743

ON THE VERY EDGE

MODERNISM AND MODERNITY IN THE ARTS AND ARCHITECTURE OF INTERWAR SERBIA
(1918-1941)

Edited by
Jelena Bogdanović
Lilien Filipovitch Robinson
Igor Marjanović

LEUVEN UNIVERSITY PRESS

© 2014 Leuven University Press / Presses Universitaires de Louvain / Universitaire Pers Leuven,
Minderbroedersstraat 4, B-3000 Leuven/Louvain (Belgium)

ISBN 978 90 5867 993 2
D / 2014 / 1869 / 45
NUR: 654

Cover design: Frederik Danko
Cover illustration: Carl van Vechten, photograph of Milena Pavlović-Barilli, 1940, New York (By permission of Van Vechten Trust)
Typesetting: Friedemann BVBA

TABLE OF CONTENTS

ACKNOWLEDGMENTS

This volume is a product of manifold collaborations, intellectual exchanges, and support networks. We have incurred many debts during the long making of this book. We are most grateful to our contributors who persevered through numerous iterations of this project and tirelessly contributed their wisdom, energy, and time to it. Without their insight and commitment, this book would not have been possible.

We would like to acknowledge the financial, logistic, and intellectual support of our home institutions, namely the Iowa State University Publication Subvention Grant program, George Washington University, and Washington University in St. Louis. We are thankful to our university colleagues and friends who provided words of encouragement and constructive criticism that kept this project alive.

At Iowa State University we thank Deborah Hauptmann, Chair of the Architectural Department, Luis Rico-Gutierrez, Dean of the College of Design, Chitra Rajan, Associate Vice President for Research, Kevin Kane, Associate Dean for Research at the College of Design, and Sandra Norvell from the Grants Office, the Center for Excellence in the Arts and Humanities and the Institute for Design Research and Outreach. Heidi Reburn, Masters Candidate in architecture at Iowa State University, prepared the bibliographical list devised from all contributions. At George Washington University, we express sincere appreciation for the support and guidance of the Chair of the Department of Fine Arts and Art History, Philip Jacks, the Dean of the Columbian College of Arts and Sciences, Ben Vinson, and the Executive Associate Dean of the Columbian College of Arts and Sciences, Roy Guenther. Our gratitude at Washington University in St. Louis goes to Deans Carmon Colangelo and Bruce Lindsey for their encouragement and support.

At Leuven University Press, our Commissioning Editor Dr. Veerle de Laet provided important guidance and insight, while Annemie Vandezande helped with graphic design and book promotion. The two anonymous reviewers carefully read the material and provided most constructive and professional recommendations, which are reflected in this book. We also acknowledge Sever J. Voicu who prepared the index.

This book is also a product of love and support of our family and friends. Jelena Bogdanović would like to acknowledge Miloš R. Perović, Ljubica D. Popovich, Marina Mihaljević, Dušan Danilović, Snežana Bogdanović, Vojislav Bogdanović, and Biljana Danilović. Lilien Robinson extends heartfelt thanks to Ljubica Popovich and Barbara von Barghahn for their wise advice and gratitude for the love and encouragement of David Robinson and Svetlana Chloupek. Igor Marjanović would like to acknowledge friendship, good humor and insight of Katerina

Rüedi Ray, but most importantly the love and support of his family, wife Jasna and son Milan who was born just about the same time as this book. To all of them we remain thankful and indebted for the opportunity to conceive and complete this book, which we hope will serve as a useful springboard for other scholars who are curious to pursue and promote further discourses *on the very edge*.

ON THE VERY EDGE:
MODERNISMS AND MODERNITY
OF INTERWAR SERBIA

Jelena Bogdanović

Belgrade, the capital of Serbia, has been completely rebuilt within the last eight or nine years. Strangers who knew the place long ago cannot recognize it to-day. ...
I have heard Belgrade called "The Concrete City," which is rather a descriptive name for it. Practically all the buildings are made of concrete. Whether owing to the speed of reconstruction, or whether from lack of architectural sense of beauty, the city unfortunately has few buildings that please the eye. They are mostly heavy in appearance, devoid of style, and there is no originality. ...

Everyone is dressed in the latest fashion, and ladies use quite as much, if not more, powder and paint than in Paris. ... They would rather go without other things than be behind the fashion. From this you must think that they are empty-headed. Far from it. At the Belgrade University there are nearly as many girls as young men studying for various careers. ...

Topchider is a fine old park, a tram drive from the town. Long ago Prince Milosh, the first ruler of Serbia when she became a semi-independent state, had his summer residence here. The house, built in the Turkish style, is a picturesque old place and is still in existence. ...

It is not surprising that the Serbs have not been able to give much time to organizing museums and other public institutions. Ever since regaining their freedom they have still had to fight for their existence ... However, in spite of turbulent times and the bombarding of Belgrade, the greater part of a valuable collection of historic treasures has been preserved. The National Museum and the Ethnographical Museum have interesting things in them. ...

Extremes and contrasts are the most striking feature of Belgrade. You see opposing forces everywhere: in the streets, in the houses, in the lives of the people even. Side

by side with the peasant in homespun clothes and sandaled feet walk smartly dressed people of the wealthier classes. The creaking ox-cart has the right of way alongside the luxurious limousine car, and tall modern structures tower above dilapidated little houses in the strangest fashion. Thus East meets West in a curious jumble, and in view of such extremes and contrasts you cannot but feel that there is a gap somewhere. The connecting link between the one and the other is missing and so you constantly find that you suddenly drop into the gap.[1]

This was how Lena Jovičić, the daughter of a Scottish mother and a Serbian father, described Belgrade in the interwar period in her 1928 book *Yugoslavia*. At the time, Belgrade was the capital city of the former Kingdom of Serbia, and a constituent entity of the Kingdom of Serbs, Croats and Slovenes, also known as Yugoslavia. Jovičić's excerpts graphically capture Belgrade's singular and stark divisions on the very edge between old and new, traditional and modern, East and West. Jovičić's own contemporary voice comes from the very edge because it simultaneously belongs to Serbian culture through her family ties and resonates the perspective of the "close other" in Piotr Piotrowski's terms[2] as she writes in English from within (Western) European culture, thus reflecting subtle curiosities of the center-and-periphery constructs that prevailed in historical and theoretical writings on architecture and arts.[3] Then again, by being the capital city, Belgrade is by definition a center of cultural and artistic practices in Serbia, while Serbia had to negotiate its place on a larger map of modernity within cultural geographies.

Almost a hundred years after Lena Jovičić in recording her firsthand observations on Belgrade touched on questions of modernity and tradition in the shifting context of geographic and cultural centers and margins, this book reassesses modernism(s) and modernity in the arts, architecture and literature in the always-changing territory of Serbian culture during the brief but complex interwar period (1918-1941). Modernism(s) and modernity of interwar Serbia were often marginalized and viewed simultaneously as "non-modern," "non-European," and in opposition to Western-European modernist values of authenticity, uniformity and superiority. The volume questions the prevalent understanding of modernism as an inherently Western-European phenomenon and its regional variants as derivatives of international modernism.[4] It seeks to recognize Serbia's own highly complex, often opposing, and unbalanced cultural landscape that existed "on the very edge" of modernist and geo-historical space – a landscape imbued with contradictions that has often puzzled some "Western" observers, and resulted in stereotypical (mis)representations of both Serbia and the Balkans.[5] Furthermore, it aims to engage in pluralist discussions about vertical and canonical versus horizontal and spatial layering of studies about modernism(s) and modernity. Without pretensions and intentions

of providing a homogeneous view, this volume gathers essays that address various, complex and often contradictory forms of production, perception and reception of modernism(s) in interwar Serbia. By using relevant literature, historical sources, archival documents, press articles and material evidence, the contributors often start with formal modernist features of selected creative accomplishments in interwar Serbia, and eventually question whether and to what extent they belong to wider modernist trends. Simultaneously, they question whether and to what extent the vernacular and historical remained significant. In some cases, the mere opening of archives remains within documentary and antiquarian studies as a deliberate choice in order to preclude jumping to conclusions where comparative studies with appropriate methodologies are still wanting. However, by focusing on few but diverse examples that account for modernism and modernity in Serbia and by covering a breadth of concepts that pertain to larger issues of politics, economy and cultural geography, case studies presented here aim to enrich contextualized discussions on modernism and its variants in the arts and architecture of interwar Balkans and (Eastern) Europe.

Lilien F. Robinson opens the discussion of modernism as innovation which resulted from academic traditions in painting in European and Serbian contexts even before the Great War. She posits that in their lengthy careers of over seventy-five years, Paja Jovanović (1859-1957) and Uroš Predić (1857-1953) were central in bringing Serbian painting to a level of equivalency with that of modern Europe and in the process eliciting considerable international recognition. Their study focused initially on Serbian religious art with its lingering dependency on medievalism, followed by instruction in the renowned traditions of Western European art at the prestigious Vienna academy. However, as Robinson argues, Jovanović and Predić sought their own thematic and stylistic direction. As serious independent thinkers, alert to the *clima mentis* of their time, they looked to progressive theories and practice. Thus, while built on a firm traditional base, their art was significantly informed by the modernist experimentations of avant-garde European painters. Through a broad repertoire of subjects and boldness of methodology, they had an indelible impact on the art of their compatriots. Similarly, they assumed important roles in advancing the arts in their homeland through organization and engagement in the first Serbian art associations of the 1890s and 1900s. In this study Robinson demonstrates how these two towering figures of Serbian culture anticipated and, to a great extent, set the requisite stage for the independent thought and avant-garde approaches of future generations of artists in Serbia.

Igor Marjanović presents the significance of the avant-garde movement of Zenitism (via "zenith"), which was active for only five years between 1921 and 1926, by focusing on the activities of its two founders and brothers, Serbs from Sošice, modern day Croatia, Ljubomir Micić (1895-1971) and Branko Ve Poljanski (1897-?, probably the 1940s). Marjanović

argues that their personal experiences not only defined their creative work but also signified the peripatetic nature of many other avant-garde networks. Displaced from any obvious homeland or traditional disciplinary field, Micić and Poljanski created a discourse that bridged cultures, disciplines and avant-garde nodes – from Micić's publication of Vladimir Tatlin's *Monument to the Third International* in 1922 – the first printing of the project outside Russia, just two years after its inception – to Poljanski's fiery exchange with the founder of the Futurist movement, Filippo Marinetti. Enabled by the emerging technologies of mass print and travel, their ideas were made significant not only by their internal content, but even more so through their dialog with *others*. Marjanović traces the role of displacement in the formulation and exchange of new ideas, in particular the interchangeable use of image and text, to signify new departures and arrivals in art, architecture and literature. Drawing upon primary texts in critical social and cultural theory, Marjanović argues that travel, exchange and cross-cultural translation were significant vehicles of cultural production, allowing the visual and literary works to constantly reinvent themselves as they entered the fluid space of international intellectual exchange – a space of peripatetic discourse that not only redrew Eastern European cultural geography, but also provided an important voice in the global avant-garde web.

Miloš R. Perović further expands on Zenitism as the major visionary and only truly "Yugoslav-born" avant-garde movement of the interwar period. The Zenitists understood the crisis of European civilization in the postwar period not only as a socio-economic crisis but above all as a cultural crisis. Zenitism's charismatic founder, Ljubomir Micić, developed this rebellious concept totally in opposition to the European rationalistic tradition, which he claimed was a system of suppression and a way of systematic destruction of man's freedom. Perović explains how Micić perceived only barbarism as real because of its irrationality. His "Manifesto to the Barbarians of Spirit and Thought on All Continents" ("Manifest varvarima duha i misli na svim kontinentima") proclaimed Zenitism a global artistic movement. Based on the "barbarian" principles of pan-Balkanism, the main goal of the Zenitist movement was the Balkanization of Europe as opposed to the Europeanization of the Balkans, the leading ideology of the interwar Serbian bourgeoisie. Perović highlights Zenitist programmatic relations with modernist architecture. He emphasizes Zenitist free-minded experimentation in art and the need for artistic innovation which facilitated distinctly different approaches from all previous attempts to participate in the avant-garde discourse. In the forty-three issues of the international journal *Zenit* architectural topics were prominent. From a historical distance the Zenitist understanding of modernist architecture remains impressive due to almost impeccable selection of critical texts on modernist architecture and the international choice of published projects or authors of the contributions.

Jasna Jovanov focuses on the art group "Oblik" (meaning "Form" in Serbian), one of the most progressive, most engaged, and largest art groups in Yugoslavia between the two world wars. During its 13 years of existence, between its inception in 1926 and 1939, when "Oblik" ceased to exist, 46 artists presented their works at 16 exhibitions in various cities in South East and Central Europe – Belgrade, Novi Sad, Split, Sarajevo, Banja Luka, Skopje, Zagreb, Ljubljana, Thessaloniki, Prague, Plovdiv, and Sofia. The group worked in the modernist idiom, bringing together some of the most prominent Serbian and Yugoslav artists, deeply familiar with contemporary European artistic trends, especially those stemming from Parisian movements in painting. Painters, sculptors, architects, graphic designers, scenographers and caricaturists active in the group, unlike most contemporaneous avant-garde groups, did not have a written manifesto. Jovanov argues that their artistic opus demonstrates that the freedom to choose a creative practice was the primary concept unifying these artists. She also highlights the personal charisma and visionary leadership of painter Branko Popović, who was the catalytic force of this diverse art group and its integration into the general artistic trends of the interwar period.

Svetlana Tomić analyzes the literary and cultural importance of the travel writings of Jelena Dimitrijević (1862-1945), Serbia's first known woman world traveler, and explains their feminist value and the distinctiveness of the genre. An intellectual, a polyglot and an active contributor to significant women's societies of her time, Dimitrijević was the first Serbian woman-writer who succeeded in publishing many of her books. Unlike Serbian male writers of the time, Dimitrijević traveled outside Europe expanding her geographical space of engagement and literary action to Africa, Asia and America. Applying methods of feminist critique and gynocriticism Tomić sheds light on Dimitrijević's travel writings that described more than different cultures and lives of women. Through accounts of encounters with leading feminists, Dimitrijević informed her Serbian audience of the reasons for the failure of feminism in other countries. Tomić demonstrates how, by resolving an apparent assimilation vs. alienation conflict, Dimitrijević's work sent a powerful positive political message of the identitarian "Self-and-Other" binome: the Self can be better understood, enhanced and enriched through the Other.

Ljubomir Milanović examines the interwar works of painter Milena Pavlović-Barilli and their conspicuous modernity. Born to a Serbian mother and an Italian father, initially inspired by surrealist and then by metaphysical literature and art, Pavlović-Barilli created her own distinctive art. Her engagement with art history as a repository of images enabled her to develop her personal artistic style and narrate her intimate emotional life. Often she located her compositions in nature or in architectural elements taken from ancient Italian towns. Milanović suggests that her references to classical and renaissance art were not so much

aligned with European values of power and order as they were a means by which the artist materialized her inner life. Milanović argues that Pavlović-Barilli's engagement with the works of other artists – working in her own art media (painting and illustration) or those working in film and literature – was "not merely one of 'influence' or quotation but a complex process of appropriation and transformation in a modernist bid for self-actualization." In contrast to many of her male peers, her artistic method of appropriation is seemingly self-conscious and playful. Her paintings and illustrations, as forms of both high and low art as traditionally defined in Western art, reveal an artist who played with educated and popular taste on various levels. By focusing on the veil, the common signifier of femininity in popular culture and the recurrent motif in her work, Milanović suggests that Milena Pavlović-Barilli both promoted and deconstructed the beauty industry, which ironically emerged almost simultaneously with the concepts of modernity. Milanović emphasizes the use of the veil in Pavlović-Barilli's self-portraits and portraits of other women as a means of looking at and accessing the Self through the eyes of the Other. Milanović also sees the veil as a signifier of psychological, historical and geographical inaccessibility, the in-between state of artistic space on the very edge of modernism. He further argues that Pavlović-Barilli managed to simultaneously maintain traditional and modern values in her work and in a way announce art forms, later recognized as post-modernist.

Bojana Popović focuses on applied arts that after the famous 1925 Exposition of Modern Decorative and Industrial Arts garnered positive status in contrast to their previous designation as "minor" or "low arts." Popović reassesses notions about fashion and emancipation of women in interwar Serbia as hinted in Jovičić's book and highlighted by Milanović in his essay. Social modernization enabled many women, especially in Belgrade, to engage in applied arts as yet another modernist phenomenon caused by socio-economic changes that offered a promise of egalitarian production and consumption of arts. Prior to the founding of the Belgrade School of Applied Arts in 1938, artists were trained in major European centers such as Paris, Vienna, Munich, Prague, Rome and London. By extension, these centers were crucial to the transformation of professional, social and gender contexts of applied arts in Serbia. Nevertheless, Popović's view is that, consistent with local contexts elsewhere in the Balkans and Europe, applied arts remained marginalized, their production and reception linked to conformist and marginalized female artists. Popović posits that women in Serbia turned to interior design, decoration of the home, clothing, and teaching of applied arts, mainly because these were traditionally linked to feminine and domestic realms. The general public embraced these female artists as they did not encroach upon traditional gender roles, and male colleagues did not view them as a competition. Concurrently, the political activism for women's rights was limited to awaking only the curiosity of the media. Even if female emancipation in

interwar Serbia was only partial, Popović argues for due recognition of numerous female artists such as Beta Vukanović, a painter who was also a professor at the Royal Academy of Arts in the interwar period; Vukosava Vuka Velimirović, a highly praised and accomplished sculptor trained in Belgrade, Rome and Paris; costume designer Milica Babić, who completed her studies under Eduard Josef Wimmer-Wisgrill at the prestigious School of Applied Arts of the Austrian Museum for Art and Industry and worked at the National Theater of Belgrade; or highly sensitive creators such as architect and interior designer Danica Kojić and textile artist Katarina Mladenović. Many female artists were actively engaged in the fashion industry and worked as book and press illustrators. Some of them also demonstrated strong leadership skills. For example, Margita Gita Predić, trained as a painter and sculptor, was the founder of the first vocational school for applied arts in Serbia and the founder of "Roda" (Stork), the first professional children's theater in Serbia. However, most of these interwar artists failed to achieve and sustain long careers; their work has been largely forgotten or irretrievably lost. It was only in the twenty-first century and for the first time that an exhibition at the Museum of Applied Arts in Belgrade (2011-12) brought attention to women in the applied arts, similar to contemporaneous exhibitions elsewhere such as those at the Georges Pompidou Center dedicated to the work of Charlotte Perriand and Eileen Gray. According to Popović, female creativity in applied arts in interwar Belgrade was trapped in the "borderline" gaps of modernism not only because it did not belong geographically to the recognized centers of European modernism, but also because it generally did not make a major impact, mostly due to the uninspiring and limiting socio-political and economic environment. Popović sees great significance in the unprecedented popularization of the applied arts in interwar Serbia within its own local context, which may enrich understanding of the transformative values of modernist idioms.

Anna Novakov further examines gender issues in the construction of modernity in her text on female architects and their work on schools in Serbia. She presents women architects Jelisaveta Načić (1878-1955) and Milica Krstić (1887-1964) as innovators in the design of Serbian schools. For some thirty years (1908-1938), Načić, Serbia's first female architect, and Krstić designed schools in eclectic, historical (the elementary school "King Peter I," 1908 by Načić and the Second High School for Girls, 1932 by Krstić) and modernist idioms (the First High School for Boys, 1936-38 by Krstić). Reflective of the reformed educational environment of modern Serbia, all three schools demonstrated the architects' interest in light, comfort and sanitation. Novakov argues that through these design innovations Načić and Krstić were able to ensure a progressive education for both male and female students. Her research confirms Jovičić's observations on female education during the interwar period. She further explains how "overcoming Serbia's long-standing resistance to female education was a major focus of

the emerging women's rights movement that sought to improve the notoriously low literacy rate among girls in villages and to provide opportunities for city girls to attend high school and even universities." Built in various architectural styles between historicity and modernism by female architects, these schools also exemplify the shifting notions of the actual role of architectural style in changing social values of education which were typical of international modernist concepts.

Aleksandar Kadijević and Tadija Stefanović re-evaluate national and historical styles within integrative modernist trends in the architecture of Expressionism. Accepted as a modernist trend in Central European architecture, Expressionism in Serbian architecture developed effectively only in the mid-1920s. It emerged in Serbia through the incorporation of the formal elements of that style. The majority of recorded examples of Serbian expressionist architecture employ predominantly formal stylistic elements applied only partially and as one of multiple expressive architectural elements. Nevertheless, in addition to Czech Cubism, French Purism and Art Deco, German Bauhaus and International Style, Expressionism was an important style that formed the framework of Serbian interwar modernism in architecture. Prominent modernist architects such as Dušan Babić, Dragiša Brašovan and Josif Najman used expressionist elements often. Leading architects who worked in the so-called national-romantic idiom, such as Momir Korunović, also used Expressionism to emphasize the visual effect of their work in space and the surrounding landscape. Seeking strong emotional expression within religious architecture, these architects also expressed their spirituality though Expressionist architecture. Kadijević and Stefanović provide a detailed and comparative examination of these two trends in Serbian Expressionistic architecture – Romantic and Modernist. By focusing on numerous examples either built or conceived in preliminary architectural drawings, the authors elucidate the significance of Expressionistic architecture in search of innovative architectural solutions.

Dragana Ćorović highlights modernist ideas in urban design in Serbia by focusing on the Garden City concept proposed by Ebenezer Howard (1902). Unlike other modernistic utopian ideas that tried to reconcile architecture and industry but were usually strictly defined and did not allow improvisation and growth, Howard's corporate concept was remarkably open to various interpretations, and above all to urban experimentations. The Serbian intellectual elite recognized the capacity of the Garden City concept and its modernity neither in its originality nor novelty, but rather in its applicability to different regional situations, including the incorporation of Ottoman-Turkish gardens and traditional family values of Serbian society. The concept was considered in Belgrade's intellectual circles even before WWI. Following WWI, philanthropists, entrepreneurs, sociologists, architects and urban planners continued their collaborative efforts in search of sustainable urban planning

in Serbia. The promotion of the Garden City in Serbia was not done through collaborations with its Western-European proponents but was achieved via public discussions, academic and public journals and films. Ćorović emphasizes the tireless collaborative work of three professionals: architect Jan Dubový, architect and urban planner Branko Maksimović, and journalist Slobodan Ž. Vidaković. In essence, as in Great Britain, interest in the concept of the Garden City in Serbia began as a social movement in the first decades of the twentieth century, and then developed as an urban design principle. The implementation of the Garden City concept in Serbia, however, occurred in large measure only after WWI because of the pressing need for housing. Kotež-Neimar (1922), Colony for Railroad Workers (1925-40), Professors' Colony (1926-27) and Clerks' Colony (1926, 1931-33) in Belgrade and the New Colony in Kragujevac (1931, 1936-38) are examples of continuous development of settlements based on the Garden City concept in interwar Serbia, even after the economic depression of the 1930s.

Viktorija Kamilić further details the development of the Professors' Colony between 1926 and 1927. The Colony was initiated by a group of Belgrade professors as a means of solving their housing problems, but doing so on a limited budget. The architectural team responsible for the project was led by Svetozar Jovanović, professor at the Technical Faculty of the University of Belgrade and future resident of the Colony, and his two younger colleagues Petar Krstić and Mihailo Radovanović. Kamilić examines the houses they designed and shows that they were mostly variations of several initial models, which were then changed on a case-by-case basis in order to comply with the owners' wishes. The unity of the whole area was achieved by a shared minimalist treatment of the façades. The modernist idiom in which the houses were built was the result of the residents' interest in affordable practical solutions rather than modernist aesthetics, according to Kamilić. By analyzing historical, social and urban aspects which led to the creation of this housing project, Kamilić demonstrates that the Professors' Colony, built at a time when modernist architectural tendencies were becoming evident in Serbia, can also be seen as heralding new economical and modern living concepts.

Marina Djurdjević reconsiders the architectural opus of the brothers Petar and Branko Krstić, the distinguished architects, who defined various directions of architectural development in Serbia. Designing with success but with different stylistic tendencies, the Krstić brothers achieved a high level of inventiveness as well as diverse creative expression. The Krstićs are recognized as designers of monumental public edifices built in academic and eclectic styles. Nonetheless, Djurdjević posits that their basic calling was modernism. They were active in the Belgrade Group of Architects of the Modern Movement and in the construction of the Professors' Colony. Their modernist vocation is most evident in several residential buildings they designed between 1930 and 1935. These villas, unhindered by rigid demands from

the commissioners of public buildings, reflective of an intimate creative commitment of the Krstić brothers, convey the authenticity of their design and full individuality of their creativity. Hence, Djurdjević advocates for appropriate recognition of the Krstić brothers in the development of modern Serbian architecture.

Nebojša Stanković examines modernist architecture outside Belgrade. He focuses on Niška Banja, a spa near Niš, a major administrative and cultural center of interwar and present day Serbia. A modest resort, Niška Banja evolved into a modern spa in the 1920s and, especially during the 1930s, concurrently with modernist architectural developments in Belgrade and elsewhere. Numerous private villas, several hotels and a public medical center with bath house were constructed in a modernist, geometric and non-ornamental idiom by either established or today unknown architects. Stanković analyzes the urban design of the spa carefully incorporated within a natural mountain slope which reveals yet another local version of site-specific modernism in which natural landscape was highly relevant for urban design. The public medical center with its building and gardens, together with the park, was the focal point of this settlement. Stanković argues that such a configuration was a statement that this spa, intertwined with the issues of health and leisure, was modern and democratic, open to everyone. Inpatients' hotels, a medical center and other public and apartment buildings may have been designed in a modernist international style because of its functionality and low cost. However, villas of upper class residents also built in the modernist idiom reveal increasing interest in modernism as a matter of taste in interwar Serbia. The incorporation of extensive areas of consciously planted greenery eventually resulted in a unified townscape as an embodiment of the idea of the modern spa.

Dejan Zec follows the changes in the field of design and construction of sports grounds and stadiums in interwar Belgrade. He examines the gradual progress from improvised and provisional sporting facilities of early 1920s Serbia to impressively modern and practical designs of soccer stadiums of the late 1920s and early 1930s, replicating the latest trends in stadium architecture in Western and Central Europe that included drainage systems with porous mounds, concrete terraces with seating, impressive frame-constructions for their roofs and special contraptions for spectacular night lighting. Zec points to parallel stadiums and training facilities for the pan-Slavic "Soko" movement in Serbia, closely connected to the era of Yugoslav nationalism and integralism of the early 1930s. Thus, Momir Korunović's temporary stadium, which was built for a one-day event to accommodate 100,000 spectators and then reassembled in a day and its material reused for other buildings, in a way reflects the very modernist idea of the mobility of modular architecture as pioneered in Joseph Paxton's 1854 Crystal Palace in Hyde Park (destroyed in 1936). An integral part of Korunović's stadium, the massive arched music pavilion, was designed in a singular "medieval-modernist" idiom of the

"Serbo-Byzantine" style here reflecting early modernist combinations of modern structure and function with selective but prominently placed traditional decorative forms, not dissimilar to the architecture of the restored Spreckel's Organ Pavilion in San Diego (1915) or Dankmar Adler's and Louis Sullivan's solution for the Auditorium Theater in Chicago (1889). Zec also highlights the interwar acceptance of German forms of neoclassicism embodied by the works of Albert Speer and Werner March. The latter worked on the never realized Belgrade Olympic complex in the late 1930s. This chapter subtly underlines complex developments in sports architecture in interwar Belgrade closely associated with different tendencies in domestic and foreign international politics and economics. At the same time, this text contributes to the understanding of the revival of sport and its modernist idioms and its close relationship to sports architecture, as a world-wide phenomenon and reflection of a new global culture.

<p style="text-align:center">*</p>

Though starting with different premises about modernism in interwar Serbia, focusing on literature, painting, sculpture and architecture, contributors to this volume occasionally cross-reference some of the same accomplishments as well as historical and artistic events that enabled them. Set against the historical background the antonymic notions of Serbia, bridging East and West and being part of the larger world, carried multiple meanings.[6] In geopolitical terms the territory and entity of Serbia was very fluid in the interwar period (1918-1941). Serbia (essentially the Kingdom of Serbia before WWI) was the territory within the Kingdom of Serbs, Croats and Slovenes (1918-1929) that in 1929 became the Kingdom of Yugoslavia (1929-1945) (Map 1). In each case Serbia remained part of the monarchy within a capitalist but essentially agrarian society. The major difference after 1929 was that three ethnic identities were forged into a new identity construct of Yugoslavs (meaning "Southern Slavs" in Serbian). This identity clash between the traditional and the new, indeed, often led scholars to focus on the politics of historical identity in their studies of new, modernist art and architecture in Yugoslavia, occasionally drawing opposing conclusions.[7] Moreover, the dissolution of the Austro-Hungarian and Ottoman Empires during World War I territorially released and expanded interwar Serbia, yet it remained pulled by divergent cultural values of the two former western and eastern empires.[8] Concurrently, it was being pulled by religious opposites—Roman Catholic, Eastern Orthodox and Muslim.[9] Ranging from the national-radical, democratic, peasants' and socialist parties, to the extreme right-wing Ljotić's and extreme left-wing communist parties, national and social political parties often had conflicting values and interests. Intellectuals and artists in Serbia were increasingly aware of Serbia's critical but unstable position in a newly redrawn world map in the interwar period. The complex network of foreign influences and the impact of their politics (tsarist and then communist Russia, Weimar and then Nazi Germany, parliamentarian Great Britain or states

that emerged from conservative Austro-Hungary after WWI) on ideas about the arts and architecture in interwar Serbia cannot be underestimated and deserve special study that is beyond the scope of this volume.[10]

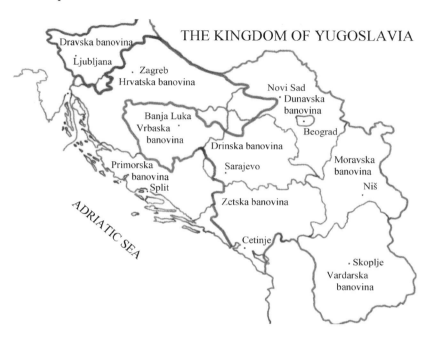

Map 1. Serbia within the Kingdom of Yugoslavia (formerly the Kingdom of Serbs, Croats and Slovenes) with nine administrative units (*banovine*), 1929 (in bold the borders of 1939)

Several themes surface as dominant in this volume, however. For Robinson, Jovanov, Milanović, Perović, Marjanović, Kadijević, Stefanović, Djurdjević, Ćorović, Stanković, and Zec it is above all freedom to experiment and to disengage from the social and creative conservativism that provided the general framework for the development of various forms of Serbian avant-garde movements and modernism(s). Modernist tendencies, chronologically starting with those in literature and poetry, through painting, illustration, graphic design and sculpture, and ultimately reaching architecture, were part of modernist discourse even before WWI. Indeed, according to Nikolaus Pevsner's highly influential book *Pioneers of the Modern Movement*, which reached its fourth edition in 2005, modernism as the new style was fully formed by 1914, on the threshold of WWI.[11]

Yet, the production and reception of modernism in Serbia was thorny and complex. During World War I Serbia lost more than 1,200,000 citizens, including members of its intellectual and artistic elite.[12] Architecture and the arts of an essentially agrarian and traditionalist Serbia were seemingly disconnected from major concurrent developments elsewhere, as foreign travelers and diplomats repeatedly recorded.[13] After the war, victorious Serbia was fueled with optimism and enthusiasm for literal and social rebuilding. The literary and artistic scene seemingly went through all possible styles and avant-garde trends, including divisions between regional and international modernisms, which became increasingly evident in the 1920s and 1930s. By the 1930s, Pevsner in his seminal book *Pioneers of the Modern Movement* and Philip Johnson and Henry-Russell Hitchcock in their Museum of Modern Art catalog and book *The International Style: Architecture since 1922* also proclaimed the universality of a modern-international style in architecture, visual arts and graphic design above all, at a time when modernism was already highly significant in literature, theater and music.[14] In search of innovation and novelty, through the massive, engaged and active transformation of traditional societal and cultural values, modernists turned towards industrialized, progressive and universal (even utopian) realms, eventually breaking from all tradition.[15] Bound to Euro-centric art-historical approaches modernism in the arts and architecture was often discussed from formal (stylistic), socio-political, cultural or historical points of view. In formal terms modernism was characterized by the abandonment of European historical styles and representational values, or simply by the rejection of ornament in favor of plain, geometric and abstract forms. Intellectual, social and industrial revolutions of the eighteenth and nineteenth centuries (the Enlightenment, the French Revolution and various Industrial Revolutions) gradually resonated with the socially engaged modernity and, by extension, with modernist architecture and arts.[16] In the interwar period, focus in the arts and architecture generally shifted from aesthetic pleasure to rationality, functionality and standardization. Unprecedented urban growth, with emergent interest in the middle and working class and feminist and gender issues, gave rise to new urban schemes (Garden City, City Beautiful, *Ville Contemporaine*) with new types of buildings in architecture (including social housing or specialized hospitals, schools and sports architecture) and new themes as a way of proclaiming socio-political agendas in the visual and other arts. New building and art techniques, mass-production, and the rise of the industrial aesthetic devoid of academicism and historicism followed.

After the 1930s modernism was often defined as an anti-traditional, anti-historical or even a-historical movement. Yet, in its essence the formative phases of modernism remained Euro-centric and the so-called regional modernisms, as distinctive but not necessarily derivative modernisms in the arts and architecture (such as German Expressionism, Czech Cubism, French Purism, the Dutch De Stijl, Spanish Art Nouveau, Munich or Vienna Secessions),

have prevailed in scholarly discourse since the 1920s.[17] "Transitional" and "regional" steps towards modernism were highly complex and not easily definable. For example, Carl Schorske magisterially examined the utilization and relativization of history in the cultural construction of modernism and simultaneous transformation and rejection of traditional cultural legacies in the quest for modernity in Vienna, which influenced both complementary and opposing versions of modernism(s) in Czechoslovakia, Hungary and Serbia.[18] As in other parts of Europe, in Serbia this re-labeling of the regional modernism(s) from a positively into negatively perceived idiom occurred during the politically and economically turbulent years of the 1920s and the 1930s.[19] In addition, the transition of Serbia from the Kingdom of Serbs, Croats and Slovenes into the Kingdom of Yugoslavia in 1929 with its consequent political ramifications coincided with both the economically devastating Stock Market Crash and the concurrent cultural impact of a fuller recognition, if not acceptance, of international modernist art worldwide. The shared contemporaneity of these events also placed modernism in the arts and architecture in Serbia "on the very edge" of geographical and cultural space. Thus modernist tendencies in Serbia and here presented their complexities, between regional and international values, belonged to wider phenomena and were not historically-chronologically or culturally belated, but with their punctual occurrences, multi-focal interests and unstable historical narratives remained marginalized in scholarly discourse.

As evidenced, as early as the latter part of the nineteenth century modernist concepts reached Serbia most often indirectly through the travels and foreign training of their major proponents in various centers of Europe with their own versions of modernisms. Architects were most often trained in Prague and Vienna, painters and sculptors and those working in the applied arts also studied in Paris, Munich, Zurich, Rome and London. The emerging intellectual and creative elite in post-war Serbia, trained in major European centers, often engaged in heated public debates about modernism and its meanings.[20] Curiously enough, most often upon their return to Serbia, they did not maintain personal or professional connections with the leaders · of avant-garde and modernist movements abroad. Much stronger connections existed among those artists, architects, poets, writers, sociologists, urban planners and occasionally politicians interested in modernist ideas within Serbia and Yugoslavia. Modernity was embodied first in private initiatives and small-scale projects and eventually expanded to public projects that received governmental support.

The unstable and edgy narrative of modernism in Serbia, one not always in accord with contemporary discussions on modernism, is also due to the scarcity of preserved accomplishments from the period and the general lack of manifestos and written accounts of the activities of individual artists and art groups. Modernist art groups, as here presented by the group "Oblik," often did not have any official documents about their mission and

aims, which seemingly fluctuated greatly. While the avant-garde movement of Zenistism had a manifesto, its mission and activities were broad, displaced and inconsistent. Perhaps, paradoxically, they were consistent only with the very definition of avant-garde as experimental and completely open to any form of creative expression. In their construct of being "the other," – the "barbarogenius,"[21] who resisted "cultivation" and thus preserved the uncorrupted and unconsumed "self" within the separate, disconnected territory of the Balkans proclaimed as the "sixth continent,"[22] – Zenitists declared the Balkans an independent cultural center but risked their role within the larger discourse. Eventually even El Lissitzky, who in 1922 participated in a special issue of *Zenit* dedicated to the Russian new art and architecture,[23] dismissed Zenitism as irrelevant.[24] In their construct of conquering the "other," Zenitists, only seemingly remained linked to European colonial values.[25] On the contrary, in their creative discourse in poetry, literature, visual arts, graphic design, architecture, theater, film and music, either via its journal *Zenit* published in numerous languages or via its peripatetic discourse with *others*, as presented by Perović and Marjanović respectively, Zenitists were most direct participants in contemporaneous modernist trends and cultural networks that operated beyond political and geographical boundaries. Never managing to fully materialize their ideas, nonetheless Zenitists closely aligned themselves with the avant-garde – which preceded both the after-developments of international modernism and the emergence of what is now called global art.

The issue of coloniality of power, social and gender orders as well as forms of knowledge as a departure point for postcolonial studies in the arts and as a part of the discourse on Serbian modernism emerges in several contributions. The authors who deal with gender and social issues advocate the abandonment of "biographical tokenism" characterized by superficial introduction of a few female or "other" names into a scholarly discourse. Rather, they focus on the recognition of their innovative, transformative and active involvement in egalitarian discourse as a feature of modernity. Milanović and Tomić develop a discussion of the epistemic identity *Self-and-Other* binome in artistic and literary work by female painter Milena Pavlović-Barilli and feminist writer Jelena J. Dimitrijević, respectively. Milanović discusses the motif of the veil in Pavlović-Barilli's work as an ambivalent construct closely associated with dense and contradictory notions of self and other, private and public, power and desire, tradition and modernity. Tomić emphasizes a postcolonial political message of understanding and enriching of *Self* through the *Other* as evidenced in Dimitrijević's work. Tomić also concludes that Dimitrijević's identity construct succeeded because of her privileged upper-class background that granted her autonomy. Novakov further examines a complex matrix of coloniality of social and gender orders and education in her work on the architectural design of schools (for girls, for boys, and coeducational) in interwar Serbia. Perović and Marjanović

discuss Zenitism from various points of view, yet both emphasize the concept of "otherness" as an important qualifier of this controversial movement and its activities in interaction with or against the *Other*. Tomić and Ćorović in their scholarly methodologies use a postcolonial approach. Tomić discusses Dimitrijević's travels to non-Western parts of Europe, to America, Africa and Asia and her interest in feminism there. Similarly, Ćorović highlights the incorporation of Serbian and non-Serbian traditions in experimental settlements in interwar Serbia and juxtaposes various colonies as different versions of the modernist Garden City concept in Serbia not only with its manifestations in Europe and America but also with those in Egypt and Japan.

Various questions regarding the reasons for and the extent of the incorporation of modernism in Serbia remain. Indeed, some modernist accomplishments such as the largely understudied Expressionist architecture or applied arts in interwar Serbia were rather conventional. More often they were also intellectual and conceptual, as Robinson, Milanović, Perović, Ćorović, Tomić, Novakov and Marjanović argue in their essays. Then again, formal elements of modernist works, and especially those in architecture and urban design can be connected to economics, which is a recognized feature of interwar European modernism. In impoverished and patriarchal interwar Serbia, where approximately 80-85% of residents lived on the verge of or below the poverty line and the literacy rate was approximately 60% (only 30% for women), government support for the development of arts and architecture was either minimal or non-existent.[26] Artists most often did not sell but gave away their works as gifts.[27] Support for architecture was mostly nominal.

There is both a relative scarcity of surviving textual and material evidence on interwar creative thought and specific accomplishments and a growing need for more nuanced integrative studies on topics of interwar culture in Serbia that would investigate in detail what Piotrowski calls "the apparatus," which reveals the ways in which modernism was promoted, implemented and received.[28] Thus, it remains somewhat unclear to what extent various singular modernist solutions in interwar Serbia were due to the need for fast and affordable, literal and social rebuilding after the Great War rather than to ideological concerns – aesthetic or socio-political. Djurdjević, Ćorović, Kamilić, Stanković, Popović and Zec open the archives within and outside Serbia and reveal often rigid requirements of the investors, who beyond pure profitable pursuit either lacked clear and consistent objectives and criteria for competition regulations in the case of public projects or habitually preferred eclecticism and academism. For Novakov, Ćorović and Kamilić, non-ornamental, modernist architecture in Serbia is related not so much to international trends in architectural design as to financial constrains in impoverished interwar Serbia. In other words, modernist architecture with its simple geometric design, devoid of extensive decorative features was an

efficient way to minimize costs. Despite these daunting socio-economic challenges there was an unprecedented receptivity to experimentation and diverse forms of artistic expression. This is especially highlighted in small-scale private projects, as Djurdjević and Stanković subtly reveal in their studies of modernist villas built in Belgrade and Niš in the 1930s. Through the examples of the Iguman's Palace and the Agrarian Bank Palace in Belgrade that produced a storm of controversy because of their overly bold breakthrough of modernism in the city center, Djurdjević unravels the story of how, despite the strict demands and constant surveillance of the investors, the Krstić brothers succeeded in re-negotiating the inclusion of modernist ideas and forms in their projects.

Robinson, Tomić, Milanović, Popović, Novakov, Kadijević, Stefanović, Ćorović, Kamilić and Zec also emphasize the role of cultural background and education in the reproduction of inherent and adopted values, sometimes coming to opposing conclusions. The first generations of artists working in the modernist idiom were often trained in major European centers of modernism and participated in international exhibitions; others remained immersed in books, films and other media that promoted modernism. Yet despite their engagement in modernist idiomatic thoughts and artistic production, many stayed on the margins of modernism because they were not active participants in "orthodox modernist" trends. While the propagators of modernism and the general public were fully aware of the Bauhaus school including the fact that in 1926 *Zenit* announced eight Bauhaus' publications such as Walter Gropius' *International Architecture*, Paul Klee's *Pedagogical Sketchbook*, and László Moholy-Nagy's *Painting, Photography, and Film* – no Serbian artist – male or female alike – ever attended the school. While the notions of health, hygiene and sports in interwar architecture in Serbia allude to Le Corbusier's ideas of fitness, cleanliness and new architecture set in parks, as evidenced in Stanković's and Zec's contributions, there is no historical evidence of active involvement of Serbian architects with his theories and architectural opus.[29] Rather, Zec shows, for example, how the pan-Slavic theory of the Czech "Soko" (Falcon) movement emphasizing physical fitness and national readiness and the revival of the Olympic Games informed the building programs of some stadiums in interwar Serbia. Similarly, those working in applied arts were seemingly not attracted to Le Corbusier's ideas on functional furniture, "equipment for living" (*équipments de l'habitation*) derived from his concept of a house as "a machine for living in."[30] Popović shows how, because of the widespread distribution of women's popular and fashion magazines in interwar Serbia, the avant-garde textile designs of Sonia Delaunay were known to Belgrade artists. Yet, their aim was the integration of traditional and modern elements in their own work as a way to moderate modernity with local identity.

Richard Etlin and Michelangelo Sabatino, for example, have already discussed the vernacular and traditional historical architecture as significant references in the contextualized

understanding of Italian interwar modern architecture.[31] The continuity of traditional values within modernist European arts and architecture moderated their identity in local areas and defined various "regionalism(s)."[32] In Serbia, such complex pluralistic relationships in search of innovative solutions between tradition (classical or medieval; regional, vernacular, or academic) and modernity are especially highlighted in the chapters by Robinson, Popović, Tomić, Milanović, Novakov, Kadijević, Djurdjević, Stefanović and Zec. Thus Robinson, Milanović, Novakov, Kadijević, Stefanović and Zec also reveal that modernity was not necessarily in stark opposition to tradition, but rather that it incorporated the perceived aesthetic, social and spiritual harmony of the national and cultural past in searching for innovative solutions. As such, these works were outside of Bauhaus' paradigm, yet they deserve their place within the pluralistic maps of modernism(s).

Kadijević and Stefanović further see undeserved marginalization of Expressionism in modernist architecture in the fact that professors such as Nikola Dobrović or Milan Zloković, who taught architecture at Belgrade University after WWII, adopted the International Style as the only true modernist idiom and strongly discouraged training in other versions of modernist architecture or studies of their historiographies. Ćorović, Kamilić and Stanković similarly emphasize the importance of newly formed values and commitment of university professors and prominent individuals in the dissemination and reinterpretation of the Garden City concept or private houses built in a modern style throughout Serbia. Kadijević, Stefanović, Novakov, Zec, Stanković and Ćorović also highlight understudied interplay of modernist design in architecture and urban planning with nature and landscape in functional and semiotic terms ranging from heroic expressiveness to containment and sincere interest in the incorporation of everyday life, education, sports, health issues and leisure in the increasingly modernist landscape of interwar Serbian society.

Therefore, the interdisciplinary approach of this volume aims to narrow the gaps in the studies of modernism(s) and regional idioms. Already by the 1960s it had become obvious that even if modernism became the mainstream movement in the arts and architecture, it had failed to respond to the heroic, universal, a-historical ideas of international modernism resulting in the reformation of modernism(s).[33] Architect Alexander Tzonis and architectural historian and theoretician Liane Lefaivre initiated critical regionalism as a way of Kantian critical thinking in place-specific architecture, which emerges from the architects' critical response to physical, social and cultural specifics of the given locale – "region."[34] Kenneth Frampton, architect and architectural historian, further promoted studies of critical regionalisms in architecture that contested colonialness of power of international modernism based on a premise of a dominant cultural center and subjugated satellites.[35] According to Frampton, critical regionalism is a self-conscious marginal practice distanced from overarching and utopian

universal modernism while still adhering to emancipating modernist values.[36] In that context, site-specific and temporal accomplishments actively engage factors, such as topography and territory in its historical context, and critically reinterpret and incorporate vernacular elements (domestic or trans-cultural; formal or technological) into regional modernisms that in turn achieved "a relevant form of contemporary practice."[37] Following various theoretical frameworks from the Marxist's Frankfurt School (Walter Benjamin, Jürgen Habermas) to the Structuralism of French critical theory (Claude Lévi-Strauss, Michel Foucault, Roland Barthes, Jacques Derrida), scholars of modernist (especially post-WWII) developments have brought forward various discussions about "other" modernisms: "national" modernisms, "second modernism(s)," "second world" modernisms, "modernisms in-between" and post-modernism(s).[38] Without going into detailed discussion on these various labels for "other" modernisms, it is worth noting that some of the regional modernisms, including, for example, modernisms in Turkey, Greece or Serbia, are receiving their due contextualized scholarly attention often some hundred years after the inception of modernism and its interwar formative phases.[39] Paradoxically, it was exactly in the interwar period that the development of these various local, regional and national modernisms overlapped with the cessation of avant-garde movements and the formation of the International Style. Such historically compressed developments in increments of some 20-30 years further confirm the possibilities for punctual and individual artistic incidents of regional modernisms with their own peculiarities that are often related to traditional values and later removed from major discussions of modernism. Although ubiquitous in a scholarly discourse, modernism in the arts and architecture and assertions of its universality and regional variants are far from being fully understood.

Thus far, modernism in the arts and architecture in the cultural space of interwar Serbia (1918-1941) has been studied independently or within wider geographical and cultural contexts by using various theoretical frameworks.[40] For example, in her invaluable book Ljiljana Blagojević examines the modernist identity of interwar Belgrade architecture and promotes its value within the studies of regional modernisms.[41] In concert with the standard definition of modernism, she begins by examining the role of Le Corbusier with respect to Serbian modernism and concludes that it was nominal and theoretical at best.[42] Le Corbusier visited Serbia during his journeys to the East in 1911. As a 24-year-old he openly revealed an aversion to what he saw in Belgrade and other parts of pre-World War I Serbia, which he generally characterized as "folklore."[43] He expressed partial interest in traditional vernacular pottery, textiles, music and red wine.[44] Le Corbusier's and the disinterest of other canonical figures of modernism in architecture and arts in Serbia would later become important. For example, Le Corbusier's influence on modernism(s) in Brazil where, during the interwar period, he actively collaborated with Oscar Niemeyer, who then became another canonical

figure of socially engaged and formal modernism, is undeniable.[45] The disconnection of the modernist idioms of interwar Serbia from canonical proponents and practitioners of international modernism contributed to the marginalized place of modernism in Serbia in scholarly discourse for a prolonged period.

Indeed, this marginalized place of modernism in Serbia cannot be attributed only to language barriers as there are a number of books addressing the topic in English, the major language used in historical and theoretical discourses today.[46] Rather, the "provincial" status can be associated with prevailing studies of modernism examined through the lenses of artistic production and reception valued against the prevailing philosophical constructs that originate in Western European thought and are based on notions of originality and authority. For example, James Elkins critiqued Steven Mansbach's seminal book which, despite its invaluable value as a pioneering study on East European art written in English, highlighted the lack of originality and artistic quality in the works he analyzed.[47] The fact that many authors in interwar Serbia for various reasons failed to communicate with their international colleagues points to what we can justly call "parochialism", whether it is set in any center, acknowledged or self-proclaimed. With the rise of pluralist studies of cultural geographies, the established canons are being adjusted. Here, it is important to highlight that despite cultural and political instability, and above all the economically underprivileged setting of interwar Serbia, many artists did exhibit their works nationally and internationally. Their works were a genuine response reflective of the cultural contexts they brought with them while working abroad or within the local contexts where they searched for modernist innovations. For example, in April 1924 Zenitists organized *The First Zenitist International Exhibition of New Art* in Belgrade; and in the same year presented their works at the international exhibition in Bucharest. In 1926 Zenitists exhibited at the Moscow exhibition of *The Revolutionary Art of the West*, organized by the State Academy of Art Studies VOKS (VOKS being the abbreviation in Russian for the "All-Union Society for Cultural Relations with Foreign Countries"). The art group "Oblik" exhibited in Prague, Sofia, Plovdiv and Thessaloniki during the economically daunting 1930s. Moreover, the texts by a philosopher and major promoter of avant-garde art and architecture in Serbia, Ljubomir Micić, were written in a dozen languages including the easy to learn and politically neutral language, Esperanto, which was invented with the hope of transcending national boundaries and fostering understanding between people who spoke and communicated in different languages. In 1922 the entire double issue of the journal *Zenit* 17/18 was dedicated to Russian avant-garde art and edited by El Lissitzky and Ilya Ehrenburg. The *Zenit* journal was distributed internationally, reaching beyond Europe. It was sent to museums and galleries in New York and San Francisco[48] until the journal was shut down in 1926 by the regime because of the Zenitists' open praises of the October Revolution and

Bolshevik society. Less known is that Micić also initiated a nationalistic journal *Srbijanstvo* in 1940, which was closed down after its first issue by the Cvetković-Maček government.[49] Therefore, the ideological, often paradoxical background of the major proponents of the avant-garde in Serbia should not be used exclusively and asymmetrically to shed light on the meanings of interwar attempts and accomplishments at the expense of the autonomy of individual works.

The authors of this volume avoid partisan scholarship and politicized discussions in their aim to understand interwar modernism and modernity in Serbia within its own cultural context. The proponents of these developments were themselves deeply aware of such controversial and superficial approaches. For example, in 1931 Nikola Dobrović, an architect and major proponent of modernist International Style architecture in Serbia, in his treatise *In Defense of Modern Architecture* (*U odbranu savremenog graditeljstva*) argued for his view of modern architecture as a social and cultural construct.[50] He juxtaposed functional, rational and structural aspects of modernist design with the decorative, *l'art pour l'art* and anti-social styles of eclecticism and some early modern movements such as Secession, Cubism and Jugendstil. With respect to the potential for politicized modernism with aggravating consequences, Dobrović, a leftist himself wittingly remarked:

> And another thing. In contemporary architecture, in terms of construction methods there is no *right-left*. It is an awkward political expression … There are only modern and non-modern experts. It seems that this awkward phrase *right-left* somehow passed as an image from politics to architecture, which is supposed to underline a fact. The Bolsheviks in Russia exploit for their own purposes and for achieving their own aims the most modern ways of building, the most modern and most rational technology, and in general, they try to use the latest results of the entire world. Whether architecture is *rightist* or *leftist* only the social environment of the construction and the function of a building perhaps may determine. In Russia, for example, collective buildings which respond to the socialist order of the state and society could be leftist … In the rest of the world therefore architecture would remain right-wing regardless of the methods used.[51]

Even when recent scholarship significantly remapped the territories of modernism, most studies remained trapped within the power-relations constructs of center-and-periphery framed by the ideas of the founders, propagators and defenders of "orthodox modernism."[52] This volume does not claim to be able to escape this construct. If for no other reason, then simply because what may be conceived as a center of artistic processes in a given cultural

territory would still be perceived as "localism" by its "outsiders," who are situated in often "self"-proclaimed "centers" that defined the prevailing scholarly constructs of center-and-periphery in the first place. This volume also aims to avoid the "parochialism," which disengages from communication with "outsiders," and highlights some of the networks of modernism and modernity that engage with and through its "other." It is significant to note that Zenitism and Micić's theories of modernity against and through the *Other* resonate with the narrative and the earliest stages of "other-ness" in subaltern and post-colonial studies that became prominent in academic discourse only after the 1970s, with the "heterotopias" of Foucault or "heterologies" of Michel de Certeau.[53] Micić's Zenitist fight for the "Balkanization of Europe"[54] from 1923 argued for equal cultural treatment of Western Europe and its "close other" in the Balkans, in the same manner Dipesh Chakrabarty's "Provincializing Europe"[55] from 2000 argued for the recognition of the European culture as being one of many and equal among "the other," non-European cultures.

Through empirical studies as epistemological means this volume also highlights the advantages and disadvantages of the prevailing methodologies in the studies of modernism and modernity, including its iconoclastic versions. Thus, the contributors aim to further the understanding of the complexities of modernity and modernism within their semantic and geo-historical frameworks. Even if the selected case studies did not make their mark on the early maps of modernism, it seems that modernism(s) in Serbia were not mere derivatives of their Western-European versions.[56] Interwar Serbia shared modernist values of social reform, interest in scientific and technological advancements, and everything "new." At the same time there was a multidirectional flow of ideas and shared cultural values from other parts of Europe, Asia, America and Africa, as several contributions in this volume demonstrate. Contemporaneous networks further confirm that there was an intellectually engaged involvement with modernism that went well beyond its merely uncritical and mechanical consumption.

The question of "truth in architecture" as propagated by Le Corbusier, and by extension relatable to his view of Belgrade as "dishonest, dirty, and disorganized,"[57] may be juxtaposed with modernist pluralisms in architecture and the arts. Lena Jovičić speaks about interwar Belgrade as the "concrete city," with concrete, presumably modernist buildings. She mentions a "few buildings that please the eye," yet it remains unclear whether she was referring to those traditional or modernist buildings that achieved aesthetic integrity. Michel de Certeau's study of culture in the plural is critical because egalitarian modernity opened opportunities to a wide spectrum of people to voice their opinions.[58] As he showed elsewhere, these other voices were often lost during the colonial process and act of writing their own history while simultaneously "un-writing" histories and traditions embodied in other, regional contexts.[59] By

drawing from de Certeau's studies, Andrew Ballantyne has already proposed a variety of ways of applying pluralist methodologies in conceiving and studying modernism in architecture.[60] He is concerned not only with the transmission of approved forms but also with constant reinvention and experiment, which is not necessarily in opposition to traditional values within a culture. Ballantyne also highlights how different histories could have been written based on selected modernist values that frame such discussions, including corporate capitalism, technological innovations, sustainable design, cultural or egalitarian socio-political values.[61] Thus Le Corbusier's, Jovičić's and Dobrović's voices resonate with both the complexities and contradictions of modernism as exemplified by Belgrade, the capital and major cultural center of Serbia at the threshold of politically defined West and East. In the highly politically charged interwar Serbia, arts and architecture were occasionally used as political tools, and the stark sociopolitical changes after WWII politicized them and further obscured their historiographical studies. Modernism and modernity were associated with the creation of yet another, new – though essentially "second," – Tito's Yugoslavia,[62] while architecture and arts of the past became associated with defeated past regime(s) and opposing cultural values. The authors of this volume thus accept de Certeau's and Ballantyne's open-system methodological framework of closely related pluralistic actual artistic accomplishments and factual data rather than framing their case studies in singular, preconceived and strictly defined idioms. Such an approach allowed for unexpected revelations of the "paradoxical" developments of modernism in interwar Serbia which are conceptually strongly related to the similar synchronic occurrences elsewhere.

The case studies presented here consider this diversity in modernist accomplishments and, therefore, question its marginalization in the context of cultural, regional and gender-related factors. This volume does not provide a definitive assessment of interwar modernism(s) in this part of the world. Nor is its aim is to suggest decisive conclusions and singular framework with respect to its regional character relative to global trends. Rather, by juxtaposing well-known and unfamiliar material, this volume is a contribution to further discussions about diverse creative processes that operated "on the very edge" of both modernist and geo-political spaces and their relevance not only for historical studies of arts and architecture but also for artistic practices and their studies today. The authors also focus attention on collaborative partnerships (artistic, familial and political) and their understudied role in the development of the vibrant and intertwined Serbian artistic scene within wider cultural networks. Our volume demonstrates how the artistic scene in interwar Serbia often embraced and occasionally transformed modernist innovations linked to questions of feminist rights, intellectual and artistic identities, and which, albeit prematurely, announced diversified interests in globalism(s) and pluralism(s).

Notes

1. Lena A. Yovitchitch, *Peeps at Many Lands. Yugoslavia* (London: A. & C. Black Ltd., 1928), 7-11. See also: David A. Norris, *Belgrade. A Cultural History* (Oxford: Oxford University Press, 2008), 204-205 with a citation and reference to Jovičić's book.

2. The "close other" for Piotr Piotrowski refers to the European other, often defined as "Eastern European" in political terms, despite the fact that architecture and the arts, including the methods of their study developed under the same umbrella as Western European traditions. In that context, the "close other" is not the "real other" as in Southeast Asia or Africa, yet its narratives are marginalized either for socio-political reasons or simply because of pragmatic issues. The most prosaic reasons belong to language barriers because narratives were not written in widely used English in historical studies of arts and architecture, but rather in local languages, thus obscuring the communication both among protagonists of modernist developments and scholars who study them. Piotr Piotrowski, "On the Spatial Turn, or Horizontal Art History," *Umeni / Art* 5 (2008), 378-383, reprinted as shorter versions "Towards Horizontal Art History," in *Crossing Cultures. Conflict, Migration, and Convergence*, ed. Jaynie Anderson (Melbourne: The Miegunyah Press, 2009), 82-85 and "Towards a Horizontal History of the European Avant-Garde," in *Europa! Europa? The Avant-Garde, Modernism and the Fate of a Continent*, eds. Sasha Bru et al. (Berlin: De Gruyter, 2009), 49-58.

3. Communication with James Elkins Chapter 1, "Principal Unresolved Issues" Section 5 On the Terms "Central," "Peripheral," and "Marginal" Draft, October 4, 2013, in *North Atlantic Art History and Worldwide Art* https://docs.google.com/document/d/1uqzIEZXcko3f7AbeVr51Boevbl-_s-7cI_1p72P5-RI/pub

4. While operating under the well established distinction between modernity, as a larger conceptual phenomenon related to novelties in post-traditional societies, and modernism, as a particular set of movements and attitudes in arts and architecture, this book brings forward several case studies that also highlight various connotations of modernity and modernism, which are not necessarily derivatives of Western-European phenomena. On modernism as an essentially Western European phenomenon, which was fully formed at the end of the 19th and mid-20th centuries see, for example: "Modernism," in Grove Art Online. Oxford Art Online, http://www.oxfordartonline.jproxy.lib.ecu.edu/subscriber/article/grove/art/T058785 (accessed July 21, 2011).

5. On the misrepresentations of Serbs in the West see, for example: Tomislav Longinović, *Vampire Nation: Violence as Cultural Imaginary* (Durham: Duke University Press, 2011).

6. See, for example: Ivana Dobrivojević, *Državna represija u doba diktature kralja Aleksandra 1929-1935* [State Repression During the Dictatorship of King Aleksandar 1929-1935] (Belgrade: Institut za savremenu istoriju, 2006); Sima M. Ćirković, *The Serbs* (Malden, MA and Oxford: Wiley-Blackwell, 2004); *Novija istorija srpskog naroda* [Recent History of Serbian People], ed. Dušan T. Bataković (Beograd: Vojna štamparija, 2000); Stevan K. Pavlowitch, *A History of the Balkans, 1804-1945* (London and New York: Longman Publishing Group, 1999); Branko Petranović, *Istorija Jugoslavije* [History of Yugoslavia], vol. 1 (Beograd: Nolit, 1988).

7. For example, Tanja Damljanović, *The question of national architecture in interwar Yugoslavia: Belgrade, Zagreb, Ljubljana*, Ph.D. Thesis Cornell University, 2003 (forthcoming as a book) demonstrates that a variety of modernist expressions in architecture do not support the national distinctiveness of either Serbian or Yugoslav architecture, and that notions of various national architectures are essentially a product of architectural historians that cannot be supported by architecture. Aleksandar Ignjatović, *Jugoslovenstvo u arhitekturi 1904-1941* [Yugoslavism in Architecture 1904-1941] (Beograd: Gradjevinska knjiga,

2007) claims that modernist architecture in the interwar period was an active and constitutive part of representing and materializing the national idea of Yugoslavism. For various approaches to this highly complex question see also, S[teven] A. Mansbach, *Modern Art in Eastern Europe: From the Baltic to the Balkans, ca. 1890-1939* (Cambridge: Cambridge University Press, 1999); *Impossible Histories: Historic Avant-Gardes, Neo-Avant-Gardes, and Post-Avant-Gardes in Yugoslavia, 1918-1991*, eds. Dubravka Djurić and Miško Šuvaković (Cambridge, MA: MIT Press, 2003).

[8] Formerly part of the Ottoman Empire, Serbia was officially recognized as an independent state in 1878, and four years later proclaimed a Kingdom. In 1918, following the collapse of the Austro-Hungarian Empire, the region of Vojvodina, where Serbs were in the majority, became part of the Kingdom of Serbia.

[9] In a simplified way it may be stated that the Serbs were predominantly Christian Orthodox, while the people who lived in the territories of the Ottoman and Austro-Hungarian Empires were Muslims and Roman Catholics, respectively. The Jews and others constituted a minority.

[10] For some major references, see: *Novija istorija*, ed. Bataković, 303-306; Ljubodrag Dimić, *Kulturna politika u kraljevini Jugoslaviji 1918-1941* [Cultural Politics in the Kingdom of Yugoslavia 1918-1941], vol. 1. *Društvo i država* (Beograd: Stubovi kulture, 1996).

[11] Nikolaus Pevsner, *Pioneers of the Modern Movement* (1936, New Haven and London: Yale University Press, 42005), especially chapters 6 and 7. Other scholars followed this concept before offering alternative methods for studying modernism. See, for example, a highly influential book that reached four editions and translations into numerous languages: Kenneth Frampton, *Modern Architecture. A Critical History* (London and New York: Thames and Hudson, 2007 [1980]).

[12] Actual numbers vary in different sources. According to Vladimir Stojančević, *Srbija i srpski narod za vreme rata i okupacije 1914-1918. godine* (Leskovac: Narodni muzej u Leskovcu, 1988), 55, the total number is around 1,175,000. Aleksandar Nedok and Milisav Sekulović, "Epilog Prvog svetskog rata u brojkama," *Vojnoistorijski pregled* 65 (2008), 98 report the total number as 1.247.435 or 28% of population of Serbia in 1914. Most historians agree that approximately 25% of the population of the Kingdom Serbia was lost in WWI.

[13] See, for example, David A. Norris, "Slavija, Englezovac and the Vračar Plateau: Belgrade under a Foreign Gaze," in *Belgrade. A Cultural History* (Oxford: Oxford University Press, 2008), 189-205.

[14] Nikolaus Pevsner, *Pioneers of the Modern Movement from William Morris to Walter Gropius* (London: Faber & Faber, 1936) and Philip Johnson and Henry-Russell Hitchcock, *The International Style: Architecture since 1922* (New York: Norton, 1932).

[15] "Modernism," in Grove Art Online. Oxford Art Online, http://www.oxfordartonline.com.jproxy.lib. ecu.edu/subscriber/article/grove/art/T058785 (accessed July 21, 2011). Pevsner canvassed the formation of modernism in the arts and architecture starting with the socially engaged art of William Morris and his followers, through the technical innovations of pre-fabricated, modular, and standardized solutions of 19th-century engineers, to the final break with the past in the accomplishments of the Bauhaus and the formation of the so-called International Style. In support of the universality and rationalism of modernism Pevsner devised a canonical claim when he drew a parallel between World Modern styles and French Gothic, as yet another Western-European phenomenon that was embraced, reinvented, and transformed globally over time. Pevsner, *Pioneers*, 27.

[16] The historical development of modernism as a social matter can be traced back to the projects of modernity of the Enlightenment and pushed as far back as to the 1500s, to the Renaissance: Walter D. Mignolo, "Coloniality: The Darker Side of Modernity," in *Modernologies. Contemporary Artists Researching Modernity and Modernism*, eds. Cornelia Klinger and Bartomeu Mari (Barcelona: Museu d'Art Contemporani de Barcelona, 2009), 39-49.

[17] "Modernism," in Grove Art Online. Oxford Art Online, http://www.oxfordartonline.com.jproxy.lib. ecu.edu/subscriber/article/grove/art/T058785 (accessed July 21, 2011), with references.

[18] Carl Schorske, *Thinking with History. Explorations in the Passage to Modernism* (Princeton: Princeton University Press, 1998).

[19] Compare with conclusions in Leen Meganck, Linda van Santvoort and Jan de Maeyer, eds., *Regionalism and Modernity, Architecture in Western Europe 1914-1940* (Leuven: Leuven University Pres, 2013).

[20] See, for example: Branislav Kojić, *Društveni uslovi razvitka arhitektonske struke u Beogradu 1920-1940. godine* [Social Conditions for the Development of the Architectural Profession in Belgrade 1920-1940] (Belgrade: Srpska akademija nauka i umetnosti, 1978); Zoran Manević, *Serbian Architecture 1900-1970* (Belgrade: Museum of Modern Art, 1972).

[21] In their first manifesto Zenitists proclaimed the barbarogenius as a vehicle of new art. Ljubomir Micić, "Zenit Manifest," *Zenit* 11 (Feb. 1922), 1.

[22] Ljubomir Micić, "Makroskop: Pet kontinenata" [Macroscope: Five Continents"], *Zenit* 24 (May 1923), n.p. and Lioubomir Mitzitch, "Avion sans appareil: poème antieuropéen," *Zenit* 37 (Nov. / Dec. 1925), n.p.

[23] Ljubomir Micić, El Lissitzky and Ilya Ehrenburg, "Ruska nova umetnost" [Russian New Art"], *Zenit* 17/18, Sep. / Oct. 1922.

[24] Esther Levinger, "Ljubomir Micić and the Zenitist Utopia," in *Central European Avant-Gardes: Exchange and Transformation, 1910-1930*, ed. Timothy O. Benson (Cambridge, MA: MIT Press, 2002), 260-278.

[25] Perhaps this Zenitist anticolonial approach may also account for its reconsideration in recent discourse on modernism. Levinger, "Ljubomir Micić and the Zenitist Utopia," 260-278, Darko Šimčić, "From Zenit to Mental Space: Avant-garde, Neo-avant-garde, and Post-avant-garde Magazines and Books in Yugoslavia, 1921-1987," in *Impossible Histories,* 294-310.

[26] Percentages are here averaged according to the data for four administrative units (*banovine* of Drina, Danube, Morava, and Belgrade) of interwar Yugoslavia which remained in the territories of modern Serbia. Dimić, *Kulturna politika*, 56.

[27] See for example, Krista Djordjević, "Osnivanje i delatnost udruženja prijatelja umetnosti 'Cvijeta Zuzorić'," in *Beograd u sećanjima 1919-1929* [Belgrade in Memories 1919-1929], ed. Milan Djoković (Beograd: Srpska književna zadruga, 1980), 76-83, esp. 80.

[28] By focusing on post-communist Europe, Piotrowski borrows Louis Althusser's term "state apparatus" to emphasize the importance of specific institutions and their concrete functions in shaping art and architectural culture in a given state. In that regard, the notion of ideology as a set of ideas and values and the specific ways in which they are related to the creative freedom or its control by various institutions, is removed from the strictly Marxist definition of ideology as an illusion, but rather belongs to historical and material realities. By examining contextually individual cultural occurrences in real-life circumstances such an approach allows for better understanding of subtle differences in the production and reception of art and architecture even under the same political regimes. Piotr Piotrowski, *Art and Democracy in Post-Communist Europe* (London: Reaktion Books, 2012), 80-124.

[29] At least three architects from Serbia worked in Le Corbusier's studio in the 1930s, but only one of them, Milorad Pantović (1910) became a leading architect after WWII, working predominantly on large-scale civic projects in pre-stressed concrete. *Wolfgang Thaler, Maroje Mrduljaš, Vladimir Kulić, Modernism In-between The Mediatory Architectures of Socialist Yugoslavia* (Berlin: Jovis, 2012), 25, with reference to Dogo Zupančić "Plečnikovi studenti pri Le Corbusieru," *ab* 185-7 (2010), 22-27.

30 See the latest translation of Le Corbusier's text *Vers une architecture* published originally in 1923: Le Corbusier, *Toward an Architecture. Text and Documents* (Los Angeles: Getty Research Institute, 2007), 151ff, 161ff.

31 Richard Etlin, *Modernism in Italian Architecture, 1890-1940* (Cambridge, MA: MIT Press, 1991), 165-376; Michelangelo Sabatino, *Pride in Modesty, Modernist Architecture and the Vernacular Tradition in Italy* (Toronto: University of Toronto Press, 2010), 57-127.

32 See, for example, Meganck, van Santvoort, and de Maeyer, eds., *Regionalism and Modernity*, 2013.

33 Anthony Giddens, *The Consequences of Modernity* (Stanford: Stanford University Press, 1990); Christopher Crouch, *Modernism in Art, Design and Architecture* (New York: St. Martin's Press, 1999).

34 Alexander Tzonis and Liane Lefaivre, "The Grid and the Pathway. An Introduction to the Work of Dimitris and Susana Antonakakis, With a Prolegomena to the History of the Culture of Modern Greek Architecture," *Architecture in Greece* 15 (1981), 164-178.

35 Kenneth Frampton, "Towards a Critical Regionalism: Six Points for an Architecture of Resistance," in Hal Foster ed., *The Anti-Aesthetic: Essays on Post-Modern Culture* (Seattle: Bay Press, 1983), 16-30; Frampton, *Modern Architecture. A Critical History* (2007 [1980]).

36 Ibid., 327.

37 Ibid.

38 See, for example: Anthony Vidler, *Histories of the Immediate Present: Inventing Architectural Modernism* (Cambridge, MA: The MIT Press, 2008); Steven A. Mansbach, "Modernist Architecture and Nationalist Aspiration in the Baltic: Two Case Studies," *Journal of the Society of Architectural Historians*, 65/1 (2006), 92-111; Mansbach, *Modern Art in Eastern Europe* (1999); Benson, *Central European Avant-Gardes* (2002); Timothy O. Benson and Éva Forgács, eds., *Between Worlds: A Sourcebook of Central European Avant-Gardes, 1910-1930* (Cambridge, Mass., 2002); *Impossible Histories,* eds. Djurić and Šuvaković (2003), *Istorija Umetnosti u Srbiji XX vek* [History of Art in Serbia, 20th century] ed. Miško Šuvaković (2010), Miloš Perović, *Srpska arhitektura XX veka: Od istoricizma do drugog modernizma* [Serbian Architecture of the 20th century: From Historicism to the Second Modernism] (Belgrade: Arhitektonski fakultet Univerziteta u Beogradu, 2003), Kimberly Zarecor, *Manufacturing a Socialist Modernity: Housing in Czechoslovakia, 1945-1960* (Pittsburgh: University of Pittsburgh Press, 2011); Thaler, Mrduljaš, Kulić, *Modernism In-between* (2012); *Architecture's Many Modernisms*, ed. David Rifkind (London: Routledge, forthcoming).

39 See, for example, the Reaktion Books series on Modern Architectures in History: Alexander Tzonis and Alcestis P. Rodi, *Greece: Modern Architectures in History* (London: Reaktion Books, 2013); Sibel Bozdogan and Esra Akcan, *Turkey: Modern Architectures in History* (London: Reaktion Books, 2012).

40 For sections on modern arts in interwar Serbia considered within a wider geographical and chronological scope (changing territories of Yugoslavia or Eastern and Central Europe) written in English and thus available to a larger audience: *The History of Serbian Culture*, ed. Pavle Ivić, (Edgware, Middlesex: Porthill Publishers, 1999), Mansbach, *Modern Art in Eastern Europe* (1999), Benson, *Central European Avant-Gardes* (2002), *Impossible Histories,* eds. Djurić and Šuvaković (2003); *Istorija Umetnosti u Srbiji,* ed. Šuvaković (2010). These books focus on selected aspects of creative accomplishments, including literature, painting, sculpture, photography, architecture, theater, dance, music and film. Important publications focusing on modernism in visual arts art during the interwar period are also: Jelena Milojković-Djurić, *Tradition and Avant-garde: The Arts in Serbian Culture between the Two World Wars* (Boulder: East European Monographs; New York: Distributed by Columbia University Press, 1984), Vladimir Rozić, *Likovna kritika u Beogradu izmedju dva svetska rata 1918-1941* [Art Criticism in Belgrade Between Two World Wars 1918-1941] (Beograd: Jugoslavija, 1983), Miodrag B. Protić, *Počeci jugoslov-*

enskog modernog slikarstva 1900-1920 [The Beginnings of Yugoslavian Modern Painting 1900-1920] (Beograd: Muzej savremene umetnosti, 1972).

[41] Ljiljana Blagojević, *Modernism in Serbia: The Elusive Margins of Belgrade Architecture, 1919-1941* (Cambridge, MA: MIT Press 2003). Other important publications focusing on modernism in architecture are: Ignjatović, *Jugoslovenstvo u arhitekturi 1904-1941* (2007); Slobodan Giša Bogunović, *Arhitektonska enciklopedija Beograda XIX i XX veka*, vol. 3 *Arhitektura, arhitekti, pojmovi* (Beograd: Beogradska knjiga, 2005), s.v. Moderna ahitektura, 1327-1344; Tanja Damljanović, *Češko-srpske arhitektonske veze 1918-1941* [Czech-Serbian Architectural Connections from 1918 to 1941] (Beograd: Republički zavod za zaštitu spomenika, 2004); Perović, *Srpska arhitektura XX veka:* (2003); Aleksandar Kadijević, *Jedan vek trazenja nacionalnog stila u srpskoj arhitekturi (sredina XIX-XX veka)* [One Century of Search for a National Style in Serbian Architecture (mid-19th-20th centuries)] (Belgrade: Gradjevinska knjiga, 1997, second edition 2007).

[42] Blagojević, *Modernism in Serbia*, 3-7.

[43] The 2007 edition of *Le Voyage d'Orient* includes a note from 1965 added by Le Corbusier, who later apologized for his negativity: *Le Corbusier, Journey to the East*, edited, annotated and translated by Ivan Žaknić (Cambridge, MA and London: The MIT Press, 2007), 43.

[44] *Journey to the East* (2007), 43-49.

[45] Richard J. Williams, *Brazil: Modern Architectures in History* (London: Reaktion Books, 2009), 12-20, 244-261.

[46] For example, Blagojević, *Modernism in Serbia* (2003); *Impossible Histories,* eds. Djurić and Šuvaković (2003), Benson, *Central European Avant-Gardes* (2002); *The History of Serbian Culture*, ed. Ivić (1999); Mansbach, *Modern Art in Eastern Europe* (1999), Milojković-Djurić, *Tradition and Avant-garde* (1984).

[47] James Elkins, "Review of Steven Mansbach's book *Modern Art in Eastern Europe: From the Baltic to the Balkans, ca. 1890-1939* (1999)," *The Art Bulletin* 82 (2000), 781-785.

[48] Ljubomir Micić, "Nova Umetnost" [Art Nouveau], *Zenit* 34 (Dec. 1924), n.p.

[49] Ljubomir Micić, "Manifest Srbijanstva" [Manifesto of Serbianism], Dubrovnik 1936, *Srbijanstvo*, Belgrade, 1940; reprinted in *Daj nam Bože municije. Srpska avangarda na braniku otadžbine*, ed. Nikola Marinković (Belgrade: Dinex, 2013), 111-129.

[50] Manević, *Serbian Architecture*, 52-54.

[51] Ibid., 54. Translation from Serbian by the author.

[52] In addition to mentioned works by James Elkins, Piotr Piotrowski, and Timothy Benson see also, Delphine Bière-Chauvel, "La revue Zenit: une avant-garde entre particularisme identitaire et internationalisme" in *Europa! Europa? The Avant-Garde, Modernism and the Fate of a Continent*, eds. Sasha Bru et al. (Berlin: De Gruyter, 2009), 138-152.

[53] Michel Foucault, "Of Other Spaces, Heterotopias." *Architecture, Mouvement, Continuité* 5 (1984), 46-49; Michel de Certeau, *Heterologies: Discourse on the Other* (Minneapolis: University of Minnesota Press, 1986).

[54] Ljubomir Micić, "Velika zenitistička večernja" [Big Zenitist Evening], Zagreb, January 31, 1923. Also, Bière-Chauvel, *La revue Zenit*, 138-152.

[55] Dipesh Chakrabarty, *Provincializing Europe* (Princeton: Princeton University Press, 2000).

[56] See, for example, IRWIN's 2000-2009 *Retroavangarde* installation on "Eastern Modernism" for the geographic space of Yugoslavia in *Modernologies* (2009), 112-115. Here, the artists' counterpart of the 1936 *Diagram of Stylistic Evolution from 1890 until 1935* by Alfred H. Barr, the founding director of MoMA, who set more-or-less linear genealogy of "Western Modernism," which considered itself universal, is presented in separate genealogy of "Eastern Modernism," stretching back to Zenitism.

[57] *Journey to the East* (2007), 43; Blagojević, *Modernism in Serbia* (2003), 7.

[58] Michel de Certeau, *La culture au pluriel* (Paris, 1974; 2nd edition, ed. Luce Giard, Editions du Seuil, 1994); trans. T. Conley, *Culture in the Plural* (Minneapolis, MN: Minnesota University Press, 1997).

[59] Michel de Certeau, *The Writing of History* (New York: Columbia University Press, 1992).

[60] On the pluralism(s) in culture and arts: Andrew Ballantyne, *Architectures: Modernism and After* (Malden-Oxford-Carlton: Wiley-Blackwell, 2003), xii-xiv, 1-32, esp. 7-8, 10.

[61] For yet another critique of traditional modernist narratives see also: Gwendolyn Wright, "Building Global Modernisms" *Grey Room* 7-9/11 (Spring, 2002), 124-134.

[62] Recently, Thaler, Mrduljaš, Kulić, *Modernism In-between* (2012); Ignjatović, *Jugoslovenstvo u arhitekturi 1904-1941* (2007).

CHAPTER 1

FROM TRADITION TO MODERNISM:
UROŠ PREDIĆ AND PAJA JOVANOVIĆ*

Lilien Filipovitch Robinson

Uroš Predić (1857-1953) and Pavle Paja Jovanović (1859-1957) were contemporaries whose painting careers extended from the 1870s to the 1950s. They had an indelible impact within Serbia, and to different degrees both achieved international recognition. Their artistic scope was inclusive. They painted subjects of religion, history and genre as well as portraits and landscapes.

Stylistically, they are frequently identified as traditionalist, and more specifically as academic realists. These terms are applicable with respect to their training, technique and methodology when their paintings are compared to those of twentieth-century avant-garde artists such as Cubists, Fauvists, Surrealists, Expressionists and Abstractionists. However, since their careers encompassed some twenty-five years of the nineteenth century their paintings require examination with reference to the dominant artistic approaches of that period. Viewed in that light, it is apparent that Predić and Jovanović were progressive artists who gave new direction to Serbian painting. They abandoned the lingering Serbian dependency on variations on Medievalism merged with Renaissance and Baroque elements. While their training was strongly anchored in the great traditions of Western European art, they were equally alert to contemporary innovations and experimentation. Building selectively on these sources they devised their own individual approaches.

The fact that they grew into maturity at a time of great transformation in every facet of Serbian life affected their personal and world view, and as a consequence their art. They were witness to foreign occupation, struggle for and the achievement of independence, and shifting governmental structures as well as dramatic social and cultural change. Products of time and place, their early years and education were in Austrian- and Hungarian-controlled territories. For both, initial artistic exposure was to local painters whose work combined Serbian Post-Byzantine and Central European Baroque styles. Within a few years of one another they enrolled at the Vienna Academy, launching successful careers from one of the centers of European culture. While they had a clear commonality of background, differences

of personality, personal and professional circumstances directed Predić and Jovanović towards divergent paths. Through their thematic preferences and methodology, inherent and appropriated, both produced new directions and, to a significant degree, informed and set the standard for the art of their compatriots. In the process both played a decisive role in shifting tradition-oriented Serbian painting decidedly towards European modernism.

Uroš Predić

Uroš Predić's enrollment in 1876 at the prestigious Academy in cosmopolitan Vienna and even his desire to be an artist may not have been anticipated for the son of a priest in the village of Orlovat.[1] Predić was raised in a family that valued education, and specifically by a father who had studied at the faculty of philosophy in Požun (Bratislava) and had a serious interest in the arts. He recalled that his father had traveled on foot from Orlovat to Vienna for the sole purpose of seeing the collection in the Belvedere Gallery.[2] Predić attended the village school and subsequently the German schools in Crepaja and Pančevo. In both, instruction in drawing was part of the curriculum. The church paintings in Orlovat, and most importantly those in Pančevo, marked his earliest exposure to the work of professional artists.[3] As Predić recounted, he remained steadfast in the choice of career that he had made while still a student. He wrote, "When I was deciding to become a painter my father asked me: 'what will you do, my dove, when you are old and your eyes betray you and your hand shakes?' I responded: 'nothing, then I will not want to live.' That is how I still think."[4]

Given the general recognition of the political and cultural importance of Vienna by educated Serbs, Predić's matriculation at the Academy was a logical step in his artistic preparation. The Academy in Vienna, like others in Central Europe,[5] based its general structure and pedagogy on that of the French Royal Academy. The highly demanding course of study began with the copying of drawings and engravings, initially parts of figures, followed by drawings of the whole figure, after master painters. Drawing from plaster casts and finally the live model followed. In addition, students were required to attended lectures on anatomy, geometry, perspective, history, mythology and aesthetics.[6] Instruction in painting at studios outside of the Academy came after successful completion of the drawing curriculum. The primary focus was on painting the human form. At the time of Predić's enrollment master classes in specialized areas were available to advanced students. Throughout their enrollment at the Academy students were also expected to participate in regularly scheduled competitions and their success was measured by the receipt of awards. This opened up opportunities for participation in public exhibitions.[7]

By all accounts, Predić was seriously and fully committed to learning all that was afforded by an institution known for its excellence of instruction and firm adherence to traditional principles and approaches. His strong intellectual interests, sustained throughout his life, were also nourished in this environment.[8] In effect, he was developing the necessary theoretical and technical foundation for his life's work. The Academy's emphasis on and instruction in the perfection of drawing, anatomy and composition were significantly supplemented when he later enrolled in the master class of Christian Grippenkerl, a specialist in history painting, and further when he entered the latter's private atelier in 1882. Grippenkerl reiterated the importance of compositional unity and symmetry, and the centrality of line. Predić's development was further influenced by study with Karl Rahl and Hans Cannon, both of whom insisted on the mastery of color, a task that Predić later described as challenging.[9]

Predić's talents, dedication and work ethic were rewarded by a three-year scholarship from Matica Srpska in 1877 and subsequently by receipt of the Academy's coveted Gundel Prize in 1879 for his painting of *Pouting Girl* (Fig. 1.1). This marked his professional debut and the beginning of a lasting identification of Predić as a genre painter. The selection of subject reflected both personal preference and the current popularity of genre themes associated with the often sentimental and at times humorous German and Austrian Biedermeier style.[10] Judging from the notations in his sketchbook, he was from the outset drawn to the familiar, depicting single figures as well as entire vignettes. In *Pouting Girl* the lessons learned at the Academy are evident. Predić confidently defines the facial details, the real but somewhat ungainly child's ratio of head to body, the firm contours of the smoothly painted full face, and the soft curvature of the arms. He combines this typical Biedermeier linearism with a far looser, more suggestive rendering of the bodice and sleeves. The young artist also introduces another element. He provides his insight into personality at an unscripted moment. The child purses her lips in a willful pout, she turns her dark eyes downward and with a sidelong glance dismisses both painter and audience. Clearly, sustaining the pose is not to her liking.

That Predić had mastered the vocabulary of the Academy and was alert to the contemporary market and tastes that fortuitously mirrored his own is evident. However, this painting also reveals another trait from which Predić never departed. He did not yield to simple replication of established or popular approaches. They informed his work, but the final image was inevitably his own. In *Pouting Girl,* he shares with the viewer a singular gentle humor merged with genuine empathy. Even as a student, when he had direct exposure to such popular Biedermeier paintings as, for example, those of Carl Spitzweg,[11] he was marking his own direction. In contrast to his Biedermeier counterparts, whose paintings are at times excessively sentimental or bitingly humorous, Predić rejected overt sentimentality as well as hurtful satire.

Fig. 1.1 Uroš Predić, *Pouting Girl*, 1879. Oil. 31x39.5 cm.

Fig. 1.2 Uroš Predić, *Busy Hands*, 1887. Oil. 15.5x21.1cm.

Predić's fascination with the world of children continued into maturity, whether in straightforward portraits or more complex scenarios. Almost a decade after *Pouting Girl*, he portrayed the opposite side of youth in his *Busy Hands* of 1887 (Fig. 1.2). Although it is this type of painting that has prompted scholars to view him as a traditionalist and, more significantly, to relegate him to the role of a sentimental genre painter, this painting suggests otherwise. It is a remarkable insight into a young girl's domestic world, its lessons and adult expectations. The little girl is undertaking what was traditionally the first knitting project, a pair of socks. Predić's presentation is honest, direct and exacting, yet subtly didactic. The intensity of her concentration and the dexterity with which she accomplishes her task are evident. Rather than contrived, she is real and her task specific.[12] As a result, we understand the implicit message of societal respect for and value of youthful industry.[13] It should also be noted that Predić was using a much freer painting technique by the late 1880s. His palette is brighter, the paint is applied in smaller, thicker, more varied strokes, and the effect is one of greater spontaneity. He was moving in a different direction from that of the Viennese traditionalists.

The domestic and familiar, constants in the artist's *oeuvre*, brought Predić considerable support from collectors from the rising middle class in Serbia. His 1887 painting, *The Happy Brothers* (Fig. 1.3) is a case in point. As a consequence of its broad popularity, Predić painted two replicas, one in 1918 and the other in 1922. The painting was also commercially duplicated, thus further expanding the viewership. Predić focused on something he knew intimately, life in rural Orlovat, scenes of which he recorded in his sketchbook throughout his career. The veracity of his depiction comes closest to what in 1888 Central and Eastern Europeans would have viewed as the progressive style of French Realists such as Rosa Bonheur and Gustave Courbet. Rejecting both Academic and Biedermeier precision and linearism, Predić's brushstrokes, like Courbet's, are heavily textured so as to define the roughness of the muddy road and the awkward, heavy steps of three happily oblivious, inebriated youths. It is a glimpse into village life in early fall when, as Predić later explained, the harvest has been gathered and the pigs slaughtered. The fires have been lit, the spits turned, the drinks dispensed and the celebrations fully underway. The air is filled with the aroma of the cooking meat and the sounds of music and drunken song that disturb the village's peace. In addition to capturing the truthfulness of this atmosphere, Predić was also hoping to convey a message. He explained that "… I observed this every day … I said to myself there must be some way of telling these people to what an unhappy level they have descended and have a moral impact on them, capturing all the [bad] habits of my compatriots …"[14] However, when they saw reproductions of the painting, the Orlovat villagers were not chastened, but delighted and flattered to have been depicted. Predić's well-meaning and subtle moralizing had no apparent effect.[15] His audiences, rural or urban, were responding to what they saw as a good natured humorous representation of reality.

The focus on contemporaneity, and specifically on the ordinary, whether middle class urbanites or rural peasants, firmly illustrates Predić's engagement with and role as a disseminator of a modern Realist approach in Serbia. It can also be argued that with his candid and humorous depiction of peasant life in the *Happy Brothers* he was intimating a further and more direct connection to the Realism of Courbet in paintings such as his *Peasants of Flagey* shown at the Paris Salon of 1850-51 along with his notorious *Stonebreakers* and *Burial at Ornans*. Whether Predić was informed specifically by Courbet's paintings of the peasant class is not documented, but the latter's work was very much in the public domain by 1887 and finding disciples throughout the European continent. It is difficult to imagine that Predić was not familiar with Courbet's mid-century revolutionary works.

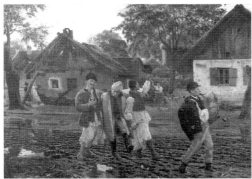
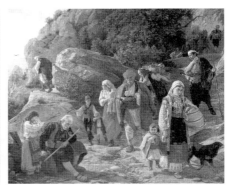

Fig. 1.3 Uroš Predić, *The Happy Brothers*, 1887. Oil.122x82cm.

Fig. 1.4 Uroš Predić, *Flight of the Bosnian Refugees*, 1889. Oil.148.5x114.5cm.

Master classes at the Academy and later his assistantship with Grippenkerl provided Predić with instruction in history painting based on adherence to Classical principles.[16] To this framework the young painter added what he had learned from contemporary Central European history painters.[17] These were the underpinnings for Predić's maturity as a painter of both religious and historical subjects. He applied these lessons while in Vienna when he was selected to assist Grippenkerl in 1884 in the prestigious project of the decoration of the Herrenhaus Hall of Vienna's new Parliament building. Predić produced thirteen large-scale scenes from Greco-Roman mythology and history. This thematic direction was not surprising as he had been drawn to the challenges of history painting even as a first-year student at the Academy, when in 1876 he began working on the subject of the *Flight of the Bosnian Refugees* (Fig. 1.4).[18]

The painting deals with the 1875 revolts in Bosnia and Hercegovina that began when the town of Nevesinje rebelled against the Turks.[19] In his reminiscences, Predić explained that as a Serb he felt a patriotic obligation to provide a commentary on one of the tumultuous events in the history of his people.[20] As in any history painting, the aim of the artist is to depict a credible scene and convey a message. To achieve the former, Predić applied the lessons of his Viennese teachers. The compositional structure is informed by Baroque paintings as it relies on an extensive use of diagonals. However, Predić's application of this compositional device is singular. He employs the implied diagonals to expand the space and give movement and psychological immediacy to the figures by bringing them forward towards the viewer and into the frontal plane. Just as he was selective in his references to past masters, he also deviated from the approaches of many contemporary history painters. Predić's aim was not a painted documentary, replete with extensive but superficial details. Rather, it was to paint what was

pertinent and most important to a full understanding of the subject. To that end, he had to be selective and to paint directly from life. Instead of studio models, he painted people he actually knew: family members and friends. Their features are real, expressive and moving. They are young children and old women and men who descend with uncertain step along a steep path framed in a rocky, unforgiving terrain, which challenges and yet seems to intimate a people's inner strength necessary for survival.

Varied approaches informed Predić's forms and composition, and in turn his solutions were considered by his Serbian colleagues. His painting of the Bosnian people marks a departure from the palette and pigment application of past masters and Viennese traditionalists. He adopted a brighter and broader palette in concert with attentiveness to natural light of the progressive Realists. His small deft brush strokes define the individuality of each figure, while the light selectively reveals their features and then glances off the rocky formations to encase the foreground in bright sunlight. Although responding as individuals they are bound by their victimhood: ordinary people driven from their homes and into an uncertain future. Yet, despite their bewilderment and fatigue they retain an underlying composure and human dignity that conveys a hopeful message of survival and eventual victory. Perhaps it was this type of reading in addition to the obvious pictorial refinements that prompted the positive responses when the painting was shown in Belgrade and at the 1889 World Exposition in Paris.[21] Although his subject was specific to Bosnia, Predić's message was universal.

While the scene in Predić's *The Maiden from Kosovo* of 1919 (Fig. 1.5) has its origins in the oral tradition of Serbian epic poetry, the painting is also a type of history painting. Like his painting of the Bosnian refugees, it addresses an event in Serbian-Turkish history, albeit one that set the stage for the dissolution of the Medieval Serbian state and centuries of Turkish occupation: the 1389 Battle of Kosovo. Predić depicts one of the most beloved figures from the Kosovo cycle of poems, the young maiden who after the battle searches the bloody field seeking the young man who, meeting her on the way to battle, had promised to marry her. As she searches, she carries and dispenses wine, bread and water.

The painting attests to Predić's facility in meeting the expectations associated with painting an immediately recognizable subject, and one with which Serbian audiences in 1919 would identify, whether out of a need to recall centuries of suffering, as an inspirational reiteration of a people's brave battles for independence, or as confirmation of recent national achievement in the victories of the First World War. The scene is both believable and inspirational. Painted in brilliantly clear colors and set against a nature at once innocent and violated, the scene is bathed in a bright almost other worldly golden glow. The details are articulated to reflect the narrative, and throughout there are juxtapositions of veracity and transcendence. In the flower and promise of her youth, the young woman is real, yet noble, sorrowful yet compassionate.

As she washes the wounds of the fallen hero and refreshes him physically and spiritually with the bread and wine of communion, she learns of the death of the one she is seeking. The last lines of the song speak to profound sorrow and loss, both personal and communal, that of the Kosovo maiden and by extension all Serbs. However, the prominence of the symbols of faith in combination with the two movingly noble figures, echoes in pictorial terms the Kosovo epic's overriding message that the destiny of the Serbs[22] was both suffering and ultimate triumph as God's chosen people. In merging the real and ideal, the physical and sacred Predić succeeds in presenting both the specific and timeless, thus bridging the divide between the fictional and the historical.

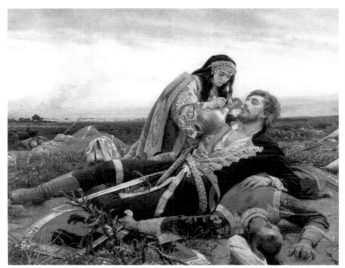 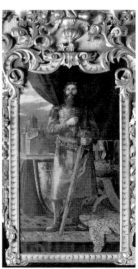

Fig. 1.5 Uroš Predić, *The Maiden from Kosovo*, 1919. Oil. 115x88cm.

Fig. 1.6 Uroš Predić, *Saint Lazar*, 1893. Oil. Choir Section.

Laudatory reviews, the success of his 1888 Belgrade exhibition and international exposure at the 1889 World Exposition were important milestones for Predić, who was already widely acknowledged as a genre and portrait painter. As a reflection of such stature and his more recently acquired fame for his large-scale history painting, Predić received a commission in 1888 that set him in another but unanticipated direction. He undertook the painting of the iconostasis and other panels for the church in Bečej. Pursuant to the terms of the agreement, the images were to be in keeping with the artistic tradition and "spirit of the Serbian Orthodox Church."[23] For Predić this meant departure from his characteristic realism. It was a type of

accommodation he was unwilling to fully make. He was invested in a different, a modern methodology that separated him from the stylistic tradition of Serbian church painting. As he explained, he had to apply "his own knowledge and imagination [and] modern methods."[24] He did not want the images he painted to be objects of worship but convincing depictions, easily understood yet transmitting and affecting emotion.[25] As a consequence, his saints in Bečej are not idealized, nor are they spiritualized attenuated forms. Like the holy figures of Rembrandt and Caravaggio, they are portraits of real, living, ordinary people.[26] They do not exist in an otherworldly atmosphere, but in concrete identifiable settings, often in detailed interiors. For example, the canonized Tsar Lazar, *Saint Lazar* (Fig. 1.6)[27] stands in front of a window, holding an accurately and finely delineated model of his *stauropigion* (foundation), the monastery at Ravanica. Predić further advances realism by incorporating extensive details of nature. The curtain is drawn back to reveal a naturalistic depiction of sky and clouds tinged with the first rosy tones of dawn. Such details underline the artist's role as observer and recorder of natural phenomena. While he could not conform to the stylistic requirements of tradition-bound church paintings, Predić still relied on selective and sophisticated incorporation of iconographical details to convey the spiritual message. His depiction of Lazar invites a dual reading. His is a worldly form; his stance firm and fully grounded. Yet, he has put aside his earthly crown and looks decidedly upward, acknowledging his choice of the sacred over the profane, heavenly eternity over earthly power. Similarly, the landscape framed by the window, while impressively real, has another layer of meaning. Just as the positioning of the model of Ravanica directs the eye to the eastern end and thus the altar, the site of Holy Communion, so dawn breaks in the East, imparting the promise of Resurrection. Predić was signaling the compatibility of the integration of stylistic innovation and iconographic quotation.

Through his paintings at Bečej and subsequent church commissions Predić was helping to establish a new standard for church painting that emphasized actuality but without compromise of traditional beliefs. The application of a level of "truth to nature,"[28] was a constant for Predić. His sketchbooks provide further testimony. From the beginning and throughout his life he filled them with quick notations of people, dwellings, costumes, animals and vegetation as well as more fully developed landscape vignettes. However, finished oil paintings of landscapes are few in proportion to Predić's other subjects. They are, nevertheless, of major importance as works of art in their own right and in what they reveal of the artist's aesthetic sensitivity and technical sophistication. Not surprisingly they represent a further and bolder exploration of the progressive approaches of the late nineteenth and early twentieth century.

The interest in nature apparent in Predić's sketches is evidenced in an early work, a painting of 1880, *Landscape in Orlovat*. Here, the paint is rather thinly applied in short strokes. These almost wash-like surfaces are effectively countered by occasional touches of more densely

built-up white paint. Following a still recent innovative practice, Predić primed his canvas in white, thus producing a startling effect of luminosity. He must have approached the canvas in its entirety rather than in separate sections in the manner of traditional landscape painting. By developing all areas of the canvas concurrently, he comes closer to replicating what the eye actually sees. It is nature viewed directly as a whole, at a moment in time. As early as 1880, then, Predić was incorporating some of the newest approaches to landscape painting, primarily those advanced by the French school.

Fig. 1.7 Uroš Predić, *Autumnal View from the Artist's Balcony*, 1917. Oil. 50x70cm.

The artist's clear inclinations and promising prospects as a landscapist were realized in works produced in 1916-1917 in Belgrade where he had settled after many years in Orlovat.[29] From the vantage point of his atelier, Predić was able to observe an expanse of nature. In his 1917 *Autumnal View from the Artist's Balcony* (Fig. 1.7) he encapsulates the spirit of seasonal change. Here, the thicket of branches still encased in russet colored leaves gives way to the angles and planes of the houses in the middle ground to reveal glimpses of distant smokestacks along the shores of the Danube. Throughout, his palette is a variation of browns, reds and oranges whose tones are reflected in the houses and then more subtly in the expanse of sky. The choice of colors and manner of application appear to be a combination of Impressionism and Post-Impressionism.[30]

Surprisingly, Predić also appears to have given a nod to Cubism, a movement of which he was frequently critical. Whether intentionally or not, there is a link to Analytical Cubism in the geometric simplification and even some faceting of form. The houses are not a detailed replication of reality. They are geometric equivalents, more universal than individual. Similarly, his other paintings evidence the artist's skill in bringing together what were potential contradictions of academic realism and modernist innovation.

Fig. 1.8 Uroš Predić, *Panorama of Belgrade from the Artist's Balcony*, 1916. Oil. 390x48cm.

In his 1916 *Panorama of Belgrade from the Artist's Balcony* (Fig. 1.8) Predić met the challenge of yet another approach to painting landscape. The five-panel panorama juxtaposes details of children playing and adults at leisure against a wide expanse of earth, trees and buildings, all seen from a variety of vantage points. Although they can be read separately, each section flows easily to the next, the end panels with their solid simplified geometry of red-roofed houses effectively anchor and frame the whole. Doubtless, executing five panels, especially ones combining figures and landscape, presented a special challenge with respect to handling composition, perspective, light and atmosphere. Fortuitously, Predić was able to draw on a broad realm of references and experience not available to other painters of his time. His solid grounding in every aspect of the academic tradition and his thorough understanding and application of its principles was a significant advantage. As an experienced painter of iconostases in Orthodox churches he had confronted and solved the problems of multi-panel compositions. However, there were also other models he could reference in planning his *Panorama of Belgrade from the Artist's Garden*.

An artist, intellectual and an active member of "Lada", the first Serbian art organization and one supportive of diverse approaches, Predić had first-hand knowledge of contemporary theoretical and aesthetic developments. He was alert to artistic innovations, and new sources, including importations from Japan. He would have had some exposure to Japanese prints and multi-panel screen paintings,[31] either directly or through the work of European painters enamored of Japanese art.[32] While Predić's *Panorama of Belgrade from the Artist's Garden* demonstrates a link in concept and pictorial solution to Japanese screen paintings, it is general and non-specific. His five panels find a far more direct counterpart in the paintings of his contemporary, Édouard Vuillard (1868-1940), and specifically his expansive scenes of the gardens of Paris.[33] Vuillard's 1894 multi-section paintings of *The Public Gardens* like Predić's *Panorama of Belgrade from my Balcony* seamlessly unfurl the rhythmic diversity of urban life. Both painters present a harmonious integration of people and nature. Adults and children engage in the daily pastimes and pleasures of two modern cosmopolitan centers, Paris and Belgrade. Both are scenes of contemporary life, woven into a landscape tapestry. Moreover, neither painter seems constrained by traditional pictorial requirements of tightly defined

space, close adherence to linear perspective, and precise delineation of form. This is of special significance in the case of Predić as it signals a remarkable level of technical boldness and one for which he had discovered the appropriate venue—landscape.

In his *Panorama of Belgrade from my Balcony,* as in other landscape paintings, Predić emphatically counters the view of some critics that his thematic repertoire was limited and that he lacked stylistic innovation. As evidenced throughout his career and supported in these five panels, he was a painter of varied subjects and his stylistic exploration was broad. His art reflects selective adherence to the past and clear attentiveness to the present.

Paja Jovanović

While both Predić and Jovanović were born in the Banat district of Vojvodina, Jovanović had the advantage of a childhood in the prosperous and culturally advanced town of Vršac. Exposure to its diverse population of Serbs, Hungarians and Romanians as well as other ethnic groups facilitated his later extensive travels over three continents and contributed to his easy integration into an international society.[34]

In Vršac Jovanović's academic studies were coupled with instruction in drawing. This was supplemented by independent study of the works of Serbian master artists. Of special impact on his early development were the portraits and religious paintings of Pavel Djurković, Jovan Popović and Arsenije Teodorović.[35] The copies Jovanović made of the works available in Vršac brought him early recognition and directed him towards a career in the arts. Those ambitions were encouraged by his family, especially his father, a professional photographer. Through his influence and guidance Jovanović became familiar with the photographic medium, exploring it further while apprenticed to another local photographer. His later copious preparation, clarity and accuracy of observation, sensitivity to the arrangement of forms, and understanding of natural light may well be traceable to these early exposures to photography. Even at this point of his training, recognition of Jovanović's abilities was confirmed when he was commissioned to produce a series of drawings for the bell tower of the main church in Vršac.

Vršac, then, provided a foundation for further study. In 1875 Jovanović traveled to Vienna to continue his artistic training. Because he did not meet the age requirement for admission to the Academy, for the first two years he received preliminary instruction at a drawing school. By 1877 he had enrolled at the Academy and was following a general course of instruction that paralleled that of Predić. The Academy's introductory curriculum reinforced the young student's aesthetic goals and convictions as well as the methodology developed in Vršac. Full facility with the rendering of anatomy, perspective and composition and, especially, precise

preparatory studies were becoming an inherent part of his artistic vocabulary. As he had in Vojvodina, Jovanović took full advantage not only of the instruction and mentoring at the Academy but what the city of Vienna offered.[36] Its abundant and impressively comprehensive collections of master works provided models to copy, while ongoing exhibitions exposed him to contemporary and even radical artistic directions, especially those of the Munich and Paris schools. The models before him included adaptations of a version of the Neo-Grec style and an earlier Romanticism, Realism as interpreted by the Biedermeier group, the significantly less sentimental works of the German Realists, and the straightforward often harsh veracity of the French and French-inspired Realists. In addition, by the late 1870s Proto-Impressionism, and early versions of Impressionism had also made their way to Central Europe. For Balkan artists and audiences it was a virtual cornucopia of approaches.

In Vienna the positive response Jovanović experienced as a schoolboy continued, but with considerably greater ramifications. As had Predić he advanced in his studies with amazing rapidity. In 1882, he received the Academy's first place prize for his painting of the *Wounded Montenegrin*, which set the stage for his artistic focus and consequent success. In addition to his Matica Srpska scholarship[37] he was also awarded an Austrian government scholarship. Thus, early in his studies Jovanović, like Predić, was the recipient of an impressive level of official recognition and support.[38]

Jovanović's studies with and especially the mentorship of Christian Grippenkerl and Leopold Müller were critical to the young painter's thematic and stylistic development. The instruction he received from Grippenkerl, the demanding and highly respected history painter who was Predić's primary mentor, was essential to Jovanović's later facility in painting complex monumental history paintings.[39] With Grippenkerl's guidance he came to understand the underlying structural principles of Renaissance and Baroque master works. This is especially evident in his remarkable solutions to spatial problems and the arrangement of large numbers of static and moving forms. Just as Karl Rahl and Hans Cannon had expanded Predić's vocabulary with respect to color and painting techniques, Leopold Müller provided those additional components essential to Jovanović's maturation.

While Grippenkerl advanced the solutions of past masters, Müller directed Jovanović to the present. Specifically, he insisted on working directly from nature, recording only what was visible rather than imagined. A further requirement of this type of naturalism, in Müller's view, was assigning a primary significance to color. Most importantly, he advised Jovanović to concentrate on what he knew and, specifically, that on his routine visits home the young Serb make direct studies of Balkan life. Müller was pointing him towards engagement with genre subjects in general, but specifically ones that would associate Jovanović with Orientalism, a highly popular style typified by vignettes of exotic life in North Africa, the Middle and the

Near East. Among Western and Central European collectors, especially middle class ones, there was significant demand for such paintings.[40] We can surmise that Müller had concluded that the same audiences would appreciate as exotic scenes of the remote and ethnically diverse Balkans, especially at a time of European awareness of the events on the Balkan Peninsula and the potential for international consequences. "The Balkan Question" was increasingly at the forefront of discourse in the capitals of Austria-Hungary, France, England and Turkey. Jovanović's Orientalist paintings provided insight, whether they were read simply as descriptions of daily life or revelations of national character.

In 1882 his *Wounded Montenegrin* (Fig. 1.9) not only garnered for Jovanović a major Academy prize but established him as a painter of Orientalist subjects, setting the stage for his international success only five years after his enrollment at the Vienna Academy. For an audience curious about the life of the Balkan peoples, Jovanović provides much information. He points to the modesty of the single-room dwelling with its dirt floor, the paucity of the haphazardly arranged utensils on the crudely made shelf, and the hand–sewn peasant shirts, rough leggings and leather shoes. Although he is presenting a group with a shared commonality, he effectively defines distinctly different individuals from the shaven-headed, fierce-eyed warrior who supports the wounded youth to the bearded elder and the cloaked, heavily-armed figure whose solid form anchors the composition on the left. However, the painting calls for a reading on a level beyond the descriptive. It reflects on conflict and war. Although Jovanović does not specify a particular event it is likely that the scene references Montenegro's wars of 1876 and 1877. As a patriotic Serb he would have had special awareness of and concerns regarding a conflict that involved Serbia. In 1875 following revolts in Bosnia and Hercegovina, Montenegro had joined Serbia in a war against Turkey. While it is unlikely that his 1882 audience in Vienna was familiar with or sought such historical data, they would have been able to make the connection between the Montenegrin struggle and the continuing conflicts on the Balkan peninsula.

In contrast to the typical examples of Orientalism, Jovanović's painting was not derived from travel accounts, literary sources or brief excursions to the site. He built the scene on observed reality and not imagination, the specific rather than the composite.[41] The environment and the characterizations, gestures and expressions of these tactile forms are convincing. The painting is devoid of the studio-contrived quality of many Orientalist paintings. However, Jovanović couples these potentially daring innovations with features essential for the critical approval of the traditionalists. His deft arrangement of eleven figures, skillful handling of linear and aerial perspective, and clarity of detail more than met their expectations. These features point to Jovanović's perfection of the Vienna Academy's traditional pictorial vocabulary.

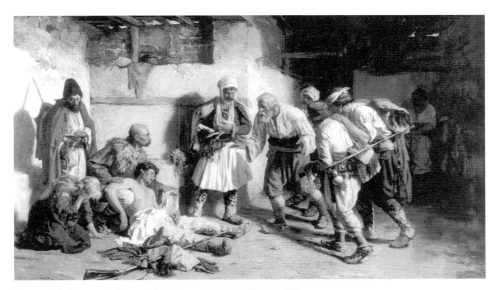

Fig. 1.9 Paja Jovanović, *Wounded Montenegrin*, 1882. Oil. 114x186cm.

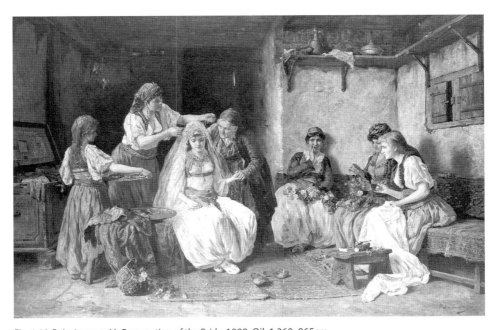

Fig. 1.10 Paja Jovanović, *Preparation of the Bride,* 1888. Oil. 1.360x965cm.

Following the success of his *Wounded Montenegrin* and through Müller's contacts in 1883 Jovanović entered into an agreement with the French Gallery in London to produce a series of paintings of life in the Balkans. These were based on the studies he had made during his travels in Albania, Montenegro, Dalmatia, Bosnia, Hercegovina and Serbia. In 1889 he signed an even more lucrative contract for his Orientalist paintings with another London Gallery, Tooth and Sons.[42] Although Jovanović was "always in the focus of current events,"[43] these groups of paintings do not address contemporary politics. Rather, they provide carefully crafted, ethnographically accurate descriptions of ethnic groups, their daily lives and interactions. They afforded a type of insight into the attitudes, responses and character of the Balkan peoples.

What separated Jovanović from other Orientalists and in large measure explains the international appeal of these paintings was their authenticity, an element traceable to the tutelage of his photographer father and reinforced by Müller's insistence that "when a picture is given birth amidst the people who will be represented, living blood will flow in that picture."[44] In his 1888 *Preparation of the Bride* (Fig. 1.10) Jovanović met that criterion. He was not a stranger to the scene. He knew his cast of village characters, their interactions, attitudes and consequent expressions and body language. He had observed and participated in their lives and celebrations. As here, the details of the interior, the characterization, demeanor and festive clothing of the women and girls convey a persuasive reality that was praised by critics, collectors and the general public.[45]

The low-ceilinged room with its sparse but solid furnishings, old, almost threadbare carpet, the worn covering of the bench set against the plain plastered walls signals a humble but comforting setting through which generations have passed and life's sorrows and joys experienced. Jovanović emphatically focuses on the latter. It is both a preparation and celebration. Old and young, the women present the rather voluptuous but demure young bride with the best of the possessions stored in the wooden chest and proffered on the copper tray. In contrast to the unassuming surroundings, the bride's traditional attire is elaborate, replete with a necklace of abundant gold coins and delicately embroidered slippers. That they, especially the necklace, are part of the requisite dowry signals familial obligation and pride as well as contractual expectations even among villagers of modest means. The artist couples descriptiveness with an insightful reading of a wide range of personalities and expressions. It is evident that he was as concerned with capturing their responses—the joyful whispering of the maidens who fashion the garland of fresh flowers, the attentiveness and concern of the elderly woman, and the serious concentration of the young girl gracefully holding the tray. Painted in a combination of long and short strokes of warm tonalities and in a frontal but diffused light, the figures move naturally, providing an additional level of understanding to the viewer.

It was this type of positive characterization of Balkan life that was at the heart of the appeal of Jovanović's genre paintings. Conversely, it has also elicited more recent criticism that he concealed the negative realities of the lives of his subjects.[46] However, the expectations of a later age are not applicable here. Jovanović was painting the world he saw, and in a way that was uniquely his own. Just as he did not accept the more typical sentimental or highly romantic type of Orientalism of his contemporaries he did not assume the role of critic. His approach was that of a realist, a painter of his time, but not one with a social or political mission or agenda. It was a type of interpretation of the present that found numerous contemporary parallels, especially among a group of French artists who represented what is often referred to as "Popular Realism".[47] Numerous critics and the public at large were especially supportive of their type of realist paintings rather than those charged with the larger and frequently controversial messages of societal failures.

Jovanović's consistent contribution to Orientalism was in the faithful descriptiveness of Balkan life and pastimes. In the process he was also revealing the singular traits of its people, knowledge essential to understanding an area of increased significance in determining a balance of power in contemporary Europe. In his most popular paintings Jovanović presented a hardy, vigorous, male-oriented and male-dominated society. This was an image consistent with a Western European conception of a society in which attitudes were born of long histories of oppression, necessity for vigilance and fierce protection of family and community. Faith, honor, loyalty and pride in country were controlling factors. The paintings produced during the height of Jovanović's Orientalist period remained in such demand that they were reproduced in lithographic form as well as replicated in oil by the artist. For example, his first version of *Rooster Fight* (Fig. 1.11) dates to 1897[48] and the second to the 1920s.[49] Characteristically, the focus is on a society in which male authority, prowess and physical engagement are central. Women either perform domestic tasks or, when shown in the company of men, assume supportive roles. In *Rooster Fight* the men, their weapons in evidence, are fully and intensely absorbed in watching the unfolding of what promises to be a bloody battle. Pipes in hand, they lean forward, their muscles taut and bodies tense. Their expressions are fixed and unyielding. They convey no hint of unmanly emotion. Nothing in their demeanor suggests or even hints at concern or empathy for the victims of the cruel sport. Battle, victory, defeat and death are inevitable facts of all existence.

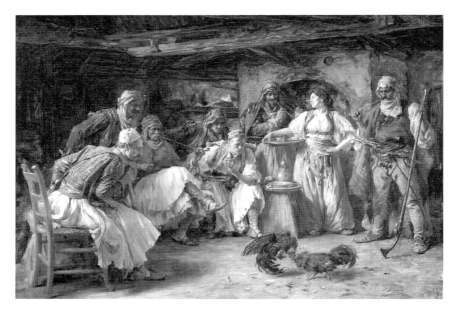

Fig. 1.11 Paja Jovanović, *Rooster Fight*, 1897. Oil. 55x76cm.

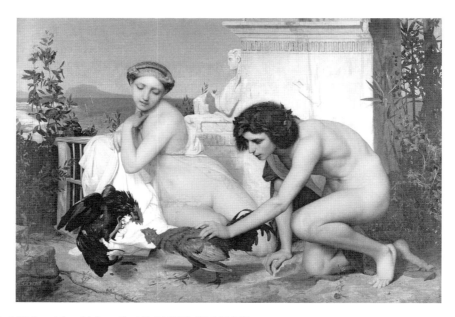

Fig. 1.12 Jean-Léon Gérôme, *Cock Fight*, 1846. Oil. 143x204cm.

The singularity of Jovanović's approach is made further apparent when the *Rooster Fight* is compared to Jean-Léon Gérôme's 1846 version of the same subject.[50] Recognized with a medal at the Salon of 1847, his *Cock Fight* (Fig. 1.12) presents an idealized, sentimental view of life in a distant and to contemporary audiences an exotic Greek past. Jovanović's powerful protagonists have been replaced by Gérôme's slender but insipid youth and his graceful female companion. They are the epitome of perfection and restraint, unmarred by the hard life of Jovanović's rugged warrior peasants. Moreover, they are startlingly disconnected from the scene. Jovanović's vigorous males are full participants. Conversely, Gérôme's pale-skinned perfectly proportioned couple assumes assigned poses, unrelated, even incongruous, to the fierce confrontation unfolding before them. Although both painters adhere to the same academic principles of symmetry, balance and control of composition, Gérôme's setting and details are generic, while Jovanović's are specific and ethnographically accurate.[51] They are also distinguished by their different handling of color and light. Gérôme employs a limited, toned down palette in which the paint is applied in smooth, barely discernible strokes. The colors are contained in tightly defined forms illuminated by a sourceless, universal light. Jovanović's figures are bathed in natural light and composed with reflected colors, whose rich warm tonalities are built up in swift textured strokes that further enhance the naturalism of the figures.

Through his vignettes of Balkan life, Jovanović acquired an early and enviable level of success. However, stature comparable to that of major European artists was solidified through his history paintings, which still occupied a significant position in the hierarchy of subject matter. Given his Academy education and alertness to the attitudes of the arts establishments and collectors and with an eye to potential commissions,[52] Jovanović would have been drawn to such subjects. Having easily mastered the methodology of large-scale history painting at the Vienna Academy, he was prepared for the undertaking. However, his interest in history painting was not simply a matter of market strategy. It was, once again, an opportunity to paint something important and personally meaningful. As he had done with his genre scenes, he looked to the familiar—in this case the history of the Serbs. Despite his life and travels abroad and an extensive international clientele he retained a firm link to his homeland.[53] Interest and pride in country, requisite technical skills and proffered commissions combined to make Jovanović a premier painter of history at a time of international actions affecting both Serbia and the Balkans. Within Serbia there was also a need for reminders and reiteration of the Serbian past. Jovanović's pictorial interpretations had the potential to affect understanding, decisions and even actions. Built on extensive reading, on-site research and consultation with historians, his paintings evolved into insightful historical accounts. Through them he provided explanations of the Serbian past as an empire, the occupation of its lands by the

Ottoman Turks, subsequent revolts and wars of independence, and the nation's contemporary aspirations and support of the legitimacy of its claims. Three paintings[54] support the validity of Jovanović's recognition as one of Serbia's preeminent history painters. They are: *Coronation of Tsar Dušan*[55] (1900), *Migration of the Serbs* (1896) and *Uprising at Takovo* (1898).[56]

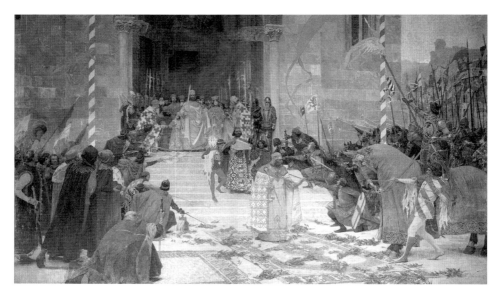

Fig. 1.13 Paja Jovanović, *Coronation of Tsar Dušan*, 1900. Oil. 390x589cm.

Jovanović's 1898 royal government commission for a painting commemorating the coronation of Tsar Dušan (Fig. 1.13) was fortuitous, as it came at an uncertain time with respect to Serbia's stature and future as a European nation. In 1892, seven years after the declaration of its kingdom, the nascent state was experiencing military failures, renewed threats from Austria and domestic instability under the Obrenović dynasty. Receipt of this commission was a special honor as the painting was to be shown in the Serbian Pavilion at the 1900 World Exposition in Paris. Jovanović was representing his country at a most important international venue. The special challenges for the artist included painting on a monumental scale (390x589 cm), effective compositional arrangement of over seventy figures in complex and various poses, selection of the right moment, and transmission of the underlying message. Jovanović chose to present a history lesson on the greatness of the Serbian past. Appropriately, it was the subject of Tsar Dušan whose reign (1331-1355) had brought Serbia to an incomparable level of political and cultural ascendancy on the Balkan peninsula. The implicit message was

that the existence of Serbia as an independent modern state and its territorial assertions were a legitimate historical right.

Jovanović's approach to the commission typifies his methodology as a history painter. He researched the historical accounts of Dušan's reign and the specific event, consulted contemporary historians, read medieval texts and examined medieval paintings and manuscript illuminations for details of architecture, costume and weaponry. He made on-site visits to Skopje where the coronation had taken place, but since the actual church had been destroyed, he used as his model the closest prototype available, the church in Dečani. Important components of his preparation were the field studies specific to this project as well as those he had made during his student days. Authenticity, always a goal, was even more critical in a painting that might have an impact on international attitudes. However, credibility of detail also required the right framework. Appropriately, the artist employs a perfect Renaissance one-point perspective to enclose the scene of the multitude that has gathered along the steps of the stately medieval church. They are arranged in orderly balanced groups from foreground to middle ground.[57] Each figure, through pose and gesture, leads the eye, without interruption, to the central figure of Dušan. While his reliance on linear perspective and symmetry of composition speak to the artist's clear allegiance to academic history painting, Jovanović was also attuned to his own time. The poses are natural, rendered from life and their expressions appropriately responsive to the event. That veracity is further reinforced by Jovanović's appropriation of contemporary understanding and exploration of natural light. Bright sunlight reveals relevant details and a full range of textures that invite the viewer's more careful scrutiny, and in the process a better understanding and appreciation of the message.

By focusing on the famed reign of Tsar Dušan, Jovanović was making a case for the respect with which Serbia should be regarded. In 1896 he had an opportunity to address Serbia's later history with respect to the Serbian experience with the politics of her Balkan neighbors. It also provided a venue for transmitting a message regarding contemporary Serbia. Jovanović was commissioned by the Congress Board of Sremski Karlovci for a painting of an event of 1690, the *Migration of the Serbs* (Fig. 1.14)[58] to be shown at the Budapest Millenium Exhibition marking a thousand years of the Hungarian Empire and reaffirming that country's territorial rights. Prompted by patriotism and contemporary politics, Jovanović's painting was to present the case for the legitimacy of the Serbian historical presence and territorial claims and, as a consequence, contemporary acceptance of the "legal and privileged position of the Serbs in the Austrian monarchy."[59] The Serbian understanding was that the migration of the Serbs was in response to Emperor Leopold's request for their assistance in protecting his country's borders against the Turks.[60] The contemporary message was that this was the genesis of the Serbian presence in the border areas now under Austria-Hungary.

The commission was a timely opportunity for Jovanović to present a subject of international significance at a politically sensitive moment, to prove his credentials as a history painter of substance, and to address, on a monumental scale, modernist methodology already evident in some of his genre scenes. For a lucid presentation of a complex historical moment, he relied on his research skills, consulting histories and historians as well as collecting ethnographic evidence. Working from life and with uncompromising realism, he confidently defines ethnicity and age, and as dictated by their location, facial details and expressive faces. Individualized portrayals of Patriarch Branković, the priests, military leaders, as well as some of the shepherds, women and children effectively inform the viewer on the composition and character of the migrating population. Concurrently, he was addressing the issues of composing in landscape, conveying an effect of real integration into nature of many forms, both generic groups and specifically defined individuals. His task was to convincingly transport a contemporary audience to a seventeenth-century event that unfolds on the rough terrain of land shared by Serbs and Hungarians. The further aim was to effectively convey and thus engage the viewer in the physical and emotional responses of the determined multitude.

Jovanović was undaunted by the compositional complexities. Rather than present an unbroken horizontal line of figures in the foreground, he staggers them, leaving a series of voids. They punctuate the foreground, directing the eye through the extended diagonals of arms, legs and weapons to the next line of figures. At first visible, the vertical lines of the muskets are the last to be gradually obscured in the dry, dusty terrain. The last vestiges of the far distance are lost in the haze, which produces a momentary visual hesitation only to redirect attention back to the multitude, determined and unstoppable. Such details provide narrative clarity required of traditional history painting. Fully met by Jovanović, they testify to a selective adherence to aspects of his academic training. However, the extent of his focus on atmospheric effects signals his understanding of and ease in incorporation of modernist techniques appropriate to his artistic goals. He was especially alert to the naturalist agenda of the new generations of landscape painters whose work he had studied in his travels throughout Europe. Jovanović was at ease with the art of the past and that of his own time, the established and the tenuous.

Painted in 1898, *Uprising at Takovo*[61] (Fig. 1.15) marked another landmark achievement for Jovanović as history painter. In large measure this is attributable to the timeliness of the subject. A pivotal moment in Serbian history, it is an exploration of the national character in the struggle for independence which began in the fourteenth century with the onset of the Turkish occupation. The subject is the declaration and organization at Takovo of the Second Uprising (1815-1817) under the leadership of Miloš Obrenović. Although the Serbs had been successful in the 1804-1805 Uprising, by 1813 the Ottoman Turks had regained considerable

control and were exerting unprecedented revenge. As depicted here by Jovanović, Serb elders and leaders meeting at Takovo declared their allegiance to the cause and to Obrenović's leadership. With the success of the new uprising Serbia gained considerable self-governance and the international recognition of Miloš Obrenović as Prince of Serbia.

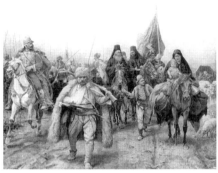 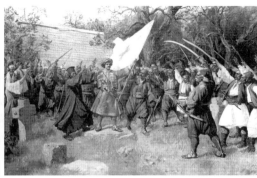

Fig. 1.14 Paja Jovanović, *Migration of the Serbs*, 1896. Oil. 126x190cm.

Fig. 1.15 Paja Jovanović, *Uprising at Takovo*, 1898. Oil. 125.5x190cm.

The painting was shown in 1889, the year following major internal and external threats and difficulties for the young kingdom of Serbia, leading to the abdication of Milan Obrenović (1868-1889) and the regency of his son Alexandar (1889-1903).[62] By depicting the event of the ascendancy of the first Obrenović and the victorious uprising that followed, the artist was presenting a timely reminder of the bravery, unity and faith that had made possible Serbian centuries-long perseverance as a people. He was also recalling the quality of leadership epitomized by the powerfully built, resolute and confident Miloš. He stands with legs extended, feet firmly planted, holding aloft the banner, the symbol of the faith that unites them. These diagonals are reiterated in the raised arms and swords of Miloš's followers.

Replicating a type of contrapposto, the active figures are enclosed in static semi-circular groupings which give grounding to the composition while reinforcing the dynamic quality of the scene.[63] In contrast to his painting of the coronation and the migration, here the composition is deliberately and appropriately simple. Although preceded by his usual attention to historical accuracy of setting and costume as well as fashioning of the figures from life, his focus is on the clarity and effectiveness of the message in 1889. That Jovanović was successful and the painting had special contemporary resonance is supported by the fact that reproductions of the painting were in almost immediate private and official demand. The Serbian Ministry of Education ordered the distribution of the prints in secondary schools,

teachers' colleges and seminaries.[64] Jovanović's contribution extended well beyond that of artistic excellence and aesthetic refinement, a fact that was confirmed at the time. That understanding has been reiterated in recent scholarship which recognizes that Jovanović was depicting " ...historical motifs nurtured and nourished with patriotism,"[65] and thus affecting not only his time but successive generations of Serbs.

Through exhibitions abroad and support of an international clientele both of which exceeded those of any other Serbian painter, Jovanović achieved early and sustained renown. Beginning in 1882 and the first public viewing of his work in Vienna, his paintings were shown in the major cities of Serbia and later Yugoslavia, in foreign venues of Munich, London, Turin, Budapest, Moscow, Bucharest and Venice. He fulfilled commissions on three continents. The history paintings, and especially the Orientalist paintings with which Jovanović established his credentials, found purchasers even into the late years of his career. Similarly, he was consistently in demand as a painter of portraits, a genre that occupied him to the end of his life and that he addressed in a broad range of styles.

While these thematic categories are distinct and separate, they can be successfully reconciled only by certain artists, Predić and Jovanović among them. Jovanović's ease with past and present, established and new, and diversity of subject was in evidence throughout his career. These subjects are brought together and effectively summarized in a commission from his home town. In 1895 the painter undertook a particularly challenging project, a three-panel painting measuring 2x200x100cm; 1x200x200cm, the *Vršac Triptych*, whose subject is *Sowing and Harvesting and Market* (Fig. 1.16).

Here, the artist faced some of the same technical issues as Predić in his 1917 *Panorama of Belgrade* (Fig. 1.8). As discussed, the latter made significant reference to Japanese screens, multi-panel contemporary European paintings as well as building on his experience as a painter of iconostases. Although not to the extent of his colleague, Jovanović had also been the recipient of church commissions that called for multi-sectional paintings. A student of the art of the past and beneficiary of the curriculum of the Academy, like Predić, he had a firm grasp of Western Medieval panel and mural painting. His *Vršac Triptych* finds close parallels in fourteenth-century Sienese paintings, and perhaps specifically Ambrogio Lorenzetti's commission from the city fathers of Siena for the fresco of *The Effects of Good and Bad Government* (1338) and Pietro Lorenzetti´s tempera triptych of the *Birth of the Virgin* (1342). He shares the three-part panel format with the latter and a secular subject and homage to city with the former.

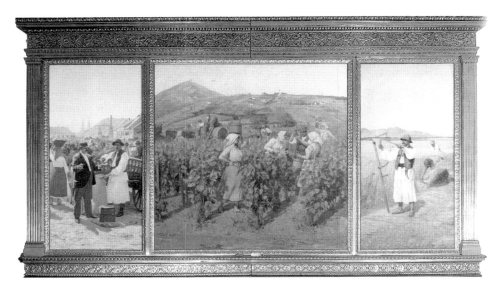

Fig. 1.16 Paja Jovanović, *Vršac Triptych* (*Sowing and Harvesting and Market*), 1895.
Oil. 200x200cm (center panel); 200x100cm (side panels).

Unlike the distinctly different stature of the tradition-bound medieval artist with his dependency on the support of the officials of church and city and thus dictates on artistic expression, Jovanović, especially as an artist with international credentials, had no such limitations. He produced a personal rather than proscribed homage to his home town, recognizing its most compelling characteristics. Against the backdrop of the visually striking city of Vršac and the rich agricultural plains of Vojvodina, Jovanović unfolds a view of the daily life of its diverse citizenry. Here, he depicts Hungarians, Germans and Serbs harvesting their rich crops, gathering the grapes, and interacting in the market place. What is so fully in evidence is that he is presenting the very groups who shared a past that was at times marked by uncertainty and conflict brought on by shifting political and territorial control as well as ethnic and religious tensions. Jovanović shows them engaged in peaceful productivity and convincing co-existence. Brought together by shared needs and purpose, they have attended to duty and now reap the harvest. Against the tranquil rolling countryside of the central panel, the grape gatherers work in rhythmic harmony to collect the ripened fruit from the neat rows of heavily laden vines. To their right, the harvest of the golden grain proceeds apace, two figures bend, sickles in hand, while a third concentrates on sharpening the scythe he holds. The scene unfolding on the left takes place in the city, against the backdrop of the neat

rows of buildings above which the spires of the main church are visible. Here in the crowded marketplace rural and urban citizens meet to sell and purchase, to negotiate and converse. Jovanović relies on easily read symbols to make his message clear. The glistening white-washed buildings, the slender but majestic church spires, the orderly attendance to the harvest of abundant crops are the products of faith, effective government, individual and communal industry. Thus the city is presented as a model of harmony on every level.[66] To accomplish this message Jovanović brings together his skills as a painter of genre, history and portrait.

Neither Predić nor Jovanović introduced new formats in painting a multiple panel composition. Past models informed their approach. Nevertheless, each one used the format in a singular way by introducing thematic originality. Stylistically, both identified their own direction. In keeping with standard methodology, traceable to his earliest training and reinforced at the Vienna Academy, Jovanović made precise drawings of individual figures, the panels and various compositional approaches for the triptych as a whole. The final version testifies to the efficacy of his solutions. While each panel is a complete scene in its own right it has a convincingly harmonious place as part of the whole. Jovanović also had the additional challenge of numerous figures engaged in actions that require precise definition. The complexity and variety of poses do not compromise the unity of the scene and subject. Each figure, although specific, fits easily and effectively into its panel which then forms an interwoven continuum across the whole.

Jovanović, a realist like Predić, wanted to convey more than surface reality—lines and details that define a form or a landscape. Both understood, as did contemporary chemists, physicists and progressive artists, that to capture life the painter had to capture color and light. In his handling of light Jovanović signals considerable innovation. Although, as noted, in some of his small genre paintings he was concerned with natural light, in his *Vršac Triptych* it is clear that he had advanced from astute observation to a real understanding and application of the theoretical studies of light of the Impressionists and Post-Impressionist modernists. Here, in the market panel he captures bright morning light that illuminates the figures, and then its gradual disintegration into the haze that still envelopes, to different degrees, the buildings and distant hills. To achieve objective reality he had to focus with a similar intensity on capturing the veracity of color, specifically, color as revealed by light, a basic principle to which the Impressionists adhered.[67] It is also evident, especially in the market scene, that he was building on the underlying theories of optical merging of pure color and the simultaneity of contrast in order to intensify the tonalities and thus more accurately replicate nature's colors. It is clear that his aim was to capture the real pulse of life in a scene that unfolds so naturally and convincingly that it conveys the sensation that the viewer, who effectuates the optical merging of juxtaposed colors, is no longer an observer but a participant in the painting process. The

extent and success of these explorations would not have been possible had Jovanović limited himself to the traditional pre-mixing of pigment on the palette and painting under studio light. For an artist who had always studied life and nature at first hand, full abandonment of the studio was not a difficult step. He was expanding on an existing methodology by painting on the spot, *en plein air*, another technique that became part of his vocabulary. It is important to note that when the painting was shown at the Hungarian Millennium Exhibition[68] in the reviews his use of pleinairism and its implications were specifically noted. "Among his friends, Jovanović is a real master of precise painting. This time he used plein air and showed so much skill that his paintings could rightfully be set as an example for younger generations."[69]

In his own time, then, Jovanović was not viewed as solely embedded in the past, but as invested in the new and experimental and as a model for younger artists. It is in this light that both he and Predić should be considered. Their contribution to Serbian painting was not simply the replication of academic formulas. Through careful selectivity they developed their own solid artistic vocabulary that influenced the art of their compatriots. Although they were building on traditional bases, they were modernists in their own time, embracing theoretical and technical advances appropriate to their beliefs and needs. They set the stage for bolder experimentation of subsequent generations of artists. In their own works they effectuated a type of thematic and stylistic synthesis, informed by past and present. They provided a link between the established and the avant-garde, the traditions of the Balkan East and the European West. They played pivotal roles in bringing Serbian art emphatically onto the international stage.

Notes

* I extend sincere appreciation to Dr. Ljubica Popovich for her advice and insightful textual recommendations and to David Robinson for his careful reading and stylistic suggestions.

[1] The village of Orlovat was in the Hungarian controlled Banat region of Vojvodina. Previously the area had also been under Turkey and Austria.

[2] Miodrag Jovanović, *Uroš Predić* (Novi Sad, 1998), 246.

[3] Specific painters that he referenced included Konstantin Danil, Stevan Todorović and Dimitrije Popović. See Vera Ristić, *Uroš Predić* (Kragujevac, 1976) 6-7.

[4] As cited from his autobiography in Jovanović, 255.

[5] These included the academies in Pest, Berlin, Munich and Dusseldorf. By the second half of the nineteenth century the latter two had adopted the most progressive approaches, many of which were built on ideas imported from Paris. The Vienna and Munich academies attracted the largest number of Serb students.

[6] A sophisticated command of the German language (in which Predić excelled) was a prerequisite.

[7] For a discussion of the academic system see Nikolaus Pevsner, *Academies of Art, Past and Present* (New York, 1973).

8 His letters and autobiography demonstrate linguistic talent (German, Italian and French) and serious interest and knowledge of history, aesthetics and philosophy. These intellectual concerns were sustained throughout his life.

9 For a discussion of Predić's training in Vienna see Jovanović, 63-70.

10 For a discussion of Biedermeier painting see Geraldine Norman, *Biedermeier Painting* (London, 1987).

11 Spitzweg (1808-1885) was best known for paintings such as his *Poor Poet* (1830) and *The Serenade* (1840).

12 According to reminiscences of the sister, the event was real. She was tasked with knitting the socks for her brother following her mother's death. M. Radivojević as cited by Jovanović, 84.

13 This type of domestic subject and gentle didacticism is comparable to that of French genre painters such as Pierre Édouard Frère (1819-1886) in, for example, his *Preparing for Church* of 1835. His work was widely collected beyond France, including in Central Europe, especially in the latter part of the century. For a discussion of Frère see Barbara Stephanic, "Pierre Édouard Frère," in *La Vie Moderne* with an essay by Lilien F. Robinson (Washington, D.C., 1983).

14 Jovanović, 86.

15 Ibid.

16 Dejan Medaković, *Srbi u Beču* (Novi Sad, 1998), 259.

17 Typical models for younger painters were Johann Krafft's recordings of Austrian history. See Norman, 24-25; 42-43.

18 The first version dates to 1876 and the second—the subject of this discussion—was completed in 1889.

19 Although revolts began more than a decade earlier, those of 1875 ultimately engaged the entire Balkan peninsula in revolts, war with and defeat of Ottoman Turkey, and the subsequent Treaty of Berlin which placed Bosnia and Hercegovina under Austria-Hungary. For further discussion of these events and their consequences see Vladimir Ćorović, *Istorija Srba*, Vol. 3 (Belgrade, 1989).

20 Jovanović, 88-89.

21 The selection by the Serbian government of two of his works for the Serbian Pavillion at the World Exposition testifies to Predić's professional stature in Serbia. Moreover, the Exposition provided further international exposure for the artist. The other painting was his *Orphan on Mother's Grave* of 1888.

22 The lines of the Kosovo epic invariably focus on the centrality of faith for Tsar Lazar and his men and the acceptance of their destiny—honorable death in battle and ultimately redemption—as the will of God and his greater design for the Serbian people.

> And that was how the Serbian tsar was slain
> And with him all seventy thousand braves,
> So all was holy, all with honor done,
> And just and meet, and pleasing to our Lord.

"The Battle of Kosovo," *Songs of Serbia* (Toronto, 2002), 92.

23 As quoted in Jovanović, 91.

24 Ibid., 96.

25 Ibid.

26 His stylistic departures at Bečej elicited considerable concerns and debate. For a discussion of the discourse with respect to this commission see Jovanović, 95-100.

27 This panel was completed in 1893.

28 Coined by the critic John Ruskin (1847), the phrase was originally associated with the British Pre-Raphaelite movement and refers to their insistence on the accurate representation of all things in nature. The international impact of these concepts was especially strong during the last three decades of the

nineteenth-century. For a discussion of the Pre-Raphaelites see Timothy Hilton, *The Pre-Raphaelites* (New York, 1970).

[29] A devoted son, he had moved back to Orlovat to join his widowed mother, remaining there until her death.

[30] The painting bears a particular resemblance to the Nabis group and the work of Pierre Bonnard (1867-1947) with respect to both color preference and application.

[31] The 1889 World Exposition in which Predić participated included a Japanese Pavilion. However, Japanese art had already been introduced into Western Europe by the mid 1860s.

[32] Édouard Manet, Claude Monet, Edgar Degas and James McNeil Whistler were among the first generation to be significantly influenced by Japanese art.

[33] For a discussion of Vuillard and *The Public Gardens* panels see Guy Cogeval, *Edouard Vuillard* (Washington D.C.), 2003.

[34] Until the end of his life he moved between two distinct societies, maintaining permanent studios in Vienna and Belgrade. Conversely, Predić maintained his firm base in Serbia. His two centers were Orlovat and Belgrade.

[35] Nikola Kusovac in *Pavle Paja Jovanović* (Belgrade, 2009), 9.

[36] While Predić was so focused on his studies that he limited his exploration of city life and the sometimes distracting student camaraderie, the outgoing Jovanović seems to have been fully engaged. For further discussion see Dejan Medaković in *Pavle Paja Jovanović* (Beograd, 2009) and Miodrag Jovanović, *Uroš Predić* (Novi Sad, 1998).

[37] Although unsuccessful in his first application in 1877, two years later he was receiving scholarship support from Matica Srpska which had awarded Predić a scholarship in 1877. Nikola Kusovac, *Slike i crteži Paje Jovanovića* (Novi Sad, 1984), 9.

[38] As discussed, Predić received the Gundel Prize in 1879.

[39] Each painter took away different elements from Grippenkerl and applied them in ways suitable to his own work.

[40] Initially a product of early nineteenth-century French Romanticism, by the 1870s Orientalism had gained international prominence. As a model for emulation Müller cited the work of Eugène Fromentin whose following was especially strong in Central Europe. He could as easily have pointed to some of the other prominent exemplars and Salon favorites such as Eugène Delacroix, Jean-Léon Gérôme, and Charles Gleyre, whose work would have been familiar to Jovanović.

[41] Jovanović received positive critical reinforcement for his approach to Orientalism when London's *Daily Telegraph* reported in 1885 that "[t]he Serbian student of Professor Müller, Paja Jovanović, is getting close to mastering the techniques of his teacher and in some cases in terms of the specificity of detail he is surpassing him." Kusovac in *Pavle Paja Jovanović,* 9.

[42] Ibid., 7.

[43] Dejan Đurić in *Pavle Paja Jovanović,* 179.

[44] Medaković, *Srbi u Beču,* 268.

[45] Even Emperor Franz Josef had admired the "intricacy of his detail". Medaković, *Paja Jovanović,* 6.

[46] For a discussion of these issues see Nikola Kusovac in *Pavle Paja Jovanović,* 41-42.

[47] Of the so-called "Popular Realists," one of the best known internationally was Jules Breton. He focused on the agrarian life of northern France, providing positive, inevitably sentimental images of peasants. For a discussion of his work see Annette Bourrut Lacouture, *Jules Breton* (New Haven, 2002).

[48] The 1897 version is the focus of this discussion.

[49] It is important to note that his Orientalist paintings continued to have a formidable presence in the twentieth century even as the public was presented with an increasing number of more avant-garde approaches.

[50] Although a practitioner of various styles, here Gérôme relies primarily on a Neo-Grec vocabulary. For an in-depth discussion of Gérôme's thematic and stylistic approach and this painting see Scott Allan and Mary Morton, *Reconsidering Gérôme* (Los Angeles, 2010).

[51] This type of accuracy was the result of his direct on-site notations as well as availability of a collection of costumes, weapons, and household objects he kept in his studios. For further discussion see Jasna Marković, *Muzej Paje Jovanovića* (Beograd, 2009).

[52] Although he was less inclined towards painting religious subjects, he did, nevertheless, fulfill a number of major church commissions such as the iconostas for the Church of Saint Nicholas in Dolovo and the Cathedral Church in Sremski Karlovci.

[53] He maintained a substantial Serbian clientele, active membership in the Serbian National Academy and engagement in national events.

[54] In the discussion that follows they are discussed in historically chronological order.

[55] The subject has been at times identified as the presentation of Tsar Dušan's Code.

[56] There are multiple versions of all three paintings. In the case of the coronation scene, Jovanović produced six versions of what became an immensely influential and popular work. Jovanović's contract gave the right of reproduction to the Serbian government.

[57] Generally informed by Renaissance art, the painting is structurally reminiscent of Raphael's frescoes in the Vatican Palace, specifically his *School of Athens*.

[58] There are three versions of this subject. The first two, one of which is the Pančevo version discussed here, date to 1896 and the third to 1945. Most of the widely distributed lithographic reproductions are of the Pančevo version.

[59] Medaković in *Pavle Paja Jovanović,* 133.

[60] The other explanation of the migration and one initially explored and depicted by Jovanović but rejected by his commissioners was that the Serbian migration was in response to the Turkish occupation of Serbia. See Kusovac in *Pavle Paja Jovanović,* 69.

[61] He painted two versions of this painting of which this is the larger. Its original purchaser donated it to the National Museum after obtaining reproduction rights. The smaller version was painted for King Aleksandar. For a discussion of the complex market history of this painting see Kusovac in *Pavle Paja Jovanović,* 80-84.

[62] The Kingdom of Serbia was declared in 1882.

[63] This potentially contradictory juxtaposition of movement and stability, tension and repose, is reminiscent of Greco-Roman sculptural reliefs that formed a basic component of the artist's study at the Vienna Academy.

[64] See Kusovac in *Pavle Paja Jovanović,* 80-4, for a discussion of lithographic reproductions.

[65] Ibid., 42.

[66] Although distinctly different in style, this was also the message of Ambrogio Lorenzetti. Because of faith and good governance, Sienese citizens are shown enjoying a prosperous, harmonious, and peaceful existence. For a discussion of Sienese painting and the work of the Lorenzetti brothers see "Pietro and Ambrogio Lorenzetti" in *The Great Italian Painters from the Gothic to the Renaissance* (Florence, 2003).

[67] For a discussion of the principles and methodology of Impressionism see John Rewald, *Studies in Impressionism* (London, 1985) and A. Callen, *Techniques of the Impressionists* (London, 1982).

[68] The *Vršac Triptych* and *The Migration of the Serbs* were commissioned concurrently by the Congress Board of Sremski Karlovci. Both were intended for the Millennium Exhibition, but only the *Vršac Triptych* was completed in time for the opening of the exhibition.

[69] As quoted by Kusovac in *Pavle Paja Jovanović*, 75.

CHAPTER 2

ZENIT: PERIPATETIC DISCOURSES OF LJUBOMIR MICIĆ AND BRANKO VE POLJANSKI

Igor Marjanović

Brotherly Departures

On Sunday, July 17 1927, Branko Ve Poljanski (1897-?), rushed up and down Belgrade's Terazije Street, distributing his books *Le Coq Rouge* (*The Red Rooster*) and *Tumbe* (*Upside Down*) to passers-by. This give-away was his symbolic rejection of literary activity in favor of painting, since Poljanski had recently decided to "convert" from a poet to a painter living and working in Paris. This departure – both disciplinary and national – is indicative of Poljanski's separation from poetry and choice of painting as his discipline in response to his dismay over traditional disciplinary boundaries. It was also a form of creative displacement that allowed avant-garde artists, architects and poets to translate revolutionary ideas from one medium to another, and an indication of a larger cultural shift within the historical avant-garde which allowed its proponents to transverse various modes and sites of production. The Bauhaus, one of the nuclei of the modern movement, was tied to its German socio-political roots as well as to its immense diaspora of students, faculty and ideas that extended from Europe to Asia, Africa and the Americas.[1] As Bauhaus teachers and students left Germany they seeded new ideas about art and architecture around the world. Yet their work is also significant, as it often crossed the traditional disciplinary confines established in the previous century – the work of architects such as Walter Gropius and Mies van der Rohe often spanned architecture, visual arts, industrial and graphic design and urban planning, erasing the boundaries between these fields through a combination of textual and visual strategies. They produced designed objects, buildings, works of art, books, theater pieces and writings, all in an effort to promote a new society in which the confines of the past would be completely abolished in favor of individual and collective liberation.

Within this web of avant-garde practices of the 1920s, we find the Bauhaus and its proponents, as well as a number of other groups, such as the Futurists, the Dadaists, the

Igor Marjanović

Cubists, the Surrealists and a number of other groups that were active in Central Europe, including Czechoslovakia, Hungary and the Kingdom of Serbs, Croats and Slovenes (renamed the Kingdom of Yugoslavia in 1929). Branko Ve Poljanski was a keen correspondent with many of these groups, most notably through his contribution to *Zenit* and *Zenitism* – an avant-garde magazine and movement led by his charismatic brother Ljubomir Micić (1895-1971) – but also through his frequent visits to other avant-garde centers: in Prague he organized an art club called *Zenit*, with the purpose of spreading *Zenitism*, and participated in Revoluční scéna (Revolutionary Theatre Company), a German style cabaret at the Adria Theater on Václavské náměstí (Wenceslas Square); in 1921 he lived in Vienna, and by 1922 he had moved to Berlin, where he associated himself with a group of artists around Herwarth Walden and his magazine and gallery *Der Sturm*.[2] Throughout this period Ve Poljanski also remained connected to his Serbian roots, publishing poems, fiction and cultural commentaries for his brother's magazine *Zenit*, disseminated on a Belgrade-Zagreb axis in the Kingdom of Serbs, Croats and Slovenes between 1921 and 1926.[3] But by 1925 his restless spirit had taken him across the border yet again, and he found himself living in Paris as an "official" *Zenit* representative and correspondent, a period that coincided with his brother's exile to Paris (1927-1936). But unlike Ljubomir Micić, who returned to Belgrade in 1936 to continue his life and work there, Ve Poljanski remained in Paris, trying to make a living as an artist and a *Zenit* progenitor. By the late 1930s, however, he had become rather impoverished and had to rely on the support of his friends. He was last seen in Paris around 1940 and was later presumed dead, possibly vanishing as one of the homeless people sleeping and dying under Parisian bridges. The exact year of his death remains unknown, only contributing to the increasing life-long peripatetic nature of his life and work.

As Micić's and Ve Poljanski's European travels unfolded, they imbued their work with a certain transitory tone – a tone of displacement and a constant search for a new homeland, both literally and figuratively. This peripatetic pattern also became the cultural identity of their entire circle – one of their main collaborators, author and journalist Boško Tokin for example, was not only one of the main *Zenit* correspondents, but also a frequent contributor to *L'Esprit Nouveau*, as well as recurrent conversant in the Futurist circles of Rome and Florence. (Fig. 2.1) [4]

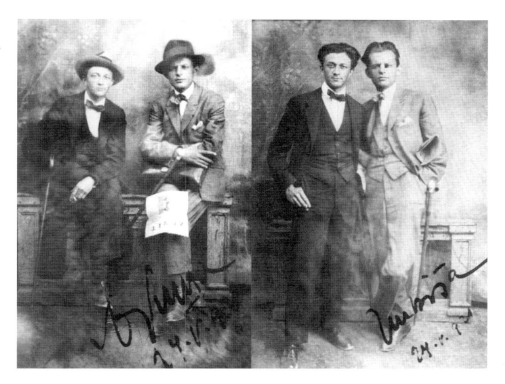

Fig. 2.1 Boško Tokin and Ljubomir Micić, Zagreb, May 24, 1921. A series of two photographs where Micić signed his nickname "Ljubiša" both in Cyrillic (left) and Latin (right) alphabets.

This traveling impulse was particularly strong in Ve Poljanski's work: even the casual observer would note that the two brothers did not share the same last name – this was a testament to Ve Poljanski's desire to change his last name from Micić to Poljanski in reference to his mother Marija's birthplace called Majske Poljane (May's Fields), near the small town of Glina. His father Petar was also from the nearby village of Majski Trtnik and both parents were members of the ethnic Serb minority within the Croatia-Slavonia region of the Austro-Hungarian Empire. The ethnic background of the Micić brothers was significant, both culturally and geographically. Culturally, their Serbian ethnicity reflected a minority status within Croatia-Slavonia that was laden with a broader dynamic of Serbo-Croatian relationships, within both Austria-Hungary and later the Kingdom of Serbs, Croats and Slovenes. Geographically, both parents came from the Vojna Krajina region (The Military Frontier) of the Austro-Hungarian Empire that between the 16th and late 19th centuries acted as a buffer zone on

the very edge of imperial territory, intended to protect it from Ottoman invasions.[5] As many Serbs fled Ottoman oppression in the South, they settled in the Military Frontier, working as *granitschari*, or frontiersmen, and bearing arms at all times. As Serbs defended the Austrian lands against steady offensives from the South, their villages were constantly burnt down in continual wars, and despite the numerous tax benefits offered to the Serbs by the Austrian Emperor, the Military Frontier remained the poorest and most isolated part of the empire; the war was its only economy. As the Ottoman Empire declined, the Military Frontier was dissolved and incorporated into the Croatia-Slavonia region of the Kingdom of Hungary in 1881, leaving a sizeable Serbian minority in that part of the Austro-Hungarian Empire. This re-drawing of boundaries created a particular dynamic of Serbo-Croatian relations that would expand in the 1920s, the time when the Micić brothers were active. As the Serbs observed the absorption of the Military Frontier into Croatia, they somewhat resisted their new position of a minority culture, increasingly looking to nearby Serbia as their homeland. On the other hand, some members of the Croatian cultural élite, aligned with the Catholic, Hapsburg and the larger Western European cultural model, perceived the impoverished Serbian frontiersmen and their Orthodox Faith "as a backward and inferior race."[6]

While these mutual perceptions certainly do not encompass all the nuanced complexities of inter-ethnic relationships, they also reveal some underlying tensions that in part influenced Micić's and Ve Poljanski's worldview. Like other members of the Serbian minority in Croatia, Slavonia and Dalmatia, they too looked at a bigger question of Serbo-Croatian relationships from a very personal perspective. The two brothers were born in the village of Sošice, near Jastrebarsko, where their father worked as a forest superintendent. Ve Poljanski's desire to "root" his name in a toponym of his mother's birthplace – Poljanski can be loosely translated as "From the Fields" – probably has something to do with his search for identity. As a member of an uprooted ethic minority, he was squeezed in between the peculiarities of his Serbian upbringing and the socio-political context of the late Austro-Hungarian Empire, where both Serbs and Croats fought against forced assimilation into either Austria or Hungary, while at the same time creating their own peculiar set of inter-ethnic relationships characterized by intense alliances, but also disagreements and animosities. When the new country of Serbs, Croats and Slovenes was formed in 1918, many believed that these tensions had been put to rest but, as history unfolded, living in a common state only exacerbated the dynamics of these inter-ethnic relationships.

Working in such a fluid context, Micić and Ve Poljanski were caught between Belgrade and Zagreb, between Croatia and Serbia, sometimes embracing them, sometimes rejecting them. Additionally, they launched *Zenit* in 1921 as a part of a larger wave of avant-garde journals that appeared throughout Europe, inevitably positioning themselves relative to the

larger European context, moving beyond the Balkans' localized context. Recent scholarship has acknowledged the importance of these links for the evolution of modernism in Serbia and former Yugoslavia.[7] While indeed *Zenit* served as a major progenitor of the modern movement in the Balkans, it also reflected the state of inter-ethnic relationships in Yugoslav lands, and, even more broadly, the role of smaller nations in the greater trajectory of European culture. By focusing on the peripatetic nature of *Zenit's* cultural production, I seek to expose identity formation and diasporic experiences as one of the primary vehicles of cross-cultural dialogues between centers and margins and a potent agent of the larger fabric of European modernity.

Promoting Modernism

Micić started the journal *Zenit* in Zagreb in February 1921 but, dismayed by the reception of his revolutionary ideas there, moved the journal to Belgrade in 1923 where he continued to publish it until 1926. But in Belgrade too his ideas were often seen as ultra-radical, and by the late 1920s both brothers rejected the Serbian context too and found themselves working and living in Paris, a place Micić would ultimately leave in 1936 in order to come back to Belgrade. Through these frequent European crossings, they developed a hybrid sense of identity that equally rejected the Croatian, Serbian and Western European political and cultural élites, often ridiculing them on the pages of their magazine.[8] Yet, as *Zenit's* editor, Micić also actively promoted what he perceived as the revolutionary currents of European modernism, including Expressionism and Dadaism. Throughout *Zenit's* 43 issues, this promotion was carried through visual and textual means, mostly through the publication of noted avant-garde projects from Germany, Russia, France, the Netherlands and other countries. These international references were often sprinkled with Micić's and Ve Poljanski's literary reflections in the form of manifestoes, poems, critical commentaries, interviews and dialogues. In that regard the pages of *Zenit* offered a form of international dialogue that testified to the ways in which modern ideas traversed Europe and were adopted and adapted to their new contexts.

A very significant aspect of that exchange occurred in 1922, when Micić published Vladimir Tatlin's Monument to the Third International (1920) on *Zenit's* cover page, widely considered the first publication of this seminal constructivist work outside Soviet Russia (Fig. 2.2).[9] Other significant references recorded on the pages of *Zenit* include Ve Poljanski's fiery exchange with Filippo Marinetti in Paris in 1925, where he questioned the Futurists' compliance with Fascism and its oppression of the Slovenian and Croatian minority in Italy.[10] While appreciative of the formal language of Futurism that was often featured on the pages of *Zenit*, Ve Poljanski rejected its political mandate. It is precisely in this dichotomy that an

important conceptual rift within *Zenit* emerges – while the journal undoubtedly promoted various strands of European avant-garde movements, it also exposed underlying tensions about the role and position of smaller nations, including the Serbs, Croats and Slovenes, in these wider currents. Indeed, *Zenit*'s editors allowed the journal to act as a traveling documentary that promoted modernism from around the world through images of buildings and works of art that were dropped off like a postcard in a mailbox, only to reappear on the pages of *Zenit* and circulated throughout the Balkans. As these images gained traction for the burgeoning modernist ideals, they also allowed the Micić brothers to reflect on their own identity, and in particular on the question of Serbian cultural identity within a larger European family of nations, ideas and movements. What is interesting about this reflection is that it fused the seemingly conflicting desires to participate in these international dialogues and to create a uniquely local voice for small Balkan nations. It is precisely in this aspiration to promote the Balkans and reposition its perception from an impoverished backward region to a globally visible cultural producer that the editorial work of the Micić brothers questioned modernism's budding geography of centers and margins.

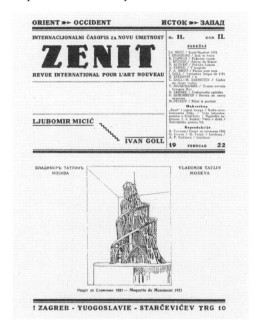

Fig. 2.2 Ljubomir Micić, editor, *Zenit* no. 11, February 1922.

Promoting the Balkans

Emerging from the pages of *Zenit* was an entire movement – Zenitism – that rejected contemporary capitalist values, already deeply shaken by the devastation of the First World War. Micić and Ve Poljanski actively promoted their nascent movement through a series of public events, most notably through the Zenitist Evenings in Ljubljana, Zagreb and Belgrade and the First Zenitist International Exhibition of New Art in Belgrade (1924). A poster

for the 1923 *Velika zenitistička večernja* (The Big Zenitist Evening) in Zagreb demonstrates the dual trajectory of Zenitistic ideas – a desire to promote modern architecture is evident in the (re)publishing of Tatlin's Monument to the Third International, which occupied a small, but prominently central, position on the poster (Fig. 2.3). Around it we find powerful captions inviting the participants to attend the event, which were written in French and in a combination of Serbian and Croatian languages using the Latin script. The poster also calls for "a new Balkan art, for an eternal youth, for the victory of the *barbarogenije* (the barbaric genius)" and against "the European paralysis, against sentimentality, against literature"; in conclusion, "Zenitism is fighting for the Balkanization of Europe."[11] This concept was later fully articulated in Micić's novel published in French in 1937 entitled *Barbarogénie le décivilisateur*.[12] This book remains a powerful testament to Micić's desire to reverse the traditional perception of identity categories – historically, the people of the Balkans were seen as inferior to their conquerors, whether Austrian, Hungarian, Venetian or Ottoman. Yet they also aspired to belong to European culture, in particular in the context of Serbia's Ottoman yoke, which saw the country occupied by the Ottomans for several centuries. Similarly, the Croats and Slovenes aspired to the cultural world of their Austrian and Hungarian conquerors and to the broader Western European cultural model. Building upon the concept of their *barbarogenije*, Micić argued for a new identity category – a confident and liberated minority culture, whether a Serbian one within Croatia or a Serbo-Croatian one within Europe, and a producer of culture as opposed to a mere recipient. Micić's *barbarogenije* also echoes the theme of the noble savage and its critique of anthropological representations and stereotypes, that had featured prominently in the West since the Enlightenment.[13] The concept of the noble savage appeared frequently in the field of modern visual culture and the work of artists such as Pablo Picasso, who looked to traditional African Art, and architects such as Le Corbusier, who early in his career studied the vernacular art and architecture of the Mediterranean.[14] This idealization of distant lands was present in the context of Serbian modernism too, where artists and poets such as Rastko Petrović looked at Africa both as an actual source of inspiration and as an imaginary nomadic land of cultural, social and even sexual freedoms.[15] But what distinguishes *barbarogenije* from other similar concepts is its radical nature, its severe rejection of Euro-centrism in favor of peripheral cultural models. This culminated in Micić's rejection of the entire construct of civilization, which he saw, like the Dadaists for example, as a major source of alienation that must be destroyed and erased. This is somewhat paradoxical, given Micić's and Ve Poljanski's extensive coverage of European avant-gardes, as well as their intense international travels. Yet this destructive impulse also mirrored their experience of the human carnage of the First World War, and could even be traced back to the burnt villages of the Habsburg Military Frontier where their parents grew up. The Great War was particularly

bloody in the Balkans where Serbia, fighting on the side of its French and Anglo-American allies, lost more than a quarter of its pre-War population, including more than half of the male population drafted into the army. Among the Serbian cultural élite such losses caused major consternation over the supremacy of Western European cultures, resulting in the questioning of moral, cultural and social alliances between Serbia and the rest of Europe. This form of critical reflection was not, however, shared by the Serbian political élite and in particular by the Serbian Royal Family, which after World War I remained close to its French and European allies, driving the political life of the Kingdom of Serbs, Croats and Slovenes and later the Kingdom of Yugoslavia towards its Western allies throughout the Interwar period. Because of their opposition to the supremacy of Western culture and implicitly also to its capitalism, Micić's and Ve Poljanski's work was often banned by Yugoslav censors, so they alternated their production sites between Zagreb and Belgrade in an effort to evade political prosecution.

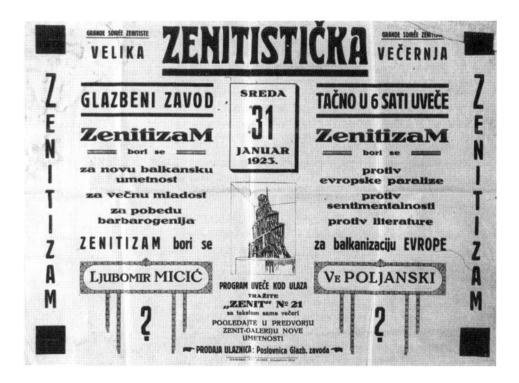

Fig. 2.3 Ljubomir Micić, Velika zenitistička večernja [Big Zenitist Evening], Zagreb, January 31, 1923, poster.

Working on the Belgrade-Zagreb axis was also not entirely without predicaments. Belgrade, the capital of Serbia and the newly unified Kingdom of Serbs, Croats and Slovenes, and Zagreb, the capital of Croatia-Slavonia, represented the two opposing, yet equally important, poles of brothers' identity. Zagreb's connections to Austria, Italy and Central Europe complemented Belgrade's Pan-Slavic and Pan-Orthodox links to Constantinople and Moscow, as well as Central European links to Budapest and Prague. The interconnectedness of the two contexts was often highlighted by the intermittent use of Latin and Cyrillic alphabets on the pages of *Zenit*, including the title itself, which was often featured as Zenit / Зенит.[16] (Fig. 2.4) Since by the end of the 19th century the Cyrillic alphabet was more closely tied to the Serbian language and the Latin alphabet to the Croatian language, this intermittent use of both alphabets reflects a quest for identity that constantly oscillated between Croatia and Serbia.[17] In *Zenit* 17-18 Micić even reversed these typical alphabetic associations, spelling "Belgrade" in the Latin alphabet and "Zagreb" in the Cyrillic alphabet (as in "Загреб"), thus fusing the identities of the two nations in the same way that they were fused in his own background and upbringing.[18] This fluid approach to identity is also evident in the changing name of the country as it was published on *Zenit's* cover page: Micić used "S.H.S" (acronym for the Kingdom of Serbs, Croats and Slovenes), but he also used "Yougoslavie" even before that name of the country was officially adopted; while he later used "Serbie" too – even though that was not the country's formal name – the last issue of *Zenit* in 1926 had no country designation at all. While these inconsistencies reflect the shifting nature of the Yugoslav lands and their ever-evolving borders and names, the ultimate erasure of any homeland in *Zenit's* last issue implies a desire to position Zenitism beyond national borders.

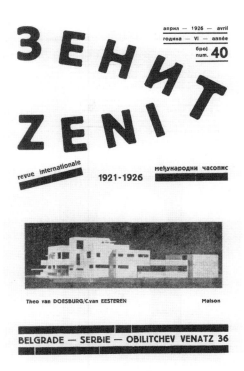

Fig. 2.4 Ljubomir Micić, editor, *Zenit* no. 40, April 1926.

This international aspiration was reflected in *Zenit's* eclectic pages that featured prominent European artists and architects, as well as texts in French, Italian, Russian, German and other languages. This dichotomy is visible in the cover page for *Zenit* 40 from April 1926, which featured Theo van Doesburg's and Cornelis van Eesteren's Villa Rosenberg (1923).[19] The same issue also featured a text by Walter Gropius titled "International Architecture",[20] as well as the use of the French language in order to reach international audiences. In that sense, the goal of Micić's and Ve Poljanski's *barbarogenije* was somewhat paradoxical: to criticize Europe, in particular its capitalist and imperial nature, yet to also reach out to it, to make it more culturally diverse by including discourses from smaller and peripheral cultural sources. Their *barbarogenije* both aspired towards Europe and rejected it: *Zenit* 40 simultaneously featured the winning competition entry for Unter den Linden in Berlin by our "friend and collaborator" Cornelis van Eesteren, while at the same time including a poem entitled "Airplane without an Engine: An Anti-European Poem," where contemporary political events in Western Europe were equated with "a death of an inflated frog."[21] Gradually, these conflicting references led the Micić brothers to use the term "Balkanization" in a positive connotation, suggesting cultural autochthony that rivals traditional Western European cultural norms – a sharp contrast to the derogatory use of the terms "Balkanized" and "Byzantine" in the Western hemisphere, which are often used to signify backward parochialism. Micić's and Ve Poljanski's use of the term "Balkan" as a metaphor for rebellion is important, as it also suggest the importance of language and literary strategies in the promotion of modernity within visual culture – a strategy of written advocacy of modernism that was particularly evident in Ve Poljanski's work as a poet.

When Poetry Ruled the Discourse

Before renouncing his poetic activity in 1927, Branko Ve Poljanski produced three books that extended some of the Zenitistic ideals into the literary arena: *Panika pod Suncem – Panique sous le Soleil* (*Panic under the Sun*), *Tumbe* (*Upside Down*), and *Crveni Petao – Le Coq Rouge* (*The Red Rooster*). These works are significant because of their connections to other radical poetic practices across the Kingdom of Serbs, Croats and Slovenes in the 1920s, many of which were developed as a direct reaction to the unprecedented war trauma. As in the case of Ve Poljanski, these poetic practices were as visual as they were textual, offering a form of critical reflection that spanned art, architecture, literature and ultimately politics.[22]

Ve Poljanski's *Panika pod Suncem – Panique sous le Soleil* (*Panic under the Sun*) was published in 1924, offering a close view of *Zenitism*: the book comprised an introduction by Ljubomir Micić titled "Ajde de!" ("Come on!"), as well as short pieces by Ve Poljanski "Manifesto"

and "Alarm" (Poljanski also read the latter at the 1923 Big Zenitist Evening in Zagreb) and a series of short poems.[23] Like the *Zenit* journal itself, the book's cover featured bilingual French and Serbian titles with a recognizable mix of Latin and Cyrillic alphabets. If these interchangeable uses of different alphabets underscore yet again the unresolved questions of identities, the poems inside the book propose a much larger conceptual framework rooted in that unstable condition. One of the poems, "A Journey to Brazil," reveals Ve Poljanski's "journey" to Brazil that took place in his own mind, guided by the imaginary snapshots of a potential Transatlantic crossing.[24] In this poem, Brazil is nothing more than a metaphor for his own room and imagination; unlike a real country, it is a space of words and discourse.

Such use of literary metaphors of distant locales was not unique to Ve Poljanski; other poets and artists from *Zenit's* extensive web succumbed to it too. Miloš Crnjanski (1893-1977) was a poet, an author and a traveling diplomat, but also a *Zenit* contributor, where in the early days of the journal he published "Poslanica iz Pariza" poem ("A Letter from Paris")[25]. This poem depicts a series of visual snapshots recorded by the poet weightlessly suspended among the clouds and gazing at the mountains below: Šar Mountain in Kosovo and Metohija, Velebit on the Adriatic coast and Fruška Gora in Syrmia. Through his literary fusion of disparate geographical locations, Crnjanski reaffirmed his role as the ultimate theoretician of the Serbian exile that would culminate in his 1929 novel *Seobe* (*Migrations*).[26] His writings often reflected his own experience of displacement that in some ways paralleled the experience of the Micić brothers: he grew up in a Serbian minority community in the Kingdom of Hungary; he was a student in various parts of the Empire – Pančevo, Timişoara (Temišvar), Rijeka (Fiume) and finally Vienna – and also served as an Austro-Hungarian soldier on the Russian and Italian fronts and later as a diplomat from the Kingdom of Yugoslavia in Berlin and Rome; finally, he became an émigré in Lisbon and London during and after World War II, only to return to Belgrade in 1965, towards the end of his life.[27] These constant displacements yielded both anxiety and inspiration, but also a worldview that identified with Surrealism, later epitomized in the lines of Crnjanski's influential poem "Sumatra" (1920):

> Now we are carefree, light and tender.
> We just think: how quiet are the snowy
> peaks of the Urals.
>
> If a pale figure makes us sad,
> the one we lost to an evening,
> we also know that somewhere, instead of it a rivulet
> flows and is all red.

Each love, each morning in a foreign land
envelops our soul closer by its hand
in an endless tranquility of blue seas,
in which red corals glitter
like the cherries of my homeland.

We wake at night and sweetly smile
at the Moon with its bent bow
and we caress those distant hills
and the icy mountains with our tender hand.[28]

The tile of Crnjanski's poem is complex, as it suggests both a distant island of Sumatra, and also a Surreal combination of the Serbian words S-uma-tra(g) that could be translated as "a trace of mind." For Nina Živančević, Sumatra "stands for Crnjanski's literary program," representing "a mixture of his early Expressionist desire for metaphysical peace and his Symbolist flight into No Man's Geography – into the quiet land of icy Ural mountains where the poet's soul dwells in the memories of his feelings and despair."[29] All these pessimistic overtones of exile reverberated in Crnjanski's writings as he sent them to the Micić brothers for inclusion in their *Zenit* magazine – a complex set of perceptions of marginalization and diaspora that powerfully resurfaced in the literary works of Ve Poljanski who was undoubtedly very familiar with Crnjanski's writings.

When Ve Poljanski published *Tumbe* (*Upside Down*) in Belgrade in 1926 he included a poem "Sumrak" (Sunset), which shows some similarities to Crnjanski's "Sumatra."[30] Both poems evoke distant landscapes and a melancholy of the soul, which, in the case of Ve Poljanski, is further accentuated by the carefully painted nocturnal landscape made of "rebellion and blood" and "loneliness under the stars."[31] (Fig. 2.5) The book featured a cover page in French-Serbian designed by Ve Poljanski, consisting of a strict geometric pattern made of horizontal and vertical black lines on a white background. The layout represents an exercise in modernist design and typography, suggesting a certain visualization of Ve Poljanski's poetry and a gradual domination of visual imagery over textual references in his work. The back cover of *Tumbe* (*Upside Down*) also featured a rather prominent modern design – a black circle penetrated by a white triangle. This was a clear reference to El Lissitzky's 1919 political poster *Krasnym klinom bei belykh* (*Beat the Whites with the Red Wedge*). El Lissitzky was featured prominently in *Zenit*, including in the special issue no. 17-18 devoted to New Russian art which also included coverage of other artists such as Vladimir Tatlin, Alexander (Aleksandr) Rodchenko, Kazimir Malevich and many others.

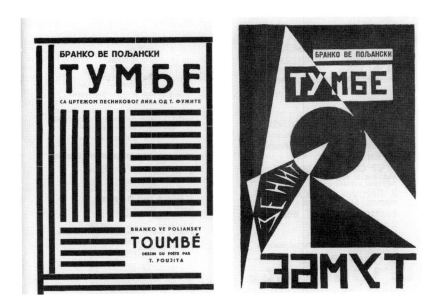

Fig. 2.5 Branko Ve Poljanski, *Tumbe* [Upside Down], Belgrade, 1926, front and back covers.

The back cover of *Tumbe* (*Upside Down*) also included the words "Zenit" and "Tumbe" (*Upside Down*) spelled out in the Serbian Cyrillic alphabet. *Tumbe* (*Upside Down*) is also included in its mirrored version, suggesting a mirror image of a Serbian text. Perhaps symbolically, this mirrored book title reveals a turning point in Ve Poljanski's work – a double negation (first "upside down" and then "mirrored") of conventional meanings, it suggests an erasure of textual meaning and a gradual departure from poetry into visual arts.

This departure is also signified by the increasing use of painting, graphic design and typography in his books – a process that culminated in his last book of poems, *Crveni Petao – Le Coq Rouge* (*The Red Rooster*) (Fig. 2.6).[32] *The Red Rooster* reflects author's heightened sense of visuality – its book cover featured a Suprematistic square inspired by Malevich and the bilingual French-Serbian title. Like El Lissitzky, Malevich was also prominently featured in *Zenit*, in particular in the special issue devoted to the New Russian Art.[33] The back cover comprised only the words "Crveni Petao" (*The Red Rooster*) in a simple sans-serif font, with the word "red" written vertically and turned sideways. An exercise in modern minimalism, this layout suggested a certain visualization of words, where letters are used as lines to achieve a particular compositional effect – an abstract geometric pattern that represented a radical departure from the past. This use of text as image and its liberation from the conventions of

language – such as the free rotation and mirroring of the letters – suggests an interplay of the textual and visual that is as fluid as Ve Poljanski's free use of Serbian and French languages to write his poetry. Yet, it also augurs his departure from literature to painting whereby the full circle of exchanges and appropriations has been closed. What began as an appropriation of ideas from literature into visual arts and architecture matured into a full rejection of literary modes of production in favor of visual production.

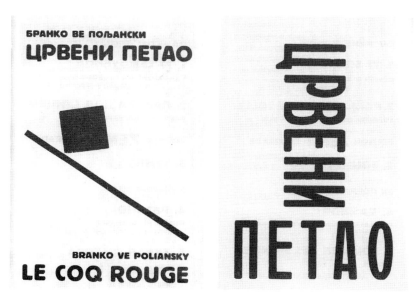

Fig. 2.6 Branko Ve Poljanski, *Crveni Petao – Le Coq Rouge* [The Red Rooster], Paris/Belgrade: 1927, front and back covers.

The Perpetual Onus of Arrivals and Departures

The Micić brothers were the main dynamos behind *Zenitism* – their visual, literary and political work championed individualism, using the pages of their publications to propose ideas about the new society and its visual culture. Their work fitted into the overall patterns of the 1920s avant-garde movements, yet it was also changed by the nature of their collaboration and the context of their work. Their collaboration was intermingled with a set of family relationships, which the two brothers tried to resolve through relentless production and mutual competition. Some critics have suggested that Branko was a bit more "open" and "flexible" than Ljubomir.[34] Dragan Aleksić even argued that it was actually Branko who was the real talent in that team;

he was "diverse," and "capable" of working in many disciplines, yet what he produced was "not permanent, not consistent."[35] These words carried positive connotation in Aleksić's reflection, suggesting a certain flexibility of mind and craft in Ve Poljanski's work, in particular an ability to work across disciplines more freely than his brother.

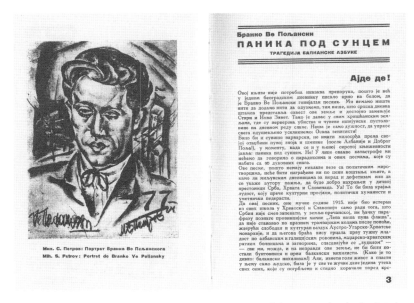

Fig. 2.7 Branko Ve Poljanski, *Panika pod Suncem – Panique sous le Soleil* [Panic under the Sun], Belgrade, 1924.

But such disciplinary flexibility was also a predicament for Ve Poljanski, as he oscillated between poetry and painting as his main fields of cultural production. His early work was rooted in poetry and writing – an effort to "Balkanize" Europe through daring texts that call for the inclusion of *barbarogenije* in mainstream culture. But gradually, Ve Poljanski shifted from poetry to painting, which he practiced exclusively from 1927 until the end of his life. His search for disciplinary identity is also evident in the constant inclusion of his portraits within his books. A careful examination of these portraits suggests a subtle psychological and disciplinary shift. (Figs. 2.7, 2.8, 2.9) *Panic under the Sun* (1924) features the author's portrait by Serbian artist Mihailo S. Petrov, showing Ve Poljanski in a dignified pose portrayed through a Cubist lens. The lines, shapes and tones are sharp, with crisp and well-defined boundaries. In *Upside Down* (1926), Ve Poljanski is represented in profile in a drawing by Japanese-French

artist Tsuguharu Foujita. The drawing is still rather figurative, albeit the author's face is drawn with fewer lines and in a fairly minimal fashion. Finally, in *The Red Rooster* (1927), Ve Poljanski is depicted in a quick sketch – almost a *croquis* that only captures the melancholic gesture of his face through a system of loose wavy lines. His face is enigmatic, gazing at the viewer with tired eyes. These portraits could be read as mirrors of Ve Poljanski's mind, yet also as a symbolic representation of his creative work and attitudes toward the arts, architecture and literature. In them we see a gradual transition from precision to indeterminacy, from figuration and well-defined forms to looseness. This desire for abstraction is perhaps yet another expression of his shift towards painting that Ve Poljanski adopted after *The Red Rooster* (1927) as his preferred mode of production. Yet this fluid set of author's portraits could also be read as a constant quest for identity, a quest evident in Micić's life too – an image during his stay in Cannes in 1934 shows him dressed up in his dandy Western clothes while gazing at the street sign entitled *Rue des Serbes* (*The Street of the Serbs*). This snapshot underscores the conflicting dilemmas of identity formation and those of his era in European history – a series of conflicting dichotomies such as the local and the global, East and West, right and left (Fig. 2.10).

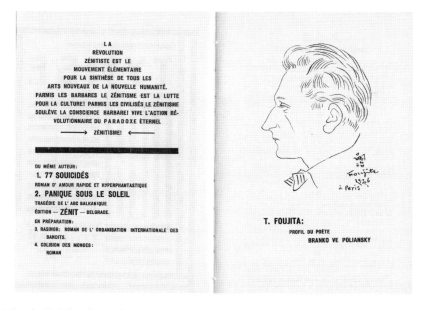

Fig. 2.8 Branko Ve Poljanski, *Tumbe* [Upside Down], Belgrade, 1926.

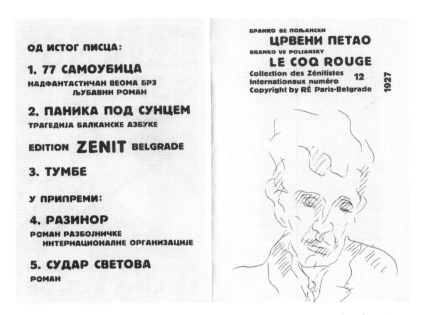

ОД ИСТОГ ПИСЦА:

1. 77 САМОУБИЦА
НАДФАНТАСТИЧАН ВЕОМА БРЗ
ЉУБАВНИ РОМАН

2. ПАНИКА ПОД СУНЦЕМ
ТРАГЕДИЈА БАЛКАНСКЕ АЗБУКЕ

EDITION ZENIT BELGRADE

3. ТУМБЕ

У ПРИПРЕМИ:

4. РАЗИНОР
РОМАН РАЗБОЈНИЧКЕ
ИНТЕРНАЦИОНАЛНЕ ОРГАНИЗАЦИЈЕ

5. СУДАР СВЕТОВА
РОМАН

БРАНКО ВЕ ПОЉАНСКИ
ЦРВЕНИ ПЕТАО
BRANKO VE POLIANSKY
LE COQ ROUGE
Collection des Zénitistes
Internationaux numéro 12
Copyright by RÉ Paris-Belgrade
1927

Fig. 2.9 Branko Ve Poljanski, *Crveni Petao – Le Coq Rouge* [The Red Rooster], Paris/Belgrade, 1927.

Any critical approach to Micić's and Ve Poljanski's work must take into account these elusive identity categories. Both explicitly and implicitly, the Micić brothers not only undermined the traditional notions of European center and periphery, but also provided an important categorization for themselves, identifying with the concept of a noble savage. Their manifestos blurred the distinction between Europe and the Balkans as the Parisian Seine merged with the small River Maja that flowed through Majske Poljane in the Military Frontier, a toponym that gave Ve Poljanski his name.[36] In fusing these imaginary landscapes through their texts, they subconsciously created a new type of homeland – a form of a textual homeland that could be written, re-written and dispersed around the world on the pages of *Zenit*. This concept of a textual homeland is present in other diasporic cultures – in

Fig. 2.10 Ljubomir Micić in Cannes, France, 1934.

his essay, "Our Homeland, the Text," the critic and philosopher George Steiner proposed that, throughout history, texts served as a Jewish portable homeland – for Steiner, the Jews were "the people of the book," with a love for texts and books enhancing their affinity with strangeness and foreignness.[37] A similar idea is extended in Susan Bassnett's book *Comparative Literature*, where she argued for the importance of exiles for writers from minority cultures, "The theme of exile, of belonging and not belonging, is a common link between writers from post-colonial cultures."[38] Consequently, the Micić brothers remained foreigners in all their homes, a constant minority that sought to rewrite the main pages of European modernism. Yet their work also extended the notion of exile from a more common textual format into a rather open-ended visual experimentation that included not only their own work, but also the eclectic combination of the work of others. Through *Zenit's* flamboyant pages they absorbed and disseminated international modernism by means of visual imagery, giving it a truly local "Balkanized" voice.

Iain Chambers theorized the link between the expansion of modernism and diaspora in his study *Migrancy, Culture, Identity*, where he wrote:

> The chronicles of diasporas – those of the black Atlantic, of metropolitan Jewry, of mass rural displacement – constitute the ground swell of modernity. These historical testimonies interrogate and undermine any simple or uncomplicated sense of origins, traditions and linear movement. Considering the violent dispersal of people, cultures and lives, we are inevitably confronted with mixed histories, cultural mingling, composite languages and creole arts that are also central to *our* history.[39]

In this passage, Chambers argues for the centrality of peripheral experiences, a form of historical reversal that would affirm minorities as producers of cultures. His acknowledgement of "violent dispersal of people" as one of the central sources of interaction between centers and margins is certainly an important impetus behind the *barbarogenije* (the barbaric genius) – growing up in the context of the impoverished and war-destroyed Military Frontier, the Micić brothers had not only come to accept the imminent erasure of culture and death as facts of life, but also to boldly reject bourgeois notions of nations and their narratives. Consequently, their *barbarogenije* simultaneously fused the disjunctive fragments of Western identity with Serbian and Pan-Slavic romanticism and nationalism even, while at the same time questioning them through the leftist political framework.

The question of cross-cultural exchange and traveling nature of ideas and people is central to discussions about hybridization that occur once the notions of centers and peripheries have been violently disrupted. As the Micić brothers changed locales with unprecedented

frequency in the 1920s and 30s, their ideas were amplified by travels that enabled dialogues to occur over great distances and across cultures, signifying to the greater significance of displacement within avant-garde discourses. Their diasporic experience not only defined their creative work, but also signified the peripatetic nature of many other avant-garde networks. Micić's and Ve Poljanski's work around *Zenit* was derived not only from their ability to collect, edit and disseminate new ideas, but also from their visits to Belgrade, Zagreb, Ljubljana and Paris, with requisite stops in Prague and Berlin. Displaced from any obvious homeland or traditional disciplinary field, Micić and Ve Poljanski created a space of discourse that bridged cultures, disciplines and avant-garde nodes. Enabled by the emerging technologies of mass print and travel, their ideas were made significant not only by their internal content, but even more so through their dialogue with *others* – in particular by the heightened tension between the Balkanized noble savage, or *barbarogenije*, and the cultivated European man. *Zenit* and *Zenitism* offered interchangeable use of image and text to signify new departures and arrivals in art, architecture and literature. Using travel, exchange and cross-cultural translation as vehicles of cultural production, *Zenit* allowed the visual and literary works to constantly reinvent themselves as they entered the fluid space of international ideas exchange. Despite *barbarogenije's* destructive drive, the pages of *Zenit* also seeded a form of a new beginning: in the wake of erasure they constructed a form of peripatetic discourse that not only redrew Europe's cultural geography, but also provided a unique and vocal minority voice in the global avant-garde web.

Notes

1 On the global diaspora of the Bauhaus students, faculty and ideas see Katerina Rüedi Ray, *Bauhaus Dream-house: Modernity and Globalization* (Oxon: Routledge, 2010).

2 For detailed biographical information on Micić and Poljanski see Vida Golubović and Irina Subotić, *Zenit i avantgarda dvadesetih godina* [Zenit and the Avant-garde of the 1920s] (Belgrade: National Museum and the Institute for Literature and the Arts, 1983); also published in Aleksandar Petrov, "Branko Ve Poljanski and his *Panic under the Sun*," in Branko Ve Poljanski, *Panika pod suncem, Tumbe, Crveni Petao* [Panic under the Sun, Upside Down, the Red Rooster], Aleksandar Petrov ed. (Belgrade: National Library of Serbia, 1988), viii-ix.

3 On the comprehensive history of *Zenit* see Vidosava Golubović and Irina Subotić, *Zenit 1921-1926* (Belgrade: National Library of Serbia, Institute for Literature and the Arts, and Zagreb: Serbian Cultural Society *Prosvjeta*, 2008).

4 Golubović and Subotić, *Zenit 1921-1926*, 83-84.

5 Founded by the Hapsburg Emperor Ferdinand I in the 16th century, the Military Frontier of the Austro Hungarian Empire was a borderline region that served as a buffer against the neighboring Ottoman Empire. The population was primarily involved in the defense of the Empire, either as soldiers or their support, and it was primarily comprised of Ethnic Serbs who gradually came to inhabit large portions

of today's Croatia between the 16th and 19th centuries. For a historical summary of the Military Frontier and other parts of former Yugoslavia see Jasminka Udovički, "The Bonds and the Fault Lines," in Jasminka Udovički and James Ridgeway eds., *Burn this House: The Making and Unmaking of Yugoslavia* (Durham: Duke University Press, 1997), 11-42.

6 Ibid., 17.

7 On the role of *Zenit* in a larger history of avant-garde movements in Serbia, Croatia and Slovenia between the two wars see Miško Šuvaković, "Impossible Histories" and Darko Šimčić, "From Zenit to Mental Space: Avant-garde, Neo-avant-garde, and Post-avant-garde Magazines and Books in Yugoslavia, 1921-1987," in Dubravka Djurić and Miško Šuvaković, eds., *Impossible Histories: Historical Avant-gardes, Neo-avant-gardes, and Post-avant-gardes in Yugoslavia, 1918-1991* (Cambridge: The MIT Press, 2003), 2–35 and 294–330. See also Miško Šuvaković "Eklektični Avangardizam: Zenit" and Nevena Daković, "Zenitizam i Film," in Miško Šuvaković, ed., *Istorija Umetnosti u Srbiji, XX Vek,* Tom 1: *Radikalne Umetničke Prakse* (Belgrade: Orion Art, 2010), 83-100; finally, for an overview of *Zenit*'s contribution to modern architecture more specifically see chapter by Perović in this volume.

8 The critique of both Croatian and Serbian political contexts is evident throughout *Zenit*'s history and even before: as early as 1915, Branko Ve Poljanski was expelled from high school for ridiculing the Croatian national anthem; see Branko Ve Poljanski, "Ajde de," *Panika pod suncem*, Petrov ed. (1988), 3; Micić on the other hand wrote parodies of Serbian, Yugoslav and Pan-Slavic patriotic songs: see Ljubomir Micić, "Hej Sloveni," *Zenit* 6/39 (March 1926), n.p.; also, in his satirical text "Thank You Serbia the Beautiful" Micić aggressively attacked the conservatism of the Serbian political and cultural élite: see Ljubomir Micić, "Thank You Serbia the Beautiful," *Zenit* 5/36 (October 1925), n.p.

9 See *Zenit* 2/11 (February 1922), cover page. Both Ljiljana Blagojević and Miloš Perović have asserted that this was the first publishing of Vladimir Tatlin's Monument to the Third International outside Russia. See Ljiljana Blagojević, *Modernism in Serbia: The Elusive Margins of Belgrade Architecture* (Cambridge: MIT Press, 2003), 11, and Miloš Perović, "The Contribution of Zenithism," in *Serbian 20th Century Architecture: From Historicism to Second Modernism* (Belgrade: Faculty of Architecture, 2003), 68. However, Svetlana Boym claimed that the first article about the tower appeared in the Munich art magazine *Der Ararat*, eventually reaching the Dadaists. See Svetlana Boym, *Architecture of the Off-Modern* (New York: Princeton Architectural Press, 2008), 11.

10 On Poljanski's dialogue with Marinetti see Branko Ve Poljanski, "Dialog Marinetti-Poljanski," *Zenit* 5/37 (November-December 1925). Reprinted in English as Branko Ve Poljanski, "Dialogue Marinetti-Poljanski," Goran Kapetanović, trans., published on the Occasion of the 100th Anniversary of the Futurist Manifesto, *New Sound* 34 (February 2009), 1-5.

11 Ljubomir Micić, Velika zenitistička večernja [Big Zenitist Evening], Zagreb, January 31, 1923, poster. National Museum, Belgrade.

12 Ljubomir Micić, *Barbarogénie le décivilisateur* (Paris: Aux Arenes de Lutece, 1938). See also Serbian translation, Ljubomir Micić, *Barbarogenije Decivilizator*, trans. Radmila Jovanović (Beograd: Filip Višnjić, 1993).

13 On the noble savage myth see Terry Ellingson, *The Myth of the Noble Savage* (Berkeley: University of California Press, 2001).

14 Adolf Max Vogt, *Le Corbusier, the Noble Savage: Toward an Archaeology of Modernism* (Cambridge: MIT Press, 1998).

15 On the nomadic practices of Rastko Petrović, Dimitrije Mitrinović, and Slavko Vorkapić see Miško Šuvaković, "Singularni Mitovi," in Šuvaković ed. *Istorija Umetnosti* (2010), 105-114.

16 See *Zenit* 6/40 (April 1926).

[17] It is also important to note that both languages have connections to both alphabets, as even contemporary Serbian and Croatian languages can be recorded in both alphabets interchangeably. Glagoljica, or the Glagolitic Script, an early form of the Slavic alphabet related to the Cyrillic, was used in Croatia as early as the 11th century. The twentieth century on the other hand saw an expanded use of the Latin alphabet in Serbian lands, with King Alexander I even contemplating a complete replacement of the Cyrillic by the Latin alphabet in the 1930s. While anecdotal and historically disconnected, this interchangeable use of two alphabets in both cultures speaks to their intellectual proximity and an intertwined quest for identity where both Serbia and Croatia searched for their identity both in the East and in the West, in this case metaphorically represented by the two alphabets.

[18] See *Zenit* 2/17-18 (September – October 1922).

[19] See *Zenit* 6/40 (April 1926), cover page with Theo van Doesburg's and Cornelis van Eesteren's Villa Rosenberg (1923).

[20] Walter Gropius, "International Architecture," *Zenit* 6/40 (April 1926), n.p.

[21] Ljubomir Micić, "Airplane without an Engine: An Anti-European Poem," *Zenit* 6/40 (1923), n.p.

[22] Dubravka Djurić, "Radical Poetic Practices: Concrete and Visual Poetry in the Avant-garde and the Neo-avant-garde," in Djurić and Šuvaković, eds., *Impossible Histories* (2003), 64-95.

[23] Branko Ve Poljanski, *Panika pod Suncem – Panique sous le Soleil* [Panic under the Sun] (Belgrade: Zenit, 1924).

[24] Branko Ve Poljanski, "Put u Braziliju" [A Journey to Brazil], in Branko Ve Poljanski, *Panika pod suncem*, Petrov ed. (1988), 14-15.

[25] Miloš Crnjanski, "Poslanica iz Pariza," *Zenit* 1/4 (May 1921), 2.

[26] Milos Tsernianski, *Migrations* (New York: Harcourt, 1994). Note the variation in spelling of Miloš Crnjanski's name.

[27] On the role of exile in Crnjanski's work see David Norris, "Miloš Crnjanski: The Poetics of Exile," in *In the Wake of the Balkan Myth: Questions of Identity and Modernity* (London: Macmillan Press, 1999), 49-59.

[28] Miloš Crnjanski, "Sumatra," Nina Živančević, translator, published in Nina Živančević, "Miloš Crnjanski and His Descendents," Electronic Book Review, 01/01/1999, URL: http://www.electronicbookreview.com/thread/internetnation/sumatrism, accessed August 6, 2011.

[29] Nina Živančević, "Miloš Crnjanski and His Descendents," Electronic Book Review, 01/01/1999, URL: http://www.electronicbookreview.com/thread/internetnation/sumatrism, accessed August 6, 2011.

[30] Branko Ve Poljanski, *Tumbe* [Upside Down] (Belgrade: Printing Workers' Union, 1926).

[31] Branko Ve Poljanski, "Sumrak," in *Panika pod suncem*, Petrov ed. (1988), 30.

[32] Branko Ve Poljanski, *Crveni Petao – Le Coq Rouge* [The Red Rooster] (Paris/Belgrade: RE, 1927).

[33] *Zenit* 2/17-18 (September-October 1922).

[34] Radomir Konstantinović, *Branko Ve Poljanski: Biće i jezik* [Being and Tongue] (Beograd, 1983), 482; also quoted in *Panika pod suncem*, Petrov ed. (1988), vii.

[35] Dragan Aleksić, *Dada tank* (Belgrade: Nolit, 1078), 113; also quoted in *Panika pod suncem*, Petrov ed. (1988), x.

[36] Branko Ve Poljanski, "Manifesto: A Fragment from a Larger Manifesto to all Nations of the World," in *Panika pod suncem*, Petrov ed. (1988), x.

[37] For a discussion of Jewish "mobile homeland" see George Steiner, "Our Homeland, the Text," *Salmagundi* 66 (Winter 1985), 5.

38 Susan Bassnett, *Comparative Literature: A Critical Introduction* (Oxford: Blackwell, 1993), 106, quoted in David Norris, "Miloš Crnjanski: The Poetics of Exile," in *In the Wake of the Balkan Myth: Questions of Identity and Modernity* (London: Macmillan Press, 1999), 58-59.
39 Iain Chambers, *Migrancy, Culture, Identity* (Oxon: Routledge, 1994), 16-17.

Chapter 3

ZENITISM AND MODERNIST ARCHITECTURE[*]

Miloš R. Perović

Modern architecture in Italy, The Netherlands, France, Germany and Russia, the countries of its birth, was a result of the experiments made in literature and the visual arts then transposed into the space of architecture. Let us just think of Filippo Tommaso Marinetti, Carlo Carrà, Umberto Boccioni and Sant'Elia, De Stijl, Theo van Doesburg and Gerrit Rietveld, Purism and Le Corbusier, Expressionism and Paul Sheerbart, Bruno Taut, Emil Nolde, George Grosz, Oskar Kokoschka, Arnold Schönberg, Berthold Brecht, Erich Mendelsohn and Hermann Finsterlin or Constructivism and Malevich, El Lissitzky, Mayakovski, Tatlin, Gabo, Kandinsky, the Vesnin brothers, Melnikov and Ivan Leonidov. However, in the case of the Serbian avant-garde, its emergence is not easily dated. "Depending on the critical approach and method," writes Predrag Palavestra, "its beginnings can either be situated exclusively in the 1920s, or moved to the beginning of the century, toward the pre-war poetic irrationalism of Svetislav Stefanović and Dimitrije Mitrinović ... or, as most frequently done before, the activities of the Serbian avant-garde could be moved forward — all the way to the emergence and announcement of Serbian Surrealism and its drawing-room leftism." Nevertheless, Palavestra continues that theoreticians and historians of Serbian literature "believe that the full period of Serbian avant-garde began in the first decade after World War I; that Futurist and Expressionist roots of the Serbian avant-garde were recorded and formed even before that war ... that the host of short-lived groups, schools, coteries, clans, publications, magazines, anthologies, almanacs, proclamations and manifestoes of many -isms: Zenitism, Dadaism, Futurism, Expressionism, Sumatrism, Constructivism, Hypnism, Proto-Surrealism and others, the avant-garde autarky was more influenced by its natural properties of dissatisfaction, defiance and denouncement than by real ideological and poetic differences among the authors."[1] In the 1920s, members of various avant-garde movements in Yugoslavia published their views in their own journals, such as *Svetokret* (Globolution), *Zenit*, *Dada Tank*, *Dada Jazz*, *Dada-Jok* (Dada-Nope), *Út* (The Way), *Putevi* (Roads), *Svedočanstva* (Testimonies), *Hipnos*, *Rdeči pilot* (Red Pilot), *Novi oder* (New Scene), *Tank*, *Večnost* (Eternity), *50 u Evropi* (50 in Europe), almanac *Nemoguće / L'Impossible*, *Nadrealizam danas i ovde* (Surrealism Today and Here) and *Nova Literatura* (New Literature).

Some of these publications closed after the first issue. Others, like *Zenit*, edited by Ljubomir Micić, were published for several years (Fig. 3.1). While Igor Marjanović[2] examines Zenitism's origins in literature, painting and various cross-cultural dialogs, this chapter focuses more specifically on the journal's engagement with modernist architecture. In returning to Micić as a poet, controversial critic, polemicist, and one of the key figures of the Yugoslav avant-garde, the essay underscores the journal's significant contribution to the spread of modernist architecture in the Balkans, as well as the impact of Micić's polemic relationships – not only with the proponents of opposite views, but also with his like-minded friends – to the journal's historical trajectory and its contemporary reception. His intolerance of all forms of non-Zenitistic activities in modern art soon after the first publications of *Zenit* caused a breach in collaboration with Miloš Crnjanski, Rastko Petrović, Dušan Matić, Stanislav Vinaver and Boško Tokin; the same happened later with German-French poet Ivan Goll, Dragan Aleksić and Mihailo S. Petrov because they also published in other periodicals, or belonged to other avant-garde movements. Josip Seissel left Zenitism because of its anarchistic tendencies; and Ljubomir Micić even broke with his brother Branko, poet and painter, for unknown reasons.

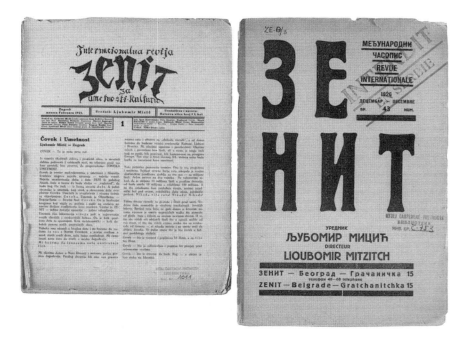

Fig. 3.1 Cover pages of the first and last issue of *Zenit*: *Zenit*, vol. 1, no. 1, February 1921, published in Zagreb, and *Zenit* vol. 6, no. 43, December 1926, published in Belgrade.

Vidosava Golubović describes the period when *Zenit* was launched as "the time of dynamic events in the Yugoslav cultural sphere: the end of World War I, creation of the Yugoslav state, radicalism of the younger generation of writers in Zagreb and Belgrade. In those revolutionary times, when the traditional values of the preceding period had collapsed, the younger generation of writers, who lived through and took part in the war, anticipated in an unusually suggestive sense the ripening of the moment when those intuitively marked revolutionary changes would take shape in individual artistic structures." "The *Zenit* journal," writes Vidosava Golubović, "was first conceived as a revolutionary periodical meant to gather together representatives of younger and more progressive generations of Belgrade and Zagreb artists; however, its initial issues did not contain a clearly structured artistic program. With its subtitle — *An International Review for Art and Culture* — and the editorial of its founder and editor Ljubomir Micić, entitled 'Čovek i umetnost' (Man and Art), the journal only indicated the basic principles of its programmatic orientation: internationalism and new humanism. In time, these general ideas congruent with the spirit of avant-garde currents (e.g. Expressionism) would shape *Zenit* into a programmatic periodical with the characteristic principles of an avant-garde movement."[3] Golubović also sees Zenitism as a result of an atmosphere of "the 1920s revolutionary European avant-garde with which it soon communicated" and "established a radical dialogue ... owing to the existing system of values in its own country that had already been in crisis."[4]

Zenitism as a movement had all of the six attributes of the avant-garde as defined by Stefan Morawski. The works of the Zenitists consistently applied the principle of antimimesis that opposed the traditional approach to artworks — identification or recognition of objects from the visual arts with things and phenomena of the real world. The Zenitists criticized and ridiculed the official attitudes to art. They refuted every tradition, were fascinated by the present and turned towards the future. They published programmatic texts and manifestoes, and worked as a group; at least Micić tried to make it look like one and to keep his colleagues together. The last, the sixth characteristic of the avant-garde, according to Morawski, comprised events full of blasphemy and scandal, and could also be related the activities of the Zenitists.[5]

The starting point of the philosophy of Zenitism was that the crisis of European civilization was all-embracing; not only the crisis of the socio-economic system, but the crisis of culture founded upon that system. This view developed an attitude totally opposed to the European rationalistic tradition, and saw only barbarism as real since it was not rational. Zenitism opposed European rationalism and its civilization as a system of suppression, as a way of systematic destruction of man's freedom and his instincts, thus coming very close to the Dadaist viewpoint on the alienation of man through civilization. Vidosava Golubović

believes that Micić came to his devastating attitude to the existing cultural systems by means of a metaphorical construction of the surge of barbarians in Europe destined to be conquered by Barbarogenius, a character from Micić's literary laboratory, the main protagonist of the symbolic meanings of the movement, an incarnation of the original primitive spirit of the Balkans.[6] The Balkan barbarians, according to the Zenitists, are not the dark, but a glorious past of contemporary Europe, to which Europe should return in the future. The Zenitists wanted to create a global artistic International constructed upon the principles of pan-Balkanism, and use it to Balkanize Europe, as Micić pointed out in his text "Manifest varvarima duha i misli na svim kontinentima" (The Manifesto to the Barbarians of Spirit and Thought on All Continents).[7] The main goal of the Zenitist movement was the Balkanization of Europe as opposed to the Europeanization of the Balkans, the leading ideology of the Serbian bourgeoisie.[8]

Steven A. Mansbach has a somewhat different attitude to this initial philosophy of Zenitism. He thinks that the positive energy provoked by the creation of a new state of the Southern Slavs on Europe's political map — the Kingdom of Serbs, Croats and Slovenes — set in motion Micić's ambition to define its cultural identity congruent with international modernism, while simultaneously relying on native tradition, history and all the ensuing contradictions.[9] He also believes that Micić deliberately used the means and expressions of modernist aesthetics — Futurism, Expressionism and Constructivism — in a dadaist attack on conventional thinking. Its leader would be Barbarogenius — a metaphorical creation that could be used to influence the Europeanization of the Balkans simultaneously with the Balkanization of Western Europe. Mansbach sees Barbarogenius as a personification of Micić himself.[10] This equalization of Micić and his metaphorical creation, Barbarogenius, is in accord with the view of Miklós Szabolcsi that "almost every avant-garde movement tends to create a New Man who is usually either utopistically irrational or the spitting image of its creator."[11] Mansbach also finds that Micić believed that the vital native primitivism of the Balkans — so evident to Zenitists in the history of the Southern Slavs — could reinvigorate a European civilization whose moral, cultural and political fatigue – had become manifested recently in the paroxysm of World War I. Similarly, the newly founded state of the South Slavs could participate to a much fuller degree in European civilization if it were prepared to embrace the new, hopeful currents from the idealistic Soviet Union (Constructivism), or the spiritual vitality from republican Germany (second-generation Expressionists), or the dynamism from resurgent Italy (Futurism).[12] Steven A. Mansbach believes that Micić's concept in its essence was a Dadaist variant of the romantic notion where an ideal state is created through a mixture of elements of the unknown Balkans, widely considered mystical and irrational, contrary to the rational West.[13] For that reason there are elements of

Expressionism, Constructivism, Futurism and Dadaism in the ideology of Zenitism, just as other avant-garde movements before that time were eclectic in some of their phases. Vidosava Golubović feels that the Zenitist relationship between the Balkan and Europe is of a somewhat different nature: "[i]n order to overcome the existing relationship between the concepts of the Balkans and Europe, i.e. the concepts that semantically did not bring anything essentially new, the Zenitists introduced a dynamic opposition: new Balkans — old Europe and attempted to use the principle of energy ('the energetic imperative') in showing this opposition as the pivotal moment of a constructive process by which Europe would be Balkanized, instead of the previous Europeanization of the Balkans. Another opposition develops from the old vs. new — the opposition of deformed vs. original, most frequently related to primitivism. Since the 'primitivism' of the European West is in its trite patterns 'conscious,' 'cultural,' 'refined,' it is confronted by Balkan primitivism which is original because it is 'unconscious,' 'naive.' Only this barbarism could be creative and able to realize the idea that all European art should be revolutionized."[14] Obviously, Micić deliberately kept a certain degree of confusion within the Zenitist movement, thus hindering every possible classification, because he deeply believed in complete freedom of creative expression. Zenitism enthusiastically propagated the new spirit of the time, supranational, cosmopolitan, profoundly permeated with pacifism, but still in conformity with the specific needs of Yugoslav modernization. Zenitism remained all the way to its end conceptually deeply illogical, full of inner controversies, with an extremely negative social-aesthetic ideology which was anti-clerical, anti-bourgeois, anti-bureaucratic, anti-traditional and anti-academic.

Apart from the superstructure of ideas, original or taken over from other avant-garde movements, the editor of *Zenit* and Zenitists themselves maintained a powerful infrastructure of direct contacts with other avant-garde movements and their magazines. As Zoran Markuš points out, it would almost be possible to say "that there was no avant-garde center or circle from Tokyo to Moscow, over Prague, Berlin, Rome and Paris, from Madrid to Buenos Aires, where one did not feel the presence and echoes of Zenitism."[15] Intensive contacts were kept with the German Expressionist circle around the magazine and gallery *Der Sturm* and Herwarth Walden, with Russian Constructivists, Italian post-war Futurists and their journal *Noi*, Dutch *De Stijl*, Belgian avant-garde magazines *Het Overzicht* and *7 Arts*, the Czech Artists' Association Devětsil, led by Karel Teige and the journals *Stavba* and *Pásmo,* the Hungarian avant-garde in emigration gathered around the journal *Ma*, the Polish avant-garde around *Blok* and the Romanian *Contimporanul*, whose editors were Marcel Janco and Ion Vinea. As underlined by Zoran Markuš and Irina Subotić, *Zenit* was highly praised by Theo van Doesburg and Hannes Meyer. Van Doesburg marked *Zenit* as one of the five world magazines of crucial significance for the development of new tendencies in the visual

arts,[16] and Hannes Meyer placed it among the most important avant-garde journals of the period.[17]

The broad scope of Zenitists' activities comprised the journal, the launching of special Zenit editions (including a significant monograph on Alexander Archipenko, among other publications), the organization of Zenitist events and evenings locally and abroad, the opening of a gallery to sell works of unconventional art, the organization of exhibitions and cooperation with other avant-garde movements. This program of cooperation enabled the Zenitists to exhibit in 1924 at the International exhibition organized in Bucharest by the editorial board of *Contimporanul*, and also two years later in Moscow, at the exhibition of *The Revolutionary Art of the West*, organized by the State Academy of Art Studies VOKS.[18]

A number of well-known artists published their works in *Zenit*: László Moholy-Nagy, Pablo Picasso, Wassily Kandinsky, Robert Delaunay, Lajos Kassák, Alexander Archipenko, Karel Teige, Kazimir Malevich, Alexander Rodchenko, Albert Gleizes, Vladimir Tatlin, Vladimir Mayakovski, Sergei Yesenin, Boris Pasternak, Ilya Ehrenburg, Herwarth Walden, Walter Gropius, Hannes Meyer, Max Jacob, Filippo Tommaso Marinetti, El Lissitzky, Vsevolod Emilievich Meyerhold, Soviet people's commissioner for culture Anatoliy Lunacharsky, Ivan Goll, Mihailo S. Petrov, Jo Klek (Josip Seissel), Boško Tokin, Branko Ve Poljanski (Branko Micić), Dragan Aleksić and others. A double issue of *Zenit* (number 17-18) in 1922 was dedicated to Russian avant-garde art and edited by El Lissitzky and Ilya Ehrenburg. Theoretical works and poetry were mostly published in the native languages of their authors, and they are in Czech, French, Hungarian, German, Flemish, Russian, Italian, Spanish, Bulgarian, Romanian, but also in Esperanto.

Ljubomir Micić gradually developed an interesting method of absorbing different experiments in the visual arts, not only into the particular Zenitist expression, but into a characteristic viewpoint. The early linocuts of Mihailo S. Petrov, full of revolt and inspired by Expressionism leading towards Kandinsky,[19] as Irina Subotić underlines, Micić supported in the expressionistic phase of *Zenit* as works of specific value, and intensively published Petrov's linocuts in issues 6 to 13.[20] The only member of the Zenitist circle whose interest would later lie in architecture was Josip Seissel. Owing to a childish prank he was expelled from school in Zagreb and was in Belgrade when the editorial board of *Zenit* moved to the capital, completing secondary school and beginning his studies in technical sciences. Jo Klek, or Josip Klek, as Seissel signed his name in the Cyrillic alphabet in *Zenit*, was then preoccupied with watercolors, collages and drawings with a strong Constructivist tone. In 1922 Micić and his wife Nina Naj (Anuška Micić) met in Berlin with the intellectuals gathered around the journal and gallery *Der Sturm*, and also met with Russian avant-garde artists. Following this visit, Zenitism progressively inclined towards Constructivism. As Irina Subotić remarks, Micić immediately

recognized in Jo Klek a true representative of Zenitist painting.[21] He also translated Klek's German neologism *PApier-FArben-MAlerei*, that signified the materialization of his works, into arbos painting (an acronym composed of the first letters of Serbian words for paper, paint and painting — ARtija-BOja-Slika). If there was no one locally with an adequate visual articulation, Ljubomir Micić would put forward a foreign artist as a paragon, elucidating his works with the Zenitist rhetoric. Since there was not a single sculptor then in Yugoslavia who could satisfy Micić's aesthetic standards, he took the works of Alexander Archipenko as the prototype of Zenitist sculpture, and used, for the first time in the history of art, the term "opticoplastic" as a synonym for and definition of "Zenitism in plastic art."[22] With regard to architecture, Micić was much more neutral, and only described those examples which he thought were major artistic achievements and possible influences on local environment.

A significant moment for Serbian modernism was the *First Zenitist International Exhibition of New Art*. Ljubomir Micić organized the show in the hall of the Stanković Music School in the April of 1924. It was the first public exhibition of unconventional painting in Belgrade. *Zenit* Number 25 of February of the same year served as the catalog. Subsequent reconstruction of the exhibition proved that certain changes had taken place between the time issue 25 was published and the actual opening of the show.[23] There were about a hundred works from about ten countries, and the authors were Louis Lozowick, Josef Peeters, László Moholy-Nagy, Herbert Behrens-Hangeler, Freudenau, Delaunay, Archipenko, Ossip Zadkin, Kandinsky, El Lissitzky, Charchoune, Albert Gleizes, Prampolini, Hélène Grünhoff, Mihailo S. Petrov, Jo Klek, Vjera Biller, Vilko Gecan and Vinko Foretić. Works of these and other avant-garde artists could also be seen at the *Zenit* gallery in central Belgrade.

Zenit began to publish contributions on architecture very early. While indeed the magazine published Vladimir Tatlin's *Monument to the Third International* in February 1922 as one of the first publications of the project in the world, Micić first engaged architecture two issues earlier. In 1921 Dragan Aleksić published a text entitled "Tatlin. HP/s + Čovek" (Tatlin. HP/s + Man) with a Dadaist interpretation of Tatlin's work.[24] The double issue 17-18 of the same year published Tatlin's project again, alongside works by El Lissitzky, Rodchenko and Kazimir Malevich.

Number 15, of June 1922, contained a text by Ljubomir Micić on Purism, with long quotations from an essay on the aesthetics of Purism by Ozenfant and Le Corbusier, taken from their journal *L'Esprit Nouveau*.[25] Two years later, there was an interesting text in issue number 34 of November 1924 entitled "Novi sistem gradjenja" (The New Building System), signed 'Architect P.T.' The text dealt with old and new architecture and the principles of new architecture. P.T. saw new architecture as that of the machine age, characterized by prefabricated, machine-processed elements, norms and standards, instead of individual

decisions made for each part of a building; new architecture was also functional, precise and used new synthetic materials and building techniques. The text was illustrated by photographs of the model of Villa Moïsi at the Lido in Venice by Adolf Loos and the Einstein Tower in Potsdam by Erich Mendelsohn.[26]

In issue number 35, from December 1924, Jo Klek published his designs for Zeniteum I and Zeniteum II. While Zeniteum I was modeled on Justinian's Byzantine churches,

stripped of ornaments, strongly recalling the first Goetheanum by Rudolf Steiner in Dornach, Zeniteum II was an abstract construction easily classified as fantastic architecture impossible to build. Issue number 36 of *Zenit* published Jo Klek's project of Villa Zenit, an imaginatively conceived, almost Escherean architectural construction (Fig. 3.2). Those were the only architectural projects of Yugoslav authors published in almost six years of the journal.

Fig. 3.2 Jo Klek, *Villa Zenit*, 1924-25, pencil, Indian ink and watercolor on paper, 39.3 x 29.4 cm.

The next text on architectural issues appeared in *Zenit* number 37 — "Beograd bez arhitekture" (Belgrade without Architecture). This is a programmatic text of Zenitist architecture. It was written by Ljubomir Micić and prepared for the architectural journal *Bouwkunde*, published in Antwerp.[27] In this text Micić underlined the difference between architecture and ordinary buildings, and asserted that there was no modern architecture in Belgrade. He believed that architecture had existed in this region only in the late Middle Ages when, he said, exceptional buildings were constructed within the framework of monastic culture. The architecture of Belgrade, founded on the principles of a revival of past styles, Micić called monstrous, and he propounded unornamental design. The only houses in Belgrade he classified as architecture were the last surviving examples of vernacular Balkan building. Micić particularly singles out "a church with white walls ... and a few simple domes ... hidden among the trees"; the church

is impossible to identify today. Like Le Corbusier in his book *Le Voyage d'Orient*,[28] Micić believed that original quality — "the Zenitism of architecture," as he called it — lay in clean surfaces without ornaments, and well defined proportions. The same issue of *Zenit* contains a text by Branko Ve Poljanski entitled "'Mi' na Dekorativnoj izložbi u Parizu" ('We' at the Decorative Exhibition in Paris) with a scornful description of the Pavilion of the Kingdom of Serbs, Croats and Slovenes and the whole *L'Exposition Internationale des Arts Décoratifs et Industriels Modernes* held in 1925. The Pavilion was designed by Stjepan Hribar, who was otherwise mainly interested in town planning. He modeled the Pavilion in the spirit of reduced 20th century Neoclassicism, with an extremely simplified geometry and an impressive monumental entrance made of oak pillars and beams ornamented with folk art motifs. Inside the Pavilion exhibition space was combined with a Central European bourgeois home. The spacious interior was bathed in light that penetrated through stained glass windows and fell on the walls ornamented with Post-Cubist frescoes, on elegant furniture done in line with the Secessionist mannerism. The exhibits ranged from architectural designs in a conservative eclectic style to objects of everyday use.[29] The general conservatism of the Pavilion and the whole exhibition with underlined Central European features were so irritating to Ve Poljanski that he wrote a host of unpleasant words about the whole affair, even mistaking Hribar for Ibler. Nevertheless, there was something at the exhibition Ve Poljanski deemed well worth attention — two pavilions he described as follows: "[t]here is one pavilion which does not represent any state, but the art journal *L'Esprit Nouveau*. It is simple and excellent. A tree grows through its ceiling. It was done by the editors of the journal ... Architect Le Corbusier holds a dominant position in the pavilion. He exhibited his designs for big cities of the future, also all issues of the journal and some analytical Cubist paintings. As a Zenitist, ... [I find interesting] ... the Russian pavilion designed by Melnikov. The Russians have understood properly their position at this exhibition. They have demonstrated modestly contemporary Russia needs, and in that way they have achieved one of the strongest effects. The architecture of the pavilion is the most interesting of all represented at the exhibition."[30]

The most architecturally oriented issue of *Zenit* was number 40, of April 1926. It contained a text by Walter Gropius, "Internacionalna arhitektura" (International Architecture)[31] and a review of eight Bauhaus books whose authors were Walter Gropius, Paul Klee, Piet Mondrian, Theo van Doesburg and László Moholy-Nagy.[32] In his text, Gropius evolved his well-known thesis that architecture should express a uniform image of the world, characteristic of our times. The issue also had illustrations: photographs of a model of the Rosenberg House, prepared for the exhibition at Gallery Rosenberg in Paris by Theo van Doesburg and Cornelis van Eesteren, and of Van Eesteren's 1925 competition entry for remodeling Unter den Linden avenue in Berlin, which won him the first prize in the international competition.

After a series of scandals, some deliberately provoked and some quite accidental, the publishing of *Zenit* was discontinued in 1926. Ljubomir Micić was not a politically engaged communist, but his frequent praising of the October Revolution and permanent calls for assistance to the new Bolshevik society and the ending of Russia's international isolation as well as publication of texts by Trotsky and Peoples' Commissar for Culture Lunacharsky made the authorities suspicious. In the last issue, number 43, there was a text by Dr. M. Rassinov, probably Micić himself, "Zenitizam kroz prizmu marksizma" (Zenitism Seen through Marxist Prism), which served as a formal reason for the interdiction of the journal, on account of "Bolshevik propaganda and encouraging citizens towards communist revolution."[33] A legal case was brought against Micić and he subsequently left the country.

After the departure of Ljubomir Micić, there was the inevitable dissolution of the Zenitist intellectual circle and Belgrade lost its most powerful catalyst of uncompromising modernist ideas. Nevertheless, the influence of the Zenitists and *Zenit* had already opened new horizons to the Serbian creative mind. First of all, they brought about awareness of the role of experiment in art and the need for artistic innovation. Their tireless engagement brought Serbian cultural circles closer to general European ones in artistic trends and facilitated a step forward, different from all of the previous attempts to master the avant-garde discourse. The published memoirs of Mihailo S. Petrov confirm the fact that activities of the Zenitists could not be neglected. He remembers how artists and intellectuals from Belgrade, who regularly met in the café *Moskva*, used to discuss the Zenitist movement as early as 1921, even before the editors of *Zenit* moved to Belgrade, and before Petrov himself began to publish his linocuts in the journal.[34] At one period there existed around *Zenit* an intellectual and visual charge that could only be compared to the atmosphere around its fraternal journals such as *De Stijl*, *L'Esprit Nouveau*, *Der Sturm*, *ABC: Beiträge zum Bauen* or Вещъ / *Gegenstand* / *Objet*, the sources of European architectural avant-garde. In the forty-three issues of *Zenit* there was not a single editorial miss with regard to texts on architecture, the choice of the published projects or authors of the contributions. Everything Ljubomir Micić published as valuable, everything he supported as a model, is still looked upon as a cult project and representative building of the European architectural avant-garde. In its history, architecture has always been the definer of stylistic change, except in the 19th and at the beginning of the 20th century when it lost that position. The leading role was taken over by painting, which then turned into a catalyst of new artistic movements and aesthetic standards. The Zenitist activities stimulated the crystallization of new ideas, particularly in the simplifying of forms and abandoning eclectic ideas and concepts; thus they became channels through which the innovative mechanism of unconventional art was transmitted into Serbian architecture.

Notes

[*] This is a revised version of an earlier essay published as Miloš R. Perović, "The Contribution of Zenithism," in *Srpska arhitektura XX veka: Od istoricisma do drugog modernizma* [Serbian Architecture of the 20th century: From Historicism to the Second Modernism] (Belgrade: Arhitektonski fakultet Univerziteta u Beogradu, 2003), 58-73.

[1] Predrag Palavestra, "Od modernizma do avangarde," *Srpska avangarda u periodici* (From Modernism to the Avant-garde, *Serbian Avant-garde in Magazines*), eds. Vidosava Golubović, Staniša Tutnjević (Novi Sad: Matica srpska / Beograd: Institut za književnost i umetnost, 1994), 11-14.

[2] See chapter by Marjanović in this volume.

[3] Vid[osav]a Golubović, "Časopis 'Zenit'" [The 'Zenit' Journal], *Književnost* 36 (1981) 7/8, 1477-1482.

[4] Golubović, *Časopis 'Zenit'*, 1477-1482.

[5] Stefan Morawski, "On the Avant-Garde, Neo-Avant-Garde and the Case of Postmodernism," *Literary Studies in Poland*, XXI, Avant-garde (Wroclaw: Ossolineum, 1988), 81-106.

[6] Vid[osav]a Golubović, "Eksperiment Zenita," in *Zenit i avangarda 20ih godina* [Zenit Experiment, Zenit and the Avant-Garde of the twenties] (Beograd: Narodni muzej, 1983), Exhibition catalog, 35-48.

[7] Ljubomir Micić, "Manifest varvarima duha i misli na svim kontinentima" [The Manifesto to the Barbarians of Spirit and Thought On All Continents], *Zenit* VI/38 (Januar/Februar, 1926), n. pag.

[8] Radomir Konstantinović, "Ko je Barbarogenije?" [Who Is a Barbarogenius?], *Treći program* (Proleće, 1969), 11-21.

[9] S[teven] A. Mansbach, *Modern Art in Eastern Europe: From the Baltic to the Balkans, ca. 1890-1939* (Cambridge: Cambridge University Press, 1999), 228.

[10] Mansbach, *Modern Art in Eastern Europe*, 231.

[11] Miklóš Sabolči, *Avangarda & Neoavangarda (Jel es kiáltás: Az avantgarde és neoavantgarde kérdéseihez)* (Beograd: Narodna knjiga, 1997), 18.

[12] Mansbach, *Modern Art in Eastern Europe*, 231.

[13] Ibid.

[14] Vid[osav]a Golubović, "Eksperiment Zenita. Zenit i avangarda 20ih godina" [Zenit Experiment, Zenit and the Avant-Garde of the twenties] (Beograd: Narodni muzej, 1983), Exhibition catalog, 35-48.

[15] Zoran Markuš, "Odlazak Ljubomira Micića" [The Departure of Ljubomir Micić], *Borba*, 11. oktobar 1980; Irina Subotić, *Likovni krug revije "Zenit," 1921-1926* [The Visual Arts Circle of the "Zenit" Journal, 1921-1926] (Ljubljana: Znanstveni institut Filozofske fakultete, 1995); Irina Subotić, *Od avangarde do Arkadije* [From the Avant-Garde to Arcady] (Beograd: Clio, 2000).

[16] Zoran Markuš, "Zvezdani tragovi naše avangarde — Zenitove izložbe" [The Starry Reflections of Our Avant-Garde — Zenit Exhibitions], *Delo* XX/3 (Mart, 1974), 360-368.

[17] Irina Subotić, "Zenit i avangarda dvadesetih godina" [Zenit and the Avant-Garde of the twenties], in *Zenit i avangarda 20ih godina* [Zenit and the Avant-Garde of the twenties] (Beograd: Narodni muzej, 1983), Exhibition catalog, 51-76.

[18] Markuš, *Zvezdani tragovi*, 360-368.

[19] Subotić, *Zenit i avangarda*, 51-76.

[20] [Ljubomir Micić], "Makroskop — Mih. S. Petrov," *Zenit* I/6 (Jul, 1921), 14.

[21] Subotić, *Zenit i avangarda*, 51-76; Ješa Denegri, "Likovni umetnici u časopisu *Zenit*" [Visual Artists in the Zenit Journal], in *Srpska avangarda u periodici* [Serbian Avant-Garde in Magazines], eds. Vidosava Golubović, Staniša Tutnjević (Novi Sad: Matica srpska / Beograd: Institut za književnost i umetnost, 1994), 431-442; Vlado Bužančić, *Josip Seissel* (Bol: Galerija umjetnina "Branko Dešković," n. d.); Marijan Susovski, *Josip Seissel* (Zagreb: Muzej suvremene umjetnosti, 1997).

[22] Zoran Markuš in collaboration with Miloš Sarić and Kosta Ivanović, *Ljubomir Micić (1895-1971): Zenitistička konstrukcija* [Ljubomir Micić (1895-1971): The Zenitist Construction] (Beograd: Muzej savremene umetnosti, 1978), Exhibition catalog.

[23] Subotić, *Zenit i avangarda,* 51-76.

[24] Dragan Aleksić, "Tatlin. HP/s + Čovek" [Tatlin. HP/s + Man], *Zenit* I/9 (Novembar, 1921), 8-9.

[25] Ljubomir Micić, "O estetici purizma" [On the Aesthetics of Purism], *Zenit* II/15 (Jun, 1922), 34-35.

[26] Arhitekt P.T., "Novi sistem gradjenja" [A New System of Building], *Zenit* IV/34 (Novembar, 1924), n. pag.

[27] Ljubomir Micić, "Beograd bez arhitekture" [Belgrade without Architecture], *Zenit* V/37 (Novembar/Decembar, 1925), n. pag.

[28] Le Corbusier, *Journey to the East*, ed. Ivan Žaknić (Cambridge, Mass.: The MIT Press, 2007).

[29] Željka Čorak, "The Yugoslav Pavilion in Paris," *The Journal of Decorative and Propaganda Arts* 17 (Fall, 1990), 37-41.

[30] Branko Ve Poljanski [Branko Micić], "'Mi' na Dekorativnoj izložbi u Parizu" ['We' At the Decorative Arts Exhibition in Paris], *Zenit* V/37 (Novembar/Decembar, 1925), n. pag.

[31] Walter Gropius, "Internacionalna arhitektura" [International Architecture], *Zenit* VI/40 (April, 1926), n. pag.

[32] "Knjige Bauhaus-a" [The Bauhaus Books], *Zenit* VI/40 (April, 1926), n. pag.

[33] Subotić, *Zenit i avangarda*, 51-76.

[34] Natalija Jakasović, Slobodan Mijušković, eds., "Sećanja Mihaila S. Petrova" [Memories of Mihailo S. Petrov], *3+4* (1985), 37-41.

CHAPTER 4

THE "OBLIK" ART GROUP, 1926-1939

Jasna Jovanov

The 'Oblik' Art Group (1926–1939)

The first artistic organization in Serbia after the First World War emerged in 1919. Known as the "Group of Artists" their initial meeting was prompted by a shared artistic orientation and recognition of the benefits of group exhibitions. Subsequently, other groups were founded; among them "Oblik" was unique in many ways (Fig. 4.1).[1] Notwithstanding the lack of a strictly outlined program, its exhibiting policy was uniform, it lasted longer than any other similar group, its membership was the most numerous, it was the most effectual and its activities covered the largest territory. Also, its members were artists of different profiles: painters, sculptors, graphic artists and architects, followers of Serbian modernism, some of whom

were the founders of that movement. Their exhibitions were specific in comparison to overall exhibition activity and provoked art critiques. "The group 'Oblik' has attracted almost all of our contemporary artists," commented art critic Stevan Hakman[2] on their first Belgrade exhibition in 1929. The group itself was established three years earlier, in the autumn of 1926 and before the show in Belgrade in the "Cvijeta Zuzorić" Art Pavilion in 1929 it had exhibited only once, at the Sixth Yugoslav Art Exhibition in Novi Sad (1927).[3] Since that was part of

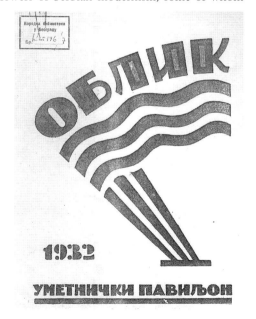

Fig. 4.1 Sreten Stojanović, Cover of the catalogue for the seventh exhibition of "Oblik", 1932.

another event, the Belgrade exhibition in 1929 is considered their first joint show out of the sixteen held between 1929 and 1939. Afterwards, the activity of the group definitely ceased.

Fig. 4.2 Photograph of the opening of "Oblik" exhibition in Sofia, 1934.

The Membership

During the existence of the group, the number of members participating in exhibitions varied from thirty-four at the first and largest to fourteen at the second in the Galić Salon in Split (1930) and twelve at the fourteenth show in Skopje (1937), when the number of participants was the smallest. The Group exhibited in all the larger cities of the Kingdom of Yugoslavia: five times in Belgrade, twice in Skopje, then in Split, Sarajevo, Banja Luka, Zagreb and Ljubljana, and also abroad: in Sofia, Plovdiv, Prague and Thessaloniki (Fig. 4.2). Shows in other important art centers were envisioned, e.g. in Budapest, Athens and Amsterdam, but the exhibitions were not realized. Unfortunately, since some of the shows did not have accompanying catalogs, there are no precise data on all the participants or the exhibited works. The originator of the idea and one of the founders was Branko Popović. Along with him, the earliest program documents list Jovan Bijelić and Petar Palavičini.[4] From the very beginning, the "task of 'Oblik' was to place artistic creation in Belgrade and the rest of the country on a high level, firstly, in accordance with contemporary artistic developments in major art centers of the world, and, secondly, in harmony with the artistic traditions of the celebrated epochs of the past".[5] Members were not only expected to exhibit regularly at the shows of the group, but they also had to show their works beforehand to a jury. The number of works that could be displayed by painters, sculptors, graphic artists and architects was specified. Judging by these regulations the founders were determined to organize the activities of the group and exclude improvisation.

Apart from the mentioned members, the founders of the group were the painters Petar Dobrović, Sava Šumanović, Veljko Stanojević, Marino Tartaglia, sculptors Toma Rosandić and Sreten Stojanović. The name of Branko Popović, as chairman of the association, appears in many documents; also the names of Jovan Bijelić, as secretary, and Svetislav Strala, as the

treasurer, but there are no documents on their election and appointment. The members later included Ivan Radović, Ignjat Job, Mihailo S. Petrov, Nikola Bešević, Zora Petrović, Milan Konjović, Mate Radmilović, Kosta Hakman and Stojan Aralica. Artists associated with the group for at least some period were also Milo Milunović, Risto Stijović, Vilko Gecan, Ivan Lučev, Nikola Martinoski, Milenko Šerban and many others. Interestingly, Sava Šumanović, one of the founders, never took part in the exhibitions, but the number of exhibitors and the territory covered by the group activities were enlarged by the guests invited to the shows. Finally, of about sixty members, there were only five women, and they were present only at certain exhibitions: Zora Petrović, Stanka Radonjić Lučev, Roksanda Zarunić Cuvaj, Katty Mahr Koester and, posthumously, Nadežda Petrović.

The Early Years

The existence of the group was first announced on 1 November 1926 in *Savremeni pregled* in the column *Through Belgrade Art Studios*, which was written in the form of a conversation with several of the group's members. The anonymous author of the text spoke with Jovan Bijelić, Veljko Stanojević, Marino Tartaglia, Petar Palavičini, Sreten Stojanović, Mihailo S. Petrov and Živorad Nastasijević (who was not a member and never exhibited with the group). The next public appearance was at the previously mentioned Sixth Yugoslav Art Exhibition in Novi Sad, in 1927. On that occasion, there was also an exhibition of old Serbian painting in honor of the centenary of Matica Srpska. The works displayed by "Oblik" at such an important event made the group significant and underscored the careful strategy in the creation of its identity and reputation. Moreover, exhibiting together with the selection of the Spring Salon[6] disclosed the presence of "a firm, constructive form" and the qualities of a pure visual language,[7] thus positioning the work of the group on a broad poetical foundation and revealing its intention to measure its art against relevant artistic developments. This exhibition was important for the future work of the group in yet another aspect: ten artists exhibited as one entity apart from the Belgrade and Zagreb sections of "Lada", the group "Sava" and the Slovenian Art Society from Ljubljana, the Artists' Association from Sarajevo, the Association of Graphic Artists and "The Independent" group from Zagreb (together with the already mentioned Spring Salon) and twenty artists "from the entire country" not related to any group; some of them later joined "Oblik". Surprisingly, Branko Popović was not among the exhibitors in Novi Sad in 1927.[8]

Since the activity of the group was always presented in public exhibitions, its development should be studied in that way. On the whole, there are a significant number of documents and critical reviews in the local press, but also in important papers from other Yugoslav

cities as well as in foreign newspapers. Moreover, when catalogs were printed, their prefaces expounded the essential ideas of the group of artists and listed the participants. Catalogs were prepared for the exhibitions in Novi Sad (1927), Beograd (1929, 1931, 1932, 1933, 1939), Zagreb (1933), Ljubljana (1933), Sofia (1934), and Prague (1934).

The Exhibitions

The catalog preface for the first solo exhibition of "Oblik" in Belgrade on 15 December 1929 states the following: "[a] group of painters and sculptors, who have already exhibited together in Belgrade, Yugoslavia and abroad, and who appeared in the first post–war years together with writers and musicians as the 'Group of Artists' (almost an artistic movement) three years ago formed the 'Oblik' Art Group. Branko Popović, Petar Dobrović, Jovan Bijelić, Sava Šumanović, Veljko Stanojević, Marino Tartaglia (painters) and Toma Rosandić, Petar Palavičini and Sreten Stojanović (sculptors) are its founders."[9] The reference to the "Group of Artists" as the first modernist-oriented art group formed after the First World War pointed to the guiding idea of "Oblik" that would mark the future activities of the group in its determination to follow progressive tendencies in contemporary art, the group saw itself as an expression of continuity in artistic creation inspired by the current European achievements. "Oblik" addressed the entire cultural space of Yugoslavia and the neighboring countries, and took an active part in the transformation of Serbian and Yugoslav modern art and its integration into much broader cultural circuits. An additional explanation of this artistic gathering was offered by Branko Popović in his opening remarks at the first exhibition: "the reasons guiding the founders of the group "Oblik" were both emotional and conceptual – they wanted to form a new artistic community which would gather together kindred artistic elements and promote warm relationships with artists from Zagreb, Ljubljana and other cities of our country; those reasons were very real, in fact irresistible."[10] On that occasion Branko Popović did not mention one significant fact: the founders of "Oblik" and the majority of members and guest exhibitors were already renowned artists at the time the group was formed, and had had noteworthy shows in Paris, Zagreb, Barcelona, London, Philadelphia, Belgrade, Prague and Vienna.

The second exhibition of "Oblik" was held in May 1930, in the Galić Salon in Split. It was opened by Kosta Strajnić and the Mayor of Split, Dr. Račić. The anonymous critic of *Novo doba* from Split, who regularly reported on the group's exhibitions, wrote an inspired text about the wonderful impression and true enthusiasm the event provoked in Split "as one of the best exhibitions to this day".[11] This commentary indicated the specific mission the art group followed from the very beginning and throughout its existence: all the exhibitions

of the group brought memorable changes into the cultural climate of the cities and had a profound influence on future artistic developments. This influence was not noticed so acutely by others as by the *Novo doba* reporter, but it survived the challenges of time and received full validation thirty years later. "From 1928 to 1930 there was a succession of mediocre shows by local painters. The gloomy atmosphere could not be brightened by occasional shows of foreigners who had come to Dalmatia by chance, but it was enlightened only in May 1930 with the exhibition of the Belgrade group 'Oblik'; beside the Dalmatian artists Tartaglia, Job, and Radmilović, there were Jovan Bijelić, Petar Dobrović, Đorđe Andrejević–Kun, Lazar Ličenoski, Ivan Radović, and others."[12] In December of the same year the group organized a show in the Officers' Club in Skopje,[13] when Milo Milunović, Stanka Radonjić Lučev and Ivo Šeremet joined the group for the first time. The exhibition in Skopje aroused considerable interest as an exceptional cultural event in a milieu which was, like Split, just beginning to acquire the qualities of a modest cultural center. Only one local artist, Lazar Ličenoski, took part in the exhibition. As a member of the Friends of the "Jefimija" Arts Association he was also in charge of the organization of the event. At this exhibition, which brought to Skopje works by the most important artists from different parts of the Kingdom of Yugoslavia, Ličenoski, well-known in Belgrade where he lived, represented a fragile link between the local cultural environment and the current development in art and was greeted with special attention. Recognizing the "national character of his motifs and the fresh, warm expression of his paintings as well as their innate beauty," the audience responded by purchasing his work and the art critics by expressing their approval and praise.[14]

The exhibiting in different cities, even in different parts of the country, was continued in 1931. Unfortunately, no catalogs were prepared for the fourth and fifth shows, held in Sarajevo and Banja Luka, and particulars about them had to be gathered from critical reviews and announcements in the daily newspapers. However, a catalog was printed for the sixth exhibition, held in the "Cvijeta Zuzorić" Art Pavilion in Belgrade (8-23 November 1931) – by then already well-known, the art group wanted to present itself in the best possible way in the country's capital. "'Oblik' is today undoubtedly the most significant and most progressive of all the art groups in Belgrade. It has gathered together almost all our painters and sculptors who have earned their distinct reputations since the war and who have also promoted a superior, more knowledgeable and modern understanding of art and the visual arts practice. The founders of 'Oblik' are the main representatives of the current modern painting and sculpture, but they are in addition the first proponents of a continuous desire to achieve new artistic creations and further develop our art in general" – with these words Todor Manojlović began his report on the exhibition.[15] Always precise in his analyses, Manojlović pointed out the generational division to the youngest "who look up to Branko Popović, Dobrović, Bijelić,

Tartaglia or Radović, and the 'elders' who rise in the company of their renowned forerunners and teachers." The author mentioned each of the exhibitors and, contrary to other art critics, commented on their best works and suggested that modern architects should join the group "because they must work together with our new painters and sculptors"; the group accepted the advice and practiced it in their future activities. The seventh exhibition was held a year later, also in Belgrade. As on several other occasions, the opening remarks were delivered by Branko Popović, and his speech was printed in two daily newspapers: *Vreme* and *Politika*.[16] Also, the critics and their reviews were more numerous than for previous exhibitions. For example, *Politika* not only printed Popović's text, but published two installments of the text written by Rastko Petrović. Dragan Aleksić had two texts on the painters in *Vreme*, and a third on sculpture and graphic art. Desimir Blagojević wrote a commentary for the influential *Pravda* and it was published in three installments. Still, two texts stand out in this mass of critical reviews and they deserve special attention because they represent a direct reflection of the leading idea in the publishing policy of "Oblik" – interactive presence in different milieus. The seventh exhibition was the first in the series of "Oblik" shows which generated eloquent reactions in other cities: in Sarajevo,[17] where the group exhibited in 1931 and in

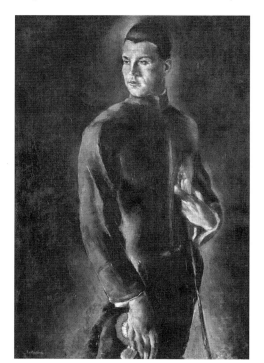

Subotica[18] where it had not had previous exhibitions and would not have one until its dissolution. Even more significant is the fact that critics believed that the vitality and importance of "Oblik" stemmed from its perpetual transformation, from changes in the composition of exhibitors and their generational structure, from a "natural, continuous and progressive influx of new forces that reconstruct the group, rejuvenate it or at least keep its high level."[19] Apart from his exact analyses of each exhibitor's work, Todor Manojlović particularly underscored the young ones, "two excellent young painters from Zagreb: Vilko Gecan and Lovro Pavelić".

Fig. 4.3 Marino Tartaglia, *Young Diplomat*, 1923.

Judging by such public reception, the group succeeded in attracting the desired attention. Still, its first progress towards international success began in 1933 with a tour of the three most important cultural centers of the Kingdom of Yugoslavia: Zagreb (Art Pavilion, in May), Ljubljana (Jakopič Pavilion, in June-July) and Belgrade ("Cvijeta Zuzorić" Art Pavilion, in December). This tour, and particularly the exhibitions in Zagreb and Ljubljana, was understood by some of the painters as a chance to present themselves more comprehensively than before, by displaying some of their older works together with recent ones. In contrast to the eighth exhibition of "Oblik" in 1932, when he exhibited only his current works, Marino Tartaglia decided to round off his artistic portrait with two paintings from 1923: the *Young Diplomat*, painted in Vienna, which Jovan Bijelić borrowed on behalf of Tartaglia from the collector Pavle Beljanski (Fig. 4.3)[20] and the *Little Drummer*. Branko Popović exhibited in Zagreb and Ljubljana, among other works, his two paintings from 1912, which are today considered his best creations: *Slim Body* and *Self-Portrait*. Both Tartaglia and Branko Popović attended the opening in Ljubljana; Popović gave an interview to the local daily paper *Jutro*, and offered a comprehensive survey of the current state in culture, and defined the place of the "Oblik" art group within that context.[21] Thirty years after the First Yugoslav Art Exhibition and his part in the organization of the show, Popović spoke of the genesis of cultural links in the Slavic South: using himself as an example, he pointed out the participation of artists in political missions at the very beginning of the 20th century, and emphasized the importance of Yugoslav exhibitions, the activities of the "Lada" Art society, the "Medulić" group and particularly the role of Nadežda Petrović in the deepening of contacts with Slovenian and Croatian artists, the significance of the art colony in Sićevo and, finally, the transformation of such a cultural engagement and commitment into a "powerful means of Yugoslav national propaganda." The exhibitions held after the First World War in Paris, Philadelphia, Barcelona, London and other world centers acquired the importance of state representational events. The gatherings of artists had a different dimension under the influence of contemporary art movements and researches in Paris and other parts of Europe, as confirmed by the appearance of "Oblik" as an opposition to the academically inclined "Lada" or "Zograf" (founded with the idea of renewing the Serbian-national tradition through new contemporary forms). Popović reiterated the basic postulates of the activities of "Oblik" and emphasized that, with twenty-nine members from all over the country and a significant number of Slovenians and Croats, the group was an expression of the necessity to have as many different artistic features as possible, in accordance with the cultural and artistic development of the country. This desire was expressed in Ljubljana at the show where twenty two artists exhibited 60 paintings, 45 graphic works, 20 sculptures, and several complete architectural designs.

In addition to Marino Tartaglia and Branko Popović, among the exhibitors were artists whose names had previously appeared at the exhibitions of "Oblik": Arpad Balaž, Jovan Bijelić, Vilko Gecan, Ignjat Job, Anton Huter, Pjer Križanić, Lazar Ličenoski, Nikola Martinoski, Petar Palavičini, Veljko Stanojević, Risto Stijović, Svetislav Strala, Milenko Šerban, Ivo Šeremet and Viktor Žedrinski. Such a selection shows that a certain "hard core" of the membership had evolved in time, and one is inclined to conclude that these artists saw the group as the best place for personal affirmation and better exhibiting possibilities and activities, because "Oblik" was clearly defined but still free of overly strict rules. On the other hand, their membership of the group did not prevent them from organizing solo exhibitions where they could exhibit only their own works to the public and fashion a corresponding image of their own individuality.

The finale of public appearances for "Oblik" in 1933 was the exhibition in Belgrade; Branko Popović and Marino Tartaglia did not participate. The focus of the exhibitors on the quality of the works rather than their quantity (the majority submitted ten works each) was striking, and therefore the show was "exceptionally powerful and passionate in an expression of specifically colorific temperaments".[22] And, as Todor Manojlović noted, "The painting is leading, prevailing, here ... and really a 'painterly' painting, a fresh and honest poetry of colors which "Oblik" has been looking for since its beginning and has realized it with a nice, progressive gradualism."[23] Paintings most admired by the critics belonged to the then latest neologism – *painterly painting* or *peinture-peinture*,[24] the colorific quality that dominated Belgrade's art scene in the early 1930s. The main proponents of this kind of painting were Jovan Bijelić and Ignjat Job; their obvious individuality was yet another plausible confirmation of a principle of "Oblik" – to inaugurate individual expression and leave the artists comprehensive creative freedom. These two painters were devoted members of the group: Jovan Bijelić did not miss a single exhibition of "Oblik" and Ignjat Job was not present at only one of them, the show in Banja Luka in 1931.

The Apex of the Group's Activities: 1934 and Exhibitions Abroad

Between 1926 and 1934 the group exhibited in different parts of the Kingdom of Yugoslavia, and in 1934 its exhibitions were moved abroad, to the Bulgarian cities of Sofia (Preslav Salon, in January), Plovdiv (in February) and then to Prague in Czechoslovakia (Salon Mánes, in September-October). Twenty-three artists were represented in Sofia and Plovdiv and nineteen in Prague. The works exhibited and the catalog prefaces written by Branko Popović (the Bulgarian text was published in French) stressed the main principles of the group's activities. In Sofia, and a month later in Plovdiv, the group appeared almost complete, with twenty-three

members. The exhibits showed all aspects of the group members' creations, from painting and graphic art, caricature, stage sets and sculptures to architectural designs. Despite such a comprehensive show the reactions of audiences in these two cities did not match expectations. Only two art reviews were published in Sofia and one, unsigned, in *Novo doba* from Split. The exhibition in Plovdiv was mentioned only by the reporter from *Novo doba*.[25] This inadequate response suggests that the show was not effectively advertised, or that the general public was not interested, or that the overall cultural climate was not sufficiently developed.

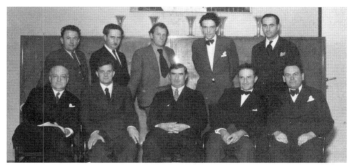

Fig. 4.4 Invitation to the opening of "Oblik" exhibition in Prague, 1934.

Fig. 4.5 Photograph of the exhibitors and organizers of the "Oblik" exhibition in Prague, 1934; second row from left to right: Lazar Ličenoski, Svetislav Strala, Pjer Križanić, Nikola Martinoski, Milan Konjović. First row from left to right: Professor Emanuel Purghart, Petar Palavičini, Chairman of the Art Association 'Mánes' Josef Gočár, Zonić (?), Councilor Haloupka.

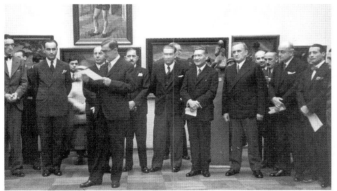

Fig. 4.6 Opening of the "Oblik" exhibition in Prague, September 7, 1934.

Fig. 4.7 A page from *The Central European Observer* of September 21, 1934, with the exhibits from the "Oblik" exhibition in Prague.

The reception in Prague, a few months later, was quite different (Figs. 4.4-4.7). No exhibition of "Oblik" before or since had brought about so many commentaries in Czech, German and English; reports also appeared in newspapers published in Zagreb, Belgrade and Subotica, as well as in the *Beaux-Arts* from Paris.[26] Announced as an outcome of intergovernmental cultural cooperation, the exhibition in Prague was organized under the patronage of the Czech Minister of Education, Jan Krčmář, and the opening was attended by the representatives of the Yugoslav Embassy, Ambassador Prvislav Grizogono and Chargé d'Affaires Ivan Ribar. Czech Minister of Foreign Affairs Edvard Beneš delivered the opening remarks, as did the Mayor of Prague Karel Baxa. The exhibition was also an outcome of ongoing cooperation with the Czech Art Association, "Mánes", and was held in their Salon. One observes the absence of some of the usual names from the list of exhibitors, such as Marino Tartaglia, Đorđe Andrejević-Kun and Vilko Gecan. Then again, it should be mentioned that eight paintings by Nadežda Petrović were on display, paintings produced over a considerable time span, from *Resnik* (1905, Serbian period) to *Vizier's Bridge* (1913), *Prizren* (1913) and *Gračanica* (1913, war period). The inclusion of these works, by an artist no longer alive, was a precedent in the policy of "Oblik" to promote contemporary art. The years of the First World War during which she tragically lost her life (in 1915) and the appearance of new generations almost obliterated Nadežda's name from public life in Serbia. By this gesture she and her works were retrieved from oblivion and the stage was set for a special exhibition of her works which took place in Belgrade in 1938.

The Belgrade daily, *Politika* reprinted the commentary of the Prague critic J. R. Marek, originally published in *Národní Listy*,[27] under the title "Great Success of 'Oblik' in Prague." A text box in Marek's review contains the names of critics who had written about the exhibition, such as V. V. Štěha in *České Slovo*, Čapek in *Lidove Noviny*, Jan Pećirka in *Prager Presse*, F. X. Harlas in *Národní Politika*. In order to introduce his readers to the basic postulate of the group's activity, Marek quoted Branko Popović and commented on the statement Jovan Bijelić had given to the Czech press agency. The commentary regarding the focus of the group on creative freedom is nothing new for us today, just as some names of the artists were not new or unknown to Czech audiences then. In order to acquaint the public with each of the nineteen artists, Marek meticulously analyzed the exhibits and once again stressed that Branko Popović had participated with Petar Dobrović in an exhibition in Prague ten years earlier (1924). The name of Milan Konjović was also mentioned in the context of earlier exhibitions in Prague (1923 and 1929). However, concentrating on his review of the current show, Marek did not note the comprehensive history of the presence of Yugoslav artists in Prague – at the "Five Yugoslav Visual Artists" exhibition, organized by Milan Konjović in Rudolfinum in 1923 (one of them was Marino Tartaglia, a member of "Oblik"); the exhibitions of Stojan Aralica

(1932) and Nikola and Petar Dobrović (1932). Moreover, one should not forget to mention – in those numerous cultural and artistic connections which were intensified with the arrival of Vlaho Bukovac at the Prague Art Academy in 1903 and culminated in the inter-war period – the "Prague episodes" of other members of the group: Petar Palavičini (studied at the Fine Arts Academy in Prague 1904-1912, and took an advanced course in sculpting), Stojan Aralica (1917), Jovan Bijelić (1915), Nikola Dobrović (graduated in architecture in Prague and lived and worked in the city until 1934), Kosta Hakman (1919-1920), Ivan Radović (since 1919), and Milan Konjović had had diverse links to Prague (education, family and friends) since 1918. These and other cultural relations were deepened during the inter-war period owing to the special contribution of Božo Lovrić, the author and art critic from Zagreb, who had lived in Prague since 1911, edited the *Centropres* bulletin, and wrote for a number of Zagreb and Belgrade papers. In Czechoslovakia he promoted Yugoslav art and sent commentaries to Yugoslavia on cultural events in Prague. He was a close friend of Milan Konjović, wrote the preface for Stojan Aralica's exhibition in Prague (1932) and texts on the shows Yugoslav painters organized in Prague. He reviewed the thirteenth exhibition of "Oblik", held in Prague, in the Zagreb paper *Jutarnji list* and Belgrade magazine *Život i rad*.[28] Undoubtedly the success of "Oblik" in Prague was additionally supported through continual cooperation with the "Mánes" Art Association, whose exhibition was presented in Belgrade in 1925 as the first international exhibition organized by the "Cvijeta Zuzorić" Association.[29] Moreover, the character of the displayed paintings played an important role in the enthusiastic reaction of Prague audiences: the paintings of Konjović, Job, Aralica, Šerban and Nadežda Petrović were full of color and expression, conveying a kind of freedom, spontaneity and the beauty of life. It was accepted as a breath of the southern temperament as opposed to the symbolistic-esoteric and cubo-constructivist painting of Czech artists.

The idea to "exhibit abroad" came about in 1931 when Branko Popović contacted the Ministry of Education and asked for assistance in the arranging of exhibitions in Thessaloniki and Athens. The management of the group returned to the same plan in 1932 when individual members received invitations to send their works to foreign shows. In that year, Petar Dobrović unsuccessfully endeavored to organize exhibitions in The Hague, Amsterdam and Rotterdam, at the same time as preparations for the exhibition of Yugoslav art in Amsterdam were underway. The organization was undertaken by the "Cvijeta Zuzorić" Association and the show was held from 10 September to 9 October 1932. This event started a debate (between Toma Rosandić, as one of the exhibitors in Amsterdam, and Petar Dobrović) and brought about a breach in the membership of "Oblik": Toma Rosandić and Petar Dobrović left the group. Later, Zora Petrović and Sreten Stojanović did the same. Negotiations for an exhibition in Budapest were also to no effect.[30] The representation of the group abroad

began only in 1934 with the already mentioned three exhibitions and continued three years later, in 1937, with the show in Thessaloniki. In fact, it seems that the success in Prague was the culmination of the group's activities, and when its members gathered together in 1937 it was in a much smaller number for the show in the Officers' Club in Skopje. There was no catalog for the exhibition, but invitations by the 'Jefimija' Society have been preserved. Additional invitation to the lecture by Branko Popović "On Artistic Life in Our Country" was delivered during the show. The press attention was scant and no reviews appeared in Belgrade papers, although they regularly followed important events in Skopje. It is not clear why the members of "Oblik" neglected this exhibition and left no accounts of it, even among themselves, especially in light of its obvious significance. In a letter written by one of the organizers, Lazar Ličenoski, to the young art historian Julka Matić (Džunić) in September 1953, he says that "'Oblik' organized fifteen exhibitions, three of which were abroad (in Sofia, Thessaloniki and Prague in 1934) then in Sarajevo and Skopje in 1930, in Zagreb and Ljubljana in 1933. The others were held in Belgrade. Until 1933 'Oblik' was represented in full membership, but afterwards the number of exhibiting members diminished and at its last show in 1939 (XV) only twenty members took part. Jovan Bijelić remained a member of the group until the end and exhibited regularly. Until 1933 he was the group's secretary."[31] Minor historical inconsistencies in the letter (including the parts not quoted here) can be attributed to lapses in memory, but do not easily explain why Ličenoski neglected the facts concerning the exhibition in Skopje, since he was one of the participants. The works shown in Skopje were later exhibited in Thessaloniki (in April and May 1937). In Thessaloniki, there were five more exhibitors than in Skopje, so that the total number was seventeen. "[The exhibition] was especially interesting for the foreigners living in Thessaloniki and they were pleasantly surprised to see such a high European level of the exhibits. Thus the exhibition of 'Oblik' in this large Balkan city did not only promote Yugoslav culture but contemporary art in general."[32] The commentary listed all the exhibitors: Stojan Aralica, Jovan Bijelić, Vilko Gecan, Sabahadin Hodžić, Anton Huter, Milan Konjović, Lazar Ličenoski, Nikola Martinoski, Branko Popović, Stanka Radonjić Lučev, Veljko Stanojević, Svetislav Strala, Milenko Šerban, Arpad Balaž, Vladimir Žedrinski, Pjer Križanić, Petar Palavičini and Risto Stijović. Those were the artists who took part in the majority of organized shows. However, since the number of exhibitors was smaller in comparison to the usual selection of the group, it might be appropriate to quote here Vladimir Rozić about the overall activities of the group: "of course, it is not irrelevant how many artists were members of 'Oblik', but it is relevant who these members were."[33]

The last exhibition of the group was in Belgrade, from December 1938 to January 1939. There were twenty-four participants including three younger artists who joined the group "as

guests:" Dušan Vlajić, Nikola Graovac and Miloš Vušković. Like all previous Belgrade shows, this one was organized in the "Cvijeta Zuzorić" Art Pavilion. In his review in *Umetnički pregled* Milan Kašanin briefly commented on the significance of the group and its survival on the art scene despite frequent changes in its membership and the irregular rhythm of exhibiting. He also underscored that its members were "typical representatives of the generation that turned our modern painting into a new direction."[34] Kašanin did not overlook the generational divide, which was more striking at this exhibition than before because of the presence of the (already mentioned) new participants. Kašanin had a characteristic epithet for each of them, and so Miloš Vušković was "serene", Nikola Graovac "more self-assured and mature", Gecan "purified", Šerban "richer and more organized". Since that was Kašanin's first text on "Oblik", a good part of it was dedicated to the importance and role of Branko Popović both in the founding and the activities of the group. The author discussed more than a decade of the group's existence. Todor Manojlović was more concerned with the current work of the group and its public appearance after a long pause "while it was somewhat 'refashioned' and [when it] accepted a few excellent new members, but, unfortunately, lost a few even more excellent old members. Still, 'Oblik' has reappeared with a very interesting and respectable exhibition (174 works)."[35] After emphasizing the avant-garde orientation of the group, Manojlović also underlined the "lively bright colorific quality, predominant with the painters of 'Oblik'" and brought this quality to the fore in his analyses of Serbian painting from the 1930s. The reviews by Kašanin, Manojlović and other critics who commented on this exhibition of "Oblik" were less concerned with the basic problem imposed by the show. Only Đorđe Popović emphasized the irrepressible turn of generations in Belgrade art.[36]

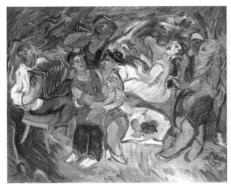

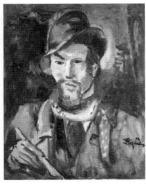

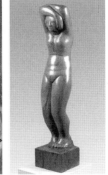

Fig. 4.8
Ignjat Job, *Lumbarda*, 1933.

Fig. 4.9
Jovan Bijelić, *Painter*, 1932.

Fig. 4.10
Risto Stijović,
Caryatid, 1931.

Epilogue

With the first Belgrade show of the art group "Oblik" began a new, exceptionally fertile and dynamic period of cultural life in the capital city. That period was mostly related to the "Cvijeta Zuzorić" Art Pavilion, and the first solo exhibition of the group in 1929 marked the institution's first birthday. The beginnings of the Art Pavilion are also connected to the first organized art exhibitions and Belgrade Salons: the Fall Exhibition of Belgrade artists and the Spring Exhibition of Yugoslav artists, as well as a number of solo exhibitions and shows of various visiting groups and individual artists from abroad. Artists born at the beginning of the 20th century were educated in Prague and in Paris after the First World War; they reached their artistic maturity in the early 1930s, which can be exemplified by paintings and sculptures done by Ignjat Job, Jovan Bijelić and Risto Stijović (Figs. 4.8-4.10). Many of them, notwithstanding their occasionally incomplete studies, saw their future in Paris and endeavored to join the artistic circles of Montparnasse. They worked in modest studios but exhibited in renowned galleries. Their goal was to compare their own talents with the creative potentials of their teachers and contemporaries at the very source, and receive affirmative reviews in this uneven competition. In the 1930s, Risto Stijović, Sreten Stojanović, Petar Lubarda, Milo Milunović, Petar Dobrović, Stojan Aralica, Marino Tartaglia, Sava Šumanović and many other artists received advanced training in the art schools and studios of Paris, absorbing the diverse intermingled influences of the School of Paris and fashioning their own artistic identities. The Black Tuesday of October 29, 1929 and the crash of the New York Stock Exchange ended the "roaring twenties" and the creative eruption which had turned Paris into a world capital of art. The predominantly weak financial security of artists was further shaken by the economic crisis which soon reached Paris. The majority of Yugoslav artists decided to return to their home country, at least for a time, find a place in the public life there and earn their living. Their artistic creativity, enhanced in Paris through echoes of Cézannism, Post–Cubism, expressionistic forms and traditionalism, was continued in full swing with an emphasized colorific quality, intimistic views and poetic realism; there was also a social aspect in their interpretations of contemporary reality. Paintings of the countryside and townscapes, frequently defined by a "sideways look," and intimistically tinged interiors painted with human figures or without them, also still-lifes and female nudes, creations of individualistically oriented artists, were nevertheless unique articulations defined by social transformation, de-structuring of the private and the public, urban and rural, the *art for art's sake* and the committed. "Oblik", as an art group and its members individually contributed to the substance of such a complex identity of overall artistic happening.

Apart from the occasional support of the Ministry of Culture of the Kingdom of Yugoslavia, the activities of "Oblik" were financed from the membership fund and a percentage taken from the acquisition of works (by the aforementioned Ministry).[37] In such a context, the gathering together of artists with diverse interests, born in the late 19th and at the beginning of the 20th century, acquires an additional dimension of existence. In the period of their group exhibitions, the majority of artists also had their solo shows in Belgrade, Zagreb, Paris, Prague, Novi Sad and other cities in Yugoslavia and abroad, with press coverage that equaled the attention paid to the exhibitions of "Oblik". Art criticism was governed by the same generational principle: the exhibitions of "Oblik" and its members enjoyed the full attention of critics such as Todor Manojlović, Rastko Petrović, Sreten Stojanović, Stevan Hakman, Sava Popović and others. Beside Branko Popović, the exhibitions were opened by other eminent contemporaries: Kosta Strajnić, Jovan Dučić or Miloš Crnjanski. The beginning of the activities of "Oblik" coincided with the launching of the group in its immediate environment. However, in the second half of the decade of its existence the focus was moved to shows abroad where the group continued its mission of awakening artistic life in undeveloped cultural surroundings, as was the case in Sofia, Plovdiv and Thessaloniki. Simultaneously, members of "Oblik" were able to compare their potentials in a milieu of a well-developed and strong tradition, such as Prague. Although oriented towards contemporary art, the group did not neglect to promote the traditional values of their own peoples, and the paintings of Nadežda Petrović were exhibited in Prague, not only for the outstanding qualities of her painting but also because of her long-lasting involvement in connecting the cultures of Slavic peoples.

As an exceptionally big and heterogeneous group, bringing together at one point almost all of the Belgrade artists, "Oblik" was in its size an obstacle for the expression of the individual ambitions of its members. "The greater the success of individual artists and the lesser the obstacles for artistic creation, it was more difficult for the group to stay together."[38] The membership was restructured, and in 1937 a new group was formed – "Dvanaestorica" or "The Twelve". It had no theoretical or social program, but based its activities on the common interests and inclinations of its members and their similar understanding of art. Except for Borislav Bogdanović and Hinko Jun, the group consisted of former members of "Oblik", and in the two years of its existence it manifested a "purely artistic relationship to the world." Its two exhibitions were in the period when "Oblik" had no shows, and it was dissolved before the last gathering of the membership for the Belgrade exhibition in 1939. When talking of the turn of generations, which also affected "Oblik", the painter and critic Đorđe Popović numbered among the younger artists Milenko Šerban (1907), Miloš Vušković (1900) and Nikola Graovac (1907), probably considering the year of his own birth (1909).[39] At that time, the real new generation of artists born immediately before the First World War or after it was

already in Paris, engrossed in its own adventures of discovering art and bohemian life: among them were Ljubica Cuca Sokić, Bogdan Šuput, Jurica Ribar, Peđa Milosavljević. They formed their own groups, launched by exhibitions: The Four (in 1934) or The Ten (in Belgrade and Zagreb, in 1940). Although followed by older art critics, they also had their own interpreters such as Aleksa Čelebonović, Jurica Ribar and D. Galogaža, a different attitude towards their own mission in the world of art.

"Oblik", the second time

The last exhibition of "Oblik" closed on January 5, 1939. There were no subsequent shows or public appearances. The long silence was interrupted by the interview of a former devoted member, the sculptor Risto Stijović, published in *Nova Makedonija* (Skopje) on October 15, 1957. The topic of the conversation was the renewal of the group and the continuance of its activities; according to Stijović, this was the desire of many former members. Stijović even mentioned that an exhibition of "Oblik" would be held in 1958 with the participation of the older generation together with a number of new, younger artists. "Oblik" was supposed to continue with its former practice of exhibiting in Yugoslavia and abroad; the painter Nikola Martinoski was also working on the renewal of the group.[40] A similar announcement appeared in the Zagreb edition of *Borba* and the interview with Stijović from *Nova Makedonija*[41] was published in the Zagreb paper *Vjesnik u srijedu*.[42] The "Oblik" Art Group was not renewed, it did not continue its activities and there was no exhibition. Presumably, Risto Stijović and Nikola Martinoski lacked the charisma of Branko Popović, the leader of "Oblik", and they could not stir up enough interest for their idea with the now very heterogeneous artistic population. One should also consider the complex developments between 1950 and 1960, another significant turn of the generations in the artistic world, more tangled relationships within the artistic population and more emphasized individual creative freedoms. Moreover, the mechanisms of the exhibition policy in the country and abroad did not depend on a group of people willing to organize the shows, but on political decisions and intergovernmental agreements. The gathering of artists in "Oblik" in the 1930s was made possible by a number of circumstances, distinctly different from the conditions in the post-war Yugoslavia of the 1950s; such gatherings and public presentations were simply not feasible.

Notes

1. For the most comprehensive survey of the activities of the group see: Vladimir Rozić, *Umetnička grupa "Oblik"* [Belgrade: Kancelarija za pridruživanje Srbije i Crne Gore Evropskoj uniji, 2005]. This research is based on documents from his legacy and from the archives of The Pavle Beljanski Memorial Collection in Novi Sad.

2. Stevan Hakman, "Izložba slika, sculpture i arhitekture Umetničke grupe 'Oblik'," *Misao* XXXI 5-8 (1929), 466.

3. *Шеста југословенска уметничка изложба* [catalog], Novi Sad 1927.

4. There are two documents on the founding of "Oblik": The Rules of the "Oblik" Art Group Association, predominantly on the organization and program, and By-Laws of the "Oblik" Art Group Association with regulations for exhibitions.

5. Rozić, *Umetnička grupa*, 15.

6. Radovan Vuković, Petar Prelog, *Proljetnji salon* (Zagreb: Umjetnički paviljon, 2007).

7. Rozić, *Umetnička grupa*, 83.

8. *Шеста југословенска уметничка изложба* [catalog], Novi Sad 1927.

9. *Облик. Прва изложба Уметничке групе "Облик"* [catalog], 15. XII 1929 – 4. I 1930. Belgrade 1929, 4.

10. From the text by Branko Popović read at the opening by Veljko Stanojević, "Изложба Уметничке групе 'Облик'," *Политика* (16 December 1929).

11. "Sinoćnje svečano otvorenje izložbe 'Oblika'," *Novo doba* (12 May 1930).

12. Kruno Prijatelj, "Ivan Galić i njegov salon," in *Ivan Galić i njegov salon*, ed. Kruno Prijatelj (Split: Galerija umetnina, 1961), 6.

13. Boris Petkovski [Борис Петковски], "Две изложбе 'Облика' у Скопљу (1930, 1937)," *Зборник народног музеја* XI–2 (Belgrade: Narodni muzej 1982), 175–185.

14. "Успех Л. Личеноског," *Скопски гласник* (11 December 1930), 2 in: Петковски, *Две изложбе*, 177.

15. Todor Manojlović [Тодор Манојловић], "Изложба 'Облика' у Уметничком павиљону у Београду," *Летопис Матице српске* CV, 330, 3 (1931) 233–237. The art criticisms of Todor Manojlović were reprinted in: Тодор Манојловић, *Ликовна критика*, ed. Jasna Jovanov (Zrenjanin: Gradska narodna biblioteka, 2008).

16. Rozić, *Umetnička grupa*, 134.

17. Stevan Hakman, "Izložba grupe 'Oblik'," *Jugoslovenska pošta* (Sarajevo, 19 November 1932).

18. F. J., "Képző müvészet. Az Oblik – csoport őszi tarlato," *Napló* (Szabatka, 16 November 1932).

19. Todor Manojlović [Тодор Манојловић], "Изложба 'Облика'," *Српски књижевни гласник* XXXVII/6 (1932), 464-467.

20. Jovan Bijelić, Handover report for the painting Young diplomat by Marino Tartaglia (Belgrade, 22 April 1933), The Pavle Beljanski Memorial Collection, Inv. No. D 1144.

21. Božidar Borko, "O jugoslovenskoj umetnosti i 'Obliku'," in Rozić, *Umetnička grupa*, 589–594.

22. Н. Ј., "Десета изложба удружења 'Облик'," *Политика* (18 December 1933).

23. Todor Manojlović, "Изложба 'Облика'," in *Ликовна критика*, ed. Jovanov (2008), 259.

24. Manojlović, *Ликовна критика*, ed. Jovanov (2008), 626, used the term *peinture–peinture* for the first time in his review of Stojan Aralica's exhibition.

25. Rozić, *Umetnička grupa*, 138.

[26] Apart from Vladimir Rozić's study "Oblik" which includes details on the majority of reviews about the exhibition in Prague, I found information on its public reception in the newspaper library of Milan Konjović from the archives of the Milan Konjović Gallery in Sombor. Some of the texts were also pointed to me by the film director Nenad Ognjanović who did a film on Serbian artists in Prague.

[27] "Велики успех 'Облика' у Прагу," *Политика* (13 October 1934).

[28] Rozić, *Umetnička grupa*, 140.

[29] Radina Vučetić Mladenović [Радина Вучетић Младеновић], *Европа на Калемегдану* (Belgrade: INIS, 2003), 61.

[30] Rozić, *Umetnička grupa*, 42-73.

[31] Lazar Ličenoski, Letter to Julka Matić, Skopje, 27 September 1953. The Pavle Beljanski Memorial Collection, Inv. No. SZPB D 3880.

[32] "Југословенска уметност у иностранству. Изложба групе 'Облик' у Солуну". *Политика* (11 May 1937).

[33] Rozić, *Umetnička grupa*, 32.

[34] Milan Kašanin [Милан Кашанин], "XV изложба 'Облика'," *Уметнички преглед* 1 (1939), 27, 28.

[35] Todor Manojlović, "Изложба у павиљону 'Цвијета Зузорић'," in *Ликовна критика*, ed. Jovanov (2008), 626.

[36] Đorđe Popović [Ђорђе Поповић], "Однос излагача 'Облика' и нових прегнућа и тенденција млађих уметника," *Правда* (24 December 1938).

[37] Rozić, *Umetnička grupa*, 45-52.

[38] Milan Kašanin, "XV изложба 'Облика'," *Уметнички преглед* 1 (1939), 27.

[39] Popović, *Однос излагача*.

[40] Р. Куз., "Облик ќе ги продолжи своите светли традиции," *Нова Македонија* (15 October 1957); Rozić, *Umetnička grupa*, 74.

[41] М., "Ponovno osnivanje grupe likovnih umjetnika 'Oblik'," *Borba* (22 October 1957). Rozić, *Umetnička grupa*, 75.

[42] R[isto] Kuz[manovski], "Razgovori u ateljeima," *Vjesnik u srijedu* (18 December 1957). Rozić, *Umetnička grupa*, 75.

CHAPTER 5

THE TRAVEL WRITINGS OF JELENA J. DIMITRIJEVIĆ: FEMINIST POLITICS AND PRIVILEGED INTELLECTUAL IDENTITY*

Svetlana Tomić

For Verica Micić and for Iva Frkić,
to your travels and support

Jelena J. Dimitrijević's travel books were mostly published in Serbia during the interwar period (1918-1941). Characterized by idiosyncratic features their modernity comes from confrontation with traditional society and literature, and simultaneously challenges patriarchal restrictions on female participation in political and public life. In her travel writings Dimitrijević's feminism is articulated with greater complexity than as presented in published interpretations of her work. Her feminist narrative was not quite new since it finds earlier

expression in the work of her older contemporary peer, Draga Gavrilović. Yet, Dimitrijević's travel books question specific male manipulators or the authority of public institutions who trivialized women and their emancipation. Her focus on influential females who undermined women's liberation is equally important. As in the case of Gavrilović, Dimitrijević stresses the connection of the feminist's struggle to the problem of societies' false intellectualism. However, Dimitrijević could not have made original and significant contributions to Serbian feminism without possessing a privileged intellectual identity, which was inseparable from her upper class origin.

Fig. 5.1 Jelena J. Dimitrijević, Cairo, 1926.

Jelena J. Dimitrijević (Kruševac, 1862 - Beograd, 1945) (Fig. 5.1) began the literary work at the end of the 19th century, when a new generation of educated women writers emerged in Serbia – women such as Milka Grgurova (1840-1924), Draga Gavrilović (1854-1917), Mileva Simić (1858-1954), Kosara Cvetković (1868-1953), and Danica Bandić (1871-1950). These authors both promoted female characters as heroines and transformed the traditional narrative by making the emancipation of both men and women a principal subject and by promoting and defending the cultural identity of female intellectuals. Even though their literary work has indisputable and, in the cases of Draga Gavrilović, Jelena Dimitrijević and Milka Grgurova, extraordinary value, male historians of Serbian literature persistently either exclude them from analyses[1] or provide inadequate interpretations.[2] Celia Hawkesworth, the first female historian of Serbian and Bosnian female literary authors,[3] sheds light on the link between truth and reliability of male "public institutional knowledge"[4] and the difficulties of the female search for knowledge.[5] Following the judgment of male historians from the region, Hawkesworth omitted the name and work of Draga Gavrilović and neglected the travel writings of Jelena Dimitrijević.[6] Moreover, Serbia's own female scholars of Serbian 19th-century fiction have so far ignored the contribution of feminist critical and theoretical work. That may be the reason that the general public is not cognizant of the distinctive *feminist* poetics of the first generation of Serbian female writers,[7] or why even today, after recent publication of papers and monographs on the literature of Dimitrijević, her narrative is not connected with the first feminist narrative of Serbian fiction authors. This opposition to the dominant patriarchal politics of culture is the fundamental reason that the literary work of these women authors is still on the cultural margins.[8] This ideological split points to the consequences of the interdependent relationship between gender and knowledge. Most importantly, it explains one of the paradoxes of how scholars undermine rather than promote the understanding of the literary works of female authors.

Both Draga Gavrilović and Jelena Dimitrijević represent the affirmation of the new emancipated women and their opposition to the patriarchal, stereotypical, subjugated and limited place which women occupied in Serbian society.[9] They present the same unconventional and complex identity of financially independent female intellectuals. While Gavrilović was single and a teacher who lived isolated in a small village, Dimitrijević was a wealthy woman who, despite her marital status, traveled around the world, freely and without obstacles, exploring different cultures and women's position in them.[10] An especially unusual aspect of Jelena Dimitrijević's experience was the sincere support of her emancipated husband – who resembles the fictional male characters Draga Gavrilović created as ideal partners for her female heroines. Even though Jovan Dimitrijević had a typical patriarchal "male" or soldier-warrior job as an officer in the Serbian royal military service, he encouraged his wife

in the pursuit all of her activities.[11] This meant much more than verbal support at a time when husbands were required to go to court to sign a "husband's approval" for a wife to work in the public sphere. From 1844 to 1946 the Serbian Civil Code did not consider married women to be any better than its immoral, delinquent and insane citizens, and thus classified them in the same group, along with the young and immature people. In contrast to adult unmarried women, who had the right to administer their own property, married women had no inheritance rights. Married women could rarely work in public and, if their husbands died, they did not possess parental rights. In all social segments of life, they were completely subjugated to their husbands.[12]

Despite the rigidly controlled and severely limited female identity and a generally humiliating male perception of the other gender, Draga Gavrilović and Jelena Dimitrijević became successful writers.[13] Gavrilović was the first female fiction writer and the creator of the first Serbian feminist novel – *Devojački roman* (*A Young Girl's Novel*) (1889). Despite her efforts, Gavrilović did not succeed in having her book published. During her lifetime, she did manage to have her work appear in periodicals. Dimitrijević achieved much more and many circumstances contributed to a more favorable reception of her work. First, when she was not travelling, she was focused on Belgrade which was also the center of Serbia's cultural life. Her privileged social status helped her not only to improve but also to benefit from her social and intellectual network. While Gavrilović could only imagine America in her narratives, Dimitrijević could easily afford to travel there twice, in 1919 and 1927. In contrast to Gavrilović, who was forced to isolate herself from society, Dimitrijević was literally connected with the world.

Quite possibly Jelena Dimitrijević was the first Serbian woman travel writer.[14] As the first prolific female Serbian author, during her lifetime she published five unusually complex and comprehensive travel books, on Niš and Thessaloniki (*Pisma iz Niša. O haremima/Letters from Niš. On Harems*, 1897; *Pisma iz Soluna/Letters from Thessaloniki*, 1918) and on distant and little known places such as India (*Pisma iz Indije, Letters from India*, 1928), the United States (*Novi svet ili U Americi godinu dana/The New World*, alias: *One Year in America*, 1934), North Africa and the Middle East (*Sedam mora i tri okeana. Putem oko sveta/Seven Seas and Three Oceans. Journey around the World*, 1940). She also published six other works – poetry (*Pesme Jelene Jov. Dimitrijevića/Poems by Jelena Jov. Dimitrijević*, 1894), short stories (*Đul Marikina prikažnja*, 1901; *Fati-Sultan, Safi-Hanum, Mejrem-Hanum*, 1907; *Amerikanka/The American Woman*, 1918; *U Americi se nešto dogodilo/Something Happened in America*, 1921), and a novel (*Nove/The New Women*, 1912). No historian of Serbian literature should ignore an author actively engaged in the international literary scene, who at the end of the 19th and the beginning of the 20th centuries succeeded in having her work published in Serbia, Bosnia

and the United States.[15] Some of her books were translated during her lifetime into English, German, Russian, Polish and Bulgarian. Concurrently, Serbian female authors were struggling to obtain serious local attention. Although at the time Dimitrijević was the first celebrated female author writer in Serbia[16] and the first Serbian female writer to introduce herself in person to the world,[17] she was not officially acknowledged by those in authority.[18] Perhaps this rejection can be explained as resistance to her devotion to improving the role and place of women in Serbian society.

According to the published sources, it is unlikely that Draga Gavrilović and Jelena Dimitrijević knew each other. However, they are firmly bound together by their feminist goals, ideas and work. Also, Dimitrijević never apologized because she wrote or traveled. She communicated easily with women of other cultures, keeping in touch with them following her visits, re-visiting them in their homelands or travelling together with them throughout the world, as she did with her American friend through the Middle East. It seems that Dimitrijević was the perfect ambassadorial representative of Serbian woman to the world. She was an intellectual, polyglot, activist, feminist, writer, world traveler. She made a breakthrough with respect to the Serbian literary market, which was directly related to her privileged upper class status.[19]

That said, while Jelena Dimitrijević possessed class power, she could not fight the patriarchal power which continued to exclude women's intellectual work from the public sphere. Dimitrijević had difficulties in publishing her travel writings which were finished during or shortly after her travels.[20] Only *Pisma iz Soluna* was published right after her journey to Thessaloniki. To see her other work printed, she had to wait up to 14 years, with much of her work still unpublished and therefore unknown.

There has been little focus on the issue of gender identity in the publication of Dimitrijević's writings. The Serbian interpretative authorities could not accept that she overcame the limitations imposed on women by patriarchal politics. Actually, she did much more than anyone expected. Like Draga Gavrilović, she positioned women in the center of her narrative, pointing to possibilities of improving their status in society. Moreover, Dimitrijević assumed the important role of an intellectual who possessed different knowledge about women around the world, which she passed on to Serbian women and the public in general. Since Dimitrijević knew how to transmit her knowledge about Serbia to the "Other", she initiated mutually active communication with the "Other". In that way, her identity as a privileged upper class woman became inseparable from her identity as a female intellectual seeking to establish the authority of her knowledge as informative and intellectually superior to that of her male counterparts. Subsequently, her travel writings were sabotaged, blocked, rejected or subjected to years of delay in publication by patriarchal politics.

Let us compare the feminist narrative politics of these two authors. While Gavrilović confronted the negative patriarchal perception of women, Dimitrijević stood up against chauvinistic devaluation of a different culture. In her first travel book, *Pisma iz Niša. O haremima* (1897), Dimitrijević criticizes the negative stand of Stojan Novaković (1842-1915)[21] – a key political figure of that time – with regard to Turkish culture. Half way through the novel one realizes that the entire work is a specific response to Novaković's travel book *S Morave na Vardar* (1894) in which he shows a one-sided and exclusively negative perception of Turkish women. Previous researchers into Dimitrijević's writings failed to notice this conflict which at its core reflects gender bias. This neglect led to the incorrect statement that "Jelena Dimitrijević in her culture has no male manipulator to whom she will send information; she has no 'addressee'."[22] Not only did a male addressee exist, but he was possibly one of the main reasons why Dimitrijević wrote *Pisma iz Niša*. Another thesis that Dimitrijević detached herself from her national culture may also be rejected.[23] The motive running through the book is the similarity of shared experience of marriages forced on young Serbian and Turkish women.[24] While she meticulously describes the Turkish way of preparing for one's wedding and the wedding ceremony, Dimitrijević underlines the fact that this marriage arrangement is one forced onto a young woman, Hajrija, dwelling on her suffering and pain which results in her death shortly after the wedding. This theme links up all the letters making up this work, unifying their, at first sight, fragmented narration into an actual novel – one with a disturbing plot. The reader then may realize that this is quite an unusual travel account. It is about one place (Niš), where two cultures (Serbian and Turkish) will not be strongly mixed or be as they were once before,[25] indulging in the private medium of letters *(Pisma)*. At the same time, these letters publicly confess the woman's truth about painful, unwanted marriage, and a secret place of Others' women culture *(O haremima)*.

Both Draga Gavrilović and Jelena Dimitrijević inscribed the feminist concept of a woman's self-determination into their female literary characters. While Gavrilović was the first Serbian author to create characters out of female writers, actors, high school students, teachers, intellectuals, mostly unmarried girls or single old women and nuns, Dimitrijević introduced the profile of female writer-intellectual-friend using the travel narrative form. Both authors rejected conventional women's roles in society, and forced onto the public new female identities, strongly defending them by criticizing patriarchal ideology. Their narratives are revolutionary – they call for change which they firmly root in education. They cry out against the lack of public support for emancipated women, representing a new identity of their gender. Most importantly, both authors incorporate into their literary work a powerful and never before voiced political message. Gavrilović reveals misogynist professors as the biggest problem in a newly opened high school for girls, while Dimitrijević unmasks powerful

female intellectuals who sabotaged feminist movements. In that way, both writers stress the connection of the feminist struggle to the problem of societies' false intellectualism. They warn that neither educational institutions nor influential women will – as one would expect – support women's emancipation. That alone is proof of the extent to which Serbian society is patriarchal and blind to the injustice which is being done to one half of the population.

Although Dimitrijević's travel writings have important feminist messages, they are not explicit. In her travel books about Thessaloniki, America and Egypt, all published in the interwar period, she is focused on women. She investigates their position and the problems different feminisms face, but there is little or nothing explicitly on Dimitrijević's feminist public activities in which she might have engaged as a significant member of different women's societies. This distinctive trait of Dimitrijević's travel writings has not received much attention.[26] Simultaneously, this trait reveals important questions. What is the relationship between Dimitrijević's strong will to travel (even at the times when she is sick, single, and old) and her persistence in writing travel books for which there was no major interest in terms of publishing? Is it possible that she had one special or even more specific mission among Serbian feminist leaders, which at first sight made her travel writings appear to be just about travel and not about women's fights for their rights? Did Dimitrijević receive an unusual assignment to travel around the world in order to establish the international feminist network and to help Serbian feminism acquire meaningful insights?[27]

From her youth Jelena Dimitrijević was engaged in women's societies in a convincing way, which confirms her gender awareness and active fight for women's emancipation. At 19 she became the youngest member of *Podružine Ženskog društva* (The Women's Society's Branch) in Niš. When she moved to Belgrade, she immediately joined the work of *Kolo srpskih sestara* (The Circle of Serbian Sisters),[28] where she took part in the initiation and establishment of a periodical, the so-called calendar *Vardar*.[29] The first studies on Dimitrijević gave undue importance to patriotism in her work. However, that was not Dimitrijević's primary focus in her travel writings.

Dimitrijević's patriotism is complementary to her feminism. Her patriotism is in evidence when she celebrates free Serbia (free from Ottoman rule), and especially when Serbia is at war, and she witnesses the misfortune and plight of innocent people (during the First World War she assisted in a shelter for orphans). Dimitrijević's patriotism does not focus on the heroic battle of male warriors, but on women's contribution to the liberation of their country.[30] It is inseparable from her work in women's societies', and their anti-war stands – the "feminist politics of peace", as Sara Ruddick stated much later.[31] Her national loyalty is connected to her ethical activism against wars' aggression and society's injustice. As such, it is a feeling qualified by love, care and nonviolence vis-à-vis the weak and unprotected who do not possess political

rights. In fact, it is an integral part of her feminism and the ethics of care. Dimitrijević stated, "Even during the war I have not considered women and children as enemies. Because women did not want the war and children did not ask for it either."[32] Through such admissions she underlines her pacifist feminism, which was spreading across Europe through the activism of Bertha von Suttner.[33] Dimitrijević asserts that women want to gain political rights so that they can vote against war.

Intriguing is the manner in which Dimitrijević inscribes elements of the feminist discourse into her travel writings. She rarely claims that the purpose of her travel was the exploration of feminist issues; that said she makes the gravity center of her travel writings the meetings with leading female politicians or feminists of the countries she visits. While incorporating the philosophy and ideas of the Serbian *Society for the Enlightenment of Woman and the Defense of Her Rights* (Društvo za prosvećivanje žene i zaštitu njenih prava) into two of her last published travel writings, she never opted to dedicate a whole book solely to such messages as this society was propagating.[34] Her values spoke out through her letters, documenting her travels while addressing her close friends – the Serbian female intellectual Lujza Jakšić or the country's leading feminist Delfa Ivanić. Some of Jelena Dimitrijević's friends, such as Lujza Jakišić and Mrs. Flag, sent her letters to a Serbian periodical or American newspaper, publishing them for a wider, female audience. Abandoning one and private circle of female friends in order to access a wider and more public female audience was possibly one of the main purposes of writing these travel books. For Dimitrijević's female friends it was obviously important to have Dimitrijević's own words read. Moreover, in her letters to her female friends, Dimitrijević never or rarely mentioned either their private life or their collaborative work, which further sheds light on the congruous nature of the private and public discourse in her travel works. Is it possible that Dimitrijević traveled to raise awareness of Serbian women, to enable them to see the world which they, because of their lack of financial means and social status, could not have experienced in person or learned directly from world feminists and leaders of women's institutions about the successes of women's struggle for rights and to thus put in perspective and give hope to the women's struggle in Serbia? This hypothesis corresponds to the serious feminist program in Serbia, which Delfa Ivanić produced in 1912, at the time that the *Serbian National Women Alliance* (Srpski narodni ženski savez) was founded.[35] This coincidence is also the reason for further exploration of the link between Dimitrijević's travels to the USA in 1919/1920 and her examination of American feminism and Ivanić's attendance at The Hague's International Congress of Women in 1922.

If not before, then by the time her second travel writing, *Pisma iz Soluna* (*Letters from Thessaloniki*) was published, Jelena Dimitrijević gained the trust and admiration of her female readership. In the summer of 1908 she decided on a whim to change her travel plans and

instead of going north, travelled south, into the heart of a revolution which had recently begun in the Middle East. She did so upon reading in the Serbian newspaper that Turkish women became emancipated right after the Young Turk Revolution in 1908.[36] As a person who had lived near Turkish men and among Turkish women, Dimitrijević knew that the liberation of Turkish women could not have been gained either quickly or easily. She decided to undertake the job of an investigative reporter, implicitly involving a moral duty to explore the public reporting of news on the emancipation of Turkish women, which she proved to be simplified and false. In her *Pisma iz Soluna* she reveals how the public media enabled injustices toward women. Skerlić decided to immediately publish her *Pisma iz Soluna,* but not because she produced profoundly elaborated political reportage. He was thrilled to publish them because of his own editor's pride and interest in immediacy and not in intellectual support of feminism. Between sensationalism and feminism, Skerlić opted for the usual journalistic fetishism. Had the opposite been the case he would have opened up discussions on public media and gender politics. But he completely forgot *Pisma iz Soluna*, and remained silent regarding Dimitrijević's literary work in his *History of New Serbian Literature.*[37]

In Serbia at that time there was only one woman journalist, Maga Magazinović (1882-1968), and she was not allowed to report on politics. Taking the new role of a feminist and investigative journalist, Dimitrijević's Thessaloniki travel writings as a whole can be described as a feminist critique of public media and their other male manipulator, Branislav Nušić (1864-1938), who was a reputable diplomat at the time and later a famous dramatist.[38] Contrary to the Serbian newspaper and its male journalist, Dimitrijević did not talk to just two Turkish women, but to numerous women of many nationalities and social positions. Rather than advocating a cause and openly proclaiming her fight for women's interests (as did Draga Gavrilović in her story *Radi nje (For Her)*), Jelena Dimitrijević in her *Pisma iz Soluna* only bore witness to the Turkish revolution. Moreover, during her interview with a Gulistan Ismet lady, she pointed to the negative role some female intellectuals played, downright sabotaging the emancipation of Turkish women.[39] The message Dimitrijević sent was one of truly advocating for women's interests. She did not only draw attention to a phenomenon taking place far away from home; possibly her prime aim was to point a finger at important names among Serbia's female intellectuals who were doing similar harm.

While in her Thessaloniki book Jelena Dimitrijević voices her disappointment with the failure of Turkish women to fight for their rights, in her travel book about America she devotes much attention to the success of women who achieved the right to vote.[40] Like Draga Gavrilović, Dimitrijević openly admires American women for their self-awareness. The crucial message of this American book is a specific 'contradiction.' Dimitrijević asks how it can be that American women got the right to vote but their position in American society was

not substantially changed. Instead of claiming to know the answer, she merely offers some observations. She exposes the attitude of American political and educational institutions, of which men were exclusively in charge, hindering women from stepping into the public domain. She shows how, despite those obstacles, American women continued to apply for different jobs, becoming professionals in numerous areas, educating themselves and actively supporting women's public work. The argument she is making is that the greater and more intense the activity of women, the more productive and tangible the results.[41]

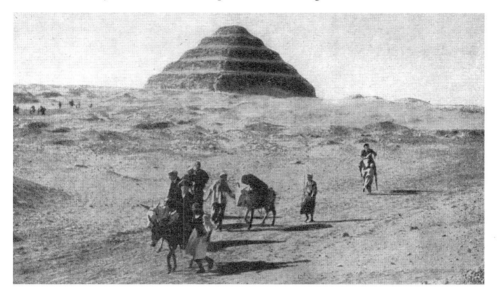

Fig. 5.2 "The Writer through the Egyptian Desert," photograph, ca. 1926.

In her book on North Africa and the Middle East, Dimitrijević emphasizes how history has devalued the importance of women. At the beginning of her travels to Egypt, in *Sedam mora i tri okeana*, the writer does not hide her disappointment when she learns that the ancient tombs

Fig. 5.3 "Her Excellency Hoda Hanem Charaoui, Cairo" photograph with the personal dedication in French to "Madame J. Dimitrijevitch" and autograph, ca. 1926.

do not contain evidence of the burial of Egyptian women rulers (Fig. 5.2). She describes contemporary Egyptian women as their husbands' slaves, who wear chains as a decorative element, underlying their dependence and subjugation. This she attributes to the lack of literacy of female children in Egyptian villages. Furthermore, she provokes her Jerusalem guide by asking him if he believes in Adam's grave, why he refutes the possibility of there being an Eve's grave.[42] Here, the writer points out the complex problem of misogynic disputation of a woman's metaphysical sphere of life. The most important message comes from Jelena Dimitrijević's meeting, in December 1926, with the President and founder of the Egyptian Feminist Movement, Hoda Charaoui (Fig. 5.3), who was also the founder of the feminist magazine *Egyptian woman*. Well informed and prepared for the interview, Dimitrijević asks Charaoui, "Will you claim the right to vote for your women?"[43] She does not fail to observe a sudden change of expression on Charaoui's face "as if this last question embarrassed her."[44] Charaoui responds that she would first ask that the right to vote be extended to Egyptian female intellectuals only. Dimitrijević's account exposes the self-interest of Egypt's "feminists" and the privileged but in fact limited and controlled political rights of female intellectuals, which did not improve the position of all women in Egypt.

Dimitrijević compares the meeting with Charaoui to her visit to the Alhambra, the palace and fortress complex in Spain. The link between the woman and the fortress was not in their beauty but in the lifestyle they shared – that of a fortress. For Dimitrijević the fortress in which Charaoui lives symbolizes an internal refuge and economic protection, safety and security for very few Egyptian upper class female intellectuals, isolated from a great number of other Egyptian women from a lower class. This is the point of divergence between Dimitrijević's feminist identity and the feminist identity of Charaoui. Both of these intellectuals were from an upper class but, unlike Charaoui, Dimitrijević left her "fortress", devoting her life to raising awareness among Serbian women of different classes, through her exploration of and discourse on feminism and its problems around the world. For those reasons, it is difficult to see the coincidence when this text is followed by Dimitrijević's other two-fold memory, of young Serbian female university students and of some conversations in the *Kolo srpskih sestara*. These recollections constitute her point that a country's progress is possible when diverse women from across the country become participants in public policy work. Unlike official Serbian historians, Dimitrijević appreciates the important historical contributions of Serbian women during the war, and recognizes their continued influence during the interwar period.

All of Jelena Dimitrijević's travel writings express her open love and respect for women, which is not something one could say, for example, in the case of Isidora Sekulić.[45] The last part of her *Sedam mora i tri okeana* which Dimitrijević dedicated to her mother ends with her meeting of the 128-year old princess Zenaida, in her palace. The latter was built by the

princess's husband as a demonstration of his "eternal love to a woman". As the writer dedicated her next journey in India to Serbian female university students, this link introduces another relationship. That is a shift from Dimitrijević's biological-genetically mother-daughter bond to her cultural-feminist bond with her young intellectual daughters, to whom she passes on her knowledge. Through this generous connection she succeeded in building the most important role of her social motherhood, by preparing her intellectual daughters for dealing with a gender-biased world.[46]

Other important features of her travel books stand high above the travel works of other contemporary Serbian writers, such as Jovan Dučić (1871-1943), Isidora Sekulić (1877-1958), Miloš Crnjanski (1893-1977) and Rastko Petrović (1898-1949). Jelena Dimitrijević's travel books offer an extraordinarily complex, intricate and sophisticated narrative.[47] Their epistolary form consists of diary, memoirs, confessions, tourist guidebooks with interesting stories from history and culture, religious customs, education and, in some quotations from literature (poetry and fiction), citations from newspaper and magazine articles, popular songs, names of celebrities, films, posters, commercials, descriptions of public university lectures, reports, interviews, polemics, anecdotes etc. For the first time in Serbian travel writings, her travel books on the USA, Africa and the Middle East provide postcards, photographs, including an autographed photograph of Hoda Charaoui. No other Serbian travel books have as many foreign language words as do *Pisma iz Niša* and *Novi svet*. Perhaps this could affect reading and the reader's interest. More likely it brings readers closer to the language as one of the integral parts of the culture of the "Other".[48] The fact that Dimitrijević herself translated all of the foreign language sections actually makes reading easier, and improves and enhances the reader's capabilities or readiness to accept the Other's language as the part of the Other's culture.

In contrast to most travel works of her time, Jelena Dimitrijević's travel writings do not feature subjectively introverted descriptions, nor lyrical impressions, sometimes transformed into fiction.[49] Instead, they offer an impressive factographic database on history and culture. Miloš Crnjanski himself was aware of that problem, stressing how useless his travel writings were for travelers themselves.[50] Isidora Sekulić fills her book about Norway with essayistic thoughts on world literature classics, together with her impressions. Jovan Dučić's writing about Egypt does not demonstrate such intellectual capacity as does Dimitrijević's work, which is informative in a significant manner. Additionally, this factography gives her travel work actuality.[51] She investigated a diversity of different sources, documenting reality in a complex way. She strove to see one country from many different angles. That is why reading her travel books is like watching well executed, informative and adventure films. Sekulić was the first to notice this strategy of representing a "modern cinematographic style", but she identifies it only in Dimitrijević's American book; in fact all her travel books have this trait.[52]

The poetics and politics of the identitarian binome of "I-and-the Other" in Dimitrijević's travel writing are more complex than those in the travel writings of other Serbian writers.[53] This is evident in her descriptions of Dzevdet Pasha, the father of Turkish female writer Alie Hanum, portrayed in *Pisma iz Niša*. In order to give her a better idea of the life of Turkish women, Dzevdet Pasha opens the door of his harem to Dimitrijević – an otherwise secret place, forbidden to foreigners. She accepts the offer, staying as long as possible leaving aside prejudices and stereotypical conclusions, examining the reliability of first impressions, and unmasking biases of "I" who studies the "Other". She lives together, with, near and beside the "Other". Similarly, she spends an entire year living in the United States (1919-1920).

Contrary to all other Serbian travel writers of the time, Dimitrijević often writes about her awareness that the travel description is simultaneously the description of its writer. That may be the reason why she places at the beginning of her American travel book the story of a wealthy Arab, who had let his younger son rule because he wanted to find richness in seeing and therefore perceiving or knowing the world.[54] Dimitrijević has a great sense of integrated coordination of the "I-and-Other" identitarian binome. Her travel books prove the thesis that the communication of "I" with the "Other" can be mutually generous. Her communication overcomes the stereotypical opposition of accepting and pushing away the strange and unknown.[55] This very part is missing in the books of other Serbian travel writers, which remain "invisible and impossible",[56] sometimes uncovering dramatic aversion to the "Other" place,[57] or a manifestation of an "arrogant European-ness".[58]

Dimitrijević's awareness of the privileged female intellectual's identity constitutes her strong gender-awareness. When she must return earlier than planned from the United States to Serbia on the transatlantic ship "Olympic" she is nonetheless very content. While the economic crisis is weighing down on everyone around her, she feels herself to be rich in a different, immaterial way. Is that just because of the richness of her knowledge, experiences and memories, which she defined as "invaluable, unexhausted wealth, to which no one can do any harm"?[59] While her ship is leaving New York harbor, Dimitrijević is thinking at the moment that "someone, however, has come to see me off."[60] That was Liberty, or the Statue of Liberty. Jelena Dimitrijević knew that liberation through knowledge was the generator of her gender knowledge, or her combining of travel and writing. The Statue could also be a link to Dimitrijević's identity as a free woman who fights for different laws in Serbia, ones that will liberate and protect women. Therefore, the Statue is not only a sculpture but a living symbol. Liberty is Jelena Dimitrijević herself. The identity of liberation metamorphoses from its passive to its active nature. Possibly, here she is suggesting her own important political role in connecting American feminist activists with the few Serbian progressive feminists. Is that not the very reason she finds it important to immediately correct one mistake? The name

"Jelma D" (or in Serbian "Dželma D.") is inaccurately written on the passenger list of the transatlantic ship. It was a woman of neither English nor American, but Serbian origin. It is me, "Jelena Dimitrijević" who traveled on that ship, she stresses at the end of her American book. She wanted us to remember that she was aware of the fact that she was the sole Serbian (woman-)writer who traveled there.

Crucially, Dimitrijević knew that she would transform her privilege by passing it on to other Serbian women and at the same time to the cultures of the "Other". She knew that, "While people pass away, things stay. The work of human hands lives longer than work of God's hands."[61] Her observation echoes Gavrilović's belief: "For now, the field of our work is: school, example and pen."[62] These considerations indicate the interconnection of gender, knowledge and action or the same feminist politicization which both writers inscribed by their courage and persistence.

In conclusion, the connection of feminist politics and a privileged intellectual identity of Jelena J. Dimitrijević demonstrate the modernism of her travel writings. Dimitrijević is an important figure within both Serbian feminism and the international feminist movements during the first half of the 20th century. The modernism of her travel writings is not on the edge between traditional and modern concepts. Rather, her modernism is deeply immersed in liberal characters, tendencies and values. Her travel writings are connected to the new social, cultural and political realities, which she accepted and promoted as an important modern need for a profound way of perceiving the world. Her modern narrative strategies reflect these kinds of complex realities, which, in addition to her other perceptive sensibilities for describing the world, culminate in her implementation of film techniques and photography as new visual components. Her understanding of travel writing is also modern because she was aware that writing about "Other" at the same time reflects the narrative about "Self." Her perception of the identitarian "I-and-Other binome" overcomes narrow concepts one may find in the travel writings of contemporary Serbian authors of her time, Isidora Sekulić, Miloš Crnjanski, Rastko Petrović and Jovan Dučić. This first full examination of the multi-level significance of the travel writings of Jelena J. Dimitrijević is a contribution that constitutes a type of "cultural capital" not only for Serbian literature but also for the literatures of countries she visited and about which she wrote. This assessment stands in opposition to the evaluations of her travel writings by the Serbian literary establishment that offers a mixture of superficially presented facts and weak and tendentious arguments. This chapter argues for different norms of the cultural memory, which do not insist on the primitive concept of an identity, but rather value its differences.

Notes

* I would like to thank Prof. Lilien F. Robinson, George Washington University and Prof. Jelena Bogdanović, Iowa State University for inviting me to participate in the project and for their helpful suggestions. All translations from Serbian are mine if not otherwise noted. Any errors remain my responsibility.

1 Serbian literature academic textbooks either trivialize the work of Jelena Dimitrijević (Jovan Skerlić, *Istorija nove srpske književnosti*, Beograd: Rad, 1953 [1914]; Jovan Deretić *Istorija srpske književnosti*, Beograd: Prosveta, 2004), or do not mention her at all (Dušan Ivanić and Dragana Vukićević, *Ka poetici realizma*, Beograd: Zavod za udžbenike, 2007). See Svetlana Tomić, "Draga Gavrilović (1854-1917), the First Serbian Female Novelist: Old and New Interpretations," in *Forgotten Serbian Thinkers – Current Relevance* (special issue of *Serbian Studies* 22 (2008) [publication date 2011]), 167-189; *Valorizacija razlika. Zbornik radova sa naučnog skupa o Dragi Gavrilović (1854-1917)* ed. Svetlana Tomić (Beograd: Altera-Multincionalni fond kulture, 2013); Svetlana Tomić, "Muške akademske norme i putopisna književnost Jelene J. Dimitrijević," in *Kultura, rod, građanski status*, eds. Gordana Duhaček and Katarina Lončarević (Beograd: Fakultet političkih nauka, Centar za studije roda i politike, 2012), 156-175. This last publication is part of a project "Rodna ravnopravnost i kultura građanskog statusa: istorijska i teorijska utemeljenja u Srbiji" (47021) supported by the Serbian Ministry for Education, Science and Technological Development.

2 In his review of "Sabrana dela Drage Gavrilović," *Letopis Matice srpske* 447 (Novi Sad, 1991), 157-159, Dušan Ivanić stated that the literary work of Gavrilović may have value only as a part of the work of other women writers. Ivanić's separation of female authors from male authors – who alone belong to the Serbian literary canon – plainly shows that the reason for the dismissal of women authors stems less from literary reasoning and more from a patriarchal attribution of negative meaning to the female sex.

3 Celia Hawkesworth, *Voices in the Shadows: Women and Verbal Art in Serbia and Bosnia* (New York, Hungary: CEU Press, 2000).

4 The meaning and the negative effects of the "public institutional knowledge", which was in the past exclusively represented by male scholars, was addressed by feminist philosopher Lorraine Code in *What Can She Know?: Feminist Theory and Construction of Knowledge* (Ithaca and London: Cornell University Press, 1991). In short, "public institutional knowledge" was created by men in powerful positions at important national institutions and thus readily accepted because of the authority of those men. When analyzed, this type knowledge rather reaffirms, as Code emphasizes, its "self-proclaimed objectivity" instead of epistemically credible and valid knowledge. It reflects self-interests of specific creators of this knowledge, not the interests of society at large.

5 Hawkesworth's book has not yet been translated into Serbian nor is available in Serbian or Bosnian bookstores. When it appeared, it was not reviewed by any male scholars, nor included in curricula as an important reference for the study of Serbian or Bosnian literature. Hence, efforts to make Serbian and Bosnian women's culture public have not been successful, since that culture remains exclusively that of a minority – the female scholars.

6 Celia Hawkesworth, "Jelena Dimitrijević," in C. Hawkesworth, *Voices in the Shadows*, 141–151.

7 Historians completely ignored the fact that most of the female writers mentioned had carved out a place for themselves in the public sphere, working as teachers, having been part of the first generations of female students attending public high schools. These women had struggled for public affirmation of their intellectual as well as their creative capacities.

[8] A rare exception is the monograph by Jovana Reba Kulauzov, *Ženski Istok i Zapad* (Beograd: Zadužbina Andrejević, 2010). See also, Svetlana Tomić, "Prvo novije temeljno čitanje putopisa Jelene J. Dimitrijević," *Polja* 476 (Novi Sad, 2012), 234-237. See also chapters by Popović and Novakov in this volume.

[9] Vladimir Milankov, *Draga Gavrilović – život i delo* (Kikinda: Književna zajednica Kikinde, 1989), 66-107; Milivoje R. Jovanović, "Duhovni prostor u stvaralaštvu Jelene Dimitrijević: Prilozi za biografiju," in *Zbornik referata sa naučnog skupa: Jelena Dimitrijević – život i delo, Niš, 28. i 29. oktobar 2004*, ed. Miroljub Stojanović (Niš: Centar za naučna istraživanja SANU i Univerzitet u Nišu, 2006), 89-97.

[10] The first women world travelers usually were from the high or upper middle class: Shirley Foster, *Across New Worlds: Nineteenth-Century Women Travelers and Their Writings* (New York, London: Harvester Wheatsheaf, 1990).

[11] Jovanović, "Duhovni prostor," 90. It is possible that Dimitrijević was childless. In that case, her harmonious marriage and her overtly expressed respect for her husband confirm that Jovan Dimitrijević was a non-patriarchal husband who did not reject his wife because she was childless. In her writings, Dimitrijević reveals a great sensitivity towards the children she meets, especially those who were forced to work.

[12] On the Serbian Civil Code see Marija Draškić and Olga Popović-Obradović, "Pravni položaj žene prema Srpskom građanskom zakoniku (1844-1946)," in *Srbija u modernizacijskim procesima 19. i 20. veka*, volume 2, *Položaj žene kao merilo modernizacije*, ed. Latinka Perović (Beograd: Institut za noviju istoriju Srbije, 1998), 11-26; Vesna Nikolić-Ristanović, "Krivičnopravna zaštita žena u Srbiji 19. i 20. veka," in *Srbija u modernizacijskim procesima*, 26-36.

[13] The statement is made in the context of currently available knowledge of Serbian female writers throughout history. It is possible that future research on the topic will uncover other individuals whose work significantly contributed to and shaped the literary tradition of Serbian female authors.

[14] It seems that *Pisma iz Niša. O haremima* (1897) is the first travel account written by a Serbian female author. Subsequently, in *Bosanska vila*, a periodical printed in Sarajevo, Milka Grgurova and Savka Subotić published articles about their travels, "Moj put u Mostar" (1903) and "Među Lužičkim Srbima" (1906).

[15] Dimitrijević's letters from Serbia and about Serbia during the Balkan war were published in 1912 in American newspapers. This was the idea of her American friend, Mrs. Flag, who saw in Dimitrijević's letters the opportunity to introduce the American people to the unknown people of Serbia. See Jelena Dimitrijević, *Novi svet*, 356. In the same book, Dimitrijević left a note that her short story "Kilogram brašna" had been read in public, but there is no information on whether that story had also been translated and published in the United States.

[16] I disagree with Slavica Garonja Radovanac, *Žena u srpskoj književnosti* (Novi Sad: Dnevnik, 2010), 53-65, that Dimitrijević was "the first acknowledged Serbian female writer." Dimitrijević had a significant circle of female readers in Serbia, but her books did not receive the serious attention of the most significant academic authorities. Tomić, "Muške akademske norme," in *Kultura, rod, građanski status*, 156-175.

[17] There was hardly a female writer in Serbia then or since who could surpass that expansiveness and intensity of international communication. In Thessaloniki, she interviewed a key female political figure, in New York she attended the lectures of recognized American female scholars and feminists, in Boston she met female writers from the Women Writers Club, in Philadelphia she gave a lecture at Pennsylvania University, in Egypt she talked with a feminist leader, in Jerusalem she talked to Patriarch Damianos, in Beirut she gave important source material to an American female journalist of *The New York Times*, and in India she was the guest of Rabindranath Tagore. It is possible that the American female journalist

was Beatrice Hill Ogilvie, who published a long article "New women of Egypt struggle to end age-old wrong" in the *New York Times,* June 17, 1928. Ogilvie did not mention Dimitrijević's role in obtaining important materials on Egyptian feminism, even though Dimitrijević mentioned her help in preparing "the three pieces" of the article Ogilvie planned to publish in the New York Times. Their meeting took place in Beirut in 1927. More in: *Sedam mora i tri okeana, 390-401.*

[18] Contemporary scholars have instead emphatically identified Isidora Sekulić (1877-1958) as "the first great woman in the Serbian literature" ("prva velika žena u srpskoj književnosti"), as stated by Jovan Deretić in his *Istorija srpske književnosti* [History of the Serbian Literature], 1010. In 1891, Ilija Ognjanović, the editor of the periodical *Javor* (Novi Sad) in its number 51 issue printed the names of 140 Serbian women writers: Ivanka Veselinov, *Javor – sadržaj po autorima,* (Novi Sad: Matica srpska, 1987), 816. At present, there is written documentation on a few of the women writers – for example, Draga Gavrilović, Jelena Dimtirijević and Milka Grgurova – and their narratives are read mostly by women readers.

[19] A Serbian working woman could rarely afford to refuse offered salary as did Dimitrijević when she realized that the salary would not provide for a comfortable life. During her stay in New York, she did not accept an appointment as a professor of Serbo-Croatian at Columbia University because she considered the salary substantially insufficient. This episode is described in her American travel writing *Novi svet ili U Americi godinu dana.* Conversely, Gavrilović could never have made ends meet because of her low salary, legally prescribed as less than the salary of male teachers. Dimitrijević received generous financial support from her relatives, most likely from her cousins. Ljubinka Trgovčević, "Žene kao deo elite u Srbiji u 19. veku. Otvaranje pitanja," in *Srbija u modernizacijskim procesima*, 259, presents the difficult economic position of Serbian female intellectuals.

[20] Dimitrijević lived in Niš from 1881 until 1898 but she managed to publish her *Pisma iz Niša* in 1897, a year before she moved to Belgrade. From Thessaloniki she wrote her first letter on 2, August 1908, and she published that travel accounts as a book in Sarajevo, in 1918, or ten years after its first appearance in the Serbian periodical, *Srpski književni glasnik.* Dimitrijević spent the year of 1919/1920 in the USA but her book on these travels was not published until 1934. She traveled to Egypt in 1926 but that book account appeared significantly later, in 1940. Dimitrijević traveled to India at the beginning of 1927, or just after her stay in Africa. She published only one small part regarding her trip to India in 1928.

[21] According to Jovan Deretić, *Istorija*, 768, Stojan Novaković was "a politician, historian, and philologist, one of the distinguished personalities in 19th century Serbia." Novaković was also professor of Serbian literature at the Belgrade High School, later the University of Belgrade. He was the author of the first *History of Serbian literature (Istorija srpske književnosti)* (1867), and the first *Serbian Bibliography (Srpska bibliografija)* (1869). Novaković was the president of the State Council (Državni savet), the Minister of education in Serbia, a diplomat in Constantinople, Paris and Saint Petersburg. He was also the president of the Serbian Royal Academy and librarian of the Serbian National Library.

[22] Svetlana Slapšak produced two studies on *Pisma iz Niša. O haremima*, contributing to a better understanding of and the presentation of the Balkans as a place which produces distinctively Oriental images. Svetlana Slapšak, "Haremi, nomadi: Jelena Dimitrijević" in *Žene, slike, izmišljaji*, ed. Branka Arsić (Beograd: Centar za ženske studije, 2000), 49–75; Svetlana Slapšak, "Harem kao prostor roda u balkanskim kulturama" in *Kultura, drugi, žene*, eds. Jasna Kodrnja, Svenka Savić and Svetlana Slapšak (Zagreb: Institut za društvena istraživanja u Zagrebu, Hrvatsko filozofsko društvo, Plejada: 2010), 39-57. My translation is taken from Slapšak, *Harem*, 54.

[23] Slapšak, *Harem*, 50.

[24] Slobodanka Peković, "Jelenina pisma," in *Jelena Dimitrijević, Pisma iz Niša. O haremima*, xi notes only that the bride is unhappy and that her sufferings gradually grow; Garonja Radovanac, *Jelena Dimitrijević*, 55, finds a paradox in Dimitrijević's decision to write about Turkish women and the culture of the defeated Ottoman Rule; Slapšak, *Harem*, 51, ignores the motif of a death and just married young woman in Jelena's *Pisma iz Niša*, but underlines it in the work of Elisavet Moutzan-Martinengou, *My Story* [Moja priča]. Only Kulauzov Reba, *Ženski Istok i Zapad*, 27 stresses the pain and suffering of a bride.

[25] From the time Niš became part of Serbian territory in 1878 the Turkish population began to move back to its homeland. Dimitrijević indicates that a few Turkish families that had remained also decided to move back.

[26] Some scholars have viewed Jelena Dimitrijević's writings about women and the fact that she joined Serbianwomen's societies as a paradox. Even though Slobodanka Peković deserves credit for editing, publishing and writing about Dimitrijević's *Pisma iz Niša* and her later works, she incorrectly presents *Dimitrijević* as a woman who is a feminist only "a little" (Slobodanka Peković, "Jelenina pisma," in *Jelena Dimitrijević, Pisma iz Niša. O haremima* (Gornji Milanovac-Beograd: Dečije novine-Narodna biblioteka Srbije: 1986), vi). Dimitrijević interviewed Đulistan-Ismet-hanum (Gulistan Ismet lady) – the female member of the Ottoman Committee of Union and Progress and asked "Do you find yourself to be a feminist?" Gulistan, and not Dimitrijević, answered: "We have many feminists here ... Yes, I am a little, but not as American women are." (Full quotation follows: "A jeste li vi feministkinja?" "U nas ima njih dosta... I ja sam pomalo, ali ne kao Amerikanke." Dimitrijević, Pisma iz Niša. O haremima, 44). Twenty years later, Peković still demonstrated the same inability to recognize the link between Dimitrijević's feminist discourse and its modernity (Slobodanka Peković, "Romani i putopisi u stvaralačkom postupku Jelene Dimitrijević" in *Jelena Dimitrijević – Život i delo*, 55–64). See also: Garonja Radovanac, "Jelena Dimitrijević", 55.

[27] Neda Božinović, *Žensko pitanje u Srbiji u XIX i XX veku* (Beograd: Devedesetčetvrta: Žene u crnom, 1996), 73, emphasizes that in 1906, in Belgrade, a small but new and important generation of women appeared inside the Serbian *Women's Society,* who connected with the leaders of the *International Council of Women* in Washington D.C.

[28] *Kolo srpskih sestara* was a women's patriotic-humanitarian and cultural-educational society, founded in Belgrade, in 1903. *Kolo* gathered together the most reputable feminists and artists of that time (Savka Subotić, Nadežda Petrović, Isidora Sekulić) who struggled to improve the position of women in Serbian society. Like all Serbian women's societies, *Kolo* did not receive support from the Serbian government. Dimitrijević's close friend, Delfa Ivanić (1881-1972), was among the initiators of *Kolo* and later president of *Srpskog narodnog ženskog saveza*, the first Serbian feminist alliance of several women's societies. Božinović, *Žensko pitanje*, 66-71; Jovan Simjanović, "Jedan osvrt na istorijski značaj osnivanja kola srpskih sestara," *Baština* 29 (2010) 81-91; Miroslava Jovanović, "The Heroic Circle of Serbian Sisters: A History," *Serbian Studies* 24/1-2 (2010) [publication date 2012]: 125-135. One of the main obstacles to in-depth research on feminist activism inside the *Kolo srpskih sestara* is that its leaders frequently destroyed the archives in order to protect the lives of its principal members.

[29] Serbian patriarchal laws at that time prevented women from working as the editors of newspapers or periodicals. The first issue of *Vardar*, as *Kolo*'s official periodical, was printed in 1906. It always had a high circulation, from ten to thirty thousand copies. In addition to the calendar of religious events, the introductory pages of *Vardar* regularly contained statements on the purpose and aims of *Kolo*.

[30] *Kolo srpskih sestara* helped the defenseless people in areas of Stara Srbija (Old Serbia), evacuated female students from areas at war, organized courses for nurses and established schools for the disabled, helping them to find jobs and keep their dignity.

31 Sara Ruddick, *Maternal Thinking: Toward a Politics of Peace* (Boston: Beacon Press, 1989).

32 Dimitrijević, *Novi svet ili U Americi godinu dana*, 30.

33 Bertha von Suttner (1843-1914) was an extraordinary feminist, the author of the first antiwar novel *Die Waffen nieder* [Lay Down Your Arms] (1889), which was translated into Serbian in 1900 by a prominent Serbian feminist, Katarina Milovuk (1844-1913). Bertha von Suttner was an outstanding member of the *International Arbitration and Peace Association*. In 1905 she received the Nobel Peace Prize.

34 The Serbian *Society for the Enlightenment of Woman and the Defense of Her Rights* was founded in April 1919, in Belgrade, a few months before Dimitrijević's first journey to the States. Many of these ideas are expressed in the Society's journal, *Ženski Pokret*, which began publication in April 1920, in Belgrade, a few months after Dimitrijević's return from her first journey to the USA, in 1920. Thomas A. Emmert, "Ženski pokret: the Feminist Movement in Serbia in the 1920s," in *Gender Politics in the Western Balkans*, ed. Sabrina P. Ramet (Pennsylvania: The Pennsylvania State University Press, 1999), 33-51.

35 "Serbian women should be educated so that they become aware of themselves, to become individuals-personas, so that they can be capable of rejecting apathy and languishing, to raise the responsibility for themselves and society. They must be organized in order, with the exception of humanitarian work, to work on feminism and actively explore women's problems, especially those of employed women, including female factory workers, so that they can work more on expanding their rights, their consciousness and cultural enrichments." Translated from Neda Božinović, *Žensko pitanje*, 74.

36 The Revolution started in July 1908 in Thessaloniki. Influenced by European ideas of nationalism and liberalism, the male elite leaders opposed the autocratic Sultan, Abdul Hamid II, opting for multi-ethnic Ottoman Empire, economic and tax reform. They also initiated debates on women's emancipation.

37 Skerlić, *Istorija*, 454.3

38 For a comparison of Dimitrijević's and Nušić's accounts of the Turkish revolution and the feminist struggle see: S. Tomić, "Dve vrste pisama iz Soluna," *Zbornik Matice srpske za književnost i jezik* 59/3 (Novi Sad, 2011), 621-639. Dimitrijević's Thessaloniki travel writing has not been translated into Turkish, only into Greek in 2008.

39 Melike Karabacak, "Osmanlı'da Politik Ve Edebi Bir Kadın: Gülistan" [A Political and Literary Woman in the Ottoman Empire: Gülistan İsmet"], in *Perspectives on Ottoman Studies: Papers from the 18th Symposium of the International Committee of Pre-Ottoman and Ottoman Studies (CIEPO)* (Berlin: Lit Verlag, 2011), 955-971. I thank Karabacak for sending me her paper.

40 Dimitrijević did not clearly state the purpose of her overseas travel. She admitted to two reasons, to escape from the World War I atrocities and to meet American women. It could be that she was a witness to a big and very new change, the triumphal attainment of suffrage by American women.

41 Shortly after Dimitrijević's arrival from the States, at the beginning of the 1920s, a substantial number of women's societies emerged in Belgrade and other Serbian towns, dedicated to female intellectuals and the improvement of the position of Serbian women in general: *Udruženje nastavnica srednjih i stručnih škola, Udruženje ženskih lekara, Udruženje ženskih studentkinja, Udruženje prijatelja umetnosti Cvijeta Zuzorić, Matica naprednih žena, Udruženje za obrazovanje domaćica i matera, Kolo devojaka, Savez pčelica u Kraljevini SHS*. Božinović, *Žensko pitanje*, 66-71 and Jovanka Kecman, *Žene Jugoslavije u radničkom pokretu i ženskim organizacijama 1918-1941* (Beograd: Narodna knjiga: Institut za savremenu istoriju, 1978), 165-167.

42 Dimitrijević, *Sedam mora*, 264.

43 Ibid., 212.

44 Ibid.

[45] In a letter of December 9, 1938 Isidora Sekulić confessed to Svetislav Petrović: "...I don't like it that I am a woman, and... I would like it best of all if I were a fish in the Mediterranean Sea" (translated by Sibelan Forrester, "Isidora Sekulić as an Early Feminist," *Serbian Studies* 5/1 (Spring 1989), 88).

[46] Dimitrijević was admired by her female students, who, as stated in *Sedam mora*, used to visit her in her Belgrade apartment "every Thursday". It is possible that Dimitrijević delivered a series of private lectures on her travels.

[47] Magdalena Koch, *...Kiedy dojrzejemy jako kultura... Tworczosc pisarek serbskich na poczatku XX wieku (kanon-genre-gender)* (Wroclaw: Wydawnictwo Universytetu Wrocławskiego, 2007), 125-130, 135-158, 194-217.

[48] Garonja Radovanac, Jelena Dimitrijević, 55 and Slapšak, *Harem*, 45, stated that Dimitrijević's Turkish language is an obstacle for contemporary readers.

[49] See, for example, Rastko Petrović, *Sicilija i drugi putopisi: iz neobjavljenih rukopisa,* ed. Radmila Šuljagić (Beograd: Nolit, 1988).

[50] Miloš Crnjanski, *Ispunio sam svoju sudbinu*, ed. Zoran Avramović (Beograd: BIGZ: SKZ: Narodna knjiga, 1992), 268.

[51] The actuality of Dimitrijević's writing about the most historical places in Egypt was firstly acknowledged by Gordana Vlahović "Aktuelnost putopisa Jelene Dimitrijević o zemlji faraona," *Bdenje* 8-9 (2005), 110-114. Dimitrijević's American travel book offers convincing and accurate descriptions of historical sites and attractions of the East Coast.

[52] Isidora Sekulić, "Jelena Dimitrijević: Novi svet ili U Americi godinu dana," *Srpski književni glasnik* 8 (1934), 604-605.

[53] Paul Gifford, "Defining Others: how inter-perceptions shape identities" in *Europe and Its Others: Essays on Interperception and Idenitiy*, eds. Paul Gifford and Tessa Hauswedell (Oxford, Bern, Berlin, Bruxelles, Frankfurt am Main: Peter Lang, 2010), 13-39.

[54] Dimitrijević, *Novi svet*, ix.

[55] Patricia Howe, "Appropriation and alienation: women travelers and the construction of identity," in *Europe and Its Others*, 77-95.

[56] Miloš Crnjanski, "Piza," in Miloš Crnjanski, *Ljubav u Toskani i drugi nežni zapisi*, ed. Aleksandar Jerkov (Beograd: Jugoslovenska knjiga, 1997), 50.

[57] In her travel work about Norway, Isidora Sekulić, *Pisma iz Norveške i drugi putopisi* (Novi Sad: Stylos, 2001), repeats several times the word 'monstrous' when describing fjords.

[58] Jovan Dučić, "Pismo iz Egipta" in *Najlepši putopisi Jovana Dučića*, ed. Radoslav Bratić (Beograd: Prosveta, 2003), 238.

[59] Dimitrijević, *Novi svet*, 394.

[60] Ibid., 392.

[61] Ibid., 290.

[62] Draga Gavrilović, *Devojački roman*, in Draga Gavrilović, *Izabrana proza*, ed. Jasmina Ahmetagić (Beograd: Multinacionalni fond kulture Kongras, 2007), 165.

CHAPTER 6

COVER GIRL: ENVISIONING THE VEIL IN THE WORK OF MILENA PAVLOVIĆ-BARILLI*

Ljubomir Milanović

The works Milena Pavlović-Barilli (1909-1945) produced between the two World Wars introduced a new, distinctly modern voice into Serbian art. Initially inspired by avant-garde literature and painting, Pavlović-Barilli created her own world through a deeply felt collaboration with the art historical past.[1] Drawing upon a pictorial vocabulary common to many avant-garde painters in this period, she appropriated historical iconographical traditions for her own ends.[2] Rather than a conservative recall to order, her references to classical and renaissance art were combined with her awareness of the art and popular culture of her time and were a means by which the artist gave material form to her personal experience.[3] This paper argues that Pavlović-Barilli's engagement with the works of other artists – living and dead – was not merely one of influence or quotation, but a complex process of appropriation and transformation in a bid for self-actualization. This is particularly evident in her work in the 1930s and 1940s. Here, Pavlović-Barilli presents her fantastic vision and individual poetical mythology within an allusive idiom that drew from the great paradigms of the grand European tradition while engaging contemporary modes of representing feminine beauty. In notable contrast to many of her male peers, this citational aspect of her work seems self-consciously playful, but does not slip into pastiche. I will explain Pavlović-Barilli's position between tradition and modernity by focusing on a single element taken from the Western iconographical tradition that was still a common trope of femininity in popular culture at the time: the veil. The veil had enduring resonance for the artist, becoming a recurrent motif in her paintings and commercial illustrations throughout her career. The Serbian artist's use of veils in her paintings and illustrations speaks to the dual nature of her oeuvre as being simultaneously oriented towards tradition and modernity.

When attempting to decipher the rationale of the veil in Milena Pavlović-Barilli's oeuvre it is important to acknowledge that this garment had long functioned as highly ambivalent signifier in Western art. Veils have appeared in art since antiquity. Ancient sources stress that the veil is a feminine garment in that it facilitates the self-effacement proper to the female sex. It was, however, not exclusively reserved for women. Notably, adult Greek men veiled

themselves at times of crisis such as death in order to hide the disfiguring effects of strong emotions or to conceal shame or loss of honor.[4] Thus, dating from antiquity, the veil was a deeply ambivalent object, functioning both to preserve the virginal purity of the female form and conceal the violation of masculine integrity. Although in post-antique art it is largely presented as a feminine accessory the veil also has a latent sexual indeterminacy. As discussed by Leo Steinberg, examples can be found where Renaissance artists drape Christ's genitals with transparent loin cloths that suggest modest concealment while in fact revealing all of his humanity.[5] Renaissance artists drew upon ancient literary and artistic examples, using veils in the depiction of both women and men.[6] In the nineteenth century, romantic artists, particularly Orientalists, used the veil to connote psychological and geographical inaccessibility, often associating it with brooding interiority or exotic, proscribed sensuality.[7]

The veil could connote revelation and concealment at the same time. Whether it was in place, lifted or depicted somewhere in between these two states, the veil served primarily as a sign of a refusal of the viewer's gaze. Generally, the veil may be understood to be a metaphor for a concealed truth or beauty itself, both of which are equated with the woman's body, which can be brought to light through the lifting of the veil. To see truth unveiled is therefore to 'know' in the double sense of full, unmediated visual access and, by implication, erotic possession of the female body. Pavlović-Barilli both draws upon and subverts this iconographic tradition of the veil, deploying it as an instrument of female sensuality that both titillates and frustrates the viewer, and thereby exposes the mechanisms by which paradigms of feminine beauty are constructed.

The story of Salome and her dance of the seven veils offers a biblical example of the power of the veil to transport the spectator into a state of frenzied distraction in his desire to unveil.[8] Pavlović-Barilli's sultry *Dancer With the Veil and the Glove* from 1939 gazes out at the viewer from beneath a translucent veil while seated in the right corner of the painting (Fig. 6.1).[9] Her veil generates the contradictory desire to bring her closer and the wish to appreciate her

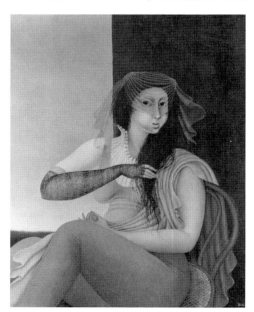

Fig. 6.1 Milena Pavlović-Barilli, *Dancer with the Veil and the Glove (Pink Pants II)*, oil on canvas, 1939.

at a distance. Its inclusion in the title draws our attention to the glove whose fingers have been removed, exposing her fingers. Elbow-length gloves have long been fetishized as erotic accessories that may be peeled off the skin. With her exposed fingers she strokes her black tresses that cascade over her shoulder and reach to below her breasts. Pavlović-Barilli's dancer is fully aware of the viewer's presence and invites observation as she toys with her hair. Coupled with the title, this erotic performance suggests Salome's celebrated strip-tease.

The association of feminine power and the ability of the veil to both hide and disclose may be found in the work of film directors of the period such as Josef von Sternberg.[10] His *The Scarlet Empress* from 1934 presents Marlene Dietrich as the Empress Catherine the Great, who appears in a scene where a powerfully situated priest offers the queen political assistance.[11] Catherine claims, "I have weapons that are far more powerful than any political machine," and this statement is followed by the gesture of raising a veil to her face covering everything except her eyes. In a later scene Catherine asks her ally and lover Alexei if he loves her as a woman or as an empress. While she waits for his answer she covers her face with her veil and begins to play with it, creating folds that both reveal and hide her features. After Alexei confesses that he loves her she withdraws behind her veil and asks him for a favor. Catherine's power to act as a monarch is exercised through her manipulation of both her men and her veil. Mary Ann Doane has investigated the role of the veiled woman in films of the 1930s writing of it as:

> A site where the classical film acknowledge the precariousness of vision and simultaneously seeks to isolate and hence contain it is the close-up of the woman, more particularly, the veiled woman. For the veil functions to visualize (and hence stabilize) the instability, the precariousness of sexuality.[12]

In covering the specter of female sexuality, the veil functions as a fetish that renders femininity palatable to the male viewer. Doane further writes that in the discourse of metaphysics the function of the veil is to make truth profound, ensuring that there is a depth behind the surface of things.[13]

Fig. 6.2 Milena Pavlović-Barilli, *Pomona (Landscape with a lamp)*, oil on canvas, 1939.

Fig. 6.3 Lucas Cranach the Elder, *Venus*, oil and tempera on red beechwood, 1532.

Fig. 6.4 Milena Pavlović-Barilli, *Venus with the Lamp*, oil on canvas, 1938.

A veil is employed as a more straightforward means of seduction in *Pomona*, a canvas from 1939.[14] The painting depicts a surprised girl standing in the middle of the composition, completely naked holding a mirror in one hand (Fig. 6.2). With her other hand she holds a translucent veil that covers her hair and upper arms. She is positioned between two other female figures: a younger woman kneels by her feet, covering her knees with a semi-transparent fabric and a second, older woman stands behind her and appears to be helping with her coiffeur. With her oval face, long throat, abundant hair and nude body, Pomona embodies a Renaissance ideal of feminine beauty. Where in ancient Roman mythology Pomona was the goddess of fruitful abundance, here she is disguised as Venus.[15] Her mirror raises the question of whether she represents a real woman, the goddess Venus, or possibly should be understood as an allegory of vanity and luxury.[16] Pavlović-Barilli's *Pomona* is clearly indebted to Germanic and Italian Renaissance sources, apparently relocating one of Lucas Cranach's well-known Venuses (Fig. 6.3), whose transparent veils leave nothing to the viewer's imagination, to a distinctly Italianate setting. With this combination, the Serbian artist synthesizes Northern and Southern Renaissance traditions.[17]

The oil lamp that sits at Pomona's feet reappears in a series of works from this period. This symbol may be an allusion to the story of the wise virgins who saved their oil and kept their lamps burning.[18] Their sensuous shapes

with their bulbous bases and elongated, limb-like chimneys echo those of the bodies of the women they accompany. These lamps could also be understood to symbolize the passing of time and the ephemeral nature of physical beauty, a notion that is emphasized in *Pomona* by the goddess being placed between two female figures of visibly different ages. The lamps are oil lamps, which belong neither to antiquity or the Renaissance, nor to the painter's own time, appear strangely anachronistic. This doubled outmodedness, however, manifests a historical fluidity the artist seems to claim here as a virtue rather than a vice.

Fig. 6.5 Milena Pavlović-Barilli, *Girl with a lamp*, oil on canvas, 1935.

The association of the goddess of beauty and a lamp is also found in *Venus with the Lamp* from 1938, where Pavlović-Barilli sets a melancholic nude within an evening landscape (Fig. 6.4). A head resembling that of the artist has been awkwardly stuck atop a Venetian Renaissance Venus lying on an expanse of folded fabric with a translucent veil wrapped round her neck. Unlike its prototype, Giorgione's *Sleeping Venus* (ca. 1510), Pavlović-Barilli's subject is fully conscious of the presence of the viewer, frankly meeting his or her gaze. In her open-eyed invitation to the viewer, however, Pavlović-Barilli refers more to a work of Giorgione's student, Titian's *Venus of Urbino* (1538).[19] Both Venetian masters showed the goddess modestly covering her genitals with her left hand. In Titian's version, however, she is not only awake but also wears jewelry, details that humanize and historicize the figure. Pavlović-Barilli's goddess is likewise partially clothed; however, rather than accessorizing her with a bracelet and earrings, the painter gives her a veil. This substitution complicates the implicit power relations between the subject and her audience; by its inclusion, the artist implies that the deity retains the power to refuse the viewer full access to her body.

Milena Pavlović-Barilli's use of Renaissance sources recalls the nineteenth century French modernist, Édouard Manet's quotation of Titian's Venus in his *Olympia* (1863-65).[21] Walter Benjamin commented on the use of the past in modern art in the work of Manet's close friend Baudelaire, writing, "the modern, with Baudelaire, appears not only as the signature of an epoch but as an energy by which this epoch immediately transforms and appropriates

antiquity." Manet's Olympia was a prostitute viewed through an art historical lens; he used a Giorgione-derived Venus as a shameless advertisement for the Parisian sex industry.[22] The French artist here conflates high and low visual culture and associates his noble profession with that of a courtesan. Just as Olympia's frank regard addresses her viewer as a potential customer, this same individual is also the viewer of the painting *Olympia* and therefore, in a manner of speaking, Manet's customer.[23] This self-reflexive gesture inaugurated a highly allusive modern classicism constructed from art of the past.

The lamp found in *Pomona* and *Venus with the Lamp*, appeared earlier in *Girl with the Lamp* (1935) (Fig. 6.5).[24] The painting represents a self-portrait in which the painter gazes out at the viewer while sitting in a formal chair wearing a strapless dress whose plunging bodice and bare shoulders emphasize her shapely figure. Notably, Milena Pavlović-Barilli has also shown herself wearing a translucent scarf or veil over her hair.[25] Behind her sits the upper half of another female figure that resembles her but has been transformed into a portrait bust. This hybrid creature confuses the animate and inanimate, being both art object and woman. The lamp on the table at her elbow vomits dark smoke from its phallic chimney, putting her face in shadow. This inky emission mingles with the dark hair of her uncanny replica, such that it takes on the function of paint itself. It also emits strands of lighter colored smoke that curl around the throat and cheek of the bust figure, slightly obscuring her features in a vaporous veil. The lamp is therefore both a source of illumination and the stuff from which dark paintings are fashioned. This unsettling double self-portrait suggests that the artist considered herself to have a dual nature, offering us a public self that presents itself decked out in feminizing finery and a second, darker alter ego associated with artistic practice.

These two poles are fused in a photographic portrait of Pavlović taken by Carl van Vechten in 1940 that shows her face partially hidden behind a curtain or veil of lace (Fig. 6.6).[26] Upon close viewing, one realizes that the veil does not in fact touch her face or head but appears to have been superimposed on top of the print itself. One is not certain if this effect was created by placing a piece of fabric over the negative in the development process or if the photograph was shot with a veil of lace over the lens. Regardless of the technical means by which it was produced, the effect is of a veil that forms a screen through which the viewer struggles to discern the subject's face. This pictorial device produces a disturbing ambivalence as to who is behind veil/screen: the viewer or the subject. This suggests that what is being veiled and, therefore, potentially unveiled is the process of image making itself. The lace screen also subverts the conventionally understood goal of formal portrait photography: the recording of an individual's true appearance; here resemblance is rejected and the viewer's search for recognizable facial features frustrated. Rather than serving the end of self-promotion, this photograph is both literally and metaphorically semi-transparent. By presenting the self as

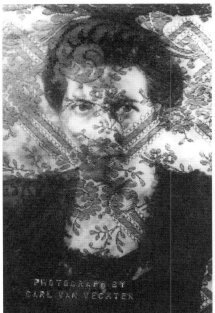
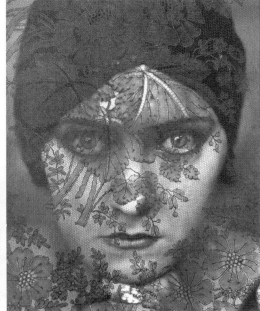

Fig. 6.6 Carl van Vechten, photograph of Milena Pavlović-Barilli, New York, 1940.

Fig. 6.7 Edward Steichen, Gloria Swanson, toned silver gelatin print, New York, 1924.

mediated by the processes of imaging, it both reveals the artifice of portraiture and insists on being viewed as an aesthetic object in itself.

Given Pavlović-Barilli's personal fascination with the veil – one that she appears to have shared with the photographer – it seems likely that the decision to use the motif of the lace filter in the van Vachten photograph was mutual.[27] In addition to their common proclivity for veils, the pair's choice seems to have been inspired by Edward Steichen's portrait of one of the silent era's biggest film stars, Gloria Swanson, in which the subject is similarly posed behind a screen of lace (Fig. 6.7).[28] Despite the shared conceit of the lace overlay, the two photographs are different in crucial ways. In Steichen's photograph, Swanson's glamour is heightened rather than disrupted by the fabric screen; it blurs her features and reinforces Steichen's choices of gentle lighting and soft focus. She remains recognizable with her sensual appeal intact. The image therefore reinforces the mystique the Hollywood culture industry had spun round Swanson. She was an international film icon, a veritable celluloid goddess, whose face, powdered into a frozen mask, was a widely circulated commodity worth millions. The tattooing lines of the lace amplify Swanson's aura of unapproachable beauty. Her eyes,

the most important tool of a silent movie actress, are plainly visible and her alluring gaze is intact.[29] Indeed, the effect of lace here is like that of a patterned silk stocking over smooth flesh, tantalizingly revealing and hiding the female form.

Conversely, in the Van Vechten photograph, the veil is heavier and more densely woven. It forms an ornamental beard that obscures Pavlović-Barilli's lower face, giving the impression of disfigurement and containment. The pattern of the fabric has been positioned such that the dark flower of lace that occurs when the bands of decoration intersect over Pavlović-Barilli's mouth, metaphorically silencing the visual artist and underscoring her intense gaze. Positioned over her lips, the flower is emblematic of romantic exchanges between lovers, a floral kiss so to speak, but one that also marks a refusal of verbal intercourse. Like a silent film star, Pavlović-Barilli speaks with her eyes. Here the lace screen both signals the desire for public recognition and generates an aura of mystery and privacy, a tension that runs throughout her oeuvre. No straightforward publicity shot, the portrait challenges the conventional motif of veiled beauty that remained untroubled by the Steichen image. Impeding as much as granting the viewer access, Milena Pavlović-Barilli refuses over-easy consumption of her public face.

The fascination with the female visage as a smooth surface of flawless beauty evidenced by Steichen's Swanson portrait was nearly a fetish in early cinema, and would continue to be so through the 1940s. This is perhaps most acutely felt in the phenomenon of the close-up.[30] As the camera moved in to focus exclusively on the face of an actress, the audience empathized with her character. Enlarged to fill the vast surface of the projection screen, the star's face became the primary site where the viewer was able to read the wordless expressions of her inner emotional state. Pushed too far, however, the vast scale of the screen could transform the face into an overwhelming presence, one that could potentially exceed the conventional frames of facial representation and produce a disorienting effect. The excessive proximity of the close-up could render the face fragmented, leaving it an unrecognizable jumble of disparate features. If brought too close, the close-up left the face unreadable and the identity of its owner uncertain and, therefore, paradoxically distant or even uncannily inhuman.

The deranging effect of the close-up was itself put on display in the famous final scene in Billy Wilder's *Sunset Boulevard* (1950).[31] The story is that of a silent movie actress who is writing a treatment of Salome in pursuit of a comeback. She hopes that it will restore her career and allow her to, as she puts it, make "one picture after another" *ad infinitum*. Swanson, herself a former silent film star, played the lead role of Norma Desmond. In the one scene Desmond bitterly declares of the silent era, "We didn't need dialogue. We had faces."[32] Restricted to unspoken communication, silent film stars were like figures in a painting, forced to mime the text in a sequence of discrete facial poses. By the end of the film Desmond has become demented. Unable to adapt to current technology, she is out of step with the present.

She remains a melodramatic anachronism, preserved in a world of cinematic artifice. In the final sequence the faded idol descends the grand stair of her airless Hollywood mansion and makes a dramatic, serpentine gesture with her arm, invoking Salome's dance. As she comes closer and closer to the camera she tilts her head back and grimaces in a grotesque pantomime of expression, her curled hair forming a Medusal aureole.[33] Staring directly into the camera, she violates the prime directive of post-silent film acting, addressing her audience as "[a]ll those wonderful people out there in the dark." Desmond here collapses the difference between her fictional fan base and the actual audience of Wilder's film. Breaking the invisible 'fourth wall' of the theater, she ruptures the fantasy that the actions on stage or screen are unfolding naturally and have not been explicitly produced for the audience's gratification.[34] Desmond's direct address materializes the transparent screen that separates the viewers from the machinery of illusion, shocking them out of their fetishistic suspension of disbelief and absorption within the narrative, and exposing it as artifice.

In the final sequence Swanson also delivers her famous line, "Mr. DeMille, I'm ready for my close-up."[35] Staring directly into the camera and filling the frame, her face begins to blur as if she is exceeding the minimum focal distance for the camera lens. Looking as if a veil of gauze has been placed over the camera, her face dissolves into a blurry field of indistinct form; her heavily mascara-ed eyes are transformed into the sunken voids of a death's head. Swanson's character here comes too close for the viewer's comfort, rending the veil of fantasy upon which the cinematic experience is predicated. Seeing too much in Wilder's film amounts to seeing nothing at all, as the otherworldly beauty of the star evaporates into a flicker of grey light and then fades to black. The exquisite, soft focus of the early Steichen photograph that preserved feminine beauty has been pushed beyond the limits of visibility and transforms the face of a deity into a grotesque, Gorgon's head.

Roland Barthes has described the focus on the face of the film star found in early cinema in relation to the face of another star of the early films, Greta Garbo; he writes, "Garbo still belongs to that moment in cinema when capturing the human face still plunged audiences into the deepest ecstasy, when one literally lost oneself in a human image as one would in a philter, when the face represented a kind of absolute state of flesh, which could neither be reached nor renounced."[36] The fantasy of Garbo's "absolute flesh" was predicated on the fantasy of distance that separated studio stars from the viewing public, a distance that has been increasingly eroded by an ever-growing taste for unfiltered reality. *Sunset Boulevard*'s final close-up thus both undoes the illusion of perfect beauty and becomes another kind of veil: a shield that protects a film goddess from the gaze of mortals. Like the famously reclusive Garbo, Desmond retreats into a fantasy of a vanished era, ensconcing herself behind an inscrutable wall of grey blur.

Regardless of whether the makers of *Sunset Boulevard* were familiar with the Steichen photograph of Swanson, the casting of Norma Desmond as an obsolete Salome suggests a strong association between the dilemma of silent stars in the era of talking film and veils in the popular imaginary of the 1940s. Although she could not have seen *Sunset Boulevard*, having died five years prior to its release, Pavlović-Barilli's appropriation of the Steichen-Swanson image and her ongoing use of veils makes the film a productive point of comparison for her paintings. Wilder's film and Pavlović-Barilli's paintings manifest a shared concern with the problem of preserving traditional paradigms of feminine beauty under the pressure of the development of technologies of increasingly realistic means of reproduction.

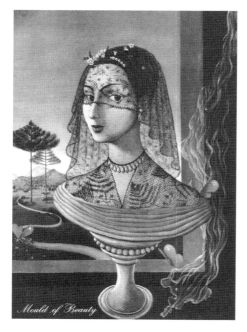

Fig. 6.8 Milena Pavlović-Barilli, *Mould of Beauty*, illustration, *Vogue* April 15, 1941.

In addition to her fine art painting, Milena Pavlović-Barilli also worked as an illustrator for American magazines.[37] Even in her purely commercial illustrations, she tried to find a symbiosis with fine art production by using traditional Western iconographical elements in many of her advertisements. Overall, however, she found this work restrictive, and feared its deleterious effect on her painting. By incorporating quotations from art history, especially renaissance masters, Pavlović-Barilli tried to form an equilibrium between her ambitions as a painter and the commercial work which gave her a living. In these commercial works Pavlović-Barilli used the veil to speak to the construction of visual ideals of feminine beauty within the beauty industry. This is most clearly evidenced by an illustration that appeared in the April 15th 1941 edition of the American fashion journal *Vogue*.[39]

Mould of Beauty stands apart from most of her work for Vogue, which largely consisted of product advertisements. This full-page work was not an advertisement but an illustration that was accompanied by text. The image shows a portrait bust of a woman on a pediment placed in a window through which one observes an idealized Renaissance landscape (Fig. 6.8).[40] The format is that of fifteenth century Italian portraiture. The artist uses art history here not as pastiche but rather demonstrates the repurposing of past art to serve the needs

of the present.[41] Snežana Kragulj has proposed that this is a portrait of the artist.[42] Milena Pavlović-Barilli here quotes herself from her *Self-portrait with the Lamp* of three years earlier; coupled with the neo-Renaissance format, this gesture implicitly construes her own painting as already being part of the art historical past (Fig. 6.5).

The subject's face is partially covered with a veil. Given its location in a fashion magazine, the multiple connotations of the veil may be interpreted here as a critical commentary on the American beauty industry of which Vogue was a major component. The accompanying article, entitled 'Make the Most of Your Face,' equates the face and the veil, advising the reader that "You can't hide your face, nor can you hide behind it for long."[43] Its anonymous author proceeds to recommend a regime of self-inspection and techniques of cosmetic improvement.

The woman looks out directly at the spectator; her lack of arms renders her a passive object of delectation and invites us to lift her veil. The serpentine line of the receding pathway repeats the undulating edge of the veil, just as the pearls on the pediment echo those encircling the woman's neck. The butterflies allow the eye to glide between the interior and exterior space, further blurring the distinction between what is to be taken as real and what is a representation. The lacy border of her gown is interrupted by a more opaque fabric, a conjunction that eases the transition between her human face and the plaster pediment that has replaced her body. The notion of a mold, a form from which an endless series of sculptures could be cast, suggests a sculptor's practice. When read in light of the painting's confusion of animate and inanimate, real and represented forms, the title implies a rewriting of the Pygmalion myth in exclusively female terms. Shown in a state of arrested objectification, the artist is both lover and beloved in Ovid's tale, closed in an echo chamber of aestheticized desire.[44] In contradistinction to the patriarchal milieu of the Hollywood studio system, it is important to remember that *Mould of Beauty* appeared in a magazine whose production team, editorial staff and readership were predominantly female.

The problem of self-portraiture recalls the position of the silent actress, whose recourse to mime reflects a fundamental relation between self and other: our emotional states are externalized and read through our facial expressions. The self thereby becomes a matter of public interpretation and is now accessible to its owner through its reflection in the eyes of its audience. Susan Stewart has explored identity as generated through a triangulation of self-face-other, arguing that the face is:

> a type of "deep" text, a text whose meaning is complicated by change and by a constant series of alterations between a reader and an author who is strangely disembodied, neither present nor absent, found in neither part nor whole, but in fact, created by this reading.[45]

Underscoring the essential involvement of the audience in the reading and construction of the self, Stewart signals the foundational status of the face in Western culture as a privileged site of subject formation in an unstable exchange between self and Other, writing:

> The face becomes a text, a space which must be "read" and interpreted in order to exist. We are surrounded by the image of the woman's face, the obsession of the portrait and the cover girl alike. The face is what belongs to the other; it is unavailable to the woman herself.[46]

Stewart's insights resonate with the caption that introduces Pavlović-Barilli's *Mould of Beauty,* in which an unknown Vogue writer describes it as "fantasy of beauty, painted by Pavlović-Barilli – with a down-to-earth significance behind its dreamy symbolism." The author continues by inviting the reader to "Let it suggest that you put your own head upon a figurative pedestal, that you look at it objectively, as a stranger would."[47]

Making a portrait of oneself involves precisely this kind of looking at oneself through the eyes of another. As Pavlović-Barilli shows, such self-objectification can take the form of a critical intervention that challenges as much as recapitulates conventional ideals of the beautiful. The artist-as-portrait bust exhibited in *Mould of Beauty* presents her as an uncanny epitome of Renaissance femininity, a mold from which new selves may be recast *ad infinitum*. The women featured in fashion magazines such as Vogue – be they film stars or painted paragons of Renaissance beauty – functioned as models for their female readers to emulate. Pavlović-Barilli's illustration both promotes and deconstructs this aspect of the beauty industry, exposing the means by which impossible ideals of attractiveness were constructed. Through her skillful use of iconic images of the female body culled from both art history and contemporary popular culture alike, she constructed a public persona that reflected her artistic sensibility. Her paintings of veiled women argue that the true self is only accessible via representation, a mediating surface: a screen. This tension is reflected in the Vogue text's simultaneously asking its reader to scrutinize herself in a mirror in order to "search for what best expresses you," and then manifest this true self by following the proffered make-up tips.[48] Made up or stripped down, Milena Pavlović-Barilli's paintings of veiled women expose the truth that the 'true' self is accessible only via the Other.

Notes

* I would like to thank Professor Lilien Filipovitch Robinson and Assistant Professor Jelena Bogdanović for inviting me to participate in this project. My special gratitude goes to Jelica Milojković, former curator at Gallery Milena Pavlović Barilli in Požarevac, Dragana Spasić, curator at the National Museum Požarevac, and Aleksandra Mirčić, head of the artistic documentation department at The Museum of Contemporary Art, Belgrade. Further thanks go to my dear friend Allan P. Doyle, PhD candidate, Princeton University for his close reading of the text and helpful suggestions and corrections. Any remaining errors remain my responsibility.

1 Scholars largely agree that Milena Pavlović-Barilli's painting dating between the mid 30s and early 40s is more indebted to metaphysical than surrealist painting. They view the works from this period through her proximity to Giorgio De Chirico and Andrea Savinio. For recent scholarly texts with bibliographies see: Zorica Stablović Bulajić, ed., *Milena Pavlović Barili: Ex post: kritike, članci, bibliografija* (Beograd: HESPERIAedu, 2009); Zorica Stablović Bulajić, ed., *Milena Pavlović Barili: Pro futuro: teme, simboli, značenja* (Beograd: HESPERIAedu, 2010); Zorica Stablović Bulajić, ed., *Milena Pavlović Barili: Vero verius: vreme, život, delo* (Beograd: HESPERIAedu, 2010). For reproductions, see: Jelica Milojković, *Zvezdanim tragom: Milena Pavlović-Barilli (Požarevac, 1909 – Njujork, 1945),* Galerija SANU, Beograd: 17. juli–25. avgust 2009 (Beograd: Srpska akademija nauka i umetnosti, 2009); Miodrag B. Protić, ed., *Milena: retrospektivna izložba, 1926-1945* (Beograd: Muzej savremene umetnosti, 1979); Miodrag B. Protić, *Milena Pavlović-Barilli. Život i delo* (Beograd: Prosveta, 1966).

2 While de Chirico and Savinio similarly developed a highly personal painterly language from historical motifs, I argue that Pavlović-Barilli references art historical sources more directly. On Giorgio de Chirico and Alberto Savinio see: Maurizio Fagiolo dell'Arco, Paolo Baldacci and Fabrizia Lanza Pietromarchi, trans. Shara Wasserman and Martha A. Davis, *The Dioscuri: Giorgio de Chirico and Alberto Savinio in Paris, 1924-1931* (Milano: A. Mondadori: Edizioni P. Daverio, 1987).

3 Recently, art historians have borrowed Jean Cocteau's title 'Le rappel à l'ordre' to identify the return to traditional modes of figuration in artists such as André Derrain and Pablo Picasso, which they view as linked to reactionary politics. See Benjamin H. D. Buchloh, "Figures of Authority, Ciphers of Regression: Notes on the Return of Representation in European Painting," *October* 102 (1981), 39-68.

4 As Lloyd Llewellyn-Jones argued, men in antiquity veiled themselves when their masculinity was compromised. He further adds that this feminine gesture essentially transformed a man into a woman, making him socially invisible. Lloyd Llewellyn-Jones, *Aphrodite's Tortoise: the Veiled Woman of Ancient Greece* (Swansea, Wales: Classical Press of Wales; Oakville, CT: Distributor in the United States, David Brown, 2003), 17.

5 Leo Steinberg, *The Sexuality of Christ in Renaissance Art and in Modern Oblivion* (Chicago: University of Chicago Press, 1996), 154-157; 199-201.

6 For an example of Sodoma's *The Beheading of Niccolò di Tuldo*, 1526, Cappella di Santa Caterina, San Domenico, Siena see: Julian Kliemann and Michael Rohlmann, *Italian Frescoes, High Renaissance and Mannerism, 1510-1600* (New York: Abbeville Press, 2004), 75.

7 Gen Doy, *Drapery: Classicism and Barbarism in Visual Culture* (London: I.B. Tauris, 2002), 132-138. The use of the veil in Islamic culture has long been an object of fascination in the Occident, a phenomenon that has been the subject of much artistic, political and scholarly interest of late. For a discussion of the social function of the veil in Islam see: Fatima Mernissi, *Beyond the Veil: Male-female Dynamics in Modern Muslim Society* (London: Sagi Books, 2003); for the veil's use in nineteenth and early twentieth century photography see: Barbara Harlow and Laek Alloula, *The Colonial Harem*, Theory and History

of Literature v. 21 (Minneapolis: University of Minnesota Press, 1986); and for the interrogation of the use of the veil in contemporary photography see John J. Corso, "The Complex Geographies of Sherin Neshat," *Art Papers* (May/June 2013), 26-31, and Allan Doyle, "The Photographic Harem," in *Lalla Essaydi: Writing Femininity. Writing Pleasure*, ed. John J. Corso (Rochester: Oakland University Press, 2013), 12-19.

8 Salome was a step-daughter of king Herod (14 – 62-71 AD). She is known from The Gospels of Mark 6:17-29 and Matthew 14:3-11, although in the Gospels she is not named. The source for her name is Flavius Josephus's *Jewish Antiquities*; Flavius Josephus, *Jewish Antiquities* (Cambridge, Mass.: Harvard University Press, 1998), Book XVIII, Chapter 5,4.

9 The title of the painting *Dancer With the Veil and the Glove* is taken from the two books by Miodrag B. Protić, from 1979, fig. 142 and from 1966, fig. 68. In her recent catalogue Jelica Milojković, *Zvezdanim tragom: Milena Pavlović-Barilli,* 378, entitled the painting *Pink pants II.*

10 John Baxter, *Von Sternberg* (Lexington, Ky.: University Press of Kentucky, 2010), 173-181.

11 Josef von Sternberg, *The Scarlet Empress* [videorecording] a Paramount Picture (Criterion Collection, 2001).

12 Mary Ann Doane, "Veiling over Desire: Close-ups of the Woman," in *Feminism and Psychoanalysis*, eds. Richard Feldstein and Judith Roof (Ithaca, N.Y.: Cornell University Press, 1989), 107.

13 Ibid., 119.

14 The alternative title is *Landscape with a lamp*: Jelica Milojković, *Zvezdanim tragom: Milena Pavlović-Barilli,* 378.

15 On Pomona see: Mark P. O. Morford and Robert J. Lenardon, *Classical Mythology* (New York: Oxford University Press, 2003), 387.

16 Sarah McHam has argued that during the Renaissance such a figure could be read as all three at once, noting that female nudity and mirrors were both identifying attributes of Venus, but also had pejoratively connotations in allegories of vanity and luxury. Sarah Blake McHam, "Reflections of Pliny in Giovanni Bellini's Woman with a Mirror," *Artibus et historiae* 58 (2008), 157-171, esp. 158-159.

17 On Cranach's Venuses and the veil see: Elke Anna Werner, "The Veil of Venus: A Metaphor of Seeing in Luca Cranach the Elder," in *Cranach*, ed. Bodo Brinkman (London: Royal Academy of Arts; New York: Distributed in the United States and Canada by Harry N. Abrams, 2007), 99-109.

18 The parable of the Wise and Foolish Virgins appears in the Gospel according to Matthew 25:1-13.

19 For the image of Giorgione's *Venus* see: Brinkman, *Cranach*, 58; For Titian's *Venus of Urbino*, see: Filippo Pedrocco, *Titian. The Complete Paintings* (London: Themes and Hudson, 2001), 167.

20 For a lengthy discussion of Manet's use of the art of the past see Michael Fried, *Manet's Modernism or The Face of the Painting in the 1860s* (Chicago, London: The University of Chicago Press, 1996), esp. 23-135.

21 Walter Benjamin, *The Arcades Project*, trans. Howard Eiland and Kevin McLaughlin (Cambridge, Mass., London: The Belknap Press of Harvard University Press, 1999), 236 (J5,1).

22 T.J. Clark, *The Painting of Modern Life* (Princeton: Princeton University Press, 1984), 79-147.

23 For a discussion of the complex relation between Manet and his painted models see Carol Armstrong, *Manet/Manette* (New Haven: Yale University Press, 2002).

24 Jelica Milojković, *Zvezdanim tragom: Milena Pavlović-Barilli,* fig. 8, 237, dated the painting in 1935.

24 Olivera Janković, "The Metamorposes of Milena Pavlović Barilli Between 'Pure' and Applied Art," in *Milena Pavlović Barili: Vero verius,* ed. Bulajić (2010), 123-208, 187-193; On Pavlović-Barilli's self-portraits see: Lidija Merenik, "Milena Pavlović-Barilli: The Portrait of a Lady," in *Milena Pavlović Barili: Ex post*, ed. Bulajić (2009), 7-63, 39.

[26] Snežana Kragulj, "Erasing Boundaries: The 'Narrowness' of Europe and the 'Wealth' of America," in *Milena Pavlović Barili: Pro futuro*, ed. Bulajić (2010), 89-207, 93.

[27] On Carl van Vechten portraits and photographs see: Nancy Kuhl, intro. Bruce Kellner, *Extravagant Crowd: Carl van Vechten's Portraits of Women* (New Haven, Conn.: Beinecke Rare Book and Manuscript Library, Yale University, 2003); James Smalls, *The Homoerotic Photography of Carl Van Vechten: Public Face, Private Thoughts* (Philadelphia, Pa.: Temple University Press, 2006).

[28] Ljiljana Petrović, "Milena and the Performing Arts: Measure of Time," in *Milena Pavlović Barili: Pro futuro*, ed. Bulajić (2010), 267-287, 277. The photograph is from 1924: William A. Ewing and Todd Brandow, *Edward Steichen: in High Fashion, the Condé Nast years, 1923-1937* (Minneapolis: Foundation for the Exhibition of Photography; New York: W.W. Norton & Co., 2008), 56-57.

[29] James Naremore, *Acting in the Cinema* (Berkeley: University of California Press, 1988), 48.

[30] Paula Marantz Cohen, *Silent Film and the Triumph of the American Myth* (Oxford: Oxford University Press, 2001), for the close-up see 115-125; for soft focus see 119.

[31] Billy Wilder, *Sunset Boulevard*, videorecording (Hollywood, Calif.: Paramount Pictures, 2002).

[32] Billy Wilder, Charles Brackett and D.M. Marshman, Jr., *Sunset Boulevard* (Berkeley, Los Angeles, London: University of California Press, 1999), 39.

[33] On the iconography of Medusa see: *The Medusa Reader*, eds. Marjorie Garber and Nancy J. Vickers (New York, London: Routledge, 2003).

[34] On the fourth wall see: Elizabeth Bell, *Theories of Performance* (Los Angeles: Sage Publications, Inc, 2008), 203; J. L. Styan, *Modern drama in theory and practice* (Cambridge; New York: Cambridge University Press, 1981), 35-36.

[35] Wilder, *Sunset Boulevard*, 126.

[36] Roland Barthes, *Mythologies*, trans. Annette Lavers (New York: Hill and Wang, 1972), 56.

[37] Kragulj, "Erasing Boundaries," 89-207.

[38] Pavlović-Barilli expressed reservations about her involvement with the world of advertising, writing to her mother: "I'm sometimes distressed because there is no pure art and fantasy for me as yet. I'm fighting as best I can against commercial influences and pressures. I often have problems with Vogue on account of this, but I succumb, they'll ruin me. That's why all the artists here have turned dull…It's so easy to go astray…" Milena Pavlović-Barilli as quoted in Kragulj, "Erasing Boundaries," 120.

[39] "Make the Most of your Face," *Vogue*, April 15, 1941, 44-45, 106.

[40] On Renaissance landscape in art, both German and Italian, see: Christopher S. Wood, *Albrecht Altdorfer and the Origins of Landscape* (Chicago: University of Chicago Press, 1993), 9-45. For a discussion of Renaissance portraiture see: *The Image of the Individual. Portraits in the Renaissance*, eds. Nicholas Mann and Luke Syson (London: British Museum Press, 1998); Lorne Campbell, *Renaissance Portraits* (New Heaven, London: Yale University Press, 1990).

[41] Michael Baxandall, *Painting and Experience in Fifteenth Century Italy: a Primer in the Social History of Pictorial Style* (Oxford; New York: Oxford University Press, 1988).

[42] Kragulj, "Erasing Boundaries," 197.

[43] *Vogue*, April 15, 1941, 45.

[44] For the Pygmalion myth see: Ovid (43 B.C.-17 or 18 A.D.), *Metamorphoses IX-XII*, ed. with an introduction, trans., and notes D.E. Hill (Warminster: Aris & Phillips, c1999), Book X (245-270); 53-55; For Pygmalion in art and popular culture see: Victor I. Stoichita, *The Pygmalion Effect: From Ovid to Hitchcock*, trans. Alison Anderson (Chicago: The University of Chicago Press, 2008); Jaffrey A. Brown, *Dangerous Curves. Action Heroines, Gender, Fetishism, and Popular Culture* (Jackson: University Press of Mississippi, 2011), esp. 63-93.

Ljubomir Milanović

45 Susan Stewart, *On Longing: Narratives of the Miniature, the Gigantic, the Souvenir, the Collection* (Baltimore: John Hopkins University Press, 1984), 125.
46 Stewart, *On Longing*, 127.
47 *Vogue*, April 15, 1941, 45.
48 Ibid.

CHAPTER 7

WOMEN AND APPLIED ARTS IN BELGRADE 1918-1941

Bojana Popović

The drive towards modernization in the period between the two World Wars significantly impacted Belgrade, a city that in 1918 had become the center of the newly created Kingdom of Serbs, Croats and Slovenes. The new societal and cultural needs of its continuously increasing number of inhabitants transformed the appearance of the city, as well as its already established customs. Applied arts, previously considered to be a privilege of affluent societies, yet also a second-rate, feminine discipline akin to crafts, found their place.[1] The 1925 Parisian Exposition of Modern Decorative and Industrial Arts reinforced this new elevated status by showcasing the flourishing of many areas of applied arts, which were aligned with the needs of modern life. They were both a reflection and a symbol of modernity.

The Belgrade School of Applied Arts was founded in 1938; prior to this, Belgrade artists studied abroad.[2] Most lived in Paris, yet Vienna, Prague, Rome and London were also cities where some were able to learn about contemporary art and architecture and were inspired to explore applied arts, which had barely existed in pre-war Serbia, and which had once been considered "low" art.[3] Thus, in the interwar period, the first steps were made towards the legitimization of applied arts, as well as the alignment of national values with international trends in applied arts. However, during these two decades, the practice of the applied arts had not reached an advanced level, as was the case within more economically and culturally developed societies. There were no specialized schools or associations of artists and artisans, nor were there journals and exhibitions or patrons and collectors. Further, a system of criticism and cooperation between the artists and the industry itself did not exist.

The struggle to create a national style, a goal that was shared by other, newly established states, as well as the prompt acceptance of European art, represented the two sides of Serbian culture. The artistic vision of Dragutin (Carlo) Inchiostri Medenjak (1866-1942), a pioneer of Serbian applied arts, was based on the modernization of the folk tradition that had begun in the early 20th century. In the search for a national style, artists close to King Alexander Karadjordjević, as well as members of the "Zograf" art group (1927-1940) were inspired by

Serbian medieval art. Artists were also inspired by European art, especially the French applied arts, which seemed to represent a "nation unrivaled" in its wealth of materials, diversity of ideas and refinement of taste and elegance. However, even for those oriented towards Western artistic tendencies, a yearning for "special, national attributes"[6] remained. Such ideas were consistent with the widely held theories regarding the existence of "racial genius," which shaped the achievements of every nation, and at the same time with the eclectic character of the applied arts and a contemporary creative mentality that strove to "modernize" various traditions – both their own and those that were spatially and temporally distant.

Research on the applied arts in interwar Serbia indicates the existence of a series of phenomena that are related to the general spirit of the time. One of these is the presence of female applied artists.[7] A more complete understanding of this topic, however, is restricted due to the lack of preserved art pieces and basic biographical data, as well as to the incomplete nature of Serbian historiography of the applied arts. Existing studies of female artists, which had started in the last decade of the 20th century, are very limited, and are mainly biographical, written largely without considering a wider context.[8] Female artists who were also involved in applied arts (such as the sculptor Vukosava Vuka Velimirović or the multi-talented Margita Gita Predić), their activities, mainly those within that specific field, tend to be overlooked or cursorily mentioned, without elaboration or deeper understanding.

Women in Serbia, as in most European countries, experienced varied levels of socio-economic and political discrimination.[9] However, the process of modernization in the late nineteenth and early twentieth centuries had a tangible impact on Serbian society, especially with respect to education. Women acquired the right to be educated at all levels, as well as the right to employment.[10] Before World War I, Belgrade's only professional women artists were painters Nadežda Petrović (1873-1915), Beta Vukanović (1875-1972) and architect Jelisaveta Načić (1878-1955). Vukanović was the only one of these three to continue to paint and teach at the Royal Art School, thus providing access to specialized training to generations of young women who were presented with educational opportunities in rapidly rising numbers. More than one quarter of the students at the Royal Art School were girls.[11] They usually attended courses in preparation for pedagogical careers, which in turn allowed them full-time employment and financial emancipation. As in modern European societies, architecture and sculpture were typically considered male artistic occupations,[12] while painting was available to women (specifically, teachers of drawing) as a supplementary activity.[13] Some Serbian women such as Natalija Cvetković (1888-1928)[14] and Milica Čadjević (1890-1947)[15] graduated from specialized schools for the applied arts abroad. Nonetheless, they limited their practice of applied arts to the production of decorative items for the home. They restricted their projects to what was considered traditional, domestic and stereotypical female activity, works not

intended for public display and sale. In milieus where applied art was "in its infancy,"[16] this was a common occurrence. There was clearly an inability to distinguish between applied arts as a "female job," one focused on beautifying domestic interiors and garments, and as a fully professional engagement. It was against the backdrop of conflicting opinions about this field that the applied art creations of successful amateurs were exhibited from 1933 to 1935 at the Autumn Exhibitions, prestigious Belgrade artists' events.[17]

Fig. 7.1 Vukosava Vuka Velimirović, facade sculpture *Industry*, Belgrade, Vračar Holding Bank (at present Turkish Embassy, Krunska Street 1), c. 1924.

However, patriarchal Belgrade society was changing, providing a window of opportunity for the "creative power of women," whose rise was recognized by the philosopher Ksenija Anastasijević in her 1924 essay.[18] At that time, Vukosava Vuka Velimirović (1888-1965), "a lady sculptor" and "our greatest artist,"[19] attracted great public attention. She was educated in Belgrade, Rome and Paris, where she spent most of her life (1918-1940).[20] She sculpted in traditional forms, which in and of itself was considered an excellent quality in Serbian society.[21] Around 1924, Velimirović created five decorative sculptures on the façade of the Vračar Holding Bank (1 Krunska Street) (Fig. 7.1).[22] Few other Belgrade sculptors would have been willing to undertake this project as it was widely considered to be artistically second-rate. That soon changed because of the influence of similar foreign projects,[23] the possibility of good wages, and the opportunity to show works of art in a public space. Façade sculpture was considered a masculine applied discipline, so Velimirović was rarely able to obtain such

Bojana Popović

commissions either in Belgrade or in Paris.[24] She did, however, have a successful career as a portraitist of the European upper classes.[25]

The person who contributed the most to the success of applied arts in 1920s Belgrade was Margita Gita Predić (1894-1970), a sculptor and painter.[26] Encouraged by the success of the Paris exhibition, she founded the School for the Decorative Arts (1926/1927 – ca. 1935), which became a well-known meeting place for wealthy hobbyists.[27] The materials used in classes were purchased in Paris and projects were created using templates taken from specialized French magazines.[28] Yet, Predić encouraged her students to be original, pushing them to work in styles that were both "national and ultra-modern; stylish and stylized." The public came to know students' work through regular school exhibitions, as well as the Autumn Exhibitions. The aesthetic appeal of the works as well as the media attention they received resulted in attracting patrons.[31]

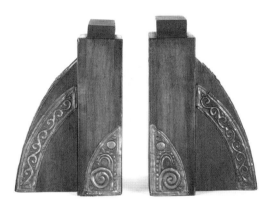

Fig. 7.2 Margita Gita Predić, book holder, Belgrade, 1920s.

Fig. 7.3 Margita Gita Predić, bowl, Belgrade, 1920s.

From Margita Gita Predić's vast creative opus, only a few works representative of her singular Art Deco style have been preserved (Figs. 7.2, 7.3). Around 1929, she created a black double door cabinet on which she applied white alloy with stylized vine ornaments in relief resembling the decorative design of Serbian medieval architecture, specifically of the Raška School (Fig. 7.4).[32] A cabinet for a library, a drawing of which was published in the magazine *Ilustrovano vreme* (*Illustrated Time*) in 1930,[33] had simple lines. The inspiration for the decorative geometric elements was the famous Pirot kilims, which came to symbolize Serbian national identity during the last decades of the 19th century (Fig. 7.5).[34] Working in the Art Deco style, Predić gave the above-mentioned works "local color" by using decorative motifs

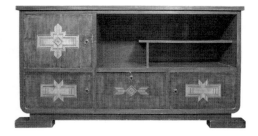

Fig. 7.4 Margita Gita Predić, cabinet, Belgrade, c. 1929.

Fig. 7.5 Margita Gita Predić, cabinet for a library, Belgrade, 1930.

that were both modernized and characteristic of Serbia's artistic tradition.[35] Yet, she was not appreciated for modernizing Serbia's artistic heritage, instead being best recognized for knowing "how to apply her art to furniture, costumes, ordinary domestic needs and clothing in a harmonious but also highly original manner. Her pieces can leave no one indifferent. Not one of her works lacks brightness, nor are they decorated to the point of exaggeration".[36] During the mid-1930s, Predić ceased to engage in applied arts and dedicated herself to her greatest passion – the 1938 founding and subsequent management of the *Roda Theater* (Stork Theater) for children.[37]

In the second half of the 1920s, architect Danica Kojić (1899-1975)[38] began to work as an interior decorator. She shared an office with and yet often worked in the shadow of her husband Branislav Kojić (1928-1941), who was a modernist and one of the founders of the *Group of Architects of the Modern Movement* (1928-1934).[39] The "Cvijeta Zuzorić" art pavilion, designed by her husband and built in 1928, was the first and one of the few public interiors created by Danica Kojić (Fig. 7.6).[40] In Belgrade, there was not an established tradition of interior design, and thus her work remained unnoticed. The marble paneling of the walls, the wrought iron on the doors, the use of masks and appliqué, Živorad Nastasijević's frescoes, and Vasa Pomorišac's stained glass gave the pavilion a trendy Art Deco look.

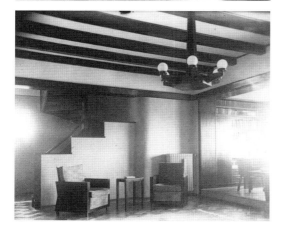

Designing spaces in which she lived, as well as spaces for her clients, Danica Kojić used traditional materials, but tried to achieve simple forms and avoid decorative elements. Thus, in her home (6 Zadarska Street) designed by her husband and built in 1927,[41] the shape of the prominent polygonal room was further emphasized by the use of monochrome walls framed by dark strips, a fireplace made of brick and wood, and simple, ornament-free furniture of her design (Fig. 7.7). To accommodate the wishes of her patrons, mostly her relatives and friends, she designed modern interiors (Fig. 7.8), as well as interiors with antique furniture, which was highly desirable in Belgrade in the period between the two wars.[42]

The general public did not know Kojić's work, but they were acquainted with that of Margaret Kofler. The inhabitants of Belgrade often entrusted interior design, especially in the "modern style", to non-professionals,[43]

Fig. 7.6 Danica Kojić, interior of the Art Pavilion *Cvijeta Zuzorić*, Belgrade, 1928.

Fig. 7.7 Danica Kojić, interior of the home of Danica and Branislav Kojić (Zadarska Street 6), Belgrade, 1927-1928.

Fig. 7.8 Danica Kojić, interior of the villa of engineer Mihajlo Kojić (Žanka Stokić Street 36), Belgrade, 1933-1934.

amongst whom Kofler enjoyed particular prestige. She owned the boutique *Beautiful Home* and, from 1931 to 1932, the *Studio of Decorative Applied Art*,[44] where she sold modern and antique furniture, decorative objects made of ceramic, glass and metal, fabrics made by "first-rate, world-renowned artists," as well as "indescribably beautiful lampshades," which she made herself.[45] Well informed about the cultural needs of her fellow citizens and having good business and artistic connections, she gave advice on interior design to many "affluent homes" and foreign embassies.[46]

The 1920s and 1930s were the "Golden Age" of fashion and textile in Belgrade. Katarina Mladenović (1887-1953), owner of a prestigious fashion showroom, freely made use of Parisian fashion patterns and supplemented them with details inspired by decorative motifs and the brilliant colors of Pirot kilims. In 1923 she patented a technique for painting on fabric using melted metals and artificial gems.[47] After having completed their studies in Vienna, the Angelus sisters, between 1926 and 1927, opened the *Atelier Réné*, which became famous for painted clothing and decorative fabrics. The sisters taught courses concerning the different techniques of working with textiles.[48]

Weaving was very popular in Western European countries among female artists and amateurs. It was considered primarily women's work, even in avant-garde schools, such as the Bauhaus.[49] In 1939, two ladies from Zagreb, Iva Vranjanin (1898-1968) and Adela Heda Kras, started teaching weaving courses at the newly founded Belgrade School of Applied Arts.[50] Until then, weaving was a favorite hobby of Belgrade ladies, amongst whom the famous Mila Bogdanović often exhibited her works.[51] Mara Rosandić (1883-1954), esteemed photographer, painter, and the wife of the famous sculptor Toma Rosandić, began to weave around 1930 in order to beautify the interior of their family house, which was considered a "museum" created by the couple and their friends, who were the most important Belgrade artists of the time.[52] Educated in Munich, Rosandić had a modernist sensibility, which gave importance to functionality and texture rather than to the decorative quality of woven fabrics like coverlets, kilims and curtains.[53]

The textile industry was one of the most developed branches of the Serbian economy. However, because the modernization of technology was a priority, investing in original designs of the products was necessarily limited.[54] As a consequence, there was no cooperation with Milica Babić (1909-1968), who from 1929 to 1930 was an associate of the Parisian Rodier factory, one of the leading manufacturers of textiles at the time.[55] She specialized in fashion, textile design and theater costumes, studying with Professor Eduard Josef Wimmer-Wisgrill at the Vienna School of Applied Arts of the Austrian Museum for Art and Industry (1925-1929).[56] In spite of a successful Parisian début, she settled in Belgrade, where she started working as a costume designer at the National Theater in 1931.[57] In accordance with

the theater repertoire, her costumes were stylizations of historical and folkloric dress with an emphasis on colorful decoration (Fig. 7.9).[58] The traditionalism of this artist was familiar to and easily understood by the public, who respected her as "the only serious connoisseur of applied art."[59] In her opinion, applied arts were "going through a very big crisis."[60] According to her, "a chair design used to be a product of a long study of nature, distilled through the art and imagination of a great painter, whereas today it is just a turning of the ruler on paper. One feels awfully silly when one sits on a chair today, while carvings and tapestries of a Renaissance chair still inspire aesthetic thinking ..."[61] Babić valued highly the work of contemporary applied artists solely in the textile industry and in book illustration.[62] She herself was the first and most respected fashion illustrator, who, starting in 1930, made drawings for a fashion column in the papers *Ilustrovano Vreme* (*Illustrated Time*) and *Politika* (*Politics*).[63]

In the early 1930s, photography took precedence over newspaper illustration, which started losing its artistic and monetary value and thus became more accessible to female artists.[64] The daily newspaper with the widest circulation, *Politika* (*Politics*), employed, apart from

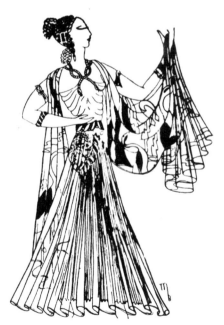

Fig. 7.9 Milica Babić, sketch for a costume in the opera *Thaïs* by Jules Massenet, *Pozorište* [Theater] No. 1, Belgrade 1931/1932, p. 6.

Fig. 7.10 Beta Vukanović, "Lady Editor-In-Chief" *Žena i svet* [*Woman and World*], January, Belgrade 1929, p. 2.

Milica Babić, Beta Vukanović (Fig. 7.10) and Nada Doroški (1915-1998), when the latter returned, in 1939, from her study of graphic arts as a scholarship student at the Prague Fine Arts Academy.[65] Desanka Jovanović-Glišić (1910-1991) drew for the competing paper *Vreme* (*Time*),[66] and Ljubica Cuca Sokić (1914-2009) for the evening newspaper *Pravda* (Justice), which was owned by her family.[67] In the early 1930s, Anita Delijanić Miryt started working for the widely circulated women's magazine *Žena i svet* (*Woman and the World*), and in 1939 she succeeded in creating the cover of the first issue of the journal *Moda u slici i reči* (*Fashion in Pictures and Words*) – the first journal cover in Belgrade entrusted to a female artist.[68]

During the period between the two world wars a small class of female artists emerged in Belgrade, influencing changes in the traditional understanding of women's professional activities. At the same time, they contributed to the development, modernization and democratization of applied arts in Serbian society. They were mostly trained as drawing teachers, painters, sculptors and architects. They worked in applied arts, thanks to Belgrade's receptivity to the modernist idea of the creative artist acting in accordance with her talent and unhindered by the limitations imposed by formal education, specificity of disciplines, and division into "higher" and "lower" arts. Then again, the modest socio-economic circumstances in Serbia limited opportunities. Without being able to achieve and sustain long careers filled with innovative approaches and active participation in the artistic developments of their time, Belgrade's female applied artists were forgotten, and their works mostly lost.

Working in the applied arts, female Belgrade artists followed the European "mainstream" trends, at times incorporating "national attributes" inspired by decorative motifs in Serbian medieval art and folk handicrafts. They also cherished classic, academic aesthetic values. Each of these art practices was part of the creative impulse of a pluralistic era and did not represent the uniqueness of Belgrade's creative realm *per se*. History, tradition, habit and societal needs did not allow the applied arts to be directed towards avant-garde and socially engaged ideas, nor towards truly innovative work. Belgrade women were neither Bauhaus students nor Le Corbusier followers, and their accomplishments were not part of modernism as an avant-garde artistic movement. As they lived and worked in Belgrade, their attitude towards art was necessarily conformist. After all, that was the case for most of their male colleagues as well. Living on the margins of modernism, Belgrade's female artists laid the foundation and achieved the basics: to visibly express female creativity and, at the same time, to contribute to changing the status of the applied arts. With the appearance of female artists as well as the corresponding rise of applied art disciplines, Belgrade participated in the universal spirit of the epoch of modernism.

Notes

1 Bojana Popović, *Primenjena umetnost i Beograd 1918-1941* [Applied Arts and Belgrade 1918-1941] (Belgrade: Museum of Applied Art, 2011).

2 About the school see Pavle Vasić, *Примењена уметност у Србији 1900-1978. Пролегомена за историју примењених уметности код нас* [Applied Arts in Serbia 1900-1978. Prolegomena for a History of Applied Arts in Serbia] (Belgrade: ULUPUDS, 1981), 35; Branko Vujović, *Факултет примењених уметности у Београду 1948-1998: 50 година Факултета примењених уметности у Београду* [Academy of Applied Arts 1948-1998: 50 Years of the Academy of Applied Arts in Belgrade] (Belgrade: Academy of Applied Arts, 1998), 14; Maja Nikolova, *Уметничке школе у Београду* [Art Schools in Belgrade] (Belgrade: Museum of Pedagogy, 2007), 26-27; Bojana Popović, op. cit., 39-40.

3 Artists of the time were encouraged to develop a renaissance-like ability to practice and unite a wide breadth of disciplines.

4 In 1928, Milan Zloković, Branislav Kojić, Jan Dubový, and Dušan Babić founded *The Group of Architects of the Modern Movement* [Grupa arhitekata modernog pravca], which advocated the principles of modern architecture and applied arts: see Quotes from Article 1 of the "Rules" on the works of the *Group* in: Ljiljana Blagojević, *Modernism in Serbia. The Elusive Margins of Belgrade Architecture 1919-1941* (Massachusetts: Massachusetts Institute of Technology, 2003), 57-76. Article 3 of the "Rules" states that in order to become a regular member of the "Group," one had to be an architect; however, craftsmen whose work was "based on modern principles and techniques of applied art" were allowed part-time membership. Ibid. 59-60. Yet, no craftsman became a member of this association.

5 Branislav Marinković, "Савремена декоративна уметност у Француској" [Modern decorative arts in France], *Уметнички преглед* [Art Survey] 3-4 (Belgrade, 1939), 124-126. Works of French Art Deco artists who designed and furnished the French Embassy in Belgrade (1929-1933) were highly valued: Roger-Henri Expert, Carlo Sarrabezolles, Raymond Subes, as were the works by Parisian and Viennese firms (*Jansen, Bézier, Bernhard Ludwig*) which decorated the interiors of the residences of the Serbian ruling family Karadjordjević in various historical styles. See Bojana Popović, op. cit., 86-94.

6 Branislav Marinković, "О нашој примењеној уметности. Поводом занатске изложбе" [On our applied arts. On the occasion of a craft exhibition], *Уметнички преглед* [Art Survey] 12 (Belgrade, 1938), 381.

7 Bojana Popović, op. cit., 51-56.

8 Divna Đurić-Zamolo, "Građa za proučavanje dela žena arhitekta sa Beogradskog univerziteta, generacije 1896-1940. godine" [Materials for a study of women architects of Belgrade University, classes of 1896-1940], *Pinus Zapisi* [Pinus Records] 5 (Belgrade, 1996) [with an afterword of the editor Aleksandar Kadijević]; Lidija Merenik, "Ja hoću da sam slikar: žene, umetnost, rod i mit" [I want to be a painter: women, art, gender and myth], *Zbornik. Muzej primenjene umetnosti* [Journal. Museum of Applied Arts] 3 (Belgrade, 2007), 43-45.

9 *Srbija u modernizacijskim procesima 19. i 20. veka. Položaj žene kao merilo modernizacije* [Modernizing Process of Serbia in the 19th and 20th centuries. Women's Position as the Measure of Modernization] Scientific Symposium, Vol. 2 (Belgrade: Institute for Recent History of Serbia, 1988). See also chapter by Tomić in this volume.

10 Miloš Nemanjić, "Žene Srbije kao deo stvaralačke inteligencije od početka stvaranja samostalne države do 1920. godine" [Women in Serbia as Part of Creative Intelligentsia since the Origins of an Independent State until 1920"], in *Srbija u modernizacijskim procesima*, 263–277.

[11] Stanislav Živković, *Уметничка школа у Београду 1919–1939* [The Art School in Belgrade1919–1939] (Belgrade: Serbian Academy of Sciences and Arts, 1987), 113-132.

[12] Such attitudes are reflected in an account of the first meeting of Le Corbusier and Charlotte Perriand. Seeing an unknown young woman who wanted to cooperate with him, Le Corbusier cynically said that his office did not deal with the embroidering of cushions. Jacques Barsac, *Charlotte Perriand. Une art d'habiter 1903–1959* (Paris: Norma éditions, 2005), 42.

[13] In the early 1930s, female painters made up half of the membership of the Serbian Artists society, "Lada" (founded in 1904), К., "Изложба Ладе у Уметничком павиљону" [Lada Exhibition in The Art Pavilion"], *Политика* [Politics] (Belgrade) 27 March 1932, 11. However, in the history of Serbian painting, few female artists, such as Zora Petrović, Ljubica Cuca Sokić and Milena Pavlović Barilli, succeeded in achieving a level of significance.

[14] Cvetković, a painter and a teacher of drawing in Artisan school, made leather covers for albums, screens, mirrors and other decorative items. She graduated from the School of Applied Arts in Munich and continued her studies at the Académie Julian in Paris. Jaša Grgašević, *Umjetni obrt* [Art Craft] (Zagreb: Yugoslav Lloyd A. D., 1926), 144; Zora Simić-Milovanović, *Сликарке у српској историји уметности* [Female Painters in Serbian Art History] (Belgrade: Printing firm Freedom, 1938).

[15] Čađević, a drawing teacher at the Women's Pedagogical School, a painter and an illustrator, worked with batik, painted on silk and wood. Jaša Grgašević, op.cit., 144. She graduated from the Women's Academy in Munich and attended the School of André Lhote in Paris. Stanislav Živković, op. cit., 132.

[16] Todor Manojlović, "Осма Јесења изложба" [The Eighth Autumn Exhibition], *Београдске општинске новине* [Belgrade Municipal Paper] 11-12 (Belgrade, 1935), 724.

[17] The exhibition of works of applied art was limited to these years (1933-1935) and this sole venue. Bojana Popović, op. cit., 32.

[18] Ksenija Atanasijević, "Pesnikinje i filozofkinje stare Grčke" [Women Poets and Philosophers of Ancient Greece], *Misao* 1 (Belgrade, 1924), 29, taken from: Ksenija Atanasijević, "Etika feminizma" [Ethics of Feminism], *Ogledi* 11 (Belgrade: Helsinki Committee for Human Rights in Serbia, 2008), 112 (ed. Ljiljana Vuletić).

[19] Н., "Г-ца Вука Велимировић – дама вајар" [Miss Vuka Velimirović – a lady sculptor], *Реч и слика* [Word and Image] 1 (Belgrade, 1926), 92.

[20] Velimirović studied sculpture at the Belgrade School for Arts and Crafts (1911-1914), École des Beaux-Arts, and Académie de la Grande Chaumière with Antoine Bourdelle in Paris (1919-1921), as well as the Academy of Fine Arts and with Ettore Ferrari in Rome. Peter V. Mikić, "Вајарка Вука Велимировић" [Sculptress Vuka Velimirović], *Зборник Народног музеја* [National Museum Journal] XIV/2 (Belgrade, 1990), 113-121; Bojana Popović, op. cit., 56, 250.

[21] It was assumed that her "loyalty" to the great classic masters "was perhaps unconsciously influenced by her first teacher of sculpture, our old yet forever young, Đoka Jovanović". Н., "Г-ца Вука Велимировић – дама вајар," 92.

[22] These are personifications of Maritime and Household Affairs, Agriculture, Industry and Viticulture. The other sculptural works was done by Živojin Lukić. Đurđica Sikimić, *Фасадна скулптура у Београду* [Façade Sculpture in Belgrade] (Belgrade, 1965), 131; Darko Šarenac, *Митови, симболи – скулптура на београдским фасадама* [Myths, Symbols-Belgrade Façade Sculpture] (Belgrade, 1991), 3. Vračar Holding Bank was built for Vojislav S. Veljković (1865-1931), politician, banker and collector of domestic and foreign sculptures, paintings, and applied art works. He built a private museum ("Museo") in 1931. Veljković was close to the Velimirović family, which may have influenced his selection of the sculptor.

23 An especially inspiring example was Antoine Bourdelle, who taught many Belgrade sculptors. Bojana Popović, op. cit., 47.

24 Velimirović collaborated on the creation of monumental sculptures that adorned the façade of the pavilion "La Maîtrise" – the studio of applied arts of Galeries Lafayette at the 1925 Paris exhibition. Н., "Г-ца Вука Велимировић – дама вајар," 92.

25 Velimirović's bust of Italian baritone Mattia Battistini brought her popularity in 1924/25 in Paris and Rome, and her short marriage with Count Lucien de la Martinière propelled her success as a portraitist. She created a series of works inspired by female characters from medieval Serbian history and folk literature (eg. *Queen Jelena Anžujska, Princess Milica, Nun Jefimija, Mother of the Jugovićs*). She had exhibits in Paris and Belgrade. In addition, Velimirović was a painter and writer. She signed her works under the name Vouka (Vélimirovitch). Petar V. Mikić, op. cit., 114-121.

26 Predić, daughter of the famous comedy writer Branislav Nušić, was the first woman to study sculpture in Belgrade. She graduated from the Academy of Painting in Prague just before the First World War. Zora Vukadinović, *Родино позориште* [Stork Theater] (Belgrade: Museum of Theatrical Art, 1996); Bojana Popović, op. cit, 24-27, 41-42, 55-61, 111-112, 244-245.

27 Pavle Vasić, op. cit., 34-35, 70; Branko Vujović, op. cit., 12-13; Zora Vukadinović, op. cit., 10, 13, Bojana Popović op. cit., 41-42.

28 Pavle Vasić, op. cit., 35, Anon., "Школа декоративне уметности г-ђе Маргите Предић" [School of Decorative Arts of Mrs. Margarita Predić], *Недељне илустрације* [Weekly Illustrations] 13 (Belgrade, 1929), 21. The text erroneously indicates that Predić studied Applied Arts in Paris, although it correctly identifies Paris as the most important European artistic center. On the influence of Paris on Serbian fine arts see Bojana Popović, op. cit., 20-21, 30, 41-42.

29 Anon., "У женском царству [In the realm of women], *Жена и свет* [Women and the World] 11 (Belgrade, 1929), 14.

30 On the exhibitions of Predić's school, and her participation in the Autumn Exhibition (1933-1935), see Bojana Popović, op. cit. 25-27, 30-32

31 That is how Ruža Panić, a prominent Belgrade lady, bought furniture for "the guest room" made of green painted wood with white nacro lacquer details at the exhibition held in 1929 – it "looked like a staged room in Folies Bergère," see Anon., "Изложба школе за примену декоративне уметности госпође Марије Предић" [Exhibition of Mrs. Marija Predić's School for Applied Decorative Arts], *Недељне илустрације* [Weekly Illustrations] (Belgrade) 20 October 1929.

32 Bojana Popović, op. cit. 111-112.

33 Anon., "Један угао собе" [A corner of the room], *Илустровано Време* [Illustrated Times] (Belgrade) 2 August 1930. A cabinet for a library was display at the exhibition of the school. See Anon., "Изложба Школе за примену декоративне уметности" [Exhibition of the School for Applied Decorative Arts], *Илустровано Време* [Illustrated Times] (Belgrade) 6 December 1930, fig. 3; Anonym, "Једна успела изложба" [A successful exhibition], *Недељне илустрације* [Weekly Illustrations] (Belgrade, 1930), no. 1.

34 The marquetry veneer technique was used for the ornamentation. Bojana Popović, op. cit., 111-112.

35 Milan Prosen and Bojana Popović. "L'Art déco en Serbie" [Art Deco in Serbia], in: *1925 quand l'Art déco séduit le monde* [1925: When Art Deco Seduced the World], eds. Emmanuel Bréon and Philippe Rivoirard (Paris: Cité de l'architecture et du patrimoine, Norma édition, 2013), 205. On Art Deco as an international style, which gained local and national attributes in various milieus, see: *1925 quand l'Art déco séduit le monde.*

36 Ђ. Б., "Изложба Школе за примену декоративне уметности" [Exhibition of the School for Applied Decorative Arts], *Недељне илустрације* [Weekly Illustrations] (Belgrade) 6 December 1930. The author's assessment is confirmed by photos of exhibited work, "pink" furniture for a girl's room, furniture decorated with inlaid patterns for "a gentleman's room," kitchen furniture, and by the description of a large hallway lamp with a glass pedestal. The latter was decorated with cacti and frogs, while "African grotesques" were painted on the parchment lampshade.

37 This was the first children's theater in Belgrade and it still exists under the name *Boško Buha*. On *Roda Theater,* see Zora Vukadinović, op. cit.

38 Kojić graduated in architecture from the Engineering University of Belgrade in 1924. About the artist see Snežana Toševa, "Danica Kojić (1899-1975)," *Годишњак града Београда* [City of Belgrade-Almanac] XLIII (Belgrade, 1996), 109-120; Bojana Popović, op. cit., 54, 99-101, 236. See also chapter by Novakov in this volume.

39 Ljiljana Blagojević places great importance on Kojić's role in informing the general public of Belgrade about conceptual and aesthetic principles of European modernist architecture. Ljiljana Blagojević, *Moderna kuća u Beogradu 1920-1941* [Modern House in Belgrade 1920-1941] (Belgrade: Andrejević Foundation, 2000), 15-16, 19-21 and beyond. Although her husband was one of the founders of the *Group of Architects of the Modern Movement* [Grupa arhitekata modernog pravca], Danica Kojić neither joined nor exhibited with the Group. See also chapters by Novakov, Djurdjević, Kadijević and Ćorović in this volume.

40 Snežana Toševa, op. cit., 113. In 1938, Kojić, along with her husband, furnished the interior of the Hotel Moscow. Ibid. 119.

41 Ibid. 113, 117, 120, fig. 7. In contrast to architecture, interior design does not have an association with vernacular heritage. Blagojević, *Modernism in Serbia*, 157, fig. 4.34.

42 On the interiors of Danica Kojić see Snežana Toševa, op. cit, 114-115, fig. 9, 10, 11; Ljiljana Blagojević, op. cit., 143, fig. 4.17.

43 Branislav Marinković, "О нашој примењеној уметности. Поводом занатске изложбе" [On our applied arts. On the occasion of a craft exhibition], *Уметнички преглед* [Art Survey] 12 (Belgrade, 1938), 380.

44 Ruža Petrov, "Модерне ситнице као неопходни оквир данашњег намештаја. Један сат у атељеу г-ђе Маргарите Кофлер" [Modern small articles as a necessary framework for contemporary furniture. One hour in the studio of Mrs. Margaret Kofler"], *Недељне илустрације* [Weekly Illustrations] (Belgrade), 1 January 1933, 12-13. Art exhibitions and sales were held in the *Beautiful Home* [Lepi Dom] boutique. Bojana Popović, op. cit., 105.

45 Ruža Petrov, op. cit., 12-13; Ruža Koen, "Модеран намештај" [Modern furniture], *Недељне илустрације* [Weekly Illustrations] (Belgrade), 22 October 1933, 5. In 1933, influenced by the Parisian custom of decorating interior spaces with art photographs, Kofler started selling her daughter Ila's photographs. Ila went to Paris to study sculpting, but ultimately became a successful photographer, often portraying animals. Ruža Petrov, op. cit., 13.

46 Ruža Petrov, op. cit., 13. None of Kofler's works have been preserved.

47 Katarina Mladenović continued her career in Paris (1924-1928). She participated at the 1925 Exposition of Modern Decorative and Industrial Arts together with a group of Yugoslav artists. Bojana Popović, op. cit., 133, 241. About fashion in Belgrade and the significant participation of women in its creation see Bojana Popović, *Мода у Београду 1918-1941* [Fashion in Belgrade 1918-1941] (Belgrade: The Museum of Applied Art, 2000).

[48] None of the works of Angelus sisters have been preserved. About Angelus sisters see Bojana Popović, *Primenjena umetnost i Beograd*, 24-26, 43, 133-134, 226.

[49] Women were encouraged to study weaving, book-binding and working with ceramics and metals. None of the women managed to study the prestigious field of architecture available to men at the Bauhaus. Magdalena Droste, "Bauhaus Archive," in *Bauhaus 1919–1933* (Cologne: Taschen, 2002), 38, 40.

[50] After the war, Vranjanin taught at the Department of Textile at the Academy of Applied Arts (1948-1968). There is not enough information about Adela Heda Kras. Bojana Popović, *Primenjena umetnost i Beograd*, 40-41, 251, 237.

[51] Not a single piece of her work has been preserved. See Ibid. 30, 32, 135-136.

[52] Ibid. 136-137, 246.

[53] Her works are kept in her family home, the Endowment of Toma Rosandić at the City Museum.

[54] Predrag J. Marković, *Beograd i Evropa 1918–1941. Evropski uticaji na proces modernizacije Beograda* [Belgrade and Europe 1918-1941. European Influence on the Modernization of Belgrade] (Belgrade, 1992), 123-124.

[55] Alain Rene Hardy, *Art Deco Textiles. The French Designers* (London: Thames and Hudson, 2003).

[56] Olga Milanović, *Живот и дело Милице Бабић* [Life and Work of Milica Babić] (Belgrade: Museum of Applied Art, 1973), pages not numbered; Bojana Popović, op. cit., 13-14, 131, 81, 227. On Wimmer-Wisgrill see *Yearning for Beauty. The Wiener Werkstätte and Stoclet House* (Vienna: MAK, 2006), 76, 92, 99.

[57] Milica Babić was the first professional costume designer who worked in Belgrade theaters. Previously, costume design was handled by theater artists. Theater papers often published Babić's work, "which helped costume designing not to become a mere abstraction between the two World Wars." Olga Milanović, op. cit.

[58] Since this artist's oeuvre between the two wars has not been preserved, her art is judged on the basis of costume drawings published in print and as a part of theater reviews. Olga Milanović, op. cit.

[59] K. Fjodorović, "Г- ца Милица Бабић" [Miss Milica Babić], *Недељне илустрације* [Weekly Illustrations] 7-8 (Belgrade, 1932), 3-4.

[60] Ibid., 4.

[61] Ibid.

[62] Ibid.

[63] Babić was also *Politika*'s fashion correspondent from Berlin, from 1939 until 1941. Olga Milanović, op. cit., 53-54.

[64] Their employment often required belonging to certain family circles. Thus, Milica Bešević (1896-1941), the National Theatre set designer, painter, and restorer, illustrated the magazine *Naš List* [Our Journal] (1921-1924), edited by her husband, poet Stevan Bešević. Vesna Lakićević-Pavićević, *Илустрована штампа за децу код Срба* [Illustrated Press for Serbian children] (Belgrade, 1994), 47.

[65] Doroški also drew humorous caricatures for the newspaper *Ošišani Jež* (1935-1937). Nada Doroški, *Отргнуто од заборава. Сећање на људе и догађаје од 1922. до 1996. године* [Snatched from Oblivion. In memory of People and Events from 1922 to 1996] (Belgrade 1997), 35, 41, 56, 81.

[66] Jovanović-Glišić was a cartoonist and illustrator for *Vreme* [Time] (1934-1941), *Ošišani Jež* (1935-1941) and, earlier, the *Trgovački glasnik* [Commercial Gazette] (1933-1934). Stanislav Živković, op. cit., 120; Vesna Lakićević-Pavićević, op. cit., 51-52, 86.

[67] Sokić produced illustrations and cartoons for the paper since the mid-1930s. Ibid., 39, 46.

[68] Delijanić Miryt, about whom very little is known, wrote sentimental stories and published them in various newspapers. Bojana Popović, op. cit., 24, 230; Idem, *Мода у Београду*, 58-59.

69 For example, Vidosava Konjiković-Maksimović (1909-?) showed a talent for sculpting. Nevertheless, sculptor Toma Rosandić, who believed that women were not suited to be sculptors, advised her to direct her talents to the modeling of porcelain. After completing her studies of ceramics in Behinj and at the State School for porcelain industry in Carlsbad, she returned to Belgrade in 1930 with a designer degree, bringing with her thirty Art Deco figurines she had made. Because Serbia had no factories for making porcelain and ceramics, she planned to open her own workshop. She failed in realizing this idea, and instead turned to another profession – law. Svetlana Isaković, *Савремена керамика у Србији* [Contemporary Ceramics in Serbia] (Belgrade: Museum of Applied Art, 1988), 47; Biljana Vukotić, "Иван Табаковић. Вечито кретање – магија модерне керамике" [Ivan Tabaković. Perpetual motion – the Magic of Modern Ceramics], in *Ivan Tabaković*, ed. Lidija Merenik (Novi Sad: Gallery of Matica Srpska, 2004), 65; Bojana Popović, op. cit., 53, 240.

70 On modernism in Serbian architecture and avant-garde movements see Blagojević, *Modernism in Serbia* (2003). On modernist developments in Serbian society and the arts see Simona Čupić, *Грађански модернизам и популарна култура – епизоде модног, помодног и модерног (1918-1941)* [Bourgeois Modernism and Popular Culture – Episodes of the Fashionable, Faddish and Modern 1918-1941] (Novi Sad: Gallery of Matica Srpska, 2011).

CHAPTER 8

EDUCATING GIRLS:
WOMEN ARCHITECTS AND THE DESIGN
OF THREE SCHOOLS IN BELGRADE, 1908-1938

Anna Novakov

> "Financial independence and modern education
> were the basis for women's independence."
> *Zla sreća devojačka* [The Ill Fortune of a Girl]
> by Draga Dejanović (1840-1871)[1]

Women architects Jelisaveta Načić (1878-1955) and Milica Krstić (1887-1964) were pioneers in their professions and innovators in the design of Serbian schools between 1908 and 1938. During those thirty years, Načić, Serbia's first female architect, designed *Osnovna Škola Kralj Petar I,* or Peter I Elementary School, Kralja Petra I, 7 (1908) while Krstić designed the *Second High School for Girls*, Narodnog Fronta Ulica, 31 (completed in 1932) and the *First High School for Boys*, Cara Dušana Ulica, 65 (1936-1938). These three schools displayed both architects' distinctive interest in light, sanitation and comfort in Serbia's reformed educational environment. Through their design innovations, they were able to ensure a progressive education for both male and female students. Overcoming Serbia's long-standing resistance to female education was a major focus of the emerging women's rights movement that sought to improve the notoriously low literacy rate among girls in villages and to provide opportunities for city girls to attend high school and even universities.

The 19th-century actress and poet Draga Dejanović "called for the *Ujedinjena omladina srpska* (The Union of Serbian Youth) to stand openly behind the demand for equal education for both girls and boys."[2] Early feminist calls for education reform were seen as opportunities by emerging women architects, who took advantage of recent social changes to design and build a series of schools for girls in villages and in Belgrade. This essay discusses the design of three schools in central Belgrade, designs that were only made more extraordinary by female architects who "pointed out that women had a legal right to public education and argued that there were no formal obstacles preventing women from acquiring education and enabling them to become equally trained for both intellectual and manual work."[3] Coincidentally,

The state adopted a policy of sending talented students to the major European universities, in order that upon their return they enter civil service and become well-qualified state functionaries. The professional differentiation of the elite emerges only in the second half of that century, when the state stipends were also given to students studying medicine, philosophy and the arts alongside the previously dominating subjects of law and engineering.[4]

Most female students at this time went to Switzerland, specifically Zurich, where universities were open to women. From 1872 to 1879, Draga Ljocić-Milošević (1855-1926) studied medicine in Zurich, returning to Serbia to become Serbia's first female physician and one of the first in Europe. After establishing her medical practice, Ljocić-Milošević became active in the universal suffrage movement. Sisters Milica (1854-1881) and Anka Ninković (1855-1923) from Novi Sad studied pedagogy at the University of Zurich from 1872 to 1874. Upon returning to Vojvodina they submitted plans for a private high school for girls in Kragujevac, based upon progressive, reform educational practices. Although unable to realize this project, they remained ardent and tireless feminist activists.

In contrast, at the beginning of the 20th century, the illiteracy rate among the general population of women in Serbia, as in many other predominantly agrarian cultures, was well above 70%. There were scant opportunities for girls to attend primary school and even fewer possibilities for more advanced studies. There were many cultural prohibitions against the education of women.

> Male peasants rationalized their authority over women by maintaining that women were stupid. Innumerable proverbs such as "Long hair, little wits," "Consult your horse or ox rather than your wife" were current. But once schools were established and a few peasant girls … were allowed to go to school, it was found that they could hold their own in learning, so that the mass of the peasants had therefore to revise their opinion about the intelligence of women.[5]

After 1918, dramatic changes began to take place in Serbia's education system. "During the interwar period, politically active women tended to be school teachers sent by the Ministry of Education to rural schools or organized university and professional women, educated women from urban families, who were frequently unmarried."[6] Likewise, "when women teachers began to be appointed to villages, the process went further, for peasant parents realized that there might be good sense in taking trouble over the education of their daughters, now that a daughter as well as a son could be expected to reflect credit on the family and bring an income to it."[7]

The real obstacle to continuing education at the high school level was the absence of grammar schools for women and finishing in one was an admission requirement for entering the university. In 1909, when the first generation graduated from the First Female Grammar School, higher numbers of women started enrolling in Belgrade University. By the First World War, 10% of all enrolled students were women.[8]

From 1911 to 1921, *Žena* (*Woman*), a monthly publication from Novi Sad, was published. The magazine, edited by Milica Jaše Tomić, explored the changing status of Serbian women. It acknowledged the strides made by the burgeoning women's movement, while warning of its dangers. In the first issue of *Žena*, a male contributor, Mita Đorđević, wrote that

> Our school structure from 1872 has ordered that female children, like male, are obligated to go to elementary school. But, if we can, we try to get female children out of that requirement. We let our female children into high school, but reluctantly, afraid that a woman might become serious competition for a man.[9]

The *Ženski Pokret* (*Women's Movement*) magazine, published in Belgrade from 1920 to 1936, focused on the expansion of educational opportunities for girls and women. The magazine was an organ of *Društvo za prosvećivanje žene i zaštitu njenih prava* (*Society for the Enlightenment of Woman and the Defense of Her Rights*). Among its many contributors was the architect Milica Krstić, who submitted articles on *Uređenje Beograda* (*The Design of Belgrade*) as early as 1926.[10] Her early writings on modernist design would presage her later contributions to the city's school of architecture.

Serbia's population explosion and shift from agrarian to urban lifestyles coincided with the women's rights movements – in 1921 women in Yugoslavia gained the right to vote, and by 1941 they had gained full legal status to own property. The late 19th and early 20th century educational system, however, still placed restrictions on where and when women could be educated. Most girls attended segregated schools, which trained them for employment in traditionally female occupations that did not offer pensions or wages that were comparable to those of their male counterparts. This started to change in 1909, when the first women were admitted to Belgrade University. By 1930, twelve female professors were on the faculty. "In the 1926-1927 academic year the student body of the University of Belgrade consisted of 4,688 men and 1,235 women, while in the Arts Faculty there were 707 women and 469 men."[11] In fact, there were enough female students to support the *Udruženje univerzitetski obrazovanih žena* (*The Association for University Educated Women*) which had its inaugural congress in 1927 in Novi Sad.

Alternative experimental arts schools for women began to open as early as 1910, when Expressionist dancer Maga Magazinović (1882-1968) founded a school for modern dance and gymnastics in Belgrade. Magazinović "was a philosopher, dancer, choreographer, and dance theoretician ... [who] developed Expressionist dance pieces."[12] Magazinović's modernist school followed the teachings of Isidora Duncan, while another dancer, Jelena Polyakova, started the first classical ballet academy in Belgrade. By 1933, Polyakova's ballet troupe had embarked on the first European tour in its history. The itinerary included Greece (1933), Romania (1936), Czechoslovakia (1938) and Bulgaria (1938).

The burgeoning artistic and academic educational opportunities for girls and women dovetailed with the emergence of female architects who found professional opportunities in the design of rural and urban schools in Serbia. Belgrade-born architect Jelisaveta Načić graduated from the Technical Faculty in Belgrade in 1900.[13] She spent her sixteen-year career working in the ministry of development and in the city's municipality. Her role for the city was limited, since those positions were open only to people who had served in the army (by definition, only men).[14]

Her younger colleague, Milica Krstić (1887-1964) was born Milica Čolak Antić on September 9, 1887 in Kragujevac.[15] She spoke many languages and had earned a degree from the Technical University in Belgrade in 1910. By 1915, she was working in the Architecture Department of the Ministry of Civil Engineering, where she would stay until her retirement on November 22, 1941. Her interests lay in her architectural practice and her associations with various women's organizations. She combined these two paths by documenting and archiving the contributions of Serbian women engineers. In the 1920s she completed a series of elementary schools in the Serbian villages of Godačica (1923), Slatina (1924), Dugo Polje (1924), Gornji Matejevac (1925), Crnobarski Salaš (1926) and Viničko (1928). This extensive series of projects was part of a larger national expansion of the educational opportunities for rural boys and girls.[16] It was also evidence of Krstić's professional energy, ambition and artistic vision.

Both Načić and Krstić designed and built a series of schools in Belgrade that reflected their interest in equal educational opportunities for boys and girls, as well as the challenge of creating a clean and healthy learning environment. By 1919,

The capital, which endured the reputation as the dirtiest and most unhealthy city in all of Europe, took first place in the number of deaths from tuberculosis and in the number of cases of communicable diseases ... In 1925, 625 people in Belgrade fell ill from scarlet fever, typhus, diphtheria, tetanus and dysentery.[17]

Much of the emphasis in the design of these new schools was the creation of a light and airy environment for Serbia's children.

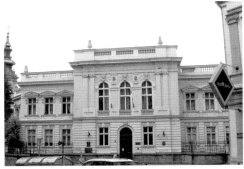

Fig. 8.1 Jelisaveta Načić, Osnovna škola Kralj Petar I, Kralja Petra I Street, No. 7, 1906. Detail of the front entrance.

Fig. 8.2 Jelisaveta Načić, Osnovna škola Kralj Petar I, Kralja Petra I Street, No. 7, 1906.

The design of the King Petar I Elementary School relies on the neo-Renaissance style that was popular in the first decade of the 20th century (Fig. 8.1). In many ways it is a precursor to the design of her later projects: the Church of Alexander Nevski (1912-1929) and the design for the grand staircase near the *Pobednik* (Victor) monument in Kalemegdan Park (1928). Načić's plan for the King Peter Elementary School has a central entryway with soaring ceilings that are flanked by two classroom wings. The neo-classical style features decorative exterior patterning, balustrades and floor-to-ceiling windows. The second floor houses an ornate formal hall while the first floors are organized around a central gymnasium for the students' daily exercise. In many ways, this elementary school embodies the marriage of cleanliness, hygiene and opulence. Its grandeur and detailed ornamentation signal a new attitude towards education in Serbia.

The school's façade is designed around a series of triadic windows. The front entrance separates the central space and two ancillary wings (Fig. 8.2). The first floor is adorned with a decorative, striped siding that evokes the horizontal lines of the city streets. These lines also accentuate the square, geometric forms of the first-story window treatments. Each division of three windows mimics the patterns established in the central block of rooms.

The school's second storey brings more elaborate ornamentation to the structure. Each of the three-window sequences is capped with decorative plasterwork pediments and a series of Palladian windows. The side windows create a similar series of repeated patterns, which

in this case are adorned with classically inspired capitals. Like the first storey, the side wings recede into space, forming a hierarchical spatial structure based on the optical dominance of the main rooms.

A decorative roof terrace or a kind of ornate entablature that joins one part of the design with that of the side wings visually unifies the school's façade. Framed by a series of neo-Ionic columns, the roof terrace links that level of the structure to the underlying faux columns that articulate the surface of the building's façade. As a unified front, the building exudes a sense of opulence and historical lineage that affirms the architect's debt to her neo-classical predecessors. Likewise, the two bas-relief portraits also give the building its historical place. On the left, Vuk Karadžić (1787-1864), Serbian linguist and reformer of the Serbian language, is depicted in profile, facing slightly to the right, while Načić captures Dositej Obradović (1741-1811), Serbian linguist, philosopher and author, whose profile is turned slightly to the left. This visual exchange between the two portraits emphasizes the symbolic scholarly heritage of the school building.

The rear of the school gives a different tone to the building. The triadic design of the fenestration of the façade is replaced with a series of four narrower double-paned windows that illuminate the classrooms and four-paned windows that indicate the location of the stairwells. The decorative patterning that is prominent on the façade is lacking in the anterior design. Likewise, the roof terrace remains only a façade articulation that is not extended to the rear of the building.

The dichotomy between the front and rear of the building can be seen as an understanding of the public and private nature of the educational process. From the front, the ornate exterior offers an alluring profile for passers-by and the urban surroundings. The rear of the structure takes its cues from the day-to-day struggles of its students and their teachers. As an institution of learning, it conveys both the opulence of its calling and the reality of its rigorous standards and processes.

The second high school for girls (renamed the *Elektrotehnička gimnazija Nikola Tesla* in 1956) is an expansive, well-organized school occupying more than 6,000 square meters (Fig. 8.3). Designed as a monumental space, it features vaulted ceilings, bas-relief decorative surface detailing, and a cupola. Its neo-classical columns, framed in iron, give the building an aura of timelessness. The school's second floor showcases a formal hall with concert acoustics and a column-lined gallery demarcated by an iron-gated partition. Its sense of opulence and clean and well-organized classrooms bear witness to the changing status of woman's education in interwar Serbia.

The four-storey school is designed around a series of curved roofs, cylinders and archways. The entryway door is capped by a fanlight window, a curved design element that is echoed in the entryway arch and the large roof (Fig. 8.4). Designed around a series of three Palladian windows, the building's façade creates a prominent and airy frontal appearance. Similarly, this fenestration pattern continues around the exterior of the building, along the side wings and towards the rear.

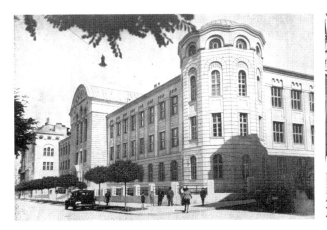

Fig. 8.3 Milica Krstić, Second High School for Girls, Kraljice Natalije Street, No. 31, 1932.

Fig. 8.4 Milica Krstić, Second High School for Girls, Kraljice Natalije Street, No. 31, 1932. Detail.

These curved archways, decorated with elaborate stonework, Doric engaged-plaster columns and surface reliefs, continue on the interior of the school, enhanced by pairs of supporting columns, soaring double archways and expansive public spaces. The October 19, 1932 issue of *Vreme* magazine described the amenities of the building, which was still under construction.

> In the basement of the high school there will be apartments for the employees, storage areas, central heating and other ancillary departments. On the first floor, besides offices and conference rooms, there is a plan for a large gymnasium, showers, a modern cafeteria and a nurse's station. On the first and second floors, there will be about ten spacious and light classrooms. Each classroom will feature a coat closet. On the upper floors there will be two offices for teachers and a larger office suite for the director and other school administrators. The high school will have its own chapel that will be built in memory of the St. Natalija church that once occupied that site. The chapel is located

in the formal main hall on the second floor. The chapel is demarcated by an iron gate that, according to need, allows a space for concerts, various formal events, as well as religious ceremonies.[18]

The partnering of opulence and attention to airy, healthy spaces is a marked attribute of the school. It is unusual in its approach to melding design, such as ornate interior ironwork, and modern showers, food-service areas and changing rooms. By the time the first students arrived in October 1933, the school had established itself as a significant, modern institution for the education of Serbian girls.

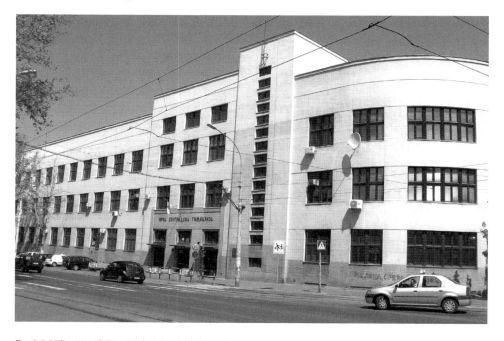

Fig. 8.5 Milica Krstić, First High School for Boys, Cara Dušana Street, No. 65, 1938.

The high school for boys, completed only six years later, is strikingly different from Krstić's earlier project. The school is now stripped of its decorative opulence (Fig. 8.5). It embraces contemporary international modernism with its emphasis on clean minimalism and ample, unadorned fenestration. Located at the corner of a busy intersection of Dušanova and Dositejeva streets, Krstić used a system of geometric blocks and curves to create a design that acknowledges Le Corbusier's interpretation of ocean liners and nautical motifs.

This school consists of three storeys and a basement. The classrooms are open and have large six- or eight-pane windows. The stairwells are dotted with a strip of single, repeated double windows that form a horizontal formation at regular intervals across the exterior façade. The school's flat roof creates a distinct optical line that links the street, the horizon and the building. A slight Corbusian nautical theme is evident in the corner curvature of the building that winds at the intersection of one busy street and the adjacent thoroughfare.

The striking differences between the 1932 and 1938 schools can, in part, be explained by the financial constraints of the time. The plummeting European economy necessitated that the 1938 school be built at much lower cost. To minimize the expense, Krstić streamlined many of the innovations in hygiene and cleanliness that had been promoted in the earlier school plan. It is also possible, however, to attribute some of the discrepancies to the gender differences of the student body. The women's high school was intended to be both an aesthetic masterpiece and an important social statement about the role that education could play in the lives of girls. The 1938 school, in contrast, asserts a more masculine visual tone that reflects the standardized educational policies that applied to male students. This building did not need to make a social statement about the education of boys.

Conclusion

It was fortuitous that Načić and Krstić were able to complete their school projects in Belgrade. These two female architects benefited from and contributed to a strong feminist social movement that linked educational reform with the need for modern hygiene. "What was lacking, argued the feminists, was an intelligent and well-organized plan for the development and modernization of Belgrade."[19] Likewise,

> the national public school system played an important role in the building of national consciousness and, therefore, also in nation-state building. The connection between female teachers and the first demands for equal citizenship is obvious, since women represented the majority of teachers and, therefore, the first massive group of formally educated women.[20]

Their school designs gave a public face to the changing social mores surrounding the value of educating both boys and girls.

By 1940, their practices had come to a halt and after the war neither woman would work as an architect again. Serbia's political and economic situation had changed drastically following the war, and little work was available for pre-war architects. It is also important to note that while these architects were excluded from post-war artistic production, many younger female practitioners, some of them active in the Partisans, would come to the fore, working on large urban projects such as the design and execution of residential housing complexes, hotels, schools, hospitals and museums in Belgrade and its suburbs.

Notes

[1] Francisca de Haan, Krassimira Daskalova and Anna Loutfi, *A Biographical Dictionary of Women's Movements and Feminisms: Central, Eastern, and South Eastern Europe, 19th and 20th Century* (Budapest: Central European University Press, 2006), 107.

[2] Ibid.

[3] Ibid.

[4] Ljubinka Trgovčević, *Planirana Elita: O studentima iz Srbije na Evropskim univerzitetima u 19. veku* (Beograd: Istorijski Institut, Službeni glasnik, 2003), 297.

[5] Susan L. Woodward, "The Rights of Women: Ideology, Policy and Social Change in Yugoslavia," in *Women, State and Party in Eastern Europe*, eds. Sharon L. Wolchik and Alfred G. Meyer (Durham, NC: Duke University Press, 1985), 244.

[6] Ibid., 239.

[7] Ibid., 244.

[8] *High Architecture Education in Serbia 1846-1971,* Faculty of Architecture, Belgrade, 1996, 39.

[9] Translation A. Novakov.

[10] Milica Krstić, "Uredjenje Beograda" *Ženski Pokret* 7/5 (May 1926).

[11] Celia Hawkesworth, *Voices in the Shadows: Women and Verbal Art in Serbia and Bosnia* (Budapest: Central European University Press, 2000), 162.

[12] Timothy O. Benson, *Central European Avant-Gardes: Exchange and Transformation, 1910-1930* (Cambridge, MA: MIT Press, 2002), 282. See also chapter by Popović in this volume.

[13] About Načić see, for example: Olivera Nožinić, "Jelisaveta Načić, prva zena arhitekta u Srbiji," *Zbornik za likovne umetnosti Matice srpske* 19, (Novi Sad, 1983), 275-293; Divna Djurić Zamolo, "Gradja za proučavanje dela žena arhitekata sa Beogradskog Univerziteta generacije 1896-1940. godine," *PINUS Zapisi* 5, ed. Aleksandar Kadijevic (Beograd, 1996), 42-46. See also chapter by Ćorović in this volume.

[14] In 1916, Načić was sent to a Hungarian concentration camp where she met and married Luka Lukai, an Albanian activist, and gave birth to a daughter. She retained her maiden name and did not practice architecture after the war. It is unclear whether she was able to draw a state retirement pension after the Second World War.

[15] See also: Snežana Toševa, "Arhitekt Milica Krstić (1887-1964)," *Godišnjak grada Beograda* XLIV (1997), 95-114.

[16] Krstić died in 1964 at her home on Silvija Krančevića ulica 7, Belgrade.

[17] Thomas A. Emmert, "Ženski Pokret: The Feminist Movement in Serbia in the 1920s" in *Gender Politics in the Western Balkans: Women and Society in Yugoslavia and the Yugoslav Successor States*, ed. Sabrina P. Ramet (University Park: Pennsylvania State University Press, 1999), 44.

[18] Translation A. Novakov. This text was published in the October 19, 1932 issue of *Vreme*. The icons from the chapel, executed by Lukjan Bibić and the architect Branko Krstić were removed and installed in the Church of St. Mark on November 14, 1948.

[19] Emmert, "Ženski Pokret," 45.

[20] Ibid., 295-296.

EXPRESSIONISM AND SERBIAN ARCHITECTURE BETWEEN TWO WORLD WARS

Aleksandar Kadijević and Tadija Stefanović

As a nursery of visionary, but mostly non-realized projects, expressionist architecture developed most fully in central and northwestern Europe in the period from 1908 to 1935.[1] Considered from a historical distance, it was the sum of the inconsistent art programs and temporary artistic phases of architects interested in expressionism. The most qualitative achievements and thematic-typological differentiation of expressionist architecture were reached in Germany, Austria, Czechoslovakia, Holland and Denmark. Its productive echoes can be observed in various Scandinavian countries, in Switzerland, Hungary, Poland, Italy, Turkey and the Kingdom of Serbs, Croats and Slovenes / Yugoslavia.

By following in the spirit of Edvard Munch's penetrating and emotional paintings such as *The Scream* (1893-1910) and works by German expressionist painters, and by working on memorial, industrial and trade fair facilities, architects Peter Behrens, Henry van de Velde, Hans Poelzig, Bruno Taut, Hans Scharoun and Max Berg developed the initial forms for a new direction in architecture, in opposition to the dictates of the straight lines of the functionalist Deutscher Werkbund, and its homogeneous typology and standardization.[2] In the years following the Great War, a spontaneous and powerful expressionistic "eruption" made a major impact on the art world by combining the fields of architecture, sculpture, easel painting, graphics, scenery, literature, theater, film and music production.

In order to overcome the apparent inconsistency inherent in lax interpretations of Expressionist architecture that often result in discussions of expressionism where there is none, it is necessary to separate methodologically *expressive form* from *expressionistic shaped buildings,* because these two are in the historiography arbitrarily identified as being the same. While in the first case the general expressive details remain primary or secondary compositional fragments, in the second case of expressionist shaped buildings the expressive details are the key elements to which the other elements of the architectural complex are subordinated.

Considered as the original works in a synchronic historical sequence of the first quarter of the last century, expressionist works primarily reflected the internal unrest of their inspired creators, who were unwilling to meet the requirements of investors through impersonal and strictly rational solutions. Refusing to adapt to the inherited historical contexts or to unify through functionalist paradigms the appearance of new settlements, expressionist architects offered an authentic vision of a recovery of culture at the time of a crisis of humanism, by restoring the architectural attributes of greatness and significance.

Compared to its pre-war period, expressionist architecture in the 1920s reached its maturity, which crystallized its ambiguous plastic language and adapted to contemporary spatial programs, constructive systems and functional materials. Failing to reach reconciliation with the major social contradictions of the turbulent interwar period, the aesthetics of expressionism in architecture became more politically engaged, which was the main reason for its later misunderstanding and suppression.

In the mid-1920s, the conceptual dichotomies of expressionist architecture led to the emergence of its avant-garde and romantic-traditionalist wings. Traceable since the inception of expressionism, such thematic polarization was fueled by the culture of nationalistic retrospectives, ideologically reinforced within an atmosphere of postwar shortages and political revisionism (in the defeated countries) or relentless triumphalism (in the victorious states). Both wings reflected the spiritual situation of the communities in which they developed, as the inner feelings and creative interests of ambitious architects. The two approaches differed significantly. The modern wing was forward-looking, thematically leaning towards abstraction, while the nostalgic wing looked towards a revival of the past and conventionally recognizable symbols. However, they were linked by a preference for dynamism of non-static, usually sculpturally modeled compositions.

Without deeper theoretical preparation and spontaneously accepted as a trend in architecture from Central Europe (Austria, Czechoslovakia and Germany) and with less delay as compared to Croatia and Slovenia, interwar expressionism in Serbia was mainly manifested through compositional exterior accents, and less frequently through a more comprehensive spatial structure. The ideas of expressionism reached Serbia indirectly via professional journals and a few international exhibitions, instead of through the study of seminal Central European architectural examples *in situ*. Moreover, in contrast to their Croatian colleagues, Serbian architects did not develop personal or professional collaborative contacts with the leading proponents of Central European expressionism, which is why their methods were not productively elaborated in domestic practice. Expressionism was not thematically taught at the university level, nor discussed within the criticism of the current architecture. Thereby it was reduced to the idiom suitable for adaptation to local conditions. However, the value

of individual works inspired by expressionism, as well as their parallelism with colorful expressionism in Serbian painting and similar trends in the avant-garde literature and music, show that the Expressionist style was substantially embodied in the Serbian cultural scene.

From the early twenties to the outbreak of the Second World War, expressionism in Serbia developed effectively through numerous examples.[3] Committed to interpreting the achievements of modern styles and their adaptation to the local environment (according to which almost every new building was treated as unique and prestigious), Serbian architects established *two types* of national expressionism. By avoiding single-styled and "clean" in favor of syncretic and layered architectural language, the followers of Romanticism had embraced expressionism wholeheartedly as a means of emphasizing the silhouette of the imaginative compositions by combining expressionism with matrices of post-secession and national styles. The modernists used expressionism to accent corners and to break down structures through rich plastic details. From these modernist tendencies expressionism appeared as a formative element of forthcoming styles. It is important to note that expressionism in Serbian architecture is embodied mainly in a moderate, noticeably restricted form, constrained by rigid building ordinances, which had impeded the horizontal and partly vertical plastic expansion of the units embedded in city blocks. Hence the larger expressionistic developments are primarily recorded in the architecture of individual public buildings, and rarely in family homes and apartment buildings.

On most realized and unrealized projects, mainly designed in Belgrade, Niš and Novi Sad (partly in Leskovac and Šabac), expressionism is evident in the form and sometimes in the organization of space, interior design and construction of recorded examples. Although only to a lesser extent embodied in a pure and fuller form, expressionism, in combination with elements of Czech cubism and Central European functionalism, French purism, and Art Deco, significantly participated in a crystallization of Serbian modernism.[4] Expressionism is also evident in pre-Modernism stages of the founders of Serbian modern architecture, and in the oeuvre of consistent advocates of national styles. In addition to proven modernists – Dušan Babić, Jan Dubový, Milan Zloković, Branislav Kojić, Dragiša Brašovan, Milan Minić and Josif Najman – an expressionistic repertoire in secular, religious and memorial architecture, as noted, was also exploited by the leading builders of a national-romantic vocation – Momir Korunović, Aleksandar Deroko, Aleksandar Vasić, Petar Popović, whose works expressed deep emotional and spiritual turmoil.

The symbolism of the free-soaring plastic components, dominant curves, sharp corners and curvilinear motifs, the search for inner "tension" in the contours of objects perceived as the "crown" of the ambiance, are evident mainly in the unrealized projects of prominent Serbian builders, but also in the works of the most talented students of architecture. Nationally-

oriented and modern-minded architects used expressionistic vocabulary to emphasize the position of objects in space and to strengthen the dynamism of their key compositional elements (entrance blocks, cantilevered projections, bay windows, openings, eaves, domes and various roof gables). In addition, by using the rich rhetorical potential of expressionist architecture (such as zig-zag ornaments, shapes, signs and structural accents that mimic means of transportation or emphasize military and religious symbols), these designers popularized the social, cultural and religious ideals that inspired them.

Compactly centralized or partially rolling jagged compositions of some of the projects of Serbian architects have been enriched by "shining," light-radiating silhouette effects, borrowed from Central European expressionists. Like their German, Austrian, Croatian and Slovenian contemporaries, Serbian architects skillfully enlivened massive walls of buildings serving different purposes by using elongated, usually hypertrophied arches of rhythmic arcades.[5]

Because of the long reign of doctrinal standards of the rationalistic historiography, it was only in the early 1990s that the two trends in Serbian Expressionism were discussed in historiographies and deserved further explanation.[6] Up to that point, all variants of modernism that deviated from strictly rational and functional International Style in architecture were neglected in Serbian discourse. For example, the most prominent Serbian modernist architects and later professors of architecture at the University of Belgrade, Milan Zloković and Nikola Dobrović, denied any quality to "subjective" Expressionist architecture. Because Zloković and Dobrović educated generations of architects and scholars in Serbia, the theme of Expressionist architecture was also suppressed in historiography. Under these circumstances, until the 1990s and the inclusion of belated post-modernist design, there was a deceiving perception that only the modernist idiom of the International Style was related to progressive and stylistically "pure" modernist architecture in Serbia. Here, a concise summary of the main examples of Expressionist architecture in the Serbian capital, including those major unrealized projects, demonstrates the relevance of the expressionist paradigm in the search for emancipatory architectural solutions. The prominent examples of expressionism conceived in Belgrade played an important role in the wider dissemination of expressionist architecture. Unlike most conventional local architects who were often restrained by building regulations, eminent Central European architects who built in Belgrade (Alexander Popp, Jože Plečnik, Hugo Ehrlich, Josip Pičman and Otto Bartning) exemplify ambitious attempts at a-perspectival expressionism.

In the creatively prosperous interwar period, architects in Serbia were hampered by economic backwardness and social conservatism. They nevertheless made major technical, social and aesthetic advances.[7] While open to outside influences, local architects adopted them loosely and elaborated selectively, thus developing concepts of national and Yugoslav styles,

enriching an eclectic methodology of academic architecture, and creating a compromised, ideologically inconsistent version of modernism.[8] In the context of coexisting trends in architecture, the matrix of contemporary European styles – Post-Secession (Austrian version of Art Nouveau), Czech Rondo-Cubism and functionalism, French purism, Dutch de Stijl, Bauhaus, Neo-classical monumentalism and Art Deco –was embedded selectively into contemporary buildings without a further theoretical superstructure. This is also the case with Expressionism, whose elements are recorded in Serbian architecture within the two already-mentioned trends – Romantic Expressionism and Modernist Expressionism.

Bigger strides in Serbian expressionist architecture are noted primarily in freestanding public facilities (in cities or outside of them), and rarely in family homes and apartment buildings. In the romantic wing, with few exceptions, the majority were perspectively static hierarchical solutions for churches and memorials, while in the modernist wing it is possible to note a-perspectival and combined designs. Anthropomorphic symbolism of the building was not developed because clients did not support such an approach, but rather expected the designers to emphasize aesthetically the conventionally recognized symbols of warfare, Serbian and Yugoslav patriotism, technical and scientific development, thereby strengthening the social impact of their own institution, company or family. While in the works of Romantic architects dominated hypertrophied sensuously rounded and spherical forms, in the works of modernists were accented sharp corners, swiftly directed surfaces, the solid geometry of the cylinder, cube, pyramid or triangle, which highlighted symbols of the dynamic materialistic age.

The Serbian cultural climate of the interwar society was susceptible to expressionism. The mentality of the population in this period was based on respect for the various regional traditions and romantic historicism – born in an atmosphere of unification of the Yugoslav peoples and their victory in World War I. The connecting tissue was a tendency to combine contemporary reality with the elements of national ethos – legends, epics and myths. In such a romanticized reality, expressionism easily found its place, instilling the dominant cultural memory with a recognizable visual identity. Hence, in Serbian architecture Romantic Expressionism developed first.

Romantic Expressionism (1918-1941)

The leader of a nostalgic quest for a national style in Serbian interwar architecture was architect Momir Korunović (1883-1969), who found support for his unfettered creative vision in the repertoire of Romantic Expressionism.[9] Trained in Czechoslovakia[10] and inspired by the epic of the recent war in which he had actively participated, Korunović

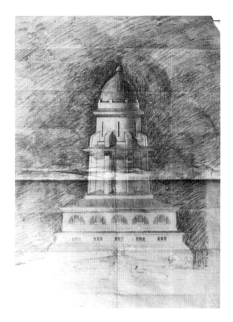

Fig. 9.1 Momir Korunović, The Memorial (Spomen-obeležje), 1921. Drawing.

upgraded nostalgic historicism in his numerous projects by means of expressionism. Thus he became the most agile affiliate of this synthesis. For example, the expressive pyramidal silhouette of his unrealized *Monument of Undead Giants* (*Spomenik neumrlih velikana*) (1918) anticipates the structure of his subsequent realized monuments.[11] The polymorphic form of the monument's dome which, along with the sharp lines of the gable, triple and oriel windows that Korunović frequently applied in his later expressionist works, is especially striking. The powerful expressive charge of the architectural forms, collected in a circular tree topped with a stylized neo-Byzantine dome, characterizes the elaborate drawing of *The Memorial* (*Spomen-obeležje*) (1921) (Fig. 9.1).[12] In this inspiring project Korunović for the first time treats expressionistically the entire design rather than only individual areas of the building, such as sharp edges of the middle zone. The preserved sketch of the monumental *Serbian Pantheon* (*Srpski panteon*) (1922) shows Korunović as an imaginative dreamer, the builder whose vision goes beyond the possibilities of real production.[13] A tense relationship between the massive, intrusively dense domes (designed with Secessionistically stylish reminiscences) reflects the expressive nature of this imaginary construction.

The infiltration of patriotic pathos and expressionistic vocabulary (with traces of Secession/Art Nouveau) dominates the design for *the Gate of Victorious Šumadinacs at the Belgrade Savinac* (*Kapija pobedonosnih šumadinaca na beogradskom Savincu*) (1922).[14] *The Gate* is characterized by its visually appealing but dominant silhouette, as well as by the pleasing polychromy and rich symbolic decoration that envelops the monolithic concrete tower. Korunović's *Tower of Saint John Vladimir* (*Pirg Svetog Jovana Vladimira*) built in the courtyard of the monastery of St. Naum on Lake Ohrid (1925-1929, demolished after the Second World War) (Fig. 9.2) thematically combines motifs of memorial and church, integrated by a solid tripartite division on the base, the shaft and the top.[15] The steep rock cliff on which *the Tower* rests represents a natural substructure for this intrusive object, which is thus organically embedded in a heroic landscape. A strong expressionistic energy of the curvilinear forms emerges from the middle

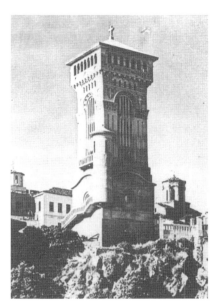

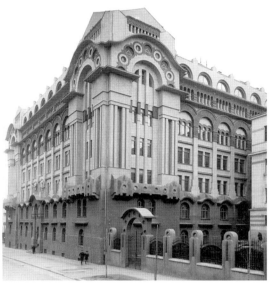

Fig. 9.2 Momir Korunović, Tower of Saint John Vladimir (Pirg Svetog Jovana Vladimira), The monastery of St. Naum on Lake Ohrid, designed in built in 1929. Demolished after the Second World War.

Fig. 9.3 Momir Korunović, The Palace of the Ministry of Post and Telegraph (Palata Ministarstva pošta i telegrafa), Belgrade, 1926-1930.

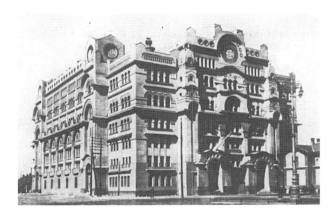

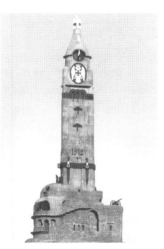

Fig. 9.4 Momir Korunović, The Post Office No. 2 (Pošta 2), Belgrade, 1927-1929. Collapsed in the bombing of 1941-1944, and after the war inadequately rebuilt by Pavle Krat.

Fig. 9.5 Momir Korunović, The Memorial Chapel (Spomen-kapela), Zebrnjak, near Kumanovo, today F.Y.R. of Macedonia, 1934-1937. Destroyed in 1941.

and upper parts of the structure. Conversely, *the Palace of the Ministry of Post and Telegraph* (*Palata Ministarstva pošta i telegrafa*) (1926-1930) in Belgrade (Fig. 9.3) which occupies the entire city block is the most striking achievement of this National-Romantic expressionist style.[16] The shapes of its basis and tripartite façades link *the Ministry* to conventional academic principles of architectural composition. Its other attributes, however, point to an unusual and original Romantic-Expressionist building. Full of inner strength that emanates from massive, compact volumes, and expressive contrasts of horizontal and vertical accents, light and dark areas, the building leaves no one indifferent. Echoes of Czech Rondo-Cubism, Saint-Petersburg's Art Nouveau and Serbian Neo-Morava medieval architecture are rhythmically intertwined along the three thematically uniformed and hierarchically even façades, covered with abstract and conventionally recognizable symbols.

For his next significant achievement, *the Post Office No. 2* (*Pošta 2*) in Belgrade (1927-1929, which collapsed in the bombing of 1941-1944, and after the war was inadequately rebuilt) (Fig. 9.4) Korunović also "stirred" the composition of vertically protruding wall blocks.[17] The swollen spatial dynamics of the elongated arcs entirely imprinted the restless expressionist silhouette. Details of the secondary plastic and colorful heraldic decorations further enlivened the expressive program of this building. Korunović reiterated in milder form elements of Romantic Expressionism in the *Church of St. Sava* (*Crkva Sv. Save*) in Celje (1929-1932, demolished in 1941).[18] The church's design was inspired by medieval church architecture of the so-called Morava style. By unforced breakdown of the primary masses and rhythmic use of spherical shapes filled with decorative applications, Korunović created his most picturesque church.

The arch has expressive connotations in Korunović's *Sokolovi's Home – Main Cultural Center* (*Sokolski dom Matica*) in Belgrade (1929-1935).[19] The building achieves the purity not of form, but of expressive power through its superimposed layers which are connected to romantic tradition, folklore, and Expressionist architecture. The characteristic rhythm of arched openings done in Korunović's idiom as a means of facilitating and enlivening façades comes to the fore in *the Sokolovi's Home* (*Sokolski dom*) in Kumanovo (1930).[20] By soft contoured shapes and contrasts of colors, Korunović initiated a live interplay of the arches and gables on all parts of the façades. And Korunović's scheme of sliding the vertical parts of the façade towards the center of the composition, enriched by original decoration of semi-abstract content, can here be seen to have been frequently applied.

The Memorial Chapel (*Spomen-kapela*) on Zebrnjak (1934-1937, destroyed in 1941) (Fig. 9.5) is the solemn and monumental symbol of the heroism of the Serbian army in its Kumanovo victory over the Turks in the First Balkan War in 1912.[21] In the architecture of this memorial building sculpturally modeled and visible from a distance, Korunović achieved the

anthological synthesis of his Romantic-Expressionist creative search. Expressionistic sensibility is contained in a triangular base, developed pedestal and the free modeling of the high tower with strong silhouetted-symbolic emphasis. It is complemented by the distinctive semiotics of the heraldic decorative plastic and night lighting by the *Petromax* paraffin lanterns placed in the niche of the egg-shaped topping of the obelisk. In its sculptural silhouette and organic composition, the *Memorial Chapel* on Zebrnjak to some extent follows the conceptual design of the Einstein Tower in Potsdam (1920) by Erich Mendelsohn.[22]

Korunović's strong Romantic-Expressionist imagination is confirmed in his *Church of St. George* (*Crkva Sv. Djordja*) in Sušak (1938).[23] The church is also the result of the renewed concept of a synthesis of the Morava school of Serbian medieval architecture and moderate forms of central European Expressionism. By using strong contrasts of curved and sharp forms, Korunović was reviving plastically the design of the traditional Morava church.

Architect Milan Minić also embraced the spirit of expressionist architecture in the early period of his creative work. His lyrical and romantic receptiveness is evident in the architecture of the *Memorial Chapel with the Ossuary* (*Spomen-kapela sa kosturnicom*) in Prnjavor, Mačva (1922-1938).[24] If Korunović's expressionism was too intrusive and outrageous, Minić's was significantly toned down and concealed. In order to achieve the original concept and avoid direct reliance on the traditions of Serbian medieval architecture, the architect has thus entered the realm of architectural improvisation, in which the expressionistic component is contained in the bold shapes of the curved tympana.

In their unrealized project for the *Pavilion of the Kingdom of Serbs, Croats and Slovenes* (*Paviljon Kraljevine SHS*) in Philadelphia (1925) brothers Petar and Branko Krstić skillfully enriched the methodology of Post-Secessionism with layers of Expressionism.[25] The compact composition of the symmetrically spaced lower compounds (arcades, arches and windows) is crowned by a centralized expressive elevation of stepped corners of the towers and the base of the dome, enriched with sharp edges. With its eclectic decor and formal stiffness, the *Philadelphia Pavilion* encouraged a future Romantic-Expressionist creative quest, visible in numerous projects by many students of architecture at the end of the 1920s – above all in the works of Djurdje Bošković, Jovan Ranković and the above mentioned Branko Krstić.[26]

Expressionistic elements are also present in several competition projects for the *Church of St. Sava* (1926) in Belgrade.[27] Since the commissioners of the church sought monumentality and authorial originality, but did not provide sufficient specificity with respect to the conditions of the competition, a number of architects demonstrated a tendency towards freer expressionism in their projects. The project submitted by the Krstić brothers represents a Romantic-Expressionistic inspired solution that captures the power of the imaginative stepped-jagged structure.[28] By its reduced construction of strong, dominant circular and

semicircular volumes, a joint project proposal of Milan Zloković and Andrey Vasilevich Papkov radiates the power of a monumental symbol, a restless and radiant expressionistic silhouette (Fig. 9.6).[29] Architect Dušan Babić also skillfully combined elements of Post-Secession, Expressionism and Art Deco. Expressionistic elements are reflected in the original modeling of the low, overhanging entrances of the church, and aggressively prominent motifs of arches which, owing to their lively and plastic rhythm, modernize the overall appearance of the imaginary building.[30]

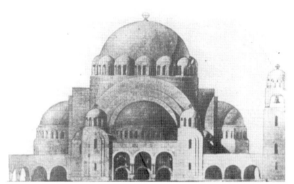 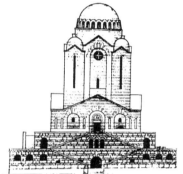

Fig. 9.6 Milan Zloković and Andrey Vasilevich Papkov, The Church of St. Sava, Belgrade, 1926. Competition design – unrealized.

Fig. 9.7 Milan Zloković, The Ossuary (Kosturnica), Zejtinlik, Thessaloniki, Greece, 1926. Competition design – unrealized.

Romantic-Expressionist momentum can be noted in the project for the *Ossuary* (*Kosturnica*) in Zejtinlik (1926) by Milan Zloković (Fig. 9.7).[31] Historians have correctly compared this project to the radio station in Kootwijk by Julius Maria Luthmann.[32] Both buildings are designed on a similar visual pattern: a solid ground with a powerful body and small openings, characteristic of the Expressionism idiom. As in Zloković's project and the completed project of the *Ossuary* in Zejtinlik (1926-1936) by Aleksandar Vasić,[33] there is a feeling of expressionist dynamism that emanates from such modernized Serbo-Byzantine architecture. Through later interventions by the academician Nikolai Krasnov the expressive power of the arch motif is somewhat alleviated through the application of academic-style profiles, archivolts and wreaths.

The Expressionism of Branislav Marinković's competition project for the *Warrior's Home* (*Ratnički dom*) in Belgrade (1929)[34] is the result of the free fusion of the Serbo-Byzantine architectural heritage and Berlin Romantic Expressionism (cf. the building of the Great Theatre by Hans Poelzig).[35] Obvious Neo-Gothic, Neo-Secession, Art Deco and Expressionistic references can be noted in the styling of the highest floors of the *Belfry in the church courtyard of St. Vasilije of Ostrog* (*Zvonara crkve Sv. Vasilija Ostroškog*) in Prijepolje (1933) by Milan Minić.[36] The morphology of the sharp triangular tympanum of the top floor is a type of continuation of his chapel in Mačva Prnjavor. In Prijepolje, by using the expressive northern form of a prominent bell tower (here understood as the crown of the city) Minić evoked trends of European architecture that did not have closer ties with the earlier Serbian cultural tradition.

Expressionism is once again evident in the sacral projects carried out by Dušan Babić. What he tried to realize in the monumental project of the national church of St. Sava he succeeded in doing in the realization of the *Memorial Church of St. Peter and Paul with the Ossuary* in Doboj a decade later (1938).[37] By combining elements of Art Deco, Art Nouveau and Expressionism, Babić achieved a remarkable artistic synthesis.

The interweaving of Romantic and Modernist elements of Expressionism in architecture was realized in the *Palace of Sima Igumanov* (1937-1938) built following the design of Petar and Branko Krstić.[38] The expressionistic character of this building is anchored in the elongated arches, which evoke the symbolic forms of the Serbo-Byzantine building tradition. A more comprehensive expressionistic program characterizes the *Student Dormitories of the Theological Seminary* (*Internat studenata Bogoslovskog fakulteta*) in Belgrade (1939-1940) by Aleksandar Deroko and Peter Anagnosti (Fig. 9.8).[39] The expressionist power of this facility is based on the rich plasticity of the primary wall masses, whose center is dominated by a cubic tower. In addition to its direct "brick expressionism," this building still attracts with its delightfully open porch in the middle of the ground floor.

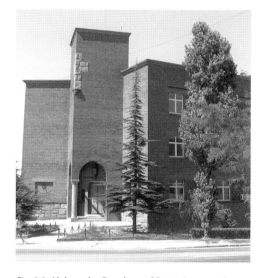

Fig. 9.8 Aleksandar Deroko and Peter Anagnosti, Student Dormitories of the Theological Seminary (Internat studenata Bogoslovskog fakulteta), Belgrade, 1939-1940.

In its most comprehensive form, the spirit of German northern Expressionism, supported by strong Gothic reminiscences, is exhibited at the *German Evangelical Church* (today's *Bitef Theater*) in Belgrade built after the project by Otto Bartning (1940-1942).[40] Expressive Neo-Gothic shapes, combined with a brown brick, complemented Bartning's previous concepts of church architecture, announcing the direction which would develop in the future.

Modernist Expressionism

Chronologically speaking, the first recorded examples of Modernist Expressionism in Serbian architecture were in the capital, and are datable to the middle of the 1920s. It was at that time that the expressionistic motifs of in-cut corners and sharp bow-windows, ribbed beams and masts, appeared in the building of *The First Steamers Company of the Danube* (*Prvo dunavsko parobrodsko društvo*) in Belgrade (1924-1926) built by Austrian architect Alexander Popp and Yugoslav designer Stevan Tobolar (Fig. 9.9).[41] Popp incorporates the expressive power of angular motifs referencing his influential mentor Peter Behrens and, specifically, his *Hoechst Office Building* in Frankfurt-am-Main. The similarities between these two structures are reflected in the dispersed arrangement of the masses, their soaring character, and the positions of the clock and mast. Although the Belgrade project was one of the first early Modern structures whose expressionist features were a radical step forward in terms of aesthetics, the Belgrade

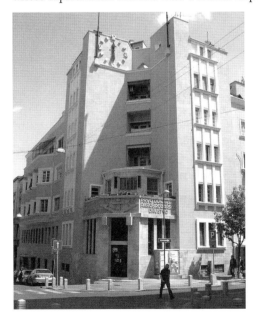

public, as usual, did not immediately accept such extreme innovation. The expressionist assembly of the building, unconventional at the time, was too incomprehensible to the wider population. This was further reiterated in the daily *Politika* (*The Politics*) when a writer opined that "half of Belgrade would, no doubt, swear that this house is not in Belgrade."[42]

Fig. 9.9 Alexander Popp and Stevan Tobolar, The First Steamers Company of the Danube (Prvo dunavsko parobrodsko društvo), Belgrade, 1924-1926.

An expressive mixture of modernist and traditional forms of secular folk architecture can be seen in the house in Zadar Street No. 6 in Belgrade (1926) by Branislav Kojić (Fig. 9.10) as an example of modernized folklore.[43] Expressionist motifs appear in the curved bow-windows on the façade that make the whole building "rolling." A significant achievement of a more moderate course of Modernist Expressionism in Serbian architecture is evident in *the Institute for Printing Banknotes and Minting Coins of the National Bank* (*Zavod za izradu novčanica i kovanog novca Narodne banke*) (1927-1929) on the Topčider hill in Belgrade built by Josif Najman (Fig. 9.11).[44] To the expressionistic representational vocabulary belong the wavy grooved structure of side façades, the disposition of windows as well as the unconventional treatment of the interior (the department for printing), with its distinct ribbed structure of the unusual, slanted vault. Here, the expressionist morphology was applied in an interior for the first time in Serbian architecture. A possible model for such a solution in the interior may have been the expressionistic vaulting of the *Hat Factory* in Luckenwalde by Erich Mendelsohn.

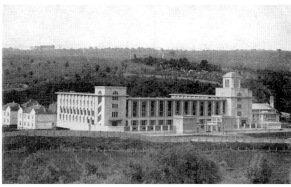

Fig. 9.10 Branislav Kojić, House in Zadar Street No. 6, Belgrade, 1926.

Fig. 9.11 Josif Najman, The Institute for Printing Banknotes and Minting Coins of the National Bank (Zavod za izradu novčanica i kovanog novca Narodne banke), Belgrade, 1927-1929.

In contrast to a peaceful, harmonious composition of the lower zones of the front of *the Institute*, the wavy corrugated structure of the eastern and western wings is rhythmically expressionistic. They are enriched by the play of light and shadow. The expressionistic dynamism on the sides is achieved by the contrasting curves of the protruding bays and window lines of the staircase towers, arranged in opposite directions (north-south). *The Institute* was inspired by industrial architecture and modeled on similar solutions in Najman's *Banque de France* located in a wooded suburban landscape. Thus, Najman inextricably merged threads of metaphysical worlds of fantasy and reality.

Jan Dubový incorporated features of expressionist urban design into his 1928 project, the *Market hall* (*Pijaca*) on *Flower Square* (*Cvetni Trg*) in Belgrade.[45] This unrealized project of an expressionistically graded centralized building somewhat follows the architectural scheme of the *Century Hall* in Wrocław, the classic accomplishment of Max Berg (1912-1913).

As an agile Serbian leader of the architectural avant-garde, Milan Zloković also employed elements of expressionism. They are visible in his project for the *Guard Maritime Museum* (*Muzej pomorske straže*) in Split (1928).[46] Here, the expressive marking of symbolic forms resulted in the effectively solved corner of the building. Through the symbolism of forms Zloković sought to express the function of the museum, and for this purpose he used the expressionist motif of the rampant prow of the ship.

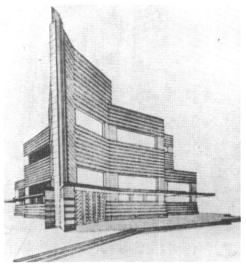 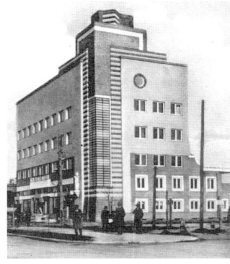

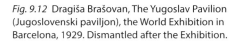

Fig. 9.12 Dragiša Brašovan, The Yugoslav Pavilion (Jugoslovenski paviljon), the World Exhibition in Barcelona, 1929. Dismantled after the Exhibition.

Fig. 9.13 Dragiša Brašovan, The Workers' Hall (Radnički dom), Novi Sad, 1929-1930.

Among the most valuable achievements of Modernist Expressionism in interwar Serbian architecture is *the Yugoslav Pavilion* (*Jugoslovenski paviljon*) presented at the World Exhibition in Barcelona in 1929 by Dragiša Brašovan (Fig. 9.12).[47] Although it was his first project realized in a modern style, Brašovan achieved the highest limits of the expressionistic idiom in architecture. The asymmetrical composition of the pavilion was confronted by harshly amplified angular bow motifs that contrasted with a calm horizontal linear structure of

decorated façades and rectangular windows. A potential model for this work could be the famous *Chile House* (*Chilehaus*) in Hamburg (1923) by Fritz Höger.[48] The general impression is that, in contrast to the *Chilehaus*, Brašovan's *Pavilion* exhibits an even narrower frontal part. Similarly, unlike in Höger's building the rampant pace of a vertical bow is not accelerated by strong accents. In its sticking expressively protruding and plastically articulated incisions of façades, treated through the horizontal rhythm of lines and openings, the *Yugoslav Pavilion* resembles a villa in Charlottenburg/West End, near Berlin designed by Erich Mendelsohn. The light-and-dark effects are similar to those of the two houses by Adolf Loos from 1928 – the Spanner country house in Vienna and the house of Josephine Baker in Paris.[49] The scattered angular forms of *the Pavilion* are similar to those in Erwin Gutkind's building *Wohnanlage Sonnenhof* in Berlin (1925). In his later work Brašovan followed Mendelsohn's and Gutkind's expressionist approach as well.

During 1929-1930, Brašovan also designed *the Workers' Hall* (*Radnički dom*) in Novi Sad in the expressionist manner (Fig. 9.13).[50] With this imposing building Brašovan demonstrated a remarkable ability to eclectically synthesize different expressionist poetics of the Amsterdam School and Northern German Expressionism. However, the greatest similarity is observed in the expressionist works of the less well-known German architect Erwin Gutkind. It is reflected in the approach to composition and choice of materials and colors (red brick, white façades and glass). The expressionist motif of a corner tower, emphasized by effective, functionalistic design of glazed surfaces, dominates the structure. Nevertheless, with its façade of scattered laminated brick, supplemented by figural architectural plastic, the building conveys a somewhat scenographic impression.

The combination of characteristic elements of expressionism (the ship's prow motif and horizontal façade slits), previously applied to the Brašovan's Pavilion in Barcelona, is also observable in a project for *the Hall of the Yugoslav Association of Engineers and Architects* (*Dom udruženja jugoslovenskih inženjera i arhitekata*) (1930) by Dušan Babić.[51] The expressionistically accented angle along the vertical axis of the frontal part of the façade with its striped horizontal incisions is juxtaposed with the glass surfaces at the corners of the façade. By using the contrast between the vertical sharp section of convex mass and horizontal eaves of the ground and upper floors, Babić considerably enlivened the cubic form of the building.

Expressionistic motifs appeared in the unrealized design for *the Post Office No.1* (*Pošta 1*) in Belgrade (1930) by architects Josip Pičman and Andrija Baranji.[52] Because the architecture of this project has been mainly characterized as functionalist, its more than evident expressionistic elements have been overlooked for long time. The strong expressive curvature and compositional asymmetry are outlined on the long street section of the building, both in its plan and façade elevation. Expressionistic visual accents proved to be an extremely daring avant-garde reaction

to traditional academic design principles. However, under King Aleksandar, the architect Androsov realized the building in a quite different, monumental neo-Academic idiom, which was the style appealing to Serbian bureaucracy and bourgeoisie at the time. Architect Androsov just kept faithful to the floor plan of Pičman's and Baranji's design.

In the early Modernist Expressionism in Novi Sad, certainly the most frequent motif was the bay window of triangular prismatic shape, which abutted the façade. This motif is particularly striking in the building of *the Chamber of Trade and Crafts* (*Trgovačka i zanatska komora*) (1930) by Milan Sekulić.[53] Here, expressionistic emphasis is mainly the result of the necessary integrative solution, which bridges the gap that emerged between traditional and modernist design principles. While the expressionistic layer remained contained in a rigid and overly static composition of *The Workers' Hall* and *The Chamber of Trade and Crafts*, expressionism in the architecture of Novi Sad became softer and more subtle in *the Center for Trade Youth of Novi Sad* (*Dom novosadske trgovačke omladine*) (1930-1931).[54] This project announced the expressionist oeuvre of its author, architect Djordje Tabaković.

The early 1930s mark the appearance of a special trend in Serbian architectural design, which is characterized by the abandonment of traditional plans (of rectangular and square shapes) in favor of more liberal and autonomous ways of arranging floor plans. In such unrealized projects as Prljević's restaurant in Topčider (1930), Kojić's pavilion in Zagreb (1930) and Simeonović's railway station in Skopje (1931)[55] there are visible elements of De Stijl architecture and Modernist Expressionism: broken trefoil or horseshoe plans, curves and rounded longitudinal cubic volumes.

While the expressive power of Prljevićev's project for the Topčider restaurant was based on the dynamic alternation of long longitudinal volumes with rounded ends and glass curtain walls, in Kojić's project for the pavilion this expressive power is a striking contrast between the dispersed longitudinal tracts of richly rounded corners and dense cubic masses in the central part of the building. An extremely diversified dynamic composition is evident in Simeonović's project for the railway station. Here, the Expressionistic emphasis is on the frontal angular side with its high cubic tower opened via thick rows of windows and strip parapets.

The motif of a curved balcony as an element of expressionism in the architecture of Belgrade and Serbia was used more frequently starting in the early 1930s. This was primarily due to the imitation by Serbian builders of the somewhat later expressionist works of Erich Mendelsohn and Hans Scharoun. Almost simultaneously this motif appeared in Belgrade and Novi Sad. The first example of the expressive curved balcony is the one the Krstić brothers used on the project for the family villa of Stjepo Kobasica.[56] This building was built in 1931 in the elite neighborhood known as the *Professors' Colony*.[57] It is a corner building of complex form. The distinctiveness of its architectural design is based on a strong contrast between

arched masses and cubic volumes. However, the creatively jagged volume of external masses is not achieved at the expense of the functionality of the interior. By the dynamic launching of the corner loggia balcony, the architects have achieved a lively, expressive rhythm. The Krstić brothers strengthened the expressionistic rhythm of the entire façade by complementing the composition through asymmetrically distributed and unevenly leveled windows.

On similar grounds was developed the expressionist aesthetics of *the Nikić's Palace* (*Palata Nikić*), today the Netherlands' Embassy in Dositejeva Street, in Belgrade (1932).[58] Architect Hugo Ehrlich himself emphasized Mendelsohn's architecture as an immediate source for this work. The expressionistic effect was achieved by free varying of the motifs of curved oriels. Expressionistic immediacy and innovation, however, were lost during the project's realization. The style of the building reflects expressionless functionalism more, while traces of expressionism were preserved to a lesser extent only in a thin glassed oriel window.

A very odd eclectic mix of modernist functionalism, romantic symbolism and organic expressionistic modernism is represented in Philip Smith's cement factory in Beočin (1934).[59] The architecture of this building is dominated by low tilted walls, an unusually carved roof and longitudinal plant set within the horizontal axis of the roof. The most expressive solution is a roof structure that boldly emerges from a low wall, and like a shield closes the longitudinal tract of the factory hall.

The former *Fire Command* (*Požarna komanda*) building in Belgrade (around 1935) built by an anonymous architect was one of the most outstanding examples of Modernist Expressionism in Belgrade, enriched by layers of popular Art Deco. An imaginative combination of glass and curved parapet walls on the semi-elliptical corner tower and continuous alternation of horizontal strips and façade slits in the background contributed to the realization of the ideal of unrestrained expressionistic vibrancy. The expressionistic layer of this building has been completely lost in the post-war reconstructions and modifications.

Associative-symbolic expressionistic motifs are woven tightly into the architectural program of the monumental *Air Force Command* (*Komanda ratnog vazduhoplovstva*) in Zemun (1935-1936) (Fig. 9.14).[60] Architect Brašovan strove to have this building (as the crown of the surroundings) reflect in symbolic terms the idea of aviation by evoking aircraft forms. The façades with emphasized rounded ends, dominated by a glass tower accented with sharp corners, belong to the expressionist architectural genre. This facility shows that expressionism in Serbian architecture tended not only to visually transform the existing environment but also to popularize science and technology.

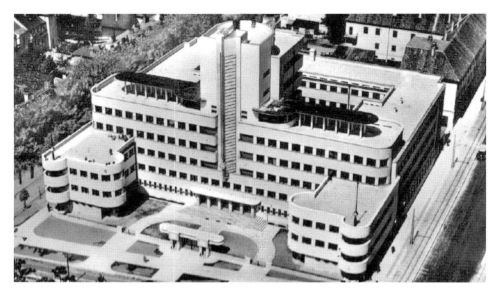

Fig. 9.14 Dragiša Brašovan, The Air Force Command (Komanda ratnog vazduhoplovstva), Zemun, 1935-1936.

The best-known work of Modernist Expressionism in Novi Sad is *the Palace of Danube Banovina* (*Palata Dunavske banovine*) (1936-1939) by Dragiša Brašovan.[61] Here, expressionism primarily managed to alleviate an extremely hard modernist scheme of its highly developed horizontal block, supplemented with a vertical tower. The symbolic layers are evident, as Brašovan sought to convey the impression "of the ship in a plain," the embodiment of safety and salvation. Along with Korunović, he was the Serbian architect most engaged in adapting the spirit of expressionist architecture to the programmatic and ideological needs of the epoch.

In southeastern Serbia expressionism is revealed in the curved entrance area and slanted roof of the house of Ljuba Marinković in Leskovac (1937-38), built by Branislav Kojić,[62] and especially in the structure of *the Apprentice's Home* (*Šegrtski dom*) in Niš (1938-1939), designed by Aleksandar Medvedev.[63] By rounding the projecting wing of the side and by curving the front façade Medvedev released the accumulated energy of *the Apprentice's Home*, here understood as a "modern crown" and expansive pivotal point of the city. In the rounding of the lateral tract of the building, this structure is similar to the *Air Force Command* building in Zemun. In the curving of the front façade the building is similar to the visionary design of the *Post Office No. 1* in Belgrade by architects Pičman and Baranji. Yet *the Apprentice's Home* essentially derives from the local reception of Mendelsohn's architectural aesthetics.

Inspired expressionist compositions prevail in unrealized projects for the Belgrade *Commercial Mortgage Bank Fund – Palace Albania* (*Hipotekarna banka Trgovačkog fonda– Palata Albanija*) from 1939. The design by architect Milan Zloković is similar to Mendelsohn's expressionist solution for the Schocken department store in Stuttgart, as well as department stores in Nuremberg, Breslau and Chemnitz. The expressionistic physiognomy of Zloković's building was formed by the bold use of rounded towers, high mezzanine and strong frame construction, and by their effective over-emphasis on suppression.

The most expressive project was submitted by Milorad Pantović, then still a student of architecture. It seems that the bold intrusive form of this project brought together the famous corner solutions of Höger's *Chile House* and Mendelsohn's *Petersdorff* department store in Breslau. The vertical broken down corner of the front of the tower looks like Brašovan's tower of *the Palace of Danube Banovina* in Novi Sad.

Elements of late pre-war Expressionism can also be observed in the building of an industrialist, Milan Dimić, in Bulevar Kralja Aleksandra nos. 81-83 built in 1938. The project was that of Russian émigré architect Valery Stashevsky.[66] Here, the expressionistic effect was achieved by alternate rhythmic overlapping of the graded façade, where by sliding the corner axis from the horizontal plane Stashevsky achieved an impression of multiple vertical bows. The prototype for this type of façade rhythm may have been Emil Fahrenkamp's famous expressionistic *Shell House* (1930) in Berlin.

In more or less explicit form Expressionism was long present in Serbian architecture between the wars. In the last few pre-war years it noticeably dodged the onslaught of sterile monumental late modernistic and academic concepts. It was revived a few decades later in the "non-canonical" wing of the so-called Belgrade School of Modern Architecture, and in the subsequent creations of the Neo-Modernists.[67] This overview of the most important architectural achievements of interwar Serbian Expressionism demonstrates the variety of methods architects used in designing structures of various purposes in search of modern architectural solutions. Prominent as well as lesser-known builders were equally inclined towards the innovative morphology and seductive symbolism of expressionism. Their work has not yet been examined sufficiently. Hence, more thorough research and analysis of many other uninvestigated examples of expressionism in architecture, especially those in the smaller towns of Serbia, is needed.[68]

Notes

¹ See: D. Sharp, *Modern Architecture and Expressionism,* New York, 1966; F. Borsi, G. K. König, *Architettura dell'Espressionismo*, Genova, 1977; W. Pehnt, *Expressionist Architecture*, London, 1973; I. Boyd Whyte, "The End of an Avant-Garde: The Example of 'Expressionist' Architecture," *Art History* 3/1 (March 1980), 102-114.; Ibid., "The Politics of Expressionist Architecture," *Architectural Association Quarterly* 12/3 (1980), 11-17; W. Pehnt, *Expressionistic Architecture in drawings*, London, 1985; K. Frampton, "The Glass Chain: European Architectural Expressionism," in *Modern Architecture, a critical history* (London, 1987), 116-122; V. M. Lampugnani, R. Schneider eds., *Moderne Architektur in Deutschland 1990 bis 1950: Expressionismus und Neue Sachlichkeit*, Stuttgart, 1994; W. Lesnikowsky ed., *East European Modernism*, London, 1996; T. Benson ed., E. Dimenberg, D. Frisby, R. Heller, A. Kaes, I. Boyd Whyte, *Expressionist Utopias: Paradise, Metropolis, Architectural Fantasy (Weimar and Now: German Cultural Criticism)*, Los Angeles, 2001; R. Stamm, Daniel Schreiber eds., *Bau einer neuen Welt: architektonische Visionen des Expressionismus*, Cologne, 2003.

² J. Campbell, *The German Werkbund: The Politics of Reform in the Applied Arts,* Princeton, 1978; K. Frampton, "The Deutsche Werkbund 1898-1927," in *Modern Architecture*, 109-115; F. J. Schwartz, *The Werkbund: Design Theory and Mass Culture before the First World War,* New Haven, 1996.

³ A. Kadijević, "Elementi ekspresionizma u srpskoj arhitekturi između dva svetska rata," *Moment* 17 (Beograd, 1990), 90-100; Ibid., "Ekspresionizam u beogradskoj arhitekturi (1918-1941)," *Nasledje* 13 (Beograd, 2012), 59-77; Ibid., "Expressionism and Serbian industrial architecture," *Зборник за ликовне уметности Матице српске* 41 (Novi Sad, 2013), 103-110.

⁴ Z. Manević [З. Маневић], "Београдски архитектонски модернизам 1929-1931," *Годишњак града Београда* XXVI (Београд, 1979), 209-226; Ibid., *Pojava moderne arhitekture u Srbiji*, Unpublished PhD dissertation, University of Belgrade 1979; A. Brkić [А. Бркић], *Знакови у камену. Српска модерна архитектура 1930-1980*, Београд 1992; Lj. Blagojević, *The Elusive Margins of Belgrade Architecture 1919-1941* (Cambridge Mass, 2003); M. R. Perović, *Srpska arhitektura XX veka* (Beograd, 2003), 11-147.

⁵ Ž. Čorak, *U funkciji znaka. Drago Ibler i hrvatska arhitektura između dva rata*, Zagreb, 1981; T. Premerl, *Hrvatska moderna arhitektura između dva rata*, Zagreb, 1990; S. Bernik, "Expressionist Tendencies in Slovene Architecture," in *Slovene Architecture of the Twentieth Century* (Ljubljana, 2008), 51-71.

⁶ A. Kadijević, *op. cit.;* A. Brkić [А. Бркић], *op. cit.*

⁷ B. Kojić [Б. Којић], *Друштвени услови развитка архитектонске струке у Београду 1920-1940. године*, Београд, 1978.

⁸ Lj. Blagojević, *op. cit.*; A. Kadijević [А. Кадијевић], *Естетика архитектуре академизма (XIX-XX век)* (Београд, 2005), 346-371; Ibid, *Један век тражења националног стила у српској архитектури (средина XIX-XX века),* Београд, 2007, 181-330; A. Ignjatović, *Jugoslovenstvo u arhitekturi 1904-1941*, Beograd, 2007.

⁹ A. Kadijević [А. Кадијевић], *Момир Коруновић*, Београд 1996.

¹⁰ T. Damljanović [Т. Дамљановић], *Чешко-српске архитектонске везе 1918-1941* (Београд, 2003), 79-88.

¹¹ A. Kadijević [А. Кадијевић], *op. cit.*, 39, 139.

¹² Ibid., 45.

¹³ Ibid., 47.

¹⁴ Ibid., 47-48.

¹⁵ Ibid., 53-54, 143.

[16] Ibid., 54-57; D. Živanović [Д. Живановић], "Прилог проучавању историје и архитектуре зграде Контролног одељења Министарства пошта, телеграфа и телефона у Београду," *Наслеђе* III (Београд, 2001), 105-113; T. Damljanović, *op. cit.*, 82-86.

[17] A. Kadijević, *op. cit.*, 63-65; T. Damljanović, *op. cit.*, 85-87.

[18] A. Kadijević, *op. cit.*, 69-70.

[19] Ibid., 85-87.

[20] Ibid., 71-72; K. Grčev, *From Origins to Style* (Skopje, 2004), 69-70.

[21] A. Kadijević, *op. cit.*, 91-97; Zoran M. Jovanović [З. М. Јовановић], *Зебрњак – У трагању за порукама једног споменика или о култури сећања код Срба*, Београд-Горњи Милановац, 2004.

[22] K. James, "Einstein, Finzl – Freundlich, Mendelsohn, and the Einstein Tower in Potsdam," in *Erich Mendelsohn Architect 1887-1953*, R. Stepan ed. (New York, 1999), 26-37.

[23] A. Kadijević, *op. cit.*, 99-100; M. Jovanović [М. Јовановић], *Српско црквено градитељство и сликарство новијег доба* (Београд, 2007), 206.

[24] A. Kadijević [А. Кадијевић] – S. Marković [С. Марковић], *Милан Минић. Архитект и сликар* (Пријепоље, 2003), 40, 68.

[25] M. Djurdjević [М. Ђурђевић], *Архитекти Петар и Бранко Крстић* (Београд, 1996), 18-20, 76. On the modernist work of Krstić brothers see also chapter by Djurdjević in this volume.

[26] See catalog of the exhibition "*Пројекти студената архитектуре*," Београд, 1928.

[27] M. Jovanović [М. Јовановић], *Храм Светог Саве у Београду*, Београд, 2005.

[28] M. Djurdjević [М. Ђурђевић], *op. cit.*, 21-23, 77.

[29] A. Kadijević [А. Кадијевић], "Милан Злоковић и тражења националног стила у српској архитектури," *Годишњак града Београда* XLII-XLIII (Београд, 2000/2001), 213-224.

[30] A. Kadijević [А. Кадијевић], *Elementi ekspresionizma*, 92.

[31] A. Kadijević [А. Кадијевић], "О архитектури спомен-обележја на Зејтинлику и Виду," *Лесковачки зборник* L (Лесковац, 2010), 197-206.

[32] A. Kadijević, *Elementi ekspresionizma,* 95.

[33] A. Kadijević [А. Кадијевић], *О архитектури спомен-обележја*, 197-206.

[34] A. Kadijević, *Elementi ekspresionizma,* 94.

[35] Ibid.

[36] A. Kadijević [А. Кадијевић] – S. Marković [С. Марковић], *Милан Минић, архитект и сликар*, 68-69.

[37] A. Kadijević, *Elementi ekspresionizma,* 92

[38] M. Djurdjević [М. Ђурђевић], "Палата Игуманов на Теразијама," *Флогистон* 1, Београд 1995, 87-94.; Ibid, *Архитекти Петар и Бранко Крстић*, 55-58; T. Borić [Т. Борић], *Теразије – урбанистички и архитектонски развој* (Београд, 2004), 117-120.

[39] A. Kadijević [А. Кадијевић], *Један век тражења*, 292.

[40] B. Vujović [Б. Вујовић], *Београд у прошлости и садашњости* (Београд, 1994), 320.

[41] M. Janakova Grujić [М. Јанакова Грујић], "Београдски опус архитекте Стевана Тоболара (1888-1943)," *Наслеђе* VII (Београд, 2006), 152-156; M. Drljević [М. Дрљевић], "О архитектури зграде председништва првог дунавског паробродског друштва у Београду," *Архитектура и урбанизам* 20/21 (Београд, 2007), 127-134.

[42] Anonymous, "Наши нови облакодери," *Политика* [Politika] 9. јул 1926, 6.

[43] A. Kadijević, *Elementi ekspresionizma*, 95; S. Toševa [С. Тошева], Бранислав Којић (Београд, 1998), 25-26.

[44] Anonymous, "Освећење темеља фабрике за израду новчаница," *Политика* [Politika] 22. септембар 1927, 6; Anonymous, "Освећење и пуштање у рад нове Државне ковнице металног новца на

Топчидеру," *Време* 8. септембар 1938, 4; Anonymous, "Освећење завода за израду новчаница Народне банке," *Политика* [Politika] 27. јануар 1930, 5; A. Kadijević, "Arhitekt Josif Najman (1894-1951)," *Moment* 18 (Beograd, 1990), 101; Ibid, *Elementi ekspresionizma*, 96-97; D. Đurić-Zamolo, "Jevreji – graditelji Beograda do 1941. godine," *Zbornik Jevrejskog istorijskog muzeja* 6 (Beograd 1992), 230-231.

45 A. Kadijević, *Elementi ekspresionizma*, 95; D. Milašinović Marić [Д. Милашиновић Марић], *Архитекта Јан Дубови* (Београд, 2001), 29-31.

46 A. Kadijević, *Elementi ekspresionizma*, 97.

47 A. Kadijević [А. Кадијевић], "Југословенски павиљон у Барселони 1929. године," *Гласник ДКС* 19 (Београд, 1995), 213-216; A. Ignjatović, *Jugoslovenstvo u arhitekturi*, 289-306.

48 Z. Manević [З. Маневић], "Дело архитекте Драгише Брашована," *Зборник за ликовне уметности Матице Српске* 6 (Нови Сад, 1970), 187-208; A. Kadijević, *Elementi ekspresionizma*, 98.

49 A. Kadijević, *Elementi ekspresionizma*, 99.

50 V. Brdar, *Od Parisa do Brašovana* (Novi Sad, 2003), 68-71; V. Mitrović, *Arhitektura XX veka u Vojvodini* (Novi Sad, 2010), 166-167.

51 A. Kadijević, *Elementi eskpresionizma*, 99-100; A. Ignjatović [А. Игњатовић], "Дом Удружења југословенских инжењера и архитеката у Београду," *Наслеђе* VII (Београд, 2006), 87-118.

52 See: M. Drljević [М. Дрљевић], "Историја и архитектура Поште 1 у Београду," *Зборник за ликовне уметности Матице српске* 37 (Нови Сад, 2009), 282; S. Mihajlov [С. Михајлов] – V. Mišić [Б. Мишић], "Палата Главне поште у Београду," *Наслеђе* IX (Београд, 2008), 252.

53 V. Mitrović, *op. cit.*, 162-163.

54 V. Brdar, *op. cit.*, 68-71; V. Mitrović, *op. cit.*, 176.

55 A. Kadijević, *Elementi ekspresionizma*, 99; S. Toševa [С. Тошева], *Архитекта Бранислав Којић* (Београд, 1998), 45-46; H. Tucić [Х. Туцић], "Дело архитекте Војина Симеоновића између два светска рата," *Наслеђе* IX (Београд, 2008), 159.

56 M. Djurdjević [М. Ђурђевић], *Архитекти Петар и Бранко Крстић* (Београд, 1996), 47. See also chapter by Djurdjević in this volume.

57 See also chapters by Ćorović and Kamilić in this volume.

58 Ž. Domljan, *Arhitekt Erlich* (Zagreb, 1979), 164-168; D. Đurić-Zamolo, *op. cit.*, 221.

59 V. Mitrović, *op. cit.*, 161.

60 A. Kadijević, *Elementi ekspresionizma*, 100; V. Brdar, *op. cit.*, 24-29.

61 D. Stančić [Д. Станчић] – M. Lazović [М. Лазовић], *Бановина*, Нови Сад, 1999.

62 A. Kadijević [А. Кадијевић] – S. Marković [С. Марковић], *Градитељство Лесковца и околине између два светска рата* (Лесковац, 1996), 77-78, 86; S. Toševa [С. Тошева], *op. cit.*, 96-97.

63 A. Keković [А. Кековић] – Z. Čemerikić [З. Чемерикић], *Модерна Ниша 1920-1941* (Ниш, 2006), 200-202.

64 M. Ceranić [М. Цeранић], "Историја и архитектура палате »Албанија« у Београду," *Наслеђе* VI (Београд, 2005), 147-162.

65 Ibid., 151.

66 M. Djurdjević [М. Ђурђевић], "Прилог проучавању делатности архитекте Валерија Владимировича Сташевског у Београду," *Годишњак града Београда* XLV-XLVI (Београд, 1998-1999), 163.

67 M. R. Perović, *op. cit.*

68 This essay resulted from work on research projects "National and Universal in Serbian Art of the 20th Century" (The Ministry of Education and Science of the Republic of Serbia) and "Serbian Architecture in the 19th and 20th Centuries" (Matica Srpska).

CHAPTER 10

THE GARDEN CITY CONCEPT
IN THE URBAN DISCOURSE OF INTERWAR
BELGRADE

Dragana Ćorović

"Health of the Country – Comforts of the Town."[1]

The Concept of the Garden City

The Garden City Concept developed at the threshold of the twentieth century as a modernist solution to difficult social problems: overpopulation, devastating hygienic conditions and in general dehumanizing living for most inhabitants in big industrial cities. London-born philanthropist and visionary Ebenezer Howard (1850-1928) published a theoretical concept of the garden city as two editions of the book *To-Morrow: A Peaceful Path to Real Reform* (1898) and *Garden Cities of To-Morrow* (1902).[2] He proposed urban planning of self-contained settlements that would have the advantages of both urban and rural lifestyles while reducing and eliminating their disadvantages. The garden city was a social movement as well. Howard hoped that a town built according to the Garden City Concept would be "the Third Magnet" that would attract most of the unhappy inhabitants of congested industrial British cities, and thus resolve one of the major national problems of the time.[3] Howard also founded the *Garden City Association* (1899) which actively promoted the concept by emphasizing the need for well-designed houses for all classes built in a human scale environment; the ways to empower people and communities to participate in decisions related to their quality of life; and the ways to improve urban planning based on sustainable development. Thus, from the outset, the concept closely intertwined the principles of social welfare and urban planning.

The first garden city in the world was initiated in 1903, and in 1919 Howard proclaimed his campaign named "One Hundred Garden Cities after the War."[4] The great success of Howard's idea and the creation of the first garden cities, and above all Letchworth (begun in 1903) and Welwyn (1919), contributed greatly to urban planning not only in Great Britain, but also worldwide (Fig. 10.1).[5] The promotional activities of the *Garden City Association* and the wide distribution of Howard's book further enriched the international discourse on the topic.

By WWI, Howard's book *Garden Cities of Tomorrow* had been translated into numerous languages including French (1903), German (1907) and Russian (1911).[6]

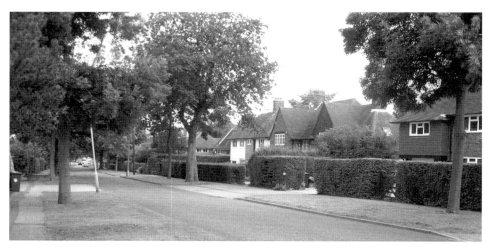

Fig. 10.1 Letchworth, Dwelling Quarters, as in 2007.

Emerging of the Garden City Concept in the Urban Discourse of Serbia

The intellectual and activist approach towards urban planning can be noted in the Princedom, respectively the Kingdom of Serbia under the Obrenović dynasty, which tried to follow the latest trends in urban development and in particular in light of the enormous growth of its capital city Belgrade.[7] There was a growing need for modern urban planning that would address hygienic standards in the residential sector, in particular. In the last decade of the nineteenth century, the *Society of Serbian Engineers and Architects* initiated a professional journal, the *Serbian Technical Paper*, which included available information on international trends in architectural and urban design theory and practice.[8] Howard's concept of garden cities reached Belgrade's intellectual elite via Austria-Hungary, Germany, the Czech Republic and France, where many practicing architects in Serbia received their training. The concept provided the unprecedented opportunity to almost seamlessly incorporate aspects of a rural society into the industrialization and modernization of Serbia.

Thus, in 1908, a Belgrade-born architect and urban planner, Dimitrije T. Leko (1863-1914) published an article in the *Serbian Technical Paper* that introduced the Concept of the Garden City in the Belgrade urban discourse:

In big cultural cities, a natural main course by which people build in order to shelter themselves from the street traffic noise and polluted air can be clearly seen. In London, its sheltered squares in the middle of big blocks and big parks in the middle of the city are the real proof that this main course exists. Furthermore, the whole towns in gardens (*Gartenstädte*) or the designed *Wald und Wiesen-Ring* around Vienna, etc, all comes closer and closer to oriental *teferič* and *bulbulder*,[9] where a man would once again feel as a man and not a small rivet in a huge deafening machine. ... even here, healthier ideas gradually infiltrate the common thinking, and this can bring some comfort. Besides that, as we have seen above, the city within the garden and oriental type of buildings are the most modern (and the most natural) aspirations of the cultural world and that is why the hope that it won't take long before we come to that cognition is justified, since we are not that fortunate to precede the world with the example created from our directly inherited surroundings.[10]

Leko emphasized the clash of man and machine, health and common thinking, and viewed the solutions from Western Europe as both well thought out and cultural. In "oriental" gardens established by the Ottoman Turks in Belgrade he saw the comparative cultural aspiration for the Garden city. What is most striking is to learn that he saw modernity not as in conflict with traditional, "oriental" (Balkan) houses, but rather recognized their modernity exactly in their design which allowed comfortable and healthy living within the city. Thus, he saw the capacity of the Garden City Concept and its modernity neither in its originality, nor novelty, but rather in its applicability to different regional situations. His approach was intellectual rather than formal and mechanical.

At this time, there were only a few examples of social housing in Serbia. The municipality of Belgrade with its "modern sanitary housing" to some extent solved housing problems of its permanent employees. In 1911, Jelisaveta Načić (1878-1955), the first Serbian female architect, designed comfortable workers' dwellings in Belgrade. It was the first construction of social housing in the Balkans.[11] Architect Dimitrije T. Leko wrote unfavorably on the economic aspect of this project, "[t]his company, deprived of a healthy basis, not only will fail but will serve as a deterrent bad example for future businesses in the construction of small and cheap apartments. And yet such companies are urgently needed on a larger scale, to curb usurious speculation, carried out by trade with the miserable and disgusting holes aka apartments for workers."[12] Instead of individual solutions for acute problems, Leko proposed a systematic approach based on the principles of Howard's concept of the Garden City.

Hence, if the Municipality of Belgrade had accepted Leko's advice to manage social housing in a manner that would make it a model of a successful business in the Balkans, with economically viable construction of workers' housing and with the social and philosophical spirit of the Garden City concept, the history of town planning in Serbia may well have been different. In 1914, on the threshold of WWI, Raymond Unwin's book *Town Planning in Practice: An Introduction to the Art of Designing Cities and Suburbs* (1909, German translation 1910)[13] was however a part of urban discourse of Belgrade: architect Stanojlo Babić referred to it as an urban design credo and theoretical framework for his design of the Theater Square in Belgrade.[14] Babić was emphasizing the importance of establishing major traffic lines in the vicinity of the square and designed it as the focus of public life and center marked by the prominent public building – the National Theater.

Implementation of the Garden City Concept in Interwar Serbia and Belgrade

After WWI, the urgent problem in Belgrade was not only the lack of living space but also the lack of standardized living space that would meet basic hygiene requirements.[15] Approximately 85% of residents lived on the verge of or below the poverty line.[16] In early 1919, through the renovation of buildings, the delivery of construction materials and the granting of loans for the construction of dwellings, the *Commission for Economic Renewal of Belgrade* tried to minimize the problem that, in the following months, led to workers' protests. The post-war anger and civic unrest in Belgrade echoed similar events throughout Europe. At the time Belgrade doubled in size, increasing from a population of 50,000 inhabitants during WWI to more than 100,000 by 1921.[17] It was the largest city in the Kingdom of Serbs, Croats and Slovenes (1918-29) with the greatest vertical social mobility. A design competition program for a new *General Plan of Belgrade* was announced in 1921.[18]

As a result, the Garden City concept was promoted through the work of three enthusiastic individuals and professionals: architect Jan Dubový, architect and urban planner Branko Maksimović, and journalist and writer Slobodan Ž. Vidaković. All three effectively communicated the potential for and suitability of the Garden City concept to the Serbian realm. They publicly and professionally promoted the implementation of the concept via films, academic journals and public media, through the *Society of Yugoslav Engineers and Architects* and through institutions of higher education, above all Belgrade University. Importantly, they were engaged in the administrative and legislative development of the 1923-24 *General Plan of Belgrade.*[19]

Jan Dubový (1892-1969), a Czech architect working in the Municipality of Belgrade, was most familiar with the concept and history of the Garden City and its implementations.[20]

That the Czechs were among the first in Europe to have translated Howard's book explains Dubový's intimate understanding of the concept. Dubový gave a detailed preview of the Garden City Concept to Serbian and Yugoslav professionals, often showing films about garden cities in England, the Czech Republic and Germany.[21] His lectures from 1924 published in the *Technical Paper* a year later addressed the theoretical framework of the Garden City and its practical realization along with integrative discussions of urban design and its socio-economic aspects (Figs. 10.2, 10.3).[22]

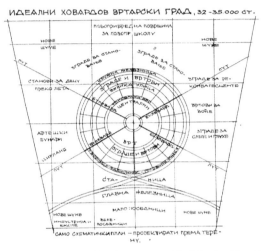

Fig. 10.2 J. Dubový, Interpretation of the Garden City concept, Ideal Garden City, 1925.

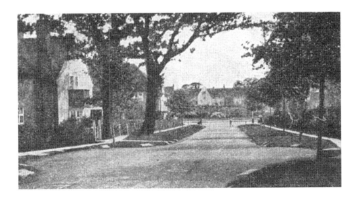

Fig. 10.3 Hampstead garden suburb, contemporary photography.

Dubový connected the design of a typical Slavic village, based on cooperation and ownership of land, with the concept of the Garden City and linked it to "Howard's communal socialism."[23] Connections between traditional trade towns and garden cities were also emphasized. Dubový envisioned the area of Old Belgrade as the trade center connected to the ports of the Danube and Sava rivers and the industrial zone of the nearby municipality of Čukarica. Slavija, one of the squares on Belgrade's outskirts at the time, was planned as the center with governmental, civic, public and monumental buildings. The traditionally residential hill of Topčider and at that time undeveloped area between Pančevo and Belgrade were reserved for garden cities. Dubový consulted the plans for the development of railroads in the Kingdom of Serbs, Croats and Slovenes, and proposed the circular railroad that would tangentially link the garden cities and connect them to the center of Belgrade.[24] In the same year, 1925, the *Technical Paper* published an invitation to members of the *Society of Yugoslav Engineers and Architects* from the *International Society for Buildings and Public Works* to participate in the *International Congress on Industry, Building and Public Works* and to visit one garden city near Paris.[25]

Architect and urban planner Branko Maksimović was especially interested in the politics of Garden City implementation, and in particular in administrative and legislative experiences for the implementation of garden cities in Great Britain and Prussia. By addressing and analyzing successful solutions and failures in his book *Problems of Urbanism* (1932),[26] (Fig. 10.4) Maksimović proposed a model for local implementation of the concept of the Garden City in Serbia. In his writings he examined modern examples of garden cities and suburbs in Germany in 1925-1930, such as *Neues Frankfurt* and *Zehlendorf Siedlung* in Berlin, as well as the work of modern architects, including Ernst May and Bruno Taut. Among widely circulated texts that dealt with this topic, Maksimović's "Politics of City Greenery and Parks of Belgrade" was prominent.[27]

Fig. 10.4 B. Maksimović, *Problems of Urbanism* (1932), cover page.

Slobodan Ž. Vidaković, a public worker, a writer and the editor of the magazine *Belgrade Municipal Paper*, published numerous articles that dealt with the Garden City concept.[28] By comparing collective communal living including high-rise rental buildings, derived from the German concept of *Mietkaserne,* with cooperative and self-sustainable living in garden cities as well as investigating their comparative social implications, Vidaković in his book *Our Social Problems* (1932) demonstrated an excellent understanding of these two concepts, which were hotly debated in Europe at the time of the peak of the economic crisis of 1930. As a director for press, tourism and cultural propaganda in Belgrade, Vidaković propagated the sociological aspect of the cooperative and socially and physically healthy living within a garden city.[29]

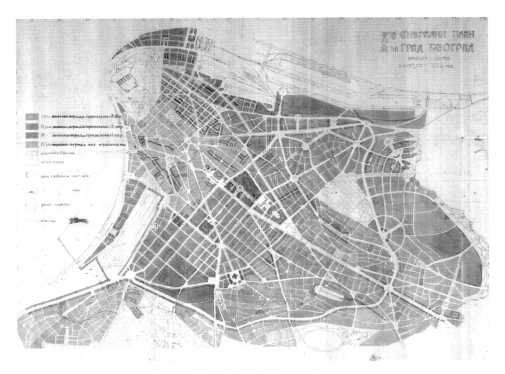

Fig. 10.5 Đorđe Kovaljevski, et al., General plan of Belgrade, 1:10.000, 1923.

In accordance with the *General Plan of Belgrade* (Fig. 10.5), which proposed new settlements built "in the spirit of contemporary views on founding the garden settlements outside the city area,"[30] approximately twenty new communities emerged during the interwar period.[31] Because of numerous speculative investments most of them however ended as illegal settlements, with

dreadful hygiene conditions. Nonetheless, several garden-city-type settlements, aptly known as "colonies" formed by joint action of a group of citizens with similar professional and social backgrounds, offered successful solutions. The first such settlement was the suburban colony of *Kotež-Neimar*[32] designed in 1922 by Viennese architects and urban planners Emil Hoppe and Otto Schönthal, former students of Otto Wagner.[33] The land was bought by the "Neimar" building corporation, immediately after WWI, followed by its urban regulation in 1924.[34] This predominantly undeveloped area was covered in orchards before WWI. By 1929 *Kotež-Neimar* had acquired a fully developed urban grid, infrastructure and bus-line to the city center. According to the plan, the central public area of 0.7 ha was envisioned as a park with two to three public buildings. Nine squares and 200 lots for individual residential buildings were also planned. Architect and honorary University professor trained in France, and also a resident of that settlement, Milutin Borisavljević (1899-1969), wrote about "ситижарден"[35] *Kotež-Neimar*: "It is a smile of Belgrade, it is its garden, it is its sun, poetry."[36] As at Letchworth, the first residents were artists, architects and in general open-minded and intellectually curious people who combined tradition and novelty without fear of breaking customary societal norms (Fig. 10.6). Three of the four founders of *The Group of Architects of the Modern Movement in Belgrade* (1928-1934), Branislav Kojić (1899-1987), Milan Zloković (1898-1965) and Dušan Babić (1894?-1948?) decided to live in *Kotež-Neimar*. However, speculative investments changed the development of *Kotež-Neimar* over time as the price of the land increased from the original 10 dinars per 1 m² in 1921 to 100-120 dinars per 1 m² in 1925,[37] eventually diverging from the Garden City principles of a self-sustained and resident-controlled development.

The Professors' Colony (1926), coordinated by architect Svetozar Jovanović (1892-1971), and *the Clerks' Colony* (1926, 1931-33), most likely coordinated by Jan Dubový, presented more successful solutions. *The Professor's Colony* was, by its urban characteristics, a direct product of the General Plan of Belgrade, 1923-24 and followed socio-economic principles of the Garden City Concept (Fig. 10.7).[38] Less is known about the *Clerks' Colony* in Voždovac. The settlement already had an elementary school and church, while the kindergarten, open market and civic center were planned in addition. By having eight different types of housing of different market values designed by prominent architects Mihailo Radovanović (1899-1973), Milan Zloković, Valery Vladimirovich Staševski (1882-1945) and Wilhelm Baumgarten (1879-1945), the *Clerks' Colony* also included residents of diverse social and professional backgrounds and thus eventually responded to Howard's egalitarian idea.[39]

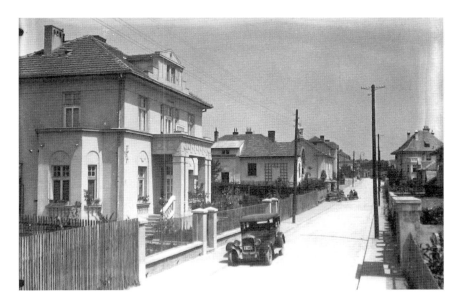

Fig. 10.6 Belgrade, Kotež Neimar, 1935.

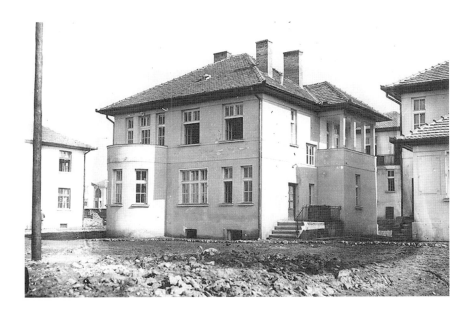

Fig. 10.7 Belgrade, Professors' Colony, c. 1930.

Between 1925 and 1940 the *Railway Colony* was built in Belgrade for the Ministry of Transport. The project helped the Transportation Association redeem land from the bank and erect the public housing settlement which had social, sports, recreational and educational facilities.[40] Each of the individual dwellings in this settlement also had a garden. At the time these ventures were a rarity in Belgrade. The construction of two rental pavilions began in 1928 in a part of the city named Bulbulder. It was planned for the accommodation of Belgrade's poor and was financed by the Municipality of Belgrade. In addition to the park and playground, two rental pavilions were planned consisting of 72 apartments each with 40 m² of living space. According to *Politika* daily, each apartment was to have "a modern kitchen, lighted sleeping room, spacious entrance, English toilets and storage room."[41] In 1929, five pavilions with a total of 40 low-cost houses were built on Topčider hill.[42] Their designer, Branko Maksimović, achieved savings in space with the inclusion of *Existenzminimum* standards for modern living, probably influenced by *CIAM*'s 1929 congress of *Die Wohnung für das Existenzminimum* (*The Dwelling for Minimal Existence*). After these two ventures, in 1937 the Belgrade Municipality began building experimental settlements in order to replace slums. These experimental settlements had several types of smaller buildings and separate family gardens.[43] A commentary in the daily newspaper *Politika* addressed the intent of the local government, noting that "[t]he municipal administration, constructing the low-cost housing settlements, will address special attention to creating enough green space and gardens within them. In addition to any house will be established a seven meters wide yard. With new formed alleys, all will seem like in a park."[44]

The major problem was financing and government support for the poorest and largest group of Belgrade residents, who also lacked any knowledge of how to actively engage in the process. Just before the so-called *January 6th Dictatorship*, in 1929, when all the democratic institutions in the Kingdom were closed, archival documents of 1927 signed by the major of Belgrade Kosta Jovanović, reveal that even an unidentified "English group" was involved in assisting with the growing problems of the construction of a total of 5,000 apartments which would have been in collective buildings downtown and in the colonies of garden cities on the outskirts.[45] The plan was not revived after WWII.

The Old Workers' Colony (1928) in Kragujevac[46] in the Šumadija District, central region of Serbia, financially supported by German reparations and realized under the guidance of University professor Žitković, in addition to its 107 houses built to the *Existenzminimum* requirements, had a school, medical and recreational facilities, grocery, and a park with fountains and sculptures.[47] Belgrade architect, urban planner and later University professor, Mihailo Radovanović, was actively involved in the design of the *Professors' and Clerks' Colonies* in Belgrade. He wrote that "The phenomenon of the Garden City in England at the end of the

nineteenth century, as well as their rapid diffusion throughout the world, was to a large extent the result of social and philosophical ideas of the contemporary society."[48] Radovanović wrote this in his university textbook *Introduction to Town-Planning* (1933) which was inspired by the Garden City potential and directed to the education of future generations of architects and urban planners who would modernize society. Participating in the production of the *General Plan of Kragujevac* of 1931, Radovanović suggested a design of several garden settlements projecting the rapid growth of the city due to its developing military industry. The realization of the plan started and ended with *New Colony* in Kragujevac. The plan reveals striking similarities to Howard's and Unwin's urban design. Built for industrial workers covering 16 ha, the colony contained 250 buildings of three different types rendered in the modernistic architectural idiom. The *New Colony* in Kragujevac realized between 1936 and 1938 may be considered as a garden city solution of the highest modernist quality in this part of the interwar Kingdom of Yugoslavia (1929-43). However, because of the changes in social and cultural values after WWII, the entire urban plan, including the development of other planned colonies, was rejected.[49]

This pattern of intellectual consideration of the concept of Garden City before WWI, followed by its implementation in the interwar period and its slow demise is evident in other countries. For example, in France economics professor Charles Gide (1847-1932) was the first to proclaim the idea of the Garden City in 1903. Yet, the first settlements — Châtenay, Plessis, Drancy, Suresnes, located near Paris, were built only after WWI.[50] In Hungary the Garden city of Wekerle, south of Budapest, was built between 1901 and 1926.[51] The first garden city in tsarist Russia, Prozorovskaia near Moscow, intended for 40,000 railroad workers, was built in 1912 under the direction of architect and city planner Vladmir Semionov, following his personal contacts with Howard and Unwin in 1909 and the translation into Russian of Howard's book in 1911.[52] Following the October Revolution of 1917, the concept was rejected in the USSR as epitomizing "bourgeois" ideas, yet the notion of "greenery" in urban design or, in other words, concern for open space, light and aeration in town planning remained.[53] The large industrial cities in Germany were also occasionally modeled on the Garden City concept. Architect Bruno Taut (1880-1938) visited England before WWI and designed two garden cities in Germany, in the vicinity of Berlin and Magdeburg. Working with Martin Wagner (1885-1957), he designed *Britz-Hufeisensiedlung* in 1924, which is considered the best functionalist interpretation of the concept.[54] In his own theoretical work *Die Stadtkrone* (1919) Taut made direct references to Howard and Unwin in the search for urban solutions for the working class. Similarly, Adolf Loos (1870-1933) as the city architect of Vienna during its socialist government propagated the Garden City concept and made a plan for Heuberg in 1920.[55] In his *Regeln für die Siedlung* (Rules for Housing) Loos even prescribed that every

settlement should be planned around a garden, the garden having a primary function and housing a secondary one.[56] Among the first and most important garden cities in the United States is Forest Hills Gardens in New Jersey built under Harvard professor and president of the American Society of Landscape Architects Frederic Law Olmsted Jr. (1870-1957) in 1912. In 1924, architects Clarence Stein (1882-1975) and Henry Wright (1878-1936) met with Howard and Unwin. Soon afterwards, in direct consultation with Unwin who had come to the U.S. in 1928, they built the garden city of Radburn, New Jersey in 1929.[57] Yet, like Kotež-Neimar and the Professors' Colony in Belgrade, Radburn altered Howard's egalitarian concept of social welfare because by 1934 the city was already characterized by a unified social structure given its majority of high-income residents.[58] Columbia professor of economics Rexford Guy Tugwell (1892-1979) reintroduced the social welfare concept within the context of President Roosevelt's (1882-1945) *New Deal* program. [59] Three cities – Greenbelt, Maryland near Washington DC, Greenhills, Ohio near Cincinnati, and Greendale, Wisconsin near Milwaukee – were built around 1935.

The Garden City concept also found adherents beyond Europe and the United States. Interwar Egypt[60] and Japan,[61] for example, experimented with the idea while developing their own regional characteristics. The Ma'àdi garden city (1905) south of Cairo with gardens appropriate for the desert climate was developed by the British government, but in conjunction with the political goal of instilling the perception of Egypt as part of European rather than African or Middle-Eastern cultures. Building contractor and philanthropist Eiichi Shibusawa (1840-1931) initiated the *Garden City Corporation Founding Association* (1916) and the *Garden City Incorporated* (1918) in Tokyo, followed by the first Japanese garden city, Denenchōfu. Shibusawa and his son, who visited the U.S. and Great Britain to learn more about the concept, followed its idealized geometric design and urban regulations literally, but were not interested in the architectural style of the specific buildings. Because of its low density, after the earthquake of 1923 Denenchōfu remained relatively well-preserved and a major attraction for celebrities and the wealthy, thus becoming Japan's Beverly Hills. In all these cases, as in Serbia, the first garden cities essentially started as suburban settlements around expanding capitals and other big cities.

After WWI, Ebenezer Howard's concept found its applicability in devastated Europe. Howard's motto of "One Hundred Garden Cities after the War" was fulfilled in the housing construction in Great Britain between the two World Wars which, like that of the British *New Towns,* built after the Second World War, had its own line of development. However, those were not settlements that had all the features of a garden city, as defined by the *Garden Cities & Town Planning Association* in 1919. Outside of Great Britain, in the application of the imported Garden City concept there was an intense inclusion of local influences. Diversity in

the application of the concept abroad depended on the political, economic and cultural level of development of the specific country as well as on the particular socio-historical moment.

Developments in interwar Serbia have been viewed by scholars as belated. However, the concept of the Garden City developed over a long period from 1903 and reached its peak in the interwar period world-wide. Serbia was following the latest world trends in consort with concurrent developments in the most prosperous and most industrial nations – Great Britain, France, Germany, Austria-Hungary, Soviet Union, the Czech Republic and even the United States and Japan. Urban discourse on the Garden City concept had been ongoing in Belgrade since 1908. In the interwar period philanthropists, entrepreneurs, sociologists, architects and urban planners continued their collaborative efforts in search of sustainable urban planning. Its promotion was achieved via public discussions, academic and public journals, and films. In essence, as in Great Britain, interest in the concept in Serbia started as a social movement in the first decades of the twentieth century, and then developed as an urban design principle. It was only after WWI that the *General Urban Plan of Belgrade* (1923-24) induced the relatively fast development of several settlements based on the Garden City concept – *Kotež-Neimar* (begun in 1922), *Colony for Railroad Workers* (1925-40), the *Professors' Colony* (1926) and the *Clerks' Colony* (1926, 1931-33). The *New Colony* in Kragujevac (1931, 1936-38) is an additional example of a surprisingly continuous development of garden cities even after the economic depression of 1930. Neither garden cities nor garden suburbs in interwar Serbia could develop fully because of the lack of governmental financial support and a lack of legislative measures. Even though the idea of the implementation of the concept evolved from the ideas of social democracy as propagated by the intellectual elite, the "longue durée" of the legislation, the socio-economic and cultural traditions influenced the uniquely "condensed" life of the Garden City in Serbia. The *General Plan of Belgrade* had received no fewer than 190 revisions and changes by 1931.[62] Moreover, there was incurable damage to implementation when the so-called *January 6th Dictatorship* of 1929 ended all democratic institutions.

After WWII, as in the Soviet Union, the concept was definitely abandoned for being "bourgeois," "elitist," and for promoting individualism. Instead, collective housing became the model for the future development. With the building of collective housing buildings in Cvijićeva Street known as "The Workers' Pavilions" in 1947-1948 [63] the Professors' Colony was completed and was ultimately perceived as an *all-class suburb*.[64] One of the main features of Howard's theoretical concept implies the existence of the protective green belt around the garden city. The Workers' Pavilions built on the edge of the Professors' Colony represented a kind of built boundary to the community. Not a fortified wall, but a structure that lets one enter the neighborhood while preserving the individual concept of the Colony, which continues until the present.

Urban Modernization in Interwar Serbia and Belgrade in the Light of the Garden City Concept Implementation

The relation between the implementation of the Garden City concept and the process of modernization in the broader framework of urbanization in Belgrade and Serbia is important. The Yugoslavia of the interwar period was a country with belated industrialization, according to historian Predrag Marković.[65] *The Modern* with its fundamental criterion – *the new*, as Jürgen Habermas noted – broke its ties with the past under the influence of French Enlightenment and faith in the continuous, linear progress of human knowledge.[66] Yet, by the end of the twentieth century, modernization was revealed as a contradictory and discordant process in the countries that had experienced belated industrialization. If the processes of modernization can be divided into the political, social and economic, then for each such "sub-process" there are different indicators that include, among others: democratization, when it comes to political modernization; social and geographic mobility, for social modernization; economic growth, in the case of industrial modernization. Among the factors that hinder the processes of modernization is excessive urbanization, because the largest proportion of private capital in Yugoslavia, much more than in industry, was invested in apartment buildings. The unfavorable geopolitical position of Serbia was the reason for the perceived failure of modernization in the interwar period, and, among others, underdevelopment of the economy and "even [an] anti-modern" cultural attitude.[67]

An indicator of modernization of the interwar urban development of Belgrade was any attempt at reining in excessive urbanization, as well as attempts at setting the framework for city development. These included the regulation of the cartographic database and cataloguing of the information of Belgrade's land registry; the initiation and organization of the international competition for the *General Plan of Belgrade* in 1921 and its execution in 1923. However, everything that followed the implementation of the *General Plan* and, even more so, that which did not follow it led to a regression. In 1910, the architects and engineers gathered around the *Serbian Technical Paper* advocated for the creation of a modern regulation plan of the city. They deemed that the competition with substantial rewards, organized for this purpose, would attract world-class professionals to take up the job.[68] Their momentum of modernization was lost in the wars of 1912-1918. Regarding a broader timeframe for conditions of modernization in Serbia, Marie-Janine Čalić states that:

> The passing from a bartering to a money-based economy, from production for subsistence to production for the market, Serbia began the long-term and irreversible project of social transformation at the beginning of the 19th century ... However, even

up until the beginning of World War II, Serbia was unable to overcome the causes and symptoms of the growing pains of this early modern period. The "long wave" ("longue durée") phenomena, in the form of legal tendencies, socio-economic structures, and cultural traditions, led Serbia to take its own path into the bourgeois world, different from countries of Western and East-Central Europe. [69]

When the overall urban development of Belgrade between the two World Wars is more carefully considered, it can be said that it vacillated with a few steps forward and a few steps back, wasting energy and going nowhere. One of the reasons for such a state may be that even " ... elite circles had no coherent concept of modernization of the country, and of urbanization as a social process that displaces populations from rural to urban areas, with the accompanying trappings."[70]

Society's lack of engagement with urban development can be connected to a lack of an established system that would deliver efficient implementation as well as oversight and control of the adopted urban plans. The economic underdevelopment, caused and sustained by the unfavorable position of the country in the web of international interests,[71] limited urban modernization. This was reflected in the pronounced misery of the new residents of Belgrade, due to the inability of the city economy to absorb the labor force. They lived in the gap between the rural and the urban, somewhere in the most squalid of hovels on the outskirts of the city, in desperate sanitary conditions, held hostage again by the very same underdeveloped economy. At the same time, the material conditions of the middle and upper classes allowed them the enjoyment of the technological inventions of modern society: "Sanitation appliances in apartments approach[ed] Central European levels. ... Aside from ... radio, an ever more common item in the city-dwellers home, household appliances become all-important, making life easier, especially for women, and raising standards of hygiene and diet."[72]

Cultural attitudes of the interwar period were suspended between tradition and the modern. In his 1934 essay "Architecture and Decor," Branislav Kojić stated, " ... strictly speaking, modern architecture in Belgrade is not really Modern. It is rather more Secessionist, in a formally different variant. ... our contemporary architecture features the use of architectural forms as decor ... entire portions of buildings flirt with one another, rise, fall, crisscross, intertwine. [All the while, the inessential elements create] a superficially dazzling effect."[73] This characteristic of Belgrade architecture can be considered as an obstruction to modernization; an imitation of the lifestyle of the upper classes of modern societies on the part of wealthier social groups in countries with belated modernization. There is also the positive aspect of the phenomenon, because this dissatisfaction impelled a society with a modernizing capacity to change, leading to vertical social mobility, to "longing for a better life."[74]

In the interwar urban planning of Belgrade, the *Professors' Colony* was one form of emulation of the Garden City concept, which emerged at the dawn of the modern development of planning.[75] In that sense, this University quarter was a local example of modernization in the field. However, while most garden cities were built in the interwar period, the concept of the Garden City itself was increasingly rejected by most modernists because it defied their proclaimed and uncompromising need for high-rise buildings intertwined with the high density in cities and the modernist concepts of rationalization and standardization. The concept became anachronistic for the solution to the changing socio-political climate after WWI. Even the *International Garden Cities and Town Planning Federation* by 1926 ultimately removed from its title the term "garden city" and became the *International Federation of Housing and Town Planning*.[76]

Notes

[1] Text on the poster *First Garden City Ltd*. 1925.

[2] Ebenezer Howard, *To-Morrow: a Peaceful Path to Real Reform* (London: Swan Sonnenschein, 1898); the second edition, Id., *Garden Cities of To-Morrow* (London: Swan Sonnenschein, 1902).

[3] Ebenezer Howard, *Garden Cities of To-Morrow* (Cambridge, Mass.: The MIT Press, 1965), 45-47.

[4] See chapter, "The Garden City and Town Planning, 1903-1918," in Stanley Buder (ed.), *Visionaries & Planners: The Garden City Movement and the Modern Community* (New York and Oxford; Oxford University Press, 1990), 96-115.

[5] On the Garden City concept, its theory and implementation see: Dugald Macfadyen, "Sociological Effects of Garden Cities," *Social Forces* 14/2 (Dec., 1935) 250-256; Walter L. Creese, *The Search for Environment — The Garden City: Before and After* (New Haven / London: Yale University Press, 1966); William Petersen, "The ideological origins of Britain's new towns," *Journal of American Institute of Planning* 34/3 (May, 1968) 160-170; Stanley Buder, "Ebenezer Howard: the Genesis of a Town Planning Movement," *Journal of American Institute of Planning* 35/6 (Nov., 1969) 390-398; A. E. J. Morris, "History of Urban Form – V, Origins of Garden City," *Official Architecture and Planning* 34/10 (Oct., 1971) 779-781; A. E. J. Morris, "History of Urban Form – VI, From Garden Cities to New Towns," *Official Architecture and Planning* 34/12 (Dec., 1971) 922-925; Buder, *Visionaries & Planners* (1990); Peter Hall, *Cities of Tomorrow: An Intellectual History of Urban Planning and Design in the Twentieth Century* (Oxford / Cambridge, Mass.; Blackwell Publishers, 2002), 87-141; Mervyn Miller, Letchworth, The First Garden City (Chichester; Phillimore & Co. Ltd, 2002); Ibid., "Garden Cities and Suburbs: At Home and Abroad," Journal of Planning History 1/1 (Feb., 2002) 6-28.

[6] See also: Peter Batchelor, "The Origin of the Garden City Concept of Urban Form" Journal of the Society of Architectural Historians *28/3* (Oct., 1969), 184-200; chapter: "The International Movement, 1900-1940," in Buder, *Visionaries & Planners*, 133-156; Dirk Schubert, "Theodor Fritsch and the German (*völkische*) version of the Garden City: the Garden City invented two years before Ebenezer Howard," *Planning Perspectives* 19 (Jan., 2004), 3-35.

[7] Despite the upheavals and wars, the number of inhabitants of Belgrade and Serbia was constantly increasing. The first modern census in Serbia in 1866 reports around 25,000 (24,612) inhabitants in Belgrade. In 1890 there were 2,161,961 people in Serbia and 55,000 (54,249) in Belgrade alone. In 1900,

Serbia had 2,429,882, and Belgrade 69,769 inhabitants. At the end of the 19th century Belgrade also had a significantly higher percentage of the state's total population. Belgrade became really important and, for immigrants, the most attractive city in the country. L. M. Kostić, "Stanovništvo Beograda," in *Beograd u prošlosti i sadašnjosti* (Biblioteka "Savremene opštine" 12; Beograd, 1927), 59-69.

[8] Branko Maksimović, "Urbanistički razvoj Beograda 1830—1941," in *Oslobođenje gradova u Srbiji od Turaka 1862—1868* (Beograd: Naučno delo and Srpska akademija nauka i umetnosti, 1970), 627-659; Branko Maksimović, "Urbanistička misao u Srbiji početkom XX veka," in *Knjiga o sintezi* (Vrnjačka Banja: Zamak kulture, 1975), 119-203; Bogdan Nestorović, *Arhitektura Srbije u XIX veku* (Beograd: Art Press, 2006).

[9] *Teferič* (in Turkish *teferüc*) means a picnic, or a celebration in the countryside with entertainment, leisure. *Bulbulder*, or Nightingale Stream, in Turkish, in the sentence refers to the enjoying the nature.

[10] D. L. [Dimitrije T. Leko], "Misli o mogućnosti primene srpskog stila," *Srpski tehnički list* 19/25 (1908), 233-234, citation on 233-234.

[11] Milan S. Minić, "Prva Beograđanka arhitekt — Jelisaveta Načić," *Godišnjak Muzeja grada Beograda* 3 (1956), 451-458; Zlata Vuksanović Macura, "Socijalni stanovi Beograda u prvoj polovini 20. veka," *Nasleđe* 12 (2011), 65-89. See also chapter by Novakov in this volume.

[12] D. T. Leko, "Radenički stanovi," *Srpski tehnički list* 22/2 (1911), 19-20, citation on 19.

[13] "Beleške, Literatura," *Srpski tehnički list* 21/52 (1910), 400.

[14] S. B. [Stanojlo Babić], "Pozorišni trg," *Srpski tehnički list* 25/9 (1914), 65-67.

[15] In Belgrade periodicals published between the wars, and especially after 1931 and the adoption of the building regulations, many of the articles were on the subject of housing. The *Belgrade Municipal Paper* conducted a public survey on the housing situation: Bogdan Krekić, "Stambeno pitanje kao javna briga," *Beogradske opštinske novine* 51/3-4 (1933), 456-466.

[16] Slobodan Ž. Vidaković, *Naši socijalni problemi* (Beograd: Geca Kon, 1932); Zlata Vuksanović-Macura, *Život na ivici: stanovanje sirotinje u Beogradu 1919-1941* (Beograd: Orion art, 2012).

[17] Tomislav Bogavac, *Stanovništvo Beograda 1918-1991* (Beograd: Beogradski izdavačko-grafički zavod / Srpska književna zadruga / Muzej grada Beograda, 1991), 74, 83.

[18] *Program stečaja za izradu generalnog plana o uređenju i proširenju Beograda* (Beograd: Opština grada Beograda, 1921).

[19] The Municipality of Belgrade announced a competition for the General Plan of Belgrade in 1919: *O uređenju Beograda, Izveštaj komisije, određene od strane odbora opštine grada Beograda* (Beograd, 1920), 3, 8. None of the twenty submitted projects won. A special commission was formed mainly of the competition judges who, starting with their own program and ideas from a variety of submitted projects, drafted the General Plan of Belgrade. Oliver Minić, "Razvoj Beograda i njegova arhitektura između dva rata," *Godišnjak muzeja grada Beograda* 1 (1954), 177-188; Maksimović, *Urbanistički razvoj*, 627-659; chapter "Urbanistički razvitak Beograda između dva rata," in Vasa Čubrilović, ed., *Istorija Beograda, 3, Dvadeseti vek* (Beograd: Prosveta, 1974), 163-171; Svetlana V. Nedić, "Generalni urbanistički plan Beograda iz 1923. godine," *Godišnjak grada Beograda* 24 (1977), 301-309; Branko Maksimović, *Ideje i stvarnost urbanizma Beograda: 1830-1941* (Beograd: Zavod za zaštitu spomenika kulture, 1983). The Bureau Chief for the plan was engineer Đorđe Kovaljevski, who was involved in planning the two most successful examples of implementation of the Garden City Concept in Belgrade: *Professors'* and *Clerks' Colonies*. The report of this commission was completed in July 1923: *Izveštaj o generalnom planu za grad Beograd, koji je izradila komisija sastavljena rešenjem Odbora i Suda Opštine Beogradske od 29. maja 1922. godine* (Beograd: Opština grada Beograda, 1923).

20 Jan Dubovi, "Vrtarski grad," *Tehnički list* 7/1 (1925), 7-11; Ibid., "Vrtarski grad," *Tehnički list* 7/2 (1925), 19-24; Ibid., "Vrtarski grad," *Tehnički list* 7/3 (1925), 42-46.

21 Anonymous, "Vesti iz Udruženja, Rad Sekcije Beograd U.J.I.A. u mesecu martu 1925. Sastanak 26. marta 1925. godine," *Tehnički list* 7/22 (1925), 343.

22 Dubový writes: "It is a city that gives us the ground for cultivation and frees us from disasters, provides a sound basis for a healthy state and thus solves social issues." Dubovi, *Vrtarski grad*, 7-11, citation on 7.

23 Ibid., 19-24, citation on 24.

24 Ibid., 44; Ibid., "Budući veliki Beograd," in *Beograd u prošlosti i sadašnjosti*, 98-103. See also chapter "Reprezentacija: Beograd na levoj obali Save, 1921-1941," in Ljiljana Blagojević, *Novi Beograd, osporeni modernizam* (Beograd: Zavod za udžbenike / Arhitektonski fakultet Univerziteta u Beogradu / Zavod za zaštitu spomenika kulture grada Beograda, 2007), 18-54.

25 Anonymous, "Razne vesti," *Tehnički list* 7/2 (1925), 30-31.

26 Branko Maksimović, *Problemi urbanizma* (Beograd: Geca Kon, 1932). On Prussian urbanism also, Branko Maksimović, "Moderni urbanizam u pruskom projektu Zakona o uređenju gradova," *Savremena opština / Savremena općina* 6/3-4 (1931), 204-221.

27 Branko Maksimović, "Politika gradskog zelenila i parkovi Beograda," in Maksimović, *Problemi urbanizma*, 53-68.

28 The *Belgrade Municipal Paper* was devoted to utility and social issues of life in the city. In the period 1932-39, when the economic crisis had escalated, it also published articles on the Garden City Concept that demonstrated the author's substantial understanding of the advantages and disadvantages of this theoretical and practical model of town planning.

29 Slobodan Ž. Vidaković, "Predlozi za rešenje pitanja malih stanova u Beogradu i rušenje Jatagan-male, Izvod iz službenog referata," *Beogradske opštinske novine* 53/9 (1935), 537-545.

30 Maksimović, *Urbanistički razvoj*, 627-659, citation on p. 649.

31 Divna Đurić-Zamolo and Svetlana Nedić, "Stambeni delovi Beograda i njihovi nazivi do 1941. godine," *Godišnjak grada Beograda* 40-41 (1993-94), 65-106.

32 *Kotež* is the literal phonetic translation of the word "Cottage." *Neimar* originated from Turkish word *mimar*, which means "Builder".

33 V. Jovančević, "Istorija i umetnost vrta," *Savremena opština* 3-4 (1935), 147-166, 248-252, 352-364, 428-439, 513-522; Snežana Toševa, *Srbija i Britanija, kulturni dodiri početkom XX veka* (Beograd: Muzej nauke i tehnike, Galerija nauke i tehnike SANU, 2007), 95; Đurić-Zamolo – Nedić, *Stambeni delovi Beograda*, 79; Zlata Vuksanović-Macura, "Plan Emila Holea i Ota Šentala za Kotež Neimar," *Nasleđe* 13 (2012), 79-91.

34 Nikola D. Ćopić, *Beogradska predgrađa između dva svetska rata 1918-1945. god*, text in manuscript (Muzej grada Beograda, 1974, Ur. 13699).

35 The term "ситижарден" is a literal phonetic translation of the French term for garden city, *cité-jardin*.

36 M. Borisavljević, "Kotež 'Neimar'," *Pravda* (November 11, 1932).

37 Milorad Stanojević, "Finansiska sretstva za podizanje Beograda," *Beogradske opštinske novine* 53/3 (1935), 141-147.

38 Dragana Ćorović, *Vrtni grad u Beogradu* (Beograd: Zadužbina Andrejević, 2009); Ibid., "The Garden City Concept: from Theory to Implementation — Case Study: Professors' Colony in Belgrade," *Serbian Architectural Journal* 1/1 (2009), 65-80. See also chapter by Kamilić in this volume.

39 Jovan Anđić, "Vrtove je pojeo beton," *Politika* (March 3, 2007); *Anonymous,* "Zidanje činovničkog naselja na Voždovcu počinje 1 aprila," *Politika* (October 30, 1930); Anonymous, "Na proleće počinje podizanje Činovničke kolonije," *Politika* (7 March, 1931); Anonymous, "Kuće za državne službenike," *Poli-*

tika (May 16, 1931); Marina Đurđević, "Prilog proučavanju delatnosti arhitekte Valerija Vladimiroviča Staševskog u Beogradu," *Godišnjak grada Beograda* 45-46 (1998-99), 151-171; Đurić-Zamolo – Nedić, *Stambeni delovi Beograda*, 65-106; Maksimović, *Ideje i stvarnost*, 48; Toševa, *Srbija i Britanija,* 103.

[40] Đurić-Zamolo – Nedić, *Stambeni delovi Beograda*, 75.

[41] Anonymous, "Opštinski stanovi za sirotinju," *Politika* (August 20, 1928).

[42] Đurić-Zamolo – Nedić, *Stambeni delovi Beograda*, 79.

[43] Maksimović, *Ideje i stvarnost*, 48.

[44] Anonymous, "Da li će nestati Jatagan male? Beogradska opština započela je radove na podizanju 118 malih radničkih stanova," *Politika* (November 7, 1937).

[45] K. Jovanović, "Još nekoliko Ustanova koje će Beograd uskoro dobiti," in *Beograd u prošlosti i sadašnjosti*, 170-177.

[46] Veroljub S. Trifunović, *Urbanizam Kragujevca, 20. vek, Knjiga prva: period od 1878. do 1974. godine* (Kragujevac: Direkcija za urbanizam i izgradnju Kragujevac, 2004), 96-130. On *Old Workers' Colony* also: L. Lilić, "Radnička kolonija u Kragujevcu," *Politika* (August 26, 1930).

[47] The so-called *English Colony* was built in 1926, in the form of an industrial village, exclusively for its engineers, by the public trading company *Trepcha Mines Limited* in Zvečane near Kosovska Mitrovica. See: Toševa, *Srbija i Britanija,* 79-82. The colony also included a tennis court, showing the importation of recreational facilities reflective of British culture. Moreover, this English colony marks the existence of foreign investors and capital in the Kingdom of Yugoslavia during the interwar period.

[48] Mihailo Radovanović, *Uvod u urbanizam, Osnovni principi i metode rada* (Beograd: Štamparija "Jovanović," 1933), 14.

[49] See also: Andjelka Mirkov, "Vrtni gradovi Ebenezera Hauarda," *Sociologija* 69/4 (2007), 313-332, esp. 329-330.

[50] See chapter "The Image Overseas," in: Walter L. Creese, *The Search for Environment — The Garden City: Before and After* (New Haven / London: Yale University Press, 1966), 299-314; chapter "The International Movement, 1900-1940," in Buder, *Visionaries & Planners*, 133-156; Kostof, *The City Shaped*, 77; Miller, "Garden Cities," Journal of Planning History 1/1 (Feb., 2002), 6-28.

[51] András Ferkai, "Cottage versus Apartment Block — Suburbanisation of Budapest," in Gyula Ernyey, ed., *Britain and Hungary, Contacts in architecture and design during the nineteenth and twentieth century, Essays and Studies* (Budapest: Hungarian University of Craft and Design, 1999), 151-170; Miller, "Garden Cities," 6-28; John Anderson, "Wekerle Garden Suburbub Kisapest Budapest," *CAP News* 3 (Nov., 2004), 18-19.

[52] Buder, *Visionaries & Planners*, 139-140; Kostof, *The City Shaped*, 78; Miller, "Garden Cities," 6-28; Mirkov, *Vrtni gradovi*, 327-329.

[53] Alexander Block, himself a resident of Letchworth, wrote that the idea of garden cities and decentralization of industry and population was politically acceptable, but not as a concept of Ebenezer Howard, but as that of Karl Marx (1818-1883). Alexander Block, "Soviet Housing: Some Town Planning Problems," *Soviet Studies* 6/1 (Jul., 1954), 1-15.

[54] Wolfgang Pehnt, "Introduction: The Theatre of the Five Thousand," in Wolfgang Pehnt, *Expressionist Architecture* (London: Thames & Hudson, 1973), 13-22, 210; Hall, *Cities of Tomorrow*, 116-127; http://housingprototypes.org/project?File_No=GER001.

[55] Panayotis Tournikiotis, *Adolf Loos* (New York: Princeton Architectural Press, 1994), 59-74, 116-122, 140-145, 152-164; "Adolf Loos and the crisis of culture 1896-1931," in Kenneth Frampton, *Modern Architecture: A Critical History* (London: Thames & Hudson, 1992), 90-95.

56 "Each housing estate is planned around a garden. The garden is primary, the dwelling secondary." According to Gilbert Lupfer, Jürgen Paul, Paul Sigel, "Adolf Loos (1870-1933)" in: Veronica Biermann *et al.*, *Architectural Theory from the Renaissance to the Present* (Köln: Taschen, 2003), 674-679, citation on 674.

57 On the implementation of the Garden City Concept in the U.S. see chapter "The Image Overseas" in: Creese, *The Search for Environment*, 299-314; chapters "Town Planning in the United States: 1915-1929," "Town Planning in the United States: 1929-1948" in: Norman T. Newton, *Design on the Land: The Development of Landscape Architecture* (Cambridge, Mass.: The Belknap Press of Harvard University Press, 1971), 479-495, 496-516; chapter "The Garden City Movement in America, 1900-1941" in: Buder, *Visionaries & Planners*, 157-180; chapter "The City in the Region" in: Hall, *Cities of Tomorrow*, 143-187; Miller, "Garden Cities," 6-28; Susan L. Klaus, *A Modern Arcadia: Frederick Law Olmsted. Jr. & the Plan for Forest Hills Gardens* (Amherst & Boston: University of Massachusetts Press / Amherst: Library of American Landscape History, 2004); http://www.radburn.org/geninfo/history.html.

58 Hall, *Cities of Tomorrow*, 128-138.

59 At least 3,000 new cities throughout the state were planned.

60 Mercedes Volait, "Chapter 2: Making Cairo Modern (1870-1950): Multiple Models for a 'European-Style' Urbanism," in Joe Nasr and Mercedes Volait, eds., *Urbanism: Imported or Exported* (Chichester, West Sussex: Wiley-Academy, 2003), 17-50.

61 Ken Tadashi Oshima, "Denenchōfu, Building the Garden City in Japan," Journal of the Society of Architectural Historians 55/3 (Jun., 1996), 140-151.

62 Minić, *Razvoj Beograda*, 177-188.

63 Those buildings were designed by the architect Vladeta Maksimović. Mate Baylon, "Stan u Beogradu," *Arhitektura urbanizam* 14/74-77 (1975), 23-42.

64 Vesna Matičević, *et al.*, *Uslovi zaštite nepokretnih kulturnih dobara, dobara koja uživaju prethodnu zaštitu ambijentalnih vrednosti za potrebe elaborata: Detaljni urbanistički plan blokova između ulica 29. novembra, Mitropolita Petra i Čarli Čaplina* [Terms of Protecting Immovable Cultural Goods, Goods which Enjoy the Protection of Previous Values for the Environmental Study: Detailed Regulation Plan of Blocks Between: 29. novembar, Mitropolita Petra and Čarli Čaplina Streets] (Belgrade: Zavod za zaštitu spomenika kulture grada Beograda / Cultural Heritage Preservation Institute of Belgrade, 1992), Signature: Ku-470, report by Zoran Manević.

65 Predrag J. Marković, "Teorija modernizacije i njena kritička primena na međuratnu Jugoslaviju i druge istočnoevropske zemlje," *Godišnjak za društvenu istoriju* 1/1 (1994), 11-34.

66 Jürgen Habermas, "Modernity – An Incomplete Project," Seyla Ben-Habib, trans., in: Hal Foster, ed., *The Anti-Aesthetic, Essays on Postmodern Culture* (Port Townsend, Washington: Bay Press, 1983), 3-15.

67 Marković, *Teorija modernizacije*, 31, 33.

68 J.T.S [Jefta Stefanović], "Regulacija Beograda," *Srpski tehnički list* 21/49 (December 5, 1910), 361-362.

69 Mari-Žanin Čalić, *Socijalna istorija Srbije 1815-1941: usporeni napredak u industrijalizaciji* (Belgrade: Clio, 2004), Ranka Gašić, trans., citation on 417; original title: Marie-Janine Calic, *Sozialgeschichte Serbiens 1815-1941. Der aufhaltsame Fortschritt während der Industrialisierung* (München: R. Oldenbourg Verlag, 1994).

70 Mira Bogdanović, "Modernizacijski procesi u Srbiji u XX veku," in *Srbija u modernizacijskim procesima XX veka (conference)* (Belgrade: Institut za savremenu istoriju Srbije, 1994), 35-58, with reference to V. Dedijer, I. Božić, S. Ćirković, M. Ekmeščić, *History of Yugoslavia* (New York), 1974, citation on 514.

[71] Peđa J. Marković, *Beograd i Evropa: 1918-1941: evropski uticaji na proces modernizacije Beograda* (Belgrade: Savremena administracija, 1992); Ranka Gašić, *Beograd u hodu ka Evropi: kulturni uticaji Britanije i Nemačke na beogradsku elitu 1918-1941* (Belgrade: Institut za savremenu istoriju, 2005).

[72] Peđa J. Marković, "Teorija modernizacije i njena primena na međuratnu Jugoslaviju i Beograd," in *Srbija u modernizacijskim,* 435-446.

[73] Branislav Kojić, "Arhitektura i dekor," *Srpski književni glasnik,* Nova serija 43/6 (Nov., 1934), 427-431.

[74] Marković, *Teorija modernizacije,* 15-16.

[75] In his text about the appearance of town planning in Great Britain in the context of the singular conditions of the late Victorian epoch, Gordon E. Cherry ("The Town Planning Movement and the Late Victorian City," *Transactions of the Institute of British Geographers, New Series, The Victorian City* 4/2 (1979), 306-319), identifies two basic streams of influence: the movements of social, housing and land reform; other influences include learning from practical experience, such as the experiments by philanthropists; contributions of new architectural practices; and the concept of the Garden City.

[76] Buder, *Visionaries & Planners,* 148.

CHAPTER 11

THE PROFESSORS' COLONY – A SUBURBAN HOUSING PROJECT AS AN EXAMPLE OF URBAN DEVELOPMENT IN 1920s BELGRADE

Viktorija Kamilić

The Professors' Colony was built between the years 1926 and 1927 on the north-eastern edge of Belgrade, in the Palilula district. It was intended as a solution to the expansion of the city through the construction of residential suburbs, something that was also envisioned in the General Urban Plan for the City of Belgrade (1923).[1] As one of many Belgrade suburbs constructed during the interwar period the Professors' Colony stands out because it was planned and executed by a specific and singular group of people – Belgrade University professors. It was created as a private initiative by university professors with the support of the city. The idea came from pure necessity. Most Belgrade University professors, while an important part of society as educators and a powerful force providing cultural and technical advances, represented the middle class and were left without real benefits for their contributions. After World War I, in the spirit of renewal, Belgrade University began to expand. New faculties were opened and new facilities were built, which at the same time meant that more professors were hired.[2] Professors, many of them having moved to Belgrade from other cities in Serbia, were left to solve their living problems by themselves since neither the state nor the university cared to provide apartments. Living often as tenants, under poor conditions, these professors used the 1920s enthusiasm for building expansion to begin a project of their own.

The idea to build a colony for professors initially came from Vladimir K. Petković, the Dean of the Faculty of Philosophy. He approached architect Svetozar Jovanović, professor at the Technical Faculty, and the two of them began developing a plan.[3] Many professors decided to join the project, and soon an Association of University Professors was formed. A Technical Bureau was organized within the Association, with Svetozar Jovanović as the leading architect and architects Petar Krstić and Mihailo Radovanović as his associates. The purpose of the Bureau was to solve all practical issues, the first of which was choosing the location for the Colony. After inspecting many sites the Technical Bureau chose the north-eastern border of the city, which at the time was filled with old brickyards in the midst of orchards. It was close

to the many University buildings as well as the center of the city, but still offered intimate and natural surroundings. With the support of the Belgrade Municipal Government and funding ensured by loans from the State Mortgaging Bank,[4] everything was ready for the main phase of development.

The area where the Colony was to be built was bordered by two existing streets Cvijićeva and Knez Miletina (today Despota Stefana Street) and Bulbulder creek towards Belgrade. The site was divided into parcels, which were then shared between members of the Association. In order for the construction to progress more rapidly and more economically most of the members agreed that the architects from the Technical Bureau should complete the plans for the houses; but still several chose to employ other architects. The residences which the Bureau designed were for the most part adaptations of several model projects, changed in order to comply with the wishes of future residents, mostly concerning the elevation, number of rooms and position on the parcel.

The Colony was spread over an area that roughly corresponded to the shape of a quarter of a circle. The residences were built along three streets. At the time only one street had a name: Novoprilepska, today Jaše Prodanovića Street, while two others were marked by numbers; today their names are Stojana Novakovića Street and Ljube Stojanovića Street. The asymmetrical form of the area affected the form of the parcels, which turned out to be mostly irregular. The houses differed in several ways: they were either one- or two-storey houses, on the regulation line of the street or located inside of the parcel, with one or two apartments, with gardens at the back or at the front and the back. With the completion of the projects all the members of the Association sent their building requests to the Construction Council of the Belgrade Municipality.[5] All the projects were approved by the end of June 1926. The building of the Colony began in July of the same year, with the first houses being finished in January of 1927, and all work being completed by the summer of the same year (Fig. 11.1). The organizing and street paving of the new Professors' Colony neighborhood, the job of the Municipality, was not finished until after most of the houses were completed. The process began in the summer of 1927 after residents of the Palilula district protested.[6] By the end of 1927 the Professors' Colony was connected by a private bus route that went through the main streets of Belgrade to the railway station.[7]

The Association of University Professors had 43 members when it was created.[8] The fact that they were employees of the University meant that they were esteemed representatives of the Belgrade intellectual scene. Among them 23 members held doctorates and 15 were members of the Serbian Academy of Science and Art.[9] Their contributions to society were immense; they were not just educators but founders of journals, creators of professional associations, and above all researchers, writers and inventors. Some of the most prominent among them

were: scientist Milutin Milanković, architect Svetozar Jovanović, historian Viktor Novak, mathematician Tadija Pejović, physiologist Ivan Djaja, and engineer Živko Tucaković.[10]

The fact that its developers and first residents were Belgrade University professors presented unique social elements in the creation of the Colony. As a consequence, the construction of the Colony was followed by the daily newspapers *Politika* and *Vreme*. Articles from both of these newspapers provided important information concerning the progress of the construction. On the other hand, periodical journals of the time, in articles dealing with social and cultural themes, termed the Professors' Colony, along with other suburbs, a 'garden colony', thus providing insight into how the Colony was received by the public once it was built.

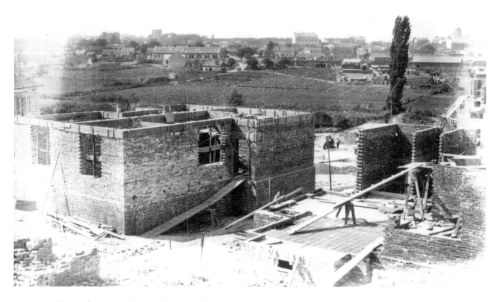

Fig. 11.1 The Professors' Colony, Belgrade, photograph shows the building of the Colony, published in *Politika*, daily newspaper, 16.9.1926.

The architect whose name can be traced from the planning to the execution of the Professors' Colony is Svetozar Jovanović (1882-1971).[11] He was involved in the project as a leading architect and as a future resident. At the time of the construction of the Professors' Colony Jovanović was a professor at the Belgrade Technical Faculty teaching architectural construction. The third decade of the 20th century was the most active period in his career. While a member of the University faculty, Jovanović oversaw the construction of three monumental public

buildings he had designed several years before the Colony project began, as an employee of the Serbian Ministry of Construction. Concurrently, he began working privately, designing family homes and apartment buildings. Jovanović's projects for monumental public-use buildings distinguish him as an architect who encouraged the development of Serbian architecture in the interwar period through simplified application of academic interpretations of historical style architecture. His residential architecture shows more diversity. Accepting orders from all social categories, Jovanović employed eclecticism and romantic readings of historical models but also responded to specifically contemporary problems of financially efficient construction by designing houses with no identifiable stylistic tendencies.[12]

In addition to architect Svetozar Jovanović all Bureau projects were signed by architects Petar Krstić (1899-1991) and Mihailo Radovanović (1899-1973). At the time both of them were young architects at the beginning of their careers. Fresh out of the University in 1925 they began working as assistants at the Belgrade Technical Faculty. Petar Krstić was Jovanović's assistant, while Mihailo Radovanović was an assistant in the course on City Regulation. Krstić would turn out to be a successful architect, doing most of his work in collaboration with his brother Branko Krstić.[13] The two participated in numerous competitions for public buildings and completed projects for many family houses and apartment buildings. Like most Serbian architects in the interwar period the Krstić brothers moved from academic modeling to research of national motifs and finally to modernism. They became prominent representatives of modern architectural tendencies in interwar Serbia, designing some of the most important buildings of the time.

At the time the Colony was being built Mihailo Radovanović was finishing his studies at the Institute for Urbanism at the University of Paris.[14] Radovanović would spend his working career as a professor at Belgrade University in the Department of Urbanism. His most important works were projects submitted for competitions for urban reconstruction of several Serbian towns. Mihailo Radovanović, along with some of the most important architects of Serbian interwar modernism: Jan Dubový, Branislav Kojić, Milan Zloković, Dragiša Brašovan and the Krstić brothers, participated in the work of the Belgrade Group of Architects of the Modern Movement who, between the years 1928 and 1934, promoted modern architectural ideas through lectures, exhibits and practical work.[15]

Working as an architectural team all three architects signed the projects, still as the most experienced of them, Jovanović, was distinguished as the leading architect. Since Jovanović was involved in the creation of the Colony from its first day, it can be assumed that the ideas for the projects were initially his. His opus supports this conclusion through an examination of several projects he made for private residences. They have similar ground plan layouts and façades to the houses in the Colony.[16] On the other hand Mihailo Radovanović was probably

involved in order to help with the urban planning of the Colony, since he was interested in urban planning; he also later designed a similar suburb in the city of Kragujevac.[17]

Typological Analysis of the Houses

The author's research at the Historical Archive of the City of Belgrade confirms the fact that the houses designed by the Technical Bureau architects were for the most part variations on several initial models.[18] After examining the original blueprints and documents concerning the building process a general classification of the houses was possible. The criteria used for the classification were: the form of the ground plan, the urban disposition and the basic interior spatial organization. While analyzing and comparing the ground plans, according to the number of storeys per residence, two types of buildings were recognized: one- and two-storey. As for their urban disposition the houses were drawn from the street regulation line by the length of small garden areas; exceptions to this rule were the street corner houses whose one side wall, by definition, bordered the regulation line of the road. With no apparent planning some houses stand alone in their parcels, while others parcels contain two houses connected by a single wall.

In terms of the internal spatial organization two distinct groups were designed: houses made according to the model projects and houses for which projects were specially made. The first group was characterized by a longitudinal irregular ground floor plan with two rooms overlooking the street. The entrance hall, lobby, bathroom and toilet were located in the middle, while kitchen, storage room and extra room or staircase (in the case of one-storey houses) were at the back.[19] The entrance was always situated on one side of the house. Some irregularities can be seen in the purpose of certain rooms, made probably in accordance with the wishes of future residents. Two-storey houses usually have terraces, balconies and bay windows overlooking the main street. In the second group we have houses with simplistic and complex ground plans. Houses with simplistic one-storey plans had either a longitudinal plan (that deviated too much from the model plan) or central plan (a rectangular plan where rooms for living, working and hygiene surround the main conversational room – lobby, on three or all four sides). Two houses had a complex ground plan with an irregular distribution of rooms, most likely the result of a need to make the most of the angular parcel of land.[20] The ground plans of the model and specially made projects with their interior spatial organization coincide with project types evidenced in Belgrade residential architecture since the beginning of the 20th century.[21] A typological analysis shows that in the case of the ground plans architects stayed within the traditional design, employing what was later signified as the 'Belgrade apartment' design.[22]

Stylistic Analysis of the Houses

What unites the houses in the Colony is the composition of their façades. Vertically, they were divided into two sections by projecting one half of the façade in front of the other, while horizontal division was accomplished by simple plaster strips. The only decorations were rectangular flat surfaces positioned to the sides of the windows, and any monotony was broken by projections such as terraces, balconies and bay windows.

At the beginning of the 1920s architects in Serbia still employed façade decoration with elements of historical styles. The grandness of the decorations was still considered to be evidence of social status and wealth. Around the years when the Colony was built the climate was changing. Younger generations of architects, influenced by modern ideas in European architecture, began a reformative campaign. In order to distinguish themselves from the conservatives they began emphasizing, first in their writings, the social elements of new architecture and the anachronism of historical styles.[23] Modernist ideas were first employed in residential architecture in 1927,[24] and a year after the active promotion of the concept was begun through the work of the Group of Architects of the Modern Movement.[25]

Serbian interwar modern architecture was largely promoted as a new style. Limited primarily by the ignorance of investors, used to imitation rather than innovation, and also by local technological backwardness, Serbian architects focused their efforts on changing only the external elements, which led to the formation of a new stylistic vocabulary to replace the old one. Talk of architecture as a mean of accomplishing social changes was forgotten, and in reality modernist architects were, like their predecessors, working for the elite. Still, an innovative approach can be seen in the works of a few gifted architects: Milan Zloković, Jan Dubový and Dragiša Brašovan.

In a chronological sense the houses of the Professors' Colony can be seen as heralds of modernity, but not as modernist examples as such. Their modernism lies in the social moment, while the architectural elements are only a means of accomplishing this goal. Since the main concern of the residents of the Professors' Colony was acquiring a home for themselves, the Bureau architects placed practicality above aesthetics, which was in that time and place a progressive way of architectural thinking. The decision to employ non-ornamental façade solutions was made in the spirit of financial efficiency, not as an example of modernity. By abandoning historical style decoration as a marker of social status residents of the Colony were making a modern social statement that probably influenced a general change among Belgrade investors. Still the Colony's architects remained one crucial step away from the true modernist concept – their traditional design lacked boldness and innovative character.

The Professors' Colony as an Interpretation of the Garden City Concept

Ebenezer Howard's Garden City concept was one of the influential theoretical prototypes in Serbia during the interwar period.[26] In the 1920s the concept got its strongest promoter in Czech architect Jan Dubový.[27] When the Professors' Colony was built Dubový worked in the Belgrade Municipality alongside engineer Djordje Kovaljevski, the chief creator of the Belgrade General Urban Plan. The two of them probably supported the initiative of the Belgrade professors, since in 1923 they designed a similar suburb, the Clerks Colony.[28]

The Professors' Colony, Kotež-Neimar and the Clerks' Colony are three Belgrade suburbs that early on were marked as 'garden colonies' or examples of the Garden City concept. As active members of the architectural society Svetozar Jovanović and his associates were probably aware of Howard's theory, but whether they had it in mind when they designed the Professors' Colony or if the public made an accidental connection between the two remains unknown. When we compare the Professors' Colony and Howard's Garden City concept we find that there are only few similarities. The Professors' Colony was built as a cooperative endeavor in the sense that it was established by a group of people who developed the whole idea on their own. The Colony's plan, approximately a quarter of a circle, coincides with Howard's circular plan, but does not suggest a direct connection, since circular plans were often used throughout history. The Professors' Colony is a suburb, while Howard planned for his city to be separate from any town. Even more important was Howard's idea of the self-sufficiency of the city, which did not apply to the Colony as it was comprised solely of family houses. At the beginning the Colony was probably surrounded by nature,

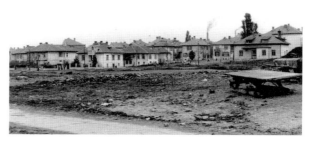

Fig. 11.2 View of the Professors' Colony from Cvijićeva Street, the 1940s.

but it was not the intended 'green belt' of Howard's city, and soon enough it was consumed by new homes (Fig. 11.2).

Since Howard's Garden City was considered to be a utopian concept the ideas that it promoted were understood in Serbia as general guidelines and not strict rules to be followed. Howard's concept and Belgrade's 'garden' suburbs both aimed to provide solutions to similar problems. The health issues that Belgrade had to deal with made the idea of preserving and encompassing nature in urban surroundings a logical solution. However, the name 'garden

colony' was more likely tagged to the Belgrade suburbs – the Professors' Colony, Kotež Neimar, the Clerks' Colony – for obvious reasons instead of theoretical: built on the edges of the city, they all had houses nestled in small gardens that provided their residents with a healthier environment than that of the overcrowded apartment buildings within the city.

Conclusion

The Professors' Colony represents a unique urban planning project built during Belgrade's interwar period. What distinguishes this suburb from other similar suburbs is the process of its creation. As an answer to the social troubles of a particular demographic group the Colony was created by professors for professors. The houses alone, designed by Bureau architects, Svetozar Jovanović, Petar Krstić and Mihailo Radovanović, are, due to the owners' financial limitations, aesthetically modest, and given their structural and stylistic qualities cannot be categorized as important examples in the history of Serbian modern architecture. Their value lies in the fact that they are a part of the suburban housing project which, in the years after World War I, promoted a new economic and modern concept of living on the borders of the capital city.

The Professors' Colony kept on growing after the professors built their initial houses in 1926-27. Soon the concept of a unified suburb was abandoned, and the area became one of the popular sites where famous modern architects designed family homes for their investors. At the beginning, the initial idea proposed by the Association of University Professors to focus on economically efficient building made some choose other suburbs as more suitable for their homes. One of them was architect Milan Zloković who initially intended to join the Association but later decided to build his home in Kotež-Neimar, which was then considered a wealthier suburb.[29]

Half a decade later, and in the area that is a short distance from the core of the old Professors' Colony, famous architects built some of the signature houses of Belgrade's interwar modern architecture. Unlike the non-ornamental but still traditional design of the first houses built in the Colony, these new homes employed all the significant features of the Serbian interwar modern style. One of the most important examples of this period's innovative approach – the Prendić family residence designed by Milan Zloković (1933) – had a purist composition of the front façade and efficient interior spatial organization as an interpretation of Adolf Loos's *Raumplan* design;[30] on the other hand the Kobasica family's residence designed by the Krstić brothers (1931) focuses primarily on the exterior, using identifiable modernist decorative elements. The entrance, windows and atypically positioned balcony were all framed by plaster strips to accentuate the asymmetrical solution of the façade (Fig. 11.3).[31]

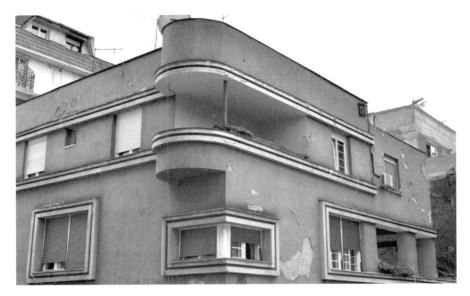

Fig. 11.3 Architects Petar and Branko Krstić, house of Stjepo Kobasica, Osmana Djikića Street no 24, the Professors' Colony, Belgrade, 1931.

Fig. 11.4 Architect Svetozar Jovanović, house of Fehim Barjaktarević, Ljube Stojanovića Street no 19, Professors' Colony, Belgrade, 1927.

Therefore, the houses were mostly variations of several initial models that were then changed on a case-by-case basis in order to comply with the owners' wishes. Additionally, the unity of the whole area was accomplished by a similar simplistic treatment of façades. Since the settlement was created for practical reasons, as a way for professors to solve their living situations and with a limited budget, the architects' main concern was practicality above aesthetics. By analyzing historical, social and urban aspects which led to the creation of this housing project, as well as the project designs made by the architectural team, this essay demonstrates that the Professors' Colony, build at a time when the promotion of modern architectural tendencies was in its infancy in Serbia, can be seen as a herald of new economical and modern living concepts.

Today the Colony continues to grow. Some of the houses are still there (Fig. 11.4); others have been changed and can no longer be recognized as belonging to that period. What were once the gardens are now lots with new houses, although one regulation is still in effect: the height of the houses in the core area must be maintained. Settled in an area surrounded by streets with busy traffic the Professors' Colony still retains the serenity of a residential suburb. Today the entrances to the gardens carry the names of the professors who built this suburb, reminding us of its importance to the history of Belgrade's urban development. These family houses were once places where great minds worked in the tranquility of their homes, where history was being written, scientific research pursued and the future envisioned.

Notes

[1] Branko Maksimović, *Ideje i stvarnost urbanizma Beograda 1830.-1941* [Ideas and Reality of Belgrade Urban Planning 1830.-1941] (Belgrade: Zavod za zaštitu spomenika kulture grada Beograda, 1983), 48; Miroslava Dimić, "Profesorska kolonija – izgradnja i njeni osnivači" [The Professors Colony – Construction and its Founders], *Godišnjak grada Beograda* XLV-XLVI (1998-1999), 71-82; Dragana Ćorović, *Vrtni grad u Beogradu* [A Garden City in Belgrade] (Belgrade: Zadužbina Andrejević, 2009). See also chapter by Ćorović in this volume.

[2] Until then Belgrade University had three faculties: Philosophy, Law and Technical. After World War I three new faculties were founded: Medicine, Agriculture and Theology.

[3] Anonymous, "Naselje univerzitetskih profesora" [The University Professors Colony], *Politika* (Belgrade), 16 September 1926, 5. Viktorija Kamilić, *Arhitekta Svetozar Jovanović* [Architect Svetozar Jovanović] (Belgrade: Zadužbina Andrejević, 2011), further studies the life and work of architect Svetozar Jovanović.

[4] In Serbia during the interwar period financing the construction of family homes through loans from the State Mortgaging Bank was the common and actually the only option for representatives of the middle class: Pedja J. Marković, *Beograd i Evropa 1918 – 1941* [Belgrade and Europe 1918 – 1941] (Belgrade: Savremena administracija, 1992), 96.

5 Written request forms were found in the files which contained the documentation regarding the build-
 ing process of the houses. These are kept amongst the technical documents in the Historical Archive of
 the city of Belgrade. Applicants filled in the addresses of the houses and each form was signed by the
 Technical Bureau's leading architect Svetozar Jovanović.

6 Anonymous, "Najjadniji i najopasniji deo varoši nosi ime najvećeg srpskog naučnika Jovana Cvijića"
 [The Poorest and Most Dangerous Part of the Town Carries the Name of the Greatest Serbian Scientist
 Jovan Cvijića], *Vreme* (Belgrade), 9 July 1927, 6; Ćorović, 74-75.

7 Dimić, 75.

8 Ibid, 72.

9 Ibid, 78.

10 Ibid, 75-76.

11 Zoran Manević, ed., *Leksikon neimara* [Dictionary of Builders] (Belgrade: Gradjevinska knjiga, 2008),
 181-182; Kamilić, *Arhitekta*.

12 Kamilić, *Arhitekta*, 57.

13 Marina Djurdjević, *Arhitekti Petar i Branko Krstić* [The Architects Petar and Branko Krstić] (Belgrade:
 Republički zavod za zaštitu spomenika kulture, Beograd, Muzej nauke i tehnike – Muzej arhitekture,
 1996). See also chapter by Djurdjević in this volume.

14 Manević, *Leksikon neimara*, 338-339.

15 Viktorija Kamilić, "Osvrt na delatnost Grupa arhitekata modernog pravca" [An Overview on the Ac-
 tivity of the Group of Architects of the Modern Movement], *Godišnjak grada Beograda* 55-56 (2008-
 2009), 239-264.

16 Kamilić, *Arhitekta*, 45-46.

17 Ćorović, *Vrtni grad*, 48.

18 In the Historical Archive of the City of Belgrade I found and examined 31 files with the original blue-
 prints and documents concerning the building process.

19 Kamilić, *Arhitekta*, 41-42.

20 Ibid, 43.

21 Bogdan Nestorović, "Evolucija Beogradskog stana" [The Evolution of the Belgrade Apartment],
 Godišnjak Muzeja grada Beograda 2 (1955), 247-248, 262-265; Mirjana Roter-Blagojević, *Stambena
 arhitektura Beograda u 19. i početkom 20. veka* [Residential architecture of Belgrade in the 19th and 20th
 century] (Belgrade: Arhitektonski fakultet Univerziteta u Beogradu, Orion art, 2006).

22 Zoran Manević, *Pojava moderne arhitekture u Srbiji* [The Emergence of Modern Architecture in Serbia]
 (PhD diss., Belgrade: Faculty of Philosophy, 1979), 150. See also chapter by Djurdjević in this volume.

23 The promotion of ideas of functionalist architecture, efficient building with minimal financial input and
 anachronism of historical architectural styles can be found in the writings and lectures of architects Jan
 Dubový, Branko Maksimović, Milan Zloković and Branislav Kojić.

24 Two family houses built in 1927-28, in the suburbs, considered to be the first modernist examples of
 residential architecture in interwar Serbia are: Jan Dubový's Dragoljub Gosić's villa in Prince Dojčin
 street no 7 in Senjak (1927) and Milan Zloković's own family house in International Brigade street no
 76 in Kotež-Neimar (1927-28).

25 Ljiljana Blagojević, *Modernism in Serbia: the Elusive Margins of Belgrade architecture, 1919-1941* (Cam-
 bridge, Massachusetts: The MIT Press, 2003), 57-76; Kamilić, *Osvrt*. See also chapters by Djurdjević
 and Ćorović in this volume.

26 See also chapter by Ćorović in this volume.

[27] Dijana Milašinović–Marić, *Arhitekta Jan Dubovi* [The Architect Jan Dubový] (Belgrade: Zadužbina Andrejević, 2001); Blagojević, *Modernism*, 130-134; Manević, 106-113.

[28] Ćorović, *Vrtni grad*, 64.

[29] Manević, *Pojava,* 68 and 70-73.

[30] Ljiljana Blagojević, *Moderna kuća u Beogradu (1920-1941)* [The Belgrade Modern House (1920-1941)] (Belgrade: Zadužbina Andrejević, 2000), 46-48; Ibid., *Modernism*, 201-202.

[31] See also chapter by Djurdjević in this volume.

CHAPTER 12

ARCHITECT BROTHERS PETAR AND
BRANKO KRSTIĆ

Marina Djurdjević

Petar and Branko Krstić belong to a circle of those prominent architects who were active between the two world wars and left a lasting impact on Serbian architecture. As almost their entire opus was tied to their home town, the Krstićs are among the few in the history of Serbian architecture who could be accurately called the architects of Belgrade. Their three grandiose public buildings, the Agrarian Bank Palace (1931-34), the Iguman's Palace (1936-37) and St. Mark's Church (1930-39), greatly influenced urban planning and design of the very center of the city. Equally successful in their designs rendered in different eclectic and historicist styles, the Krstićs demonstrated a high level of inventiveness and adaptability to various forms of creative expression in their architecture. Their unrealized design for the Yugoslav Pavilion in Philadelphia in 1925 and subsequent projects for monumental religious and public buildings — such as the churches of St. Sava and St. Mark in Belgrade as well as the Agrarian Bank Palace and the Iguman's Palace — accommodated both academic dictates and official requests for building in the so-called Serbo-Byzantine style, which became a national style as it included formal and formative references to ecclesiastical architecture in the medieval territories of Serbia and the former Byzantine empire. Nevertheless, in essence the Krstićs were modernists because of their orientation. The Krstićs' commitment to modern architecture is most evident in their residential buildings and unrealized projects for monumental public facilities, which were not in keeping with the tastes of their conservatively oriented clients. These projects anticipate the power and progressiveness of the works of their contemporaries who were committed to modernism but had not yet attained stylistic maturity. Olga Lazić's Villa (Fig. 12.1) and the building of Josif Šojat in Brankova Street (Fig. 12.2) represent excellent examples of mature modernism. Devoid of investors' rigid requests evident in public buildings, these smaller residential buildings reflect the intimate creative orientation of the Krstić brothers, their authentic authorship, and full individuality of their creative expression. These achievements represent the embodiment of purity and contemporaneity of the architectural preference for modernism by the Krstić brothers and the very core of their contribution to modernism in Serbia. However, they remained outside of the purview of

both the professional and the broader audience, who mostly consider the Krstićs as designers of public monumental edifices which express the architectural spirit between tradition and modernity of the interwar period, rather than the brothers' personal views on architecture. This casts a light on the hitherto incorrect assessment of the Krstić brothers' contribution and the unjustified dispute regarding their importance and place in the development of modern architecture in Serbia.

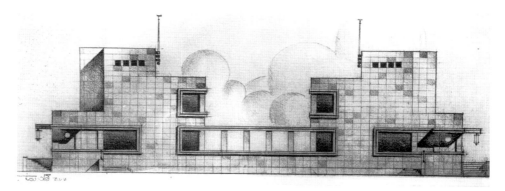

Fig. 12.1 Petar and Branko Krstić, Olga Lazić's Villa, Belgrade, 1931, drawing of the main façade.

Fig. 12.2 Petar and Branko Krstić, Josif Šojat's building, Belgrade, 1934-35, drawing of the main façade.

It was not until 1996 that the architectural opus of the Krstić brothers became a subject of serious scholarly research.[1] Short and fragmented reference to the creative endeavors of the Krstićs can be found in general architectural surveys of Serbian architecture and the few texts of critics and newspaper articles published on the occasion of their deaths.[2] Together with the projects, sketches and drawings, the periodicals published during the construction of the buildings they designed provide excellent documentation on the brothers and their work. Thanks to the data carried by the daily press of the interwar period, we are able to reconstruct the whole process through which the Krstićs' public buildings evolved from the inception to

construction, through fund collection, site selection, opening competition and its results, to full implementation. Valuable professional debates regarding topical architectural issues could be frequently found in the daily papers, but they unfortunately do not provide the sequence of architectural developments to a significant extent. However, they do afford valuable insight into that period of time and a way of thinking about architecture. By fervently following all occasional events related to architecture on the one hand and conflicts about questions of various kinds from the most serious to the banal on the other, it is possible to get a more complete picture of the socio-political and cultural climate in which these works were created. It greatly determined not only the purpose, contents and function of these buildings, but also their style, which is why they provide a truthful picture of their times in almost all spheres of activities.

Having lost their father early in their lives, Petar and Branko Krstić were raised by their mother from whom they inherited their artistic talents. By jointly signing their architectural projects they never separated, even in private life. However, behind this seeming unity they were people of different character, interests and sensibilities. It was precisely these differences that made possible their individual contributions to their joint ventures. If architecture could be reduced to the unity of technique and art, then the recognition for the technical component would go to the older brother, a marked pragmatist, while the multitalented younger sibling would be credited with the artistic component. Several projects independently signed by Branko contain a form-related vocabulary that is also recognizable in their jointly signed projects. Many conceptual sketches preserved in the family archive bear the signature of the younger brother. His personality represented the merging of architect, sculptor and painter in consort with a passionate interest in philosophy, history of literature and music. Of all of his contemporaries Branko Krstić was closest to a renaissance type of artist. "Parallel studies and active participation in fine arts made me feel, as an architect, closer to complex problems of architecture as an art," wrote Branko in the catalog of his fine art works.[3] Such an approach to design enabled Branko to give their joint creations an unusual visual direction that extended beyond pure architecture. More inclined to the practical side of designing, the older brother assumed the responsibility for construction and functional solutions as well as for establishing contacts with investors and contractors. The final product combined subtlety of architectural design with virtuously executed form. It is precisely this quality that makes the buildings of the Krstić brothers unique and easily recognizable in the context of the contemporaneous accomplishments of Serbian architecture.

The Krstić brothers were active at a time when three different style models coexisted in Serbian architecture. Greatly dependent on the socio-political situation, academism, Serbo-Byzantine style and modernism all took turns as preferred approaches. The Krstićs moved

skillfully within the frameworks of all three paradigms. Their competitively awarded projects and those responding to the dictates of commissioners both provide persuasive evidence of the high quality of their work. In interwar Serbia, young architects could receive recognition through participation in public competitions. However, less usual was the success that the Krstićs achieved at the very beginning of their careers. All their works were either awarded or purchased. Apart from recognition, these competitions gave the Krstić brothers valuable experience. Through these competitions they learned and matured.

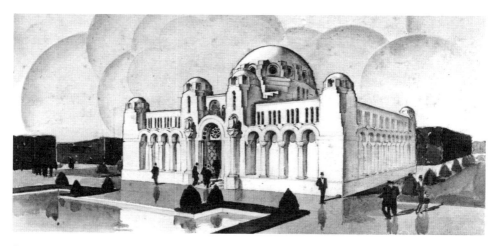

Fig. 12.3 Petar and Branko Krstić, Project for the Yugoslav Pavilion, Philadelphia, 1925.

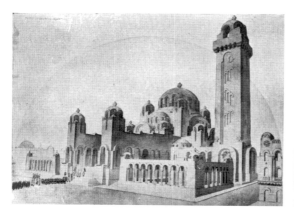

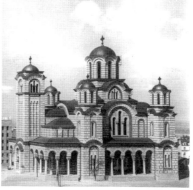

Fig. 12.4 Petar and Branko Krstić, Project for St.Sava's Cathedral, Belgrade, 1926.

Fig. 12.5 Petar and Branko Krstić, St. Mark's Church, Belgrade, 1930-39.

The designs created during the first two years of the Krstićs' active participation in architectural competitions reflect the characteristics of Serbo-Byzantine style, which was an imperative item in competition requirements during times of aroused nationalistic aspirations. Their earliest first-prize-winning project for the Yugoslav Pavilion in Philadelphia in 1925 was also their first competition work done in the Serbo-Byzantine style (Fig. 12.3). It remained unrealized because of disagreements, indecisiveness and inconsistency in decision making on the part of the committee. They also had a bitter experience at the competition for the design of the St. Sava Cathedral (Fig. 12.4) a year later, as a result of disagreement between the investors' requests and the competition requirements. The cathedral had to be "in the spirit of the old Serbian church architecture" with a bell tower constructed separately from the church.[4] Bogdan Nestorović's winning design was in keeping with the competition rules. The Krstićs claimed that in their concept of St. Sava's Cathedral they had focused principally on functionality of the church's interior structure. They found their inspiration in the former Orthodox patriarchal basilica of Hagia Sophia in Constantinople (modern Istanbul) rather than Serbian medieval architecture. This divergence from the competition rules was the main reason the Krstićs' proposal, one of the most impressive projects at the competition, was purchased but not awarded. The irony was that the committee suddenly changed its decision and selected the design of the Hagia Sophia to be a new model for the visual identity of St. Sava's Cathedral. Under such circumstances, when the committee showed inconsistency and countermanded its own rules and guidelines, a new competition was the only logical solution. However, it never took place. Contrary to all the regulations and common practices, architects Nestorović and Deroko were entrusted with the final architectural draft according to the new model, which also remained unrealized. An attempt to push their ideas despite the investor's demands for St. Sava's Cathedral caused the Krstićs grave professional damage. Perhaps this experience also resulted in their subsequent more lenient and flexible approach towards investors.

Only three years after the competition for St. Sava's Cathedral, in 1930 the Krstićs again had an opportunity to design a church of general public and national importance. An invitation-only competition was organized for the purpose of acquiring conceptual sketches for the church of St. Mark in Belgrade. The Krstićs, Deroko and Nestorović were invited on the basis of their projects for St. Sava's Cathedral. The required style was "free Old Byzantine."[5] However, the management and the highest church authorities demanded that the exterior of St. Mark's Church resemble as much as possible the exterior of the fourteenth-century monastery church of Gračanica. The Krstićs' design was awarded the first prize because, as stated by the commissioner, "it has corresponded to the required rules and guidelines best."[6] Given their experience with the competition for the design of St. Sava's Cathedral, the Krstićs

did not repeat their youthful mistake. They had deviated from the required framework of competition rules and guidelines while designing St. Sava's Cathedral, firmly believing that these requirements were not appropriate to the goal to be achieved. In their project for St. Mark's Church (Fig. 12.5), they demonstrated that they could produce the best design within the rigid framework of the required rules and beat the more prominent competitors. The paradox remains that their more successful design for St. Sava's Cathedral, which more effectively displays the originality of their artistic expression, was only purchased, while the design for St. Mark's Church, the least creative of their entire opus, brought the Krstićs their first major commission and consequent fame.

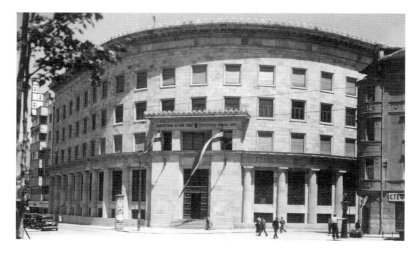

Fig. 12.6 Petar and Branko Krstić, The Agrarian Bank Palace, Belgrade, 1931-34.

A year later when the construction of St. Mark's Church pursuant to their design began, the Krstićs started working on one more monumental public edifice, a business building commissioned by the Privileged Agrarian Bank (Fig. 12.6). Now already recognized, the Krstićs were among the few architects invited to participate in the competition. However, it remains unclear how they got the commission since they had been awarded third prize. Unlike with their design for St. Mark's Church, which they had completed without any additional interventions, the Krstićs had to make a concession to the Construction Committee of the Bank which had demanded changes to the original concept for the façade, as at that time their simply shaped volume, quite devoid of any decoration, represented too bold a

breakthrough of modernism in the design of public buildings. The monumental entrance part and the mid zone of the facade screen without ornamentation, consistent with the original concept, were kept. However, under duress, the tripartite division of the facade was altered to include neo-classical decoration on the ground floor and cornice. As a result their original modernist concept thus assumed features of academism. Although they were not allowed to push through their original modernist concepts, which were dominant on the residential buildings they had designed and constructed, the Krstićs created, in the case of the Agrarian Bank, an edifice which, because of the functionality of its treatment of space and structure, artistic expression, and clear visual identity, played an important role in creating the modern architectural image of Belgrade and its idiosyncratic character. Upon its completion, art critic Predrag Karalić declared that the facade of the Agrarian Bank was "the most beautiful one in Belgrade"[7] and Branko Krstić wrote in his *Memoirs* that the Agrarian Bank was their top architectural project.[8]

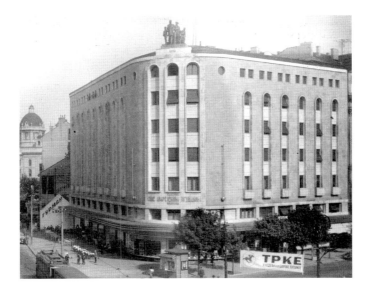

Fig. 12.7 Petar and Branko Krstić, The Iguman's Palace, Belgrade, 1936-37.

The Iguman's Palace was the Krstićs' third and last design for a public building within their architectural opus (Fig. 12.7). Due to their reputation as experienced and reliable architects they were invited once again to participate in the competition on an invitation-only basis.

The Serbo-Byzantine style was again one of the main postulates of the competition rules and once again, by following all the competition requirements to the letter, the Krstićs created a design that won the first prize. However, when the competition was over, cunningly and cautiously the Krstićs introduced changes into their original concept. They eliminated double lancet windows at the mezzanine-floor height and the colonnade on the ground floor, which resulted in a simplified and modernized composition of the building exterior. In a clever, subtle way and contrary to the investor's demands, the Krstićs succeeded in creating a building in the spirit of their time. The transformation of the original design for the Legacy Palace of Iguman from the Serbo-Byzantine style into a modernist one with a series of alterations, in spite of the constant surveillance of the investor's representatives, is an excellent example of the development of modernist ideas and forms in interwar Serbia.

In the late 1920s and early 1930s the architectural development of the Krstić brothers was therefore characterized by the search for their own creative expression, as well as a concurrent distancing from the dominant Serbo-Byzantine and academic ideals and the inclusion of modernist elements. They also formally confirmed their commitment to modernism by joining a group of architects of the modern stream, a professional organization founded by architects Milan Zloković, Dušan Babić, Jan Dubovi and Branislav Kojić on November 11, 1928. They brought together "architects who understand architecture based on modern ethical and technical novelties, founded in the cultural life of the today's society" in order "to organize the work on promoting and nurturing the architecture of Belgrade in particular."[9] The most productive design activities of the Krstić brothers and their most valuable achievements date to the 1940s. In the post war period the brothers chose separate paths both in their lives and their work, marked by projects which, by neither their number nor their quality reached the level of their outstanding achievements in the period between the two wars. During the period of the country's reconstruction in the first years after the end of World War II, changed socio-political circumstances did not give architects a chance to express their creativity in any form. Basic survival problems were being solved and material resources were extremely limited. Under such conditions, designing became a marginal preoccupation for the Krstić brothers. Petar fully dedicated himself to educational work at the Faculty of Architecture and Branko mostly turned to other artistic creativity – painting and sculpture.

The Krstićs' diversity of ideas and their compromise solutions were unfavorably received by the public, and the brothers were labeled as "eclectics with knowledge and taste."[10] Their award-wining projects brought work and great popularity, but also the negative perception of the brothers as eclectics, an erroneous label that has persisted to the present. It remains relatively unknown that their original project for the Agrarian Bank Palace, considered presumptuous by the investors, was never realized. Yet, it predates some of the anthological

and widely recognized examples of Serbian modern architecture such as the Child Hospital by Milan Zloković and the State Printing House by Dragiša Brašovan. The brothers produced their purest and most original modernist solutions with respect to residential buildings that they built during the interwar period and the non-executed projects for monumental public facilities. Because of the timeliness, strength and progressiveness of their ideas the Krstić brothers' designs represent a special level of achievement.

The Krstić brothers, like other Serbian modernists of the interwar period, formed their modernism independent of the direct influence of the world centers of modern architecture. Primarily they were informed indirectly and sporadically on international architectural developments through magazines, congresses and exhibitions. Often Serbian architects initially accepted formal elements of modern architecture. The fundamental problems of function, use of new building materials and constructive systems, as well as the social role of the new, modernist architecture frequently remained on the margins. This can be demonstrated by the residential buildings which, unburdened by more complex functional considerations, fit into the general scheme of a so-called "Belgrade apartment."[11] The "Belgrade apartment" was almost a uniform solution for Serbian residential architecture in the interwar period. It consisted of a two-track floor plan with wings next to light wells. Subsequent versions occasionally did not have these light shafts. The modernism in later examples is reflected in the formal departure from the academic observance of symmetry. The Krstićs' family houses belong to the type of unpretentious single-floor or low-rise buildings with free non-standardized floor plans, adjusted to the needs of families with modest means. In most cases, these were free-standing villas set in a large or small garden and frequently also had a front garden. What makes the Krstićs' buildings unique is their artistically shaped architectural form which, irrespective of stylistic features, gives the impression of true lived experience and convincing individuality. The texture of the façades of most of their buildings provides a unique view of a synthesis of architectural elements, sculpture, reliefs and artistically treated details, adjusted with the exquisite feeling for measure and harmony. The carefully conceived architectural parti of the entrance is the most characteristic element of the Krstićs' formative vocabulary. The ultimate meaning of the creative effort that the Krstićs invested in shaping their architecture was the monumentality and harmony of forms in space. The directness of expression in their achievements is based on the sincerity with which they approached the spatial interpretation of each specific program. The scale of the visual aspect achieved ranged from still and simple to monumental and attractive. The Krstićs' diverse creative power, talent and successful stylistic flexibility elicited satisfaction from their investors, even in the face of opposing views. Clearly satisfied with the results, they repeatedly placed their trust in the brothers. This was true of Josif Šojat who was considered a progressive investor, but also

of Nikola Krstić who expressed extreme conservativeness in his demands. Professor of the Technical Faculty, Dušan Tomić, an expert in architecture, paid them a special tribute by entrusting them with the design of his home. Tomić's villa (Fig. 12.8) is the earliest example of the Krstić brothers' mature modernism and an anthological work of Serbian architecture. The high level of inventiveness and unlimited wealth of spatial expression of the Krstić brothers are also reflected in the fact that they did almost all of their projects in several equally successful variants. This was the case of their project for the Yugoslav Pavilion in Philadelphia, when the brothers sent two solutions to the competition and won two main awards.

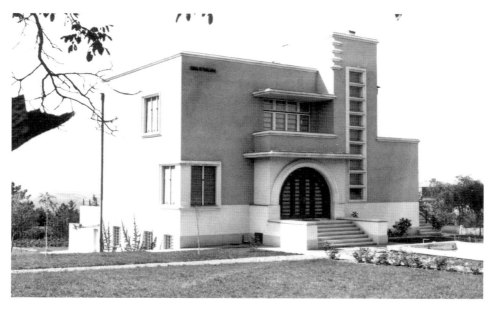

Fig. 12.8 Petar and Branko Krstić, Dušan Tomić's Villa, Belgrade, 1930-31.

Irrespective of type or style, the buildings of the Krstić brothers convey a specific expression primarily based on a search for monumental effects, both in composition and in detail. By the harmonious impact of balanced, rhythmically placed masses, their edifices form a plastic picture filled with aesthetic effects. The unity and harmony of the form are based on the successful adjustment of the values of the specific within the general, of architectural details in the whole design, of buildings in their setting. Volumetric balance rather than the symmetry typical of architecture rooted in academism imbued their buildings with modernist vivacity. The Krstićs' architectural expression, based on harmony and stylized sensitiveness, is spatially

expressed by shape, harmonious relationship between surfaces, the balance of large reliefs and optical effects. As architects with imagination and talent, the Krstićs considered architecture a living treasury of inner pictures, waiting for the right moment to turn into reality. Ultimately, this essay argues for the accurate evaluation of the architectural oeuvre of Petar and Branko Krstić and recognition of their contribution to modernism in interwar Serbia.

Notes

[1] Marina Djurdjević, *Architects Petar and Branko Krstić* (Belgrade: Institute for the Protection of Cultural Monuments of Serbia, Museum of Science and Technology, 1996), 1-102.

[2] Zoran Manević, "The Krstić Brothers," in *Builders* (Belgrade: Cultural Heritage preservation Institute of Belgrade, 1986), 42-51; Ibid., "Serbian architecture of 20th century," in *The Art at Yugoslavia* (Belgrade, Mostar, Zagreb: Prosveta, 1986), 26; Ibid., *Serbian architecture 1900-1970* (Belgrade: Museum of Modern Art, 1972), 22, 24; Uroš Martinović, *The Belgrade Moderna* (Belgrade: Belgrade Publishing and Graphic-Institute, 1971), 31, 47, 64; Miodrag Jovanović, *Serbian Church Building and Painting of Recent Times* (Belgrade-Kragujevac: Kalenić, 1987), 204, 211-12, 215, 219, 221-22; Željko Škalamera, "The Renewal of the Serbian Style in Architecture," *Collected papers on fine arts of the Matica srpska* 5, Novi Sad, 1969, 228; Djurdje Bošković, "Modern Architecture at the Exhibition of Oblik," *The Serbian Literary Gazette* 29, Belgrade 1930, 214-219; Todor Manojlović, "Exhibition of the art group 'Oblik'," *The Serbian Literary Gazette* 29, Belgrade 1930, 59-62; Mihajlo Mitrović, "Architect Branko Krstić," *Politika* October 21, 1978; Ibid., "The Golden circle of culture," *Politika* September 7, 1991.

[3] Branko Krstić, *Branko Krstić* (Catalogue of works of fine arts, author's edition), Belgrade 1964, 1.

[4] Anonymous, "Stečaj za hram Sv. Save" [Fundraising for the Church of St. Sava], *Politika*, 3.11.1926.

[5] Djurdjević, *Architects Petar and Branko Krstić*, 36.

[6] Anonymous, "Novi hram Sv. Marka i palata Glavne pošte" [New Church of St. Mark and the Palace of Main Post Office], *Vreme*, 18.9.1930.

[7] Predrag Karalić, "The Most Beautiful Facade in Belgrade," *Život i rad* 110/18, Beograd 1934.

[8] Branko Krstić, *Memoirs* (manuscript), the Archives of the Cultural Heritage Preservation Institute of Belgrade.

[9] Minutes of meetings of the founders of the "Group of architects of modern stream" held in Belgrade in the months of November and December in 1928; a copy of the original document, the Archives of the Cultural Heritage Preservation Institute of Belgrade.

[10] Todor Manojlović, "Exhibition of the Oblik art group," *Serbian Literary Gazette* 29 (Belgrade 1930), 59-62.

[11] Bogdan Nestorović, "Evolution of a Belgrade apartment," *Annual of the Belgrade City Museum* 2 (Belgrade 1955), 247-267.

CHAPTER 13

NIŠKA BANJA:
MODERN ARCHITECTURE FOR A MODERN SPA

Nebojša Stanković

Open-air spatial planning, white, neutral, easy to maintain and easy to clean surfaces, and purely functional aspects of modernism are closely related to the modernizing agendas with respect to health and hygiene. The architectural responses to the demands for physical and mental health were especially vital after the Great War, as recently shown by P. Overy in his book *Light, Air and Openness: Modern Architecture between the Wars*, where he effectively re-contextualized some sanatoriums and clinics, otherwise attested as recognizable examples of modernist architecture.[1] This chapter aims to assess the architecture and urban planning of Niška Banja, a spa town located 9 km east of the city of Niš, which underwent rapid development in the 1930s, when many private villas, several hotels and a public medical center with a bathhouse were built.[2]

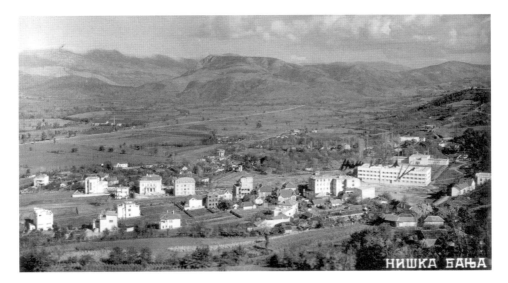

Fig. 13.1 Niška Banja, panorama from southwest, a postcard from c. 1937.

The layout of Niška Banja combines planned and unplanned elements built on and around a natural amphitheater-like terrace on a mountain slope (Fig. 13.1). The public medical center, consisting of a bathhouse and an inpatients' hotel with a garden in between, was more regularly planned and served – together with an adjacent park – as the focal point of this layout. Villas and houses occupied the surrounding areas. Most of these buildings were designed in the modernist, non-ornamental idiom which emerged in the 1930s throughout Yugoslavia. This new, simpler, more functional and low-cost 'style' was frequently employed for public and apartment buildings, and well-suited to hotels and the medical center. Nonetheless, it also found expression in a number of private houses and villas. The architects were not the only proponents of the new style, since the owners themselves often demanded the modernist style for their houses and villas. As a consequence, over time many modernist structures were incorporated into this small town. Together with extensive areas of consciously planted greenery they produced the impression of a stylistically and aesthetically unified townscape, an embodiment of the idea of the modern spa. At the time this was unprecedented in Yugoslavia and even beyond the country's borders. This idea never reached its full realization due to the Second World War and the political changes that followed. Nevertheless, what was actually built as well as the unrealized urban planning of the spa reveals the potential of both designers and society to combine and put into practise contemporary ideals of spa therapy and leisure resorts. Moreover, the entire project demonstrates coherence in that endeavor and implementation on a grand scale.

Historical Background

Niška Banja has been known for its thermal springs since at least the 2nd century AD, when Roman *thermae* were built.[3] Banja received renewed attention during the Ottoman rule in this region (16th-19th centuries).[4] By the mid-19th century, Banja comprised two Ottoman-style bathhouses, built over the main thermal spring, a few *hans* (roadside inns), a mosque and a hamlet at some distance northeast of the bathhouses.[5] In 1878 the region became part of Serbia. Prince (later King) Milan (1868-89), who established his second, non-official residence in Niš, began to frequent Banja. Well-to-do citizens of Niš followed suit. The area around the bathhouses was transformed into a park. Banja gained a train station in 1887, but that did not affect its status as a local resort. Greater potential for Banja as a spa was suggested in 1911, when a study of its thermal waters revealed that they were radioactive.[6] Interest in their use for therapeutic purposes increased, but the onset of WWI impeded further development.

The decade after the war was marked by efforts to provide Niška Banja with the necessary infrastructure that would improve living standards: electricity was introduced in 1925 and a tram line connecting it to Niš opened in 1930.[7] The public water supply was inaugurated in 1934.[8] The park was reconfigured in 1925 and enlarged in the early 1930s. Simultaneously, many well-off Niš families built their houses in the previously undeveloped area west of the park, thus forming the section occasionally referred to as the 'New Banja' (Fig. 13.1), as distinguished from the original village, the Old Banja. However, Banja still largely dwelled in anonymity.[9] That gradually changed with the frequent visits of King Alexander I of Yugoslavia (1921-34), who first came in 1928.[10] The tram line started operating in October 1930 and Đoka Jovanović's hotel opened in 1932.[11]

Apart from these locally momentous events, some other factors – on both regional and national levels – contributed to the subsequent urban and architectural development of Niška Banja. An intensive construction campaign of public and private apartment buildings was a major characteristic of the interwar urban development of the city of Niš. This was in response to the status of Niš as a regional center and the elevation of Niš as the seat of Moravska Banovina in 1929. An additional catalyst in this process was the ongoing modernization of the fast-growing city. In architecture, this meant greater use of the modern style in state-sponsored projects, due to the perception that it lacked ethnic specificity and thus could function as national and unifying, following the reforms of King Alexander I.[12] The needs of Niš, as a newly-designated administrative center, as well as certain points in the country's development agenda were significant. One of the aims was the improvement of medical care. Another demand, on the part of the city's elite, was for a lavish suburb. Niška Banja met both.

The building activities intensified after a new national bill on construction was passed in 1932[13] and the General Plan of Regulation for Niška Banja was approved in 1933.[14] It is likely that this development was instigated by an active and entrepreneurial politician, Dragiša Cvetković. A native and mayor of Niš (1923-29 and 1935-36), he was Minister of social policy and public health (1935-39) and later Prime Minister of Yugoslavia (1939-41). In those high positions he could secure financial resources, including a 20 million dinar loan from several banks for the purpose of building Banja "in an expedited manner."[15] One can imagine that a model of the plan – of which two photos survive (Fig. 13.2) – was produced to convince bankers to approve the loan.[16] The fact that all former and current mayors of Niš, including Cvetković, had their villas in Banja probably served as sufficient guarantee to the bankers of a lucrative future for it.[17] Although Cvetković's own views on modern architecture are unknown, he undoubtedly took an active role in the process of Banja's development.[18] Banja soon replaced Bled in Slovenia as the most visited inland resort in Yugoslavia.[19]

Urban Planning

The first plan of regulation for Niška Banja was adopted in 1924.[20] This was followed by the rearrangement of the park pursuant to a new design in 1925.[21] The General Plan of Regulation for Niška Banja was drawn up by the architects Dušan S. Mirosavljević and Pavle Liler.[22] It established a new set of planning regulations (Građevinski pravilnik) in compliance with the new Bill on Construction providing the basis for the subsequent urban and architectural development of Banja. According to a report published in the Belgrade daily *Pravda* in December 1934, "the construction and serious development of Niška Banja are additionally secured with the General Plan [of Regulation], which bans further uncontrolled building activities, which have been dominant in past years."[23]

The plan's monumental, symmetrical layout is impressive (Fig. 13.2). Although it incorporates some existing features – such as the park and its basic configuration, the main promenade, and the traffic patterns – and follows the lines of the terrain, had it been executed in its entirety it would have completely transformed the town. The centerpiece of the layout is the existing park – which is now given a more regular, semicircular form – together with a new bathhouse and a *kursalon*.[24] From the bathhouse, the thermal waters go through the park and then fall as a waterfall over the semicircular retaining wall of the park. Further down, the stream was to flow from one pool to another and form an axis of a fan-shaped park of exotic trees all the way down to the highway in the valley. The promenade – perpendicular to the axis and lined with tall trees – is extended both east and west of the park and its ends are marked with monumental public buildings. The other streets, along which private houses were to be built, spread radially from a semicircular road around the park.

Probably the first action undertaken was the enlargement, leveling and planting of the garden between the future New Bathhouse and Banovinski Hotel – also known as the 'Upper Park.'[25] The park was enlarged southward, reaching the very base of the wooded Koritnjak Mountain. When these buildings were finished, they formed an ensemble that indeed became the centerpiece of the town (Figs. 13.1, to the

Fig. 13.2 Model of the General Plan of Regulation of Niška Banja, 1933.

right, 13.4, and 13.7). This was not only thanks to its formal qualities and the importance of the bathhouse as the major destination point in Banja, but also due to the fact that with the development of Banja by the late 1930s the complex was in the actual physical center of the urban agglomeration, with major streets leading to it.

Only a few other projects proposed in the plan were executed. For the purpose of opening up two new streets west of the park an expropriation of private land took place in 1939.[26] In the same year, the new entrance avenue was constructed.[27] It established a straight-line connection between the highway in the valley bellow and the center of Banja. It also accommodated tram tracks, which had been moved from their original route in the street east of the avenue. Planted rows of poplar trees on both sides of the avenue further accentuated the monumentality of the ascending entrance way. The war stopped the full realization of this plan. Had it been achieved, Banja would have been fully transformed into a *mondaine* spa (Fig. 13.3).

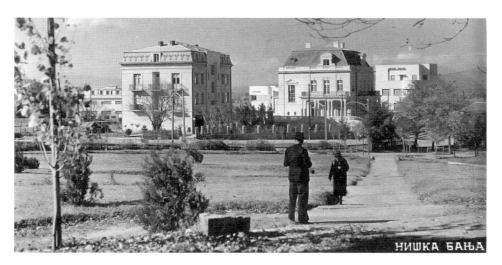

Fig. 13.3 Villa of Trifun Stefanović, Villa Toplica, Villa Kosovka, Villa Ristić, and Villa Živković in Niška Banja, view from southeast, a postcard from 1939.

The New Bathhouse and Banovinski Hotel

The beginnings of the development of Niška Banja as a public health center are marked by the years 1923, when it was put under state care, and 1926, when Dr Đoka Mihajlović was appointed Banja's head physician.[28] During that period, only the existing bathhouses were in

use. When King Alexander I began visiting Banja and after he pointed out the inadequacy of the old Ottoman baths, the idea of building a new bathhouse emerged. The efforts were further supported by Alexander himself, who made several personal donations to the building fund.[29]

The New Bathhouse (*Novo kupatilo*, at the beginning *Narodno kupatilo*, literally the *People's Bathhouse*),[30] located close to the Old Turkish Bathhouse and built on the main thermal spring, was completed in 1935.[31] According to a newspaper report, it was designed by Pavle Liler, a Russian émigré architect in the service of the Moravska Banovina administration in Niš.[32] As one of the authors of the 1933 General Plan of Regulation, he was in a position to give the plan actual physical form. In addition to the two indoor pools (for men and women), the New Bathhouse was equipped with 40 bath tubs for individual hydro-therapy and other facilities – including an "inhalatorium" – that represented an innovation in clinical and thermal therapy of the time.[33] Another novelty, unique for the country, was that both pools and bath tubs had direct access from the cabins, thus, providing more privacy for the users.[34] The upper floor was reserved for the "Radium Institute," which was expected to conduct research on the impact of radioactivity on humans.[35]

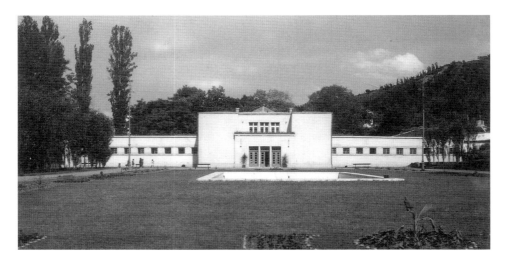

Fig. 13.4 New Bathhouse, Niška Banja, view from west, a postcard from c. 1938.

Although the building is symmetrically organized and overlooks the gardens that define the center of Banja, it is not monumental (Fig. 13.4). The exterior of the building conveys compositional balance as well as simplicity because of its lack of ornamentation. It transmits

an aura of cleanliness and modesty, and an overall impression of a utilitarian, but tasteful edifice. The interior organization follows the functional logic of a modern bathhouse, with all amenities to which any 20th-century patient – whether king or peasant – was entitled. There was no attempt to make it a luxurious and elite healthcare center, of the type usually found in the pre-World War I fashionable spas. Nonetheless, the west entrance façade, with its higher central part – where the windows had been consciously moved to the lateral façades in order to leave blank the pylon-like surfaces – suggests a modern "temple of health."

This play on the theme of tempered monumentality, justified by the need to make something tasteful though utilitarian, continues inside. The entrance vestibule and a lobby lead through a set of glazed doors into a hall. The centralized but modest hall

Fig. 13.5 New Bathhouse, Niška Banja, built c. 1935, interior of the hall with a skylight, as in 2011.

extends upwards through a circular opening, which is formed by the upper storey's gallery and designed to allow natural light brought in through a skylight (Fig. 13.5). Four conches in the corners house statues of bathers – an artistic touch in the austere interior. Through another set of glazed doors, the hall connects with a corridor, perpendicular to the entrance axis. It leads to two stairwells, situated in the east corners. The entrance lobby doubles as a waiting room in front of the doctors' offices, located on the sides, in the west corners of the central part. Small corridors on each side of the lobby lead to lower wings, each with a pool in the center and a ring of cabins around it. The pools receive natural light through clerestory windows (Figs. 13.6, 13.7). Rooms with individual bathtubs and rooms for rehabilitation form the outer ring. Roof terraces over the wings were used for sunbathing and 'fresh air' therapy, which was considered important as part of the process of rehabilitation.[36]

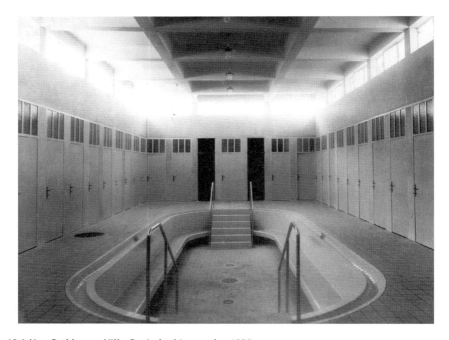

Fig. 13.6 New Bathhouse, Niška Banja, bathing pool, c. 1935.

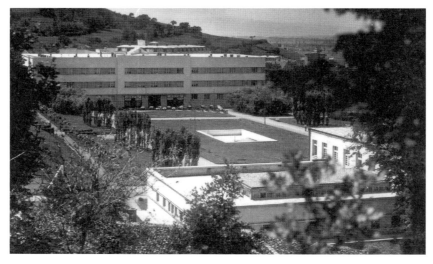

Fig. 13.7 Banovinski Hotel and the New Bathouse, Niška Banja, view from southeast, a postcard from c. 1938.

When Banovinski Hotel ('the Banovina's Hotel,' today Stacionar "Zelengora") was built in 1937 it was the largest building in Niška Banja and the largest hotel of any spa town in Yugoslavia.[37] Besides regular rooms, it had suites with balconies at the corners, an elevator and a post office.[38] It was owned by Moravska Banovina and served as the main accommodation unit for the bathhouse.

Designed by the architect of the New Bathhouse, Pavle Liler,[39] and built across the open garden, it represents a compositional counterpart to the New Bathhouse in accordance with the General Plan of Regulation (Figs. 13.1, 13.2, 13.7). Liler followed the rhythm established in the bathhouse façade and the motif of horizontally sequenced windows, but did not slavishly copy its architecture. The bands of windows terminate in balconies, which break the monotony, lighten the bulkiness of the block-like volume and bring in some liveliness. The simple façades convey the impression of functional minimalism, which was even more evident in the supremely utilitarian and ergonomic furnishing of the rooms. This furniture has been lost and is known only through a photograph from a Niška Banja tourist brochure, published between 1938 and 1941 (Fig. 13.8). The avant-garde functionalist look of the 'Breuer-esque' tubular-steel furniture is striking. These modernist furnishings would have been highly unusual in interwar Yugoslavia.[40] After WWII, the Banovinski Hotel was transformed into an inpatients' facility (*stacionar*), preserving its original character.

Fig. 13.8 Banovinski Hotel, Niška Banja, interior of a room, from a c. 1940 tourist brochure.

Private Hotels and Lodging Houses

A number of private hotels and lodging houses were also built in modern style. Built around 1932-33, the Villa of Trifun Stefanović (Fig. 13.9) is most likely the oldest modernist structure in Niška Banja. Information on the history of this building is virtually non-existent.[41] Judging from its structure – each floor divided into apartment units – it seems that the villa was built as a lodging house.[42] The features that make it appear modern are the plain façades, narrow horizontal windows, a roof terrace and undistinguished (almost hidden) entrance. Only the strong cornice and the attic wall (which doubles as the railing of the roof terrace), both decorated, look non-modern. Their decorative patterns are simple and geometric; they might be classical in spirit, but they are ultimately modern reinterpretations

of traditional architectural elements. The main façade faces the southeast, another concession to functionalist and hygienic demands, and completely disregards the views opening to the north. The avant-garde horizontal sliding windows, relatively low and narrow, had never been seen before or since in Niška Banja or Niš.[43]

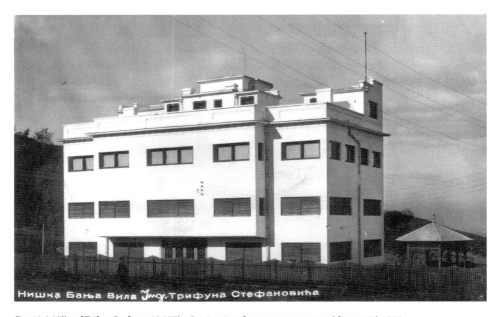

Fig. 13.9 Villa of Trifun Stefanović, Niška Banja, view from east, a postcard from mid-1930s.

The Villa of the Brothers Živković, merchants from Niš, was built c. 1935.[44] In its exterior, this building is the best example of modern architecture in Niška Banja (Fig. 13.10). It features the typical elements of modern architecture in Serbia, and combines them in a modernist manner. Its dynamic composition of masses seems to be the aim in itself. It pays no respect to the potential of utilizing north vistas. Rather, its horizontal tract with a semicircular ending interacts with the street in front of it (Fig. 13.3). It mimics a tram heading up the hill, thus reflecting modernist ideals of machine aesthetics and movement. The lack of openness and fluidity of spaces in the interior suggests that this villa was built as a lodging house. Also, it clarifies why there is no real interaction with the yard, which is compensated for by the placement of large terraces on the first floor and a roof terrace on the third.

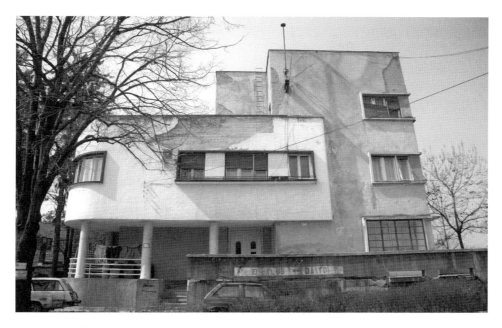

Fig. 13.10 Villa Živković, Niška Banja, c. 1935, view from northeast, as in 2011.

Architectural details of the façade are carefully elaborated. All the windows have plastered frames which, while similar, give them different qualities: three windows above the entrance are all placed within a single frame, thus stressing their horizontal alignment; the windows of the 'tower' are shifted close to the very corner – as close as was structurally permissible – and they are connected via frames that wrap around the corner, thus simulating corner windows, often seen in technologically more advanced examples of modern architecture. Modest decorative elements – such as the flag pole and the basement window bars – discretely suggest an Art Deco provenance. Then again, the simple horizontal metal bars for the railings underline the openness of the entrance porch and enhance the 'flying' effect of the projecting upper floor. These architectural solutions show that an effective modern expression could be achieved with technologically limited resources. The evident talent of an unknown architect of the Villa of the Brothers Živković compensated for this insufficiency.

Nebojša Stanković

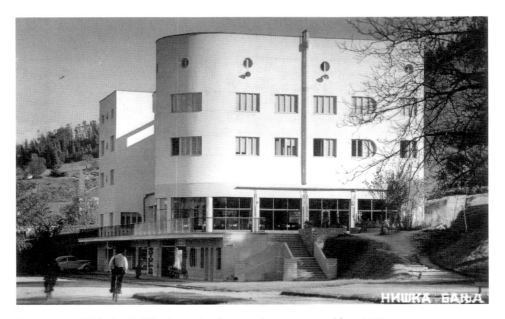

Fig. 13.11 Hotel Milenković, Niška Banja, view from northeast, a postcard from 1939.

The Hotel Milenković (Fig. 13.11) was built in 1935 and owned by Milivoje Milenković.[45] It is one of the modern buildings built in the Old Banja, on the part of the main promenade that had been the town center of sorts before the promenade was extended through the park and further to the west. The architect is unknown. The building consists of a body with two massive vertical wings, one rectangular in plan and the other with a semicircular end. Both are austerely plain, with a conscious balance of windows and wall surfaces. The rooms are distributed along the east, north and west façades, using the best views, whereas on the south

Fig. 13.12 Hotel Dubrovnik, Niška Banja, drawing of the street façade by A. Medvedev, 1940.

there were long terraces for sunbathing and enjoying the fresh air of the mountain woods. The building is raised from the ground, on a platform which was used as the terrace garden of a restaurant on the hotel's first floor and was also intended as a way of establishing contact with the wooded slopes that form the backdrop. The main entrance to the hotel and the reception, the entrance to a garage, a pastry

258

shop and other shops were located underneath the terrace and at street level. All of these efficiently solve the problem of sloping terrain.[46]

Hotel (or Villa) Dubrovnik was owned by T. Glavić and M. Stanković. It was designed by Aleksandar I. Medvedev (1900-1984), a prolific Russian émigré architect, who was based in Niš after 1935.[47] The design was made in 1940 (Fig. 13.12) and the construction was completed in 1941, the year war started in Yugoslavia.[48] The building is located on the entrance avenue that was constructed less than two years before. Its elongated, three-storeyed form follows and enhances the straight line of the avenue. The ground floor, partly dug into the slope, contained two dining halls, utility rooms and an office.[49] Each of the three floors had single-, double- and triple-bed rooms, and a suite, organized along a central corridor. Two semicircular stairwells were at both ends. The simple and serene façades reflect this functional organization. The street façade is enlivened only by long balconies and the shadows they cast. The symmetry is slightly and intentionally misbalanced by the addition of glazed loggias at the northwest corner and some dynamicity – which corresponds to the inclination of the sloping street. In turn, the back façade is anchored by the semicircular 'towers' of the stairwells.

Villas and Houses

Villa Erna (Fig. 13.13) by the well-known Serbian architect Branislav Kojić (1899-1987), who organized the "Group of Architects of Modern Orientation" in Belgrade in 1928,[50] exemplifies modernist residential architecture in Banja.[51] Designed for Momčilo Janković, a lawyer from Niš, it was built sometime between 1932 and 1934.[52] Villa Erna and its slightly older neighbor, the Villa of T. Stefanović, represent some of the earliest modern buildings in Niška Banja; it may be that only the construction of the New Bathhouse could have started earlier. Both villas feature elements of modern architecture, such as the sliding windows of the Villa of T. Stefanović, and open interior organization, free composition of cubic masses, and many terraces and balconies of Villa Erna. These features were not repeated again in any other villa in Banja.

Villa Erna was a bold, though not an entirely radical step forward in the treatment of a vacation house. Built on the outskirts of the "New Banja," and away from streets and roads, it did not have a main façade – the entrance was on the northeast, the large open terrace (with the living room and the study) was on the northwest, overlooking the Nišava river valley, and the dining room was on the southeast. The architect himself explained: "The site, oriented towards the Nišava valley and the Svrljiške Mountains, dictated the basic disposition of spaces: the terraces, the balconies, and the main windows are all looking north and northwest, towards open vistas."[53] The composition of masses of clean, cubic shapes is governed by these

'directives' of the landscape and appears chaotic at first. However, every detail is carefully designed to play its role in the well-balanced whole. The first-floor cubic projection and the roof terrace pergola have special places. By continuing the stepping-down composition of the higher parts, the cubic projection brings dynamicity to what would otherwise have been a clean-cut, stark, and massive cube. The supporting piers are made of dark brick in order to give the study wing the appearance of a cantilevered projection. The roof pergola provides a transparent and light finish to a rather heavy and closed structure, perforated only with relatively small windows.

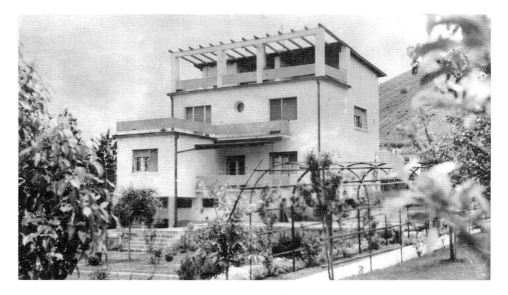

Fig. 13.13 Villa Erna, Niška Banja, view from west, a postcard from 1940.

With its interior organization around a central hall, projecting masses, porches and terraces, Villa Erna is a modern reinterpretation of a traditional vernacular house, perceived as organic to the local environment.[54] Nonetheless, nothing in this house was aimed at causing any kind of impression and making it agreeable, but rather fulfilling its main purpose – to be useful and functional.[55] That, even more than its form and lack of decoration, made it modern. This remarkable example of modern architecture not only in Banja, but also in Serbia, was devastated by its remodeling beyond recognition in the 1970s. The spiral staircase, which once led to the garden, is the only part that preserves its original form.

Other villas, such as Villa Vera, built in the area north of the park in 1937,[56] are examples of more modest, middle-class houses. Built for Father Ž. Novaković, Villa Vera is a town house rather than a villa. Each of its two floors has an apartment, with a plan typical of interwar city apartments: a small central hall, three rooms on one side, and dining room, kitchen and bathroom on the other. Again, the orientation of the building benefited from the view towards the valley. In the case of Villa Vera, the surviving archival documentation and the building itself confirm that the client rejected original classicist design – which included pilasters with Corinthian capitals and other plastered ornaments, some echoing Art Deco – and asked for a simpler, non-ornamental modern design.[57] It remains unknown whether this demand was instigated by a genuine appreciation of the modern style or by mere economic concern, yet it speaks of the active engagement of the owner in the design process.

Fig. 13.14 Villa Zone (first from left), with villas Teokarević and Čavdarević, Niška Banja, view from east, a postcard from c. 1940.

Villa Zone (Fig. 13.14, to the left), located on the slope of a hill and on a street that formed the west extension of the central promenade, was built in 1939.[58] The owner, Dragiša Cvetković, who became the prime minister in the same year, used the villa for family vacations as well as for business meetings.[59] Architect Medvedev took full advantage of one of the best locations in Niška Banja, although in a more traditional, slightly monumental manner. Here, the ground plan, which develops freely in all directions, is reminiscent of a traditional vernacular house organization of rooms around a central hall, offering the best vistas. A large porch opens up at the north corner of the house and, via two flights of stairs, connects the house with the terraced yard spreading down the slope. Debts to traditional vernacular architecture

are visible in the exterior with its pitched roof of low inclination, long-projecting eaves and traditional roof tiles, as well as in the design of the chimneys and the horizontal rows of closely placed windows. Judging by the architecture of the neighboring villas of D. Živković (Villa Vera), M. Čavdarević and another one (Fig. 13.14), all built around the same time, the preference for vernacular elements seems to be a general trend of the late 1930s, rather than a personal inclination. However, Medvedev gave Villa Zone a non-classical and more modernist treatment.

Conclusion

In the period between 1927 and 1941, 22 villas, 4 hotels, an inpatients' hotel and a bathhouse were built in Niška Banja.[60] Although the building activities in Niška Banja were conducted according to the General Plan of Regulation, the plan itself did not indicate a preference for any particular architectural style. Nonetheless, the vast majority of these buildings were designed in the modern style. Their number and the quality of designs – produced in a society with limited financial and technological resources, and executed in a small area and in a brief period of time (1932-41) – are impressive.

The buildings themselves offer a deeper understanding and acceptance of modernity, mostly in the domain of form and design, but even in the sphere of function and planning. The most obvious modern features of the buildings in Niška Banja are plain, non-ornamental façades and free, non-classical compositions of masses – with a stress on horizontality. In this emphasis on horizontality, windows are often grouped in horizontal sequences, further accentuated with horizontal moldings and darker shades of the paint applied to the sections between windows (Figs. 13.4, 13.7, 13.10, 13.14). These features contribute to the visual effect of long, horizontal strips. Proper horizontal windows, however, are found only in the Villa of T. Stefanović (Fig. 13.9). Sliding, as the system of their opening, is unique in Niška Banja and even over a wider region.[61] Semi-circular elements – stairwells, living rooms (salons) and balconies – are frequently employed as accentuating parts in composition (Figs. 13.10, 13.11). Protruding eaves or just cantilevered slabs have a more functional purpose – sun and rain protection (Fig. 13.14). They also bring in the play of shadows, which enliven otherwise blank façade surfaces. A number of buildings have flat roofs or roof terraces, but more commonly, a pitched roof. The traditional pitched roof is also a product of practicality – demands imposed by the local climate, as well as easier construction and maintenance. Nonetheless, there are a few examples of roof terraces – such as the ones in the bathhouse, Villa of T. Stefanović, Villa Živković and Villa Erna (Figs. 13.7, 13.9, 13.10, 13.13) – in compliance with the modernist advocacy of particular forms of dwelling, exercise and therapy in the open air.[62]

Reinterpreted elements of vernacular architecture (pitched roofs, long-projecting eaves, arcaded porches and balconies) point to national sentiments.[63] These elements are commonly found in later buildings (Fig. 13.14), which may suggest a shift in clients' taste or change in the meaning applied to domestic architecture. The latter may have meant that some elements of vernacular architecture were viewed as more appropriate responses to the requirements of local terrain, climate and cultural habits. Considerations of terrain and climate were part of the modernist discourse, so this dialog with vernacular architecture – although somewhat romantic – should not necessarily be viewed solely as a recreation of the 'national' idiom. This is supported by a creative interpretation of the vernacular in Villa Erna. Nonetheless, it is possible that the vernacular stylistic elements were used to express the regional flavor of south Serbia, in a way permissible and even desirable for vacation houses as, for example, Mediterranean in Dalmatia or Alpine in Bled would be. They were used to situate the building in its environment, both natural and cultural, moving away from the 'international modern' to the 'national modern'.

The plans of buildings in Niška Banja are usually compact, inscribed within a rectangle. The bathhouse and the hotels follow a contemporary functional scheme, whereas in the villas the plan is somewhat more conservative, closer to the organization of domestic space characteristic of urban houses and apartments. They were advanced, modern-equipped versions of pre-WWI homes. The standard set of rooms was only appended with a separate and functionally defined kitchen, with a smaller or bigger utility block, as well as a bathroom. The modern flow of spaces ('free plan') appears only in a rudimentary form and only in a few villas such as in the Villa Erna. The plans and the treatment of both interior spaces (divided into distinctly formed rooms) and façade masses (as a composition of offset and recessed planes) point to what Adolf Loos termed *Raumplan* and exemplified in his Villa Müller in Prague (1928-30).[64]

Then again, there is a stronger emphasis on physical and visual contacts with gardens and the surrounding landscape, through the use of terraces, balconies, pergolas and gardens, "the privileged liminal spaces of modernism."[65] With the exception of the bathhouse, which is inward oriented, all the hotels, villas and houses interact with the landscape, either directly or through created vistas, or both. The respect for the sloping terrain and even the taking advantage of such a disposition – e.g. direct contact with the ground on two levels – was another way of engaging in a dialog with the landscape. Exterior walls – with large windows and balconies – unfold to create vistas that direct the eye down a street or, more often, towards the valley. This openness to and dialog with the exterior is something that is built into modernity. Yet, 'liminal spaces,' such as different types of porches and open rooms, and their use as living areas during the summer months, were typical of traditional Serbian and Balkan houses in villages and small provincial towns, which Niš still was in the 1930s. Forms of a

'symbiotic' relationship between buildings and nature were already in evidence there, deeply rooted in the local culture, facilitating the acceptance of the ideas about light, fresh air and openness which featured prominently in modernist discourse, photographs, and films during the late 1920s and early 1930s.[66]

Regarding the urban layout of Niška Banja, a striking feature of the 1933 General Plan of Regulation is its monumentality and symmetrical design (Fig. 13.2). As such, it is reminiscent of late 19th-century and early 20th-century urban designs, but only on a micro scale. It is actually close to the contemporaneous urban designs in which both symmetry and openness figure prominently.[67] With its detached houses and abundant greenery, as well as Niška Banja's suburban location, it bears a relationship to contemporary and experimental German and Austrian *Werkbundsiedlungen*, and Czech 'colonies.'[68]

The ensemble of the New Bathhouse, Banovinski Hotel and the park constitutes a public medical center (Fig. 13.7). With the addition of the planned but never realized *kursalon*, it would have constituted a complete community center.[69] Its central position was a statement that a modern spa is democratic, open to everyone. This was additionally underlined by the location of the terminal station of the Niš-Niška Banja tram line in the park. Hotels – which, with their restaurants, cafés and cabarets, made up for the lack of a *kursalon*, by then obsolete – were built in the areas adjacent to this central complex. Lodging houses and villas nestled on the periphery invested Banja with an elite character as well.

All these characteristics – modern, yet traditional; cutting-edge, yet affordable; new forms executed in well-known materials; utilitarian, yet tasteful; fashionable, yet modest; and both democratic and *mondaine* – put Niška Banja on 'the very edge' of modernism. These contradictions, or rather complexities, are not unique; they found equivalency throughout Europe.[70] Perhaps these ambiguities made the modern style quickly and widely accepted by Banja's inhabitants and developers. They probably chose modern architecture as consistent with the time of fast-paced progress and adequate to modern living standards, as well as more hygienic and 'healthier,' yet cheaper to build and maintain. The functionality and modesty it offered was appropriate with respect to the requirements of public health and therapy, on the one hand, and leisure and vacation, on the other. The non-radical, domesticated modernism (close to both Art Deco and *Neue Sachlichkeit*), which – with its artistic potentials despite its non-ornamentality – was on 'the very edge,' made this version of modern architecture easier to understand and accept.[71] Also, the level of economic and technological development in interwar Serbia could not sustain wide use of framework structures and large glass walls typical of West-European industrial and governmental buildings.[72] The modernism of Niška Banja may be best described as a possible or sustainable modernism. Implemented on both levels – architecture and urban planning – it was the means to put into practise the idea of the Serbian modern spa.

Notes

1 P. Overy, *Light, Air and Openness: Modern Architecture between the Wars* (New York: Thames and Hudson, 2007).

2 Niška Banja's modern architecture and urban development have received limited attention. A. Keković and Z. Čemerikić, in their article "Moderna u Niškoj Banji – Vile i hoteli" [The Modern architecture of Niška Banja: Villas and Hotels], *Arhitektura i urbanizam* 8 (2001), 60-71, made a pioneering contribution, later expanded and published in their book *Moderna Niša 1920-1941* [The Modern Architecture of Niš 1920-1941] (Niš: Društvo arhitekata Niša, 2006).

3 M. D. Šijački, *Niška Banja* (Belgrade: Knjižarnica Radomira D. Đukovića, 1936), 8-14; J. Vasić, *Niška Banja* (Niš: Atlantis, 2007), 21-22.

4 B. Andrejević, *Stari zapisi o Nišu, od V do XIX veka* [Old Records on Niš, 5th-19th Centuries] (Niš: Prosveta, 1997), 73.

5 The native Serb population of the village was forced by the Ottomans to move away from the area around thermal springs, after the old village was burned down in reprisal for the villagers' participation in the Niš Uprising of April 1841 (Vasić, *op. cit.*, 39, 41).

6 Marko T. Leko, a chemist and Professor at the University of Belgrade, conducted the research in 1909 and published the results in 1911 (ibid., 60).

7 D. Milić, (ed.), *Istorija Niša* [The History of Niš] (Niš: Gradina; Prosveta, 1984), Vol. 2, 478; S. M. Stanković, *Niška Banja* (Belgrade: Turistička štampa; Niš: Turistički savez opštine, 1981), 8; Vasić, *op. cit.*, 63; Keković-Čemerikić, *Moderna Niša*, 29.

8 *Istorija Niša*, Vol. 2, 478. From a newspaper report published in the daily *Politika* on June 16, 1935 (cited in: Vasić, *op. cit.*, 70) it can be inferred that works on the water supply system had been finished, but it was not yet working.

9 The major encyclopedia of the period, St. Stanojević ed., *Narodna enciklopedija srpsko-hrvatsko-slovenačka* (Zagreb: Bibliografski zavod, 1928), Vol. 3 (N-R), does not have an entry on Niška Banja.

10 Vasić, *op. cit.*, 64, 83.

11 The total number of tram passengers in 1932 was 1.2 million (S. M. Stanković, *op. cit.*, 8), which was a large number considering the fact that Niš had only 35,465 inhabitants according to the 1931 census.

12 A. Ignjatović, *Jugoslovenstvo u arhitekturi, 1904-1941* [Yugoslavism in Architecture, 1904-1941] (Belgrade: Građevinska knjiga, 2007).

13 *Istorija Niša*, Vol. 2, 480.

14 Vasić, *op. cit.*, 66.

15 Ibid., 73.

16 According to Vasić (ibid., 72), the photos are in the Historical Archives of Niš.

17 Villa Čavdarević of Milorad Čavdarević, former mayor (1929-35), was built c. 1937, Villa Vera of Dragi Živković (mayor, 1936-41), was built in 1938-39, and Cvetković's own Villa Zone was built in 1939, all close to one another (see Fig. 13.14).

18 Similarly, as Minister of social policy and public health, Cvetković greatly influenced the decision to build Yugoslavia's largest anti-tuberculosis sanatorium (1936) in Knez-Selo near Niš (*cf.* Keković-Čemerikić, *Moderna Niša*, p. 204).

19 Vasić, *op. cit.*, 72.

20 Keković-Čemerikić, *Moderna Niša*, 29.

21 Vasić, *op. cit.*, 63.

22 Ibid., 66. The plan has the dates July 1, 1933 (in the upper left corner) and September 21, 1933 (when it was approved by the Minister of Construction). A photocopy kept in the Historical Archives of Niš has been consulted for this study.

23 Vasić, *op. cit.*, 81.

24 *Kursaal* (Ger.) was a sort of community center, with a cinema theater, a restaurant, a café, etc in European spas.

25 These works can be dated to c. 1933 (*cf.* Vasić, *op. cit.*, 68-69) or to 1934-35, according to a report in the daily *Politika*, June 16, 1935 (ibid., 70). It is likely that they were undertaken in conjunction with the building of the New Bathhouse.

26 Historical Archives of Niš, The GraPo Fund, TO, box 69 – "Plan za izvlaštenje dobara radi otvaranja ulica broj 1 i 13 zapadno od centra parka u Niškoj Banji" [The Plan for the Expropriation of Land for the Purpose of Opening Up Streets Nos. 1 and 13 West of the Center of the Park in Niška Banja] (scale 1:1000), The Municipal Authority of Niška Banja, No. 1255, 9 June 1939. This information indirectly confirms the dating of the construction of Villa Zone to 1939 (see below), since one of the streets that was cut through in that year connects the villa to the center of Banja.

27 Vasić, *op. cit.*, 67.

28 http://www.radonnb.co.rs/index.php?option=com_content&view=article&id=66&Itemid=87&lang=sr&p=3&h=1 (retrieved on 25 July 2011).

29 Šijački, *op. cit.*, 44.

30 Ibid.

31 Ibid.; *Istorija Niša*, Vol. 2, 521; Vasić, *op. cit.*, 70.

32 Vasić, *op. cit.*, 70. The report is from an unspecified newspaper published in 1934.

33 Vasić, *op. cit.*, 69-70. The inhalatorium was a special and unique feature, designed by Dr Dragoljub Jovanović, professor at the University of Belgrade and director of the Medical Institute in Niška Banja (ibid., 70).

34 Ibid.

35 Ibid. (according to a newspaper report).

36 *Cf.* P. Overy, *op. cit.*, *passim*.

37 Vasić, *op. cit.*, 71.

38 Ibid.

39 Keković-Čemerikić, *Moderna Niša*, 224.

40 Such functionalist furniture was first produced for sanatoriums and hospitals, and only during the 1920s and 1930s became fashionable for the homes of the European and American middle class. Overy, *op. cit.*, 78-82.

41 Many architectural records were lost either during the Second World War or in the catastrophic flooding of Niš in 1948. Fortunately, a lot of different photographs and postcards from the 1930s survive. Through examination of such pictorial evidence and in concert with the information gathered from written records, relative and approximate dates of construction of the buildings discussed in this study have been established. It can be concluded that the Villa of T. Stefanović was built prior to most of its neighbors, including Villa Veličković (1935) and Villa Erna (see below), but certainly after the hotel of Đoka Jovanović (1932).

42 In Serbian spa towns the term 'villa' is commonly applied to both single-family vacation houses (with no regard to their size and amenities) and lodging houses.

[43] Both the sliding windows and the classicizing elements suggest that the design was that of a well-trained architect. Considering the lack of educated architects in Niš at that time, perhaps this design could be ascribed to a Russian émigré architect, yet this supposition must remain a speculation.

[44] Keković and Čemerikić date it to 1938-39 ("Moderna u Niškoj Banji – Vile i hoteli," 66, and *Moderna Niša*, 37). However, some panoramic photographs of Niška Banja clearly show that it was erected prior to the Neo-Baroque Villa Ristić (1936), which is located on a neighboring plot.

[45] Vasić, *op. cit.*, 23, 69.

[46] The hotel's upper parts were substantially altered by the addition of another floor and a mansard roof in 1985 (Keković-Čemerikić, *Moderna Niša*, 220-21).

[47] M. Medvedev, "Projekti i arhitektura Aleksandra I. Medvedeva" [The Projects and Architecture of Aleksandar I. Medvedev], *Arhitektura i urbanizam* 8 (2001), 79-84, and M. Medvedev, *Projekti i arhitektura ing. Aleksandra I. Medvedeva, ovl. arhitekta* [The Projects and Architecture of Ing. Aleksandar I. Medvedev, Authorized Architect] (Niš: Društvo arhitekata Niša, 2012), which was published after the completion of this chapter.

[48] Keković-Čemerikić, "Moderna u Niškoj Banji," 68, and *id.*, *Moderna Niša*, 223.

[49] Ibid.

[50] See chapters by Djurdjević, Kamilić, and Ćorović in this volume.

[51] S. Toševa, "Prilog proučavanju rada Branislava Kojića u jugoistočnoj Srbiji" [A Contribution to the Study of Branislav Kojić's Oeuvre in Southeast Serbia], *Leskovački zbornik* 37 (1997), 75-82, 78, 79; Keković-Čemerikić, *Moderna Niša*, 160-61.

[52] Villa Erna has been dated to 1937 by Toševa, *op. cit.*, 79, 80. However, comparison of several old photographs and postcards points to the conclusion that it was built prior to Banovinski Hotel (1937) and even Villa Veličković (1935), but after the hotel of Đoka Jovanović (1932). Based on what can be seen in a photograph from a tourist brochure, the Villa of Trifun Stefanović was built before Villa Erna. Therefore, Villa Erna was most likely built in 1932-1934.

[53] The Biography of Branislav Kojić, member of the Academy, Belgrade 1975, The Archives of the Serbian Academy of Sciences and Arts, Historical Collection, No. 14380 (cited in Toševa, *op. cit.*, 80).

[54] Kojić designed his own house in Belgrade as a modern version of the traditional town house.

[55] *Cf.* Toševa, *op. cit.*, 81.

[56] Keković-Čemerikić, "Moderna u Niškoj Banji," 66, and id., *Moderna Niša*, 34. This date can be confirmed by an aerial photograph taken in 1937 or 1938.

[57] Ibid.

[58] Medvedev, *op. cit.*, 84. Keković and Čemerikić, however, date the construction of the villa in 1937, "Moderna u Niškoj Banji," 62, 65, and *Moderna Niša*, 29, 32, as does Vasić, *op. cit.*, 71. The preference should be given to Medvedev's dating for two reasons: he owns his father's project drawings and archives, from which he probably extracted the date; and several photographs taken in 1937-38 (after Banovinski Hotel was finished) clearly show that this building and the whole area around it were not yet built.

[59] Vasić, *op. cit.*, 72.

[60] Keković-Čemerikić, "Moderna u Niškoj Banji," 62; Vasić, *op. cit.*, 72.

[61] There is no similar feature in either Niška Banja or Niš (*cf.* Keković-Čemerikić, *Moderna Niša*, passim).

[62] Overy, *op. cit.*, passim.

[63] See: A. Kadijević, *Jedan vek traženja nacionalnog stila u srpskoj arhitekturi (sredina XIX – sredina XX veka)* [A Century of a Search for a National Style in Serbian Architecture (Mid-19th – Mid-20th Centuries)] (Belgrade: Građevinska knjiga, 2007²).

⁶⁴ For the concepts of *Raumplan* and *plan libre* and their facets see: M. Risselada ed., *Raumplan versus Plan Libre: Adolf Loos, Le Corbusier* (Rotterdam: 010 Publishers, 2008). On Villa Müller see: K. Ksandr ed., *Villa Müller* (Prague: Argo, 2000).

⁶⁵ Overy, *op. cit.*, 10.

⁶⁶ Ibid., 9, 12.

⁶⁷ For example, the Jan Duiker's Zonnestraal Sanatorium complex (1925-31) in Hilversum, The Netherlands, despite its avant-garde functionalist architecture, has a symmetrical layout.

⁶⁸ Weissenhofsiedlung in Stuttgart (1927), Kolonie Nový Dům in Brno (1928), WuWa in Breslau (Wrocław, 1929), Werkbundsiedlung Wien in Vienna (1932), to mention but a few. Yet, socio-economic backgrounds, ideas and intentions behind these varied and were different from those that governed the planning of Niška Banja. See also chapters by Ćorović and Kamilić in this volume.

⁶⁹ The sanatorium, the cinema and the middle-class hotel were central to the society of the 1930s (based on Peter Smithson's 1962 examination of Jan Duiker's oeuvre; *cf.* Overy, *op. cit.*, 19).

⁷⁰ See, for example, the intentions for the Weissenhofsiedlung in Stuttgart as outlined by the Mayor of Stuttgart, K. Lautenschlager, and the President of Deutscher Werkbund, P. Bruckmann, in 1925 and cited at http://www.weissenhof2002.de/english/weissenhof.html; retrieved on 23 August 2012.

⁷¹ *Cf.* Keković-Čemerikić, *Moderna Niša*, 26-27, who claim that, "[t]he concurrence of investors' interests in fast and cheap construction, tenants' needs for adequate and functional space, and architects' championing of the contemporary trends, led to embracement of the Modern style ... maybe even faster and to a larger extent than in other European countries."

⁷² A similar use of modern forms and implementation of modern principles with 'low-tech' means can be found throughout Central and Eastern Europe.

MONEY, POLITICS, AND SPORTS:
STADIUM ARCHITECTURE IN INTERWAR SERBIA

Dejan N. Zec

The Rise of Sports in Early Twentieth-Century Serbia

At the end of the nineteenth and the beginning of the twentieth centuries members of the Serbian economic, cultural and political elite made every effort to modernize the Kingdom of Serbia in order to bring the country from the periphery to the very heart of Europe. They addressed the modernization of the economy, urbanization, political emancipation, transportation, health care, education, and life style in general. Serbs who had studied, conducted business or spent time in European countries shared with their fellow countrymen newly developed enthusiasm for modern art, literature, theater and opera as well as sports.

In Europe, sports were becoming increasingly popular.[1] The romantic movement of new-age sporting chivalry and amateurism championed by Pierre de Coubertin (1863-1937) led to the rebirth of the Olympic Games in Athens in 1896.[2] By the end of the nineteenth century, sporting matches attracted large crowds of spectators and generated enormous public attention. Private schools in the United Kingdom and large, industrialized cities, both in the British Isles and on the continent, were the cradles of popular competitive sports. Rugby and soccer (association football) became favorite pastimes for European young people, especially students, across class lines.

When the Serbian government sent outstanding students to study at the best European Universities in preparation for governmental leadership and service, many of them were drawn into the prevailing craze for sports. They participated in sports, played for amateur clubs at their universities and on their return to Serbia became fanatical pioneers of sports.[3] Although quite resounding, their enthusiasm was insufficient to overcome all the obstacles of an essentially conservative Serbian society. Even after a general acceptance of sports by the authorities and society, physical education in the Kingdom of Serbia was viewed primarily as a way to increase combat readiness and to maintain good health. Gymnastics, fencing, weightlifting and stone throwing were considered socially beneficial sports.[4] Competitive

team sports, including soccer, were considered inappropriate because they were deemed simply entertaining or even childish.

Yet, at the beginning of the twentieth century, the first amateur soccer clubs in Serbia were founded: "Soko" ("Falcon") and "Srpski mač" ("Serbian Sword") in Belgrade, "Šumadija" in Kragujevac, "Dušan Silni" ("Dušan Mighty") in Šabac, "Vihor" ("Whirlwind") in Obrenovac, "Deligrad" in Aleksinac.[5] Their organization was rudimentary. A few enthusiasts, who were willing to invest their own time, money and energy, played soccer in the streets, parks, meadows and larger backyards. Only a few clubs managed to secure a piece of land big enough for a regular soccer field. Often, these were nothing more than fenced pieces of land on which goal posts were erected and the lines painted with lime on the grass. The clubs also lacked good leather balls, proper soccer boots, jerseys and other necessary equipment.[6] Despite the material shortages and organizational difficulties, soccer was becoming increasingly popular.[7] By 1914 soccer was by far the most popular sport in Serbia. The soccer clubs gained reputation and followers. Most clubs acquired good organizational structures, financial security and basic training and playing facilities.

A Challenging Beginning: Amateur Sporting Clubs and Their Makeshift Stadiums

The first authentic soccer club in Serbia was Belgrade's "Soko" ("Falcon"). Based on the typical European model, it was established in the spring of 1903 by a group of Serbian students who were studying abroad. Some of the founders were well-known in Serbian society. Hugo Buli (1875-1941) was the son of the rich trader, Ljubomir Jovanović (1865-1928) later became President of the Yugoslav National Assembly, Stevan Stefanović (?-1945) was the son of a wealthy industrialist, and Momir Korunović (1883-1969) later became a famous architect.[8] During their holidays in Belgrade they exercised with the athletes of the local "Soko" gymnastics association. This association was part of a larger "Soko" cultural movement, originally founded in the mid nineteenth century in the Czech areas of the Austro-Hungarian Empire. It combined physical exercise routines with an emphasis on Czech nationalism and Pan-Slavism.[9] Because the athletes in the "Soko" organization were not open to the idea of adding soccer to their exercise routine, the young rebellious players separated themselves from the gymnastics society and created an exclusive soccer club. The newly formed "Soko" soccer club played the first few matches at the provisional exercise grounds of the "Soko" gymnastics society in Braće Jugovića Street, in Dorćol, an old part of Belgrade, but was soon forced to leave. Using their family connections, the soccer players secured a piece of wasteland near Belgrade's Central Railway Station. Known as Bara Venecija (the Venice Swamp), it was always flooded during the spring and infested with mosquitoes during the summer. A year

later, the club moved to a more suitable location in a recreational area outside of Belgrade, known as Košutnjak.

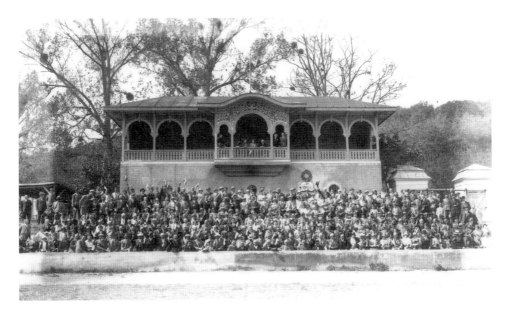

Fig. 14.1 Momir Korunović, Central lodge of the "Soko" stadium in Košutnjak, Belgrade, built in 1923.

The "Soko" stadium, built in 1904 in Košutnjak, was the first real soccer stadium in Serbia.[10] The oval playing field could be modified to accommodate major competitions. The stands were elliptical, provided good visibility, and held up to 3,000 spectators. This small stadium at Košutnjak Park was modern in all respects, and with some adjustments it functioned satisfactorily for more than twenty years. In 1923, a small but lavish lodge for distinguished guests and dignitaries was added to the stadium to commemorate the wedding of King Aleksandar I Karađorđević (1888-1934) and Princess Maria of Romania (1900-1961).[11] The V.I.P. stadium lodge was built in the vernacular heavily ornamented Serbian national style. Despite the lack of archival documents that would confirm who had built it, it is possible that the architect of the lodge was Momir Korunović, a member of the "Soko" soccer club and renowned architect who worked mostly in the Serbo-Byzantine and Romantic Expressionist idioms (Fig. 14.1).[12]

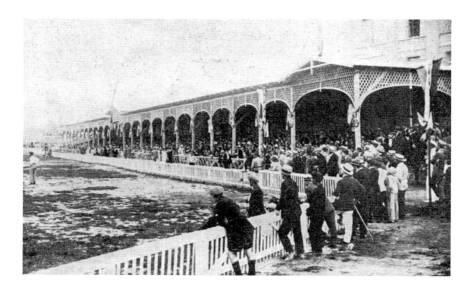

Fig. 14.2 Detail of the terrace of the old "BSK" stadium at "Trkalište", Belgrade, built in 1914.

The Stadium for "B.S.K." ("Beogradski Sport Klub"–"Belgrade Sports Club") was built in 1914 in central Belgrade between Vračar and Palilula in the so-called *Trkalište* ("Racetrack") sector (Fig. 14.2). Founded in 1911 "B.S.K." was the most famous and successful Serbian soccer club until its dissolution in 1945. Its supporters were often viewed as rich and conservative and as Serbian nationalists. The founding member of "B.S.K.," Ljubomir Davidović (1863-1940), a prominent politician and Mayor of Belgrade (1910-1914), used his position and personal connections to build the stadium on this highly-priced urban site.[13] Despite the use of the cheap forced labor of Belgrade convicts, who were paid a meager salary of only 0,20 dinars per day (approximately 4 cents per day; dollar– dinar ratio of 1914),[14] the cost of construction was immense. As a consequence, club members had to collect significant funds to put up as collateral for a bank loan.[15] It took three years for the completion of the basic work. The stadium was officially opened on Easter Sunday 1914, with a friendly soccer tournament. The press reported:

> The agile management of "B.S.K." had arranged the soccer field given to them by the Belgrade City Council in a modern fashion. Out of their own funds "B.S.K." had spent more than 10,000 dinars [approximately $1930 at the time]; they have made a roofed grandstand with luxury lodges and seats for approximately 500 spectators.

Wardrobes, barriers, a playing field with goal posts and running track are also built. But the playing field itself is in poor condition, which makes it difficult for the players to show their skills.[16]

When the "Velika Srbija" ("Greater Serbia") soccer club was created in 1913, the city authorities approved the unused area opposite the "B.S.K." stadium at *Trkalište*.[17] The plot was rough, covered with large holes, construction waste and weeds. A heavily used pedestrian shortcut intersected the field. In order to begin work, the engineers had to dig trenches around the field and enclose it with barbed wire. Most of the hard labor was done by volunteers, members of the club, and the "Velika Srbija" soccer players themselves. Because "Velika Srbija" was not as ambitious as "B.S.K." and lacked comparable financial means, its much smaller and modest field only had the basics: a fenced grass field with goal posts and a small shack for equipment storage. Nevertheless, this provisional stadium, which opened to the public in August 1913, often accommodated crowds of several hundred.

The First True Stadiums in Belgrade: Soccer Moves to Topčider

The first real stadiums in Belgrade were built after WWI, when soccer decidedly became the most popular sport in the newly formed Kingdom of Serbs, Croats and Slovenes. Soccer matches which, at best, had drawn several hundred visitors before the Great War now brought in thousands of people. Most impressively, the number of people interested in sports rose to a couple of million.[18] Croatian clubs, which had been integrated into the new Yugoslav soccer system, brought with them both quality and prestige acquired mostly through matches played before WWI against excellent Czech, Austrian and Hungarian clubs. The latter were part of the so called *Danube* school of soccer. Nurtured by the nations in the Danube region, at the time their particular playing style was the best in Europe. The Croatian clubs "Građanski," ("Citizen") "H.A.Š.K." ("Hrvatski Akademski Športski Klub"–"Croatian Academic Sports Club") and above all "Concordia" elicited great support and drew high average attendances at their matches, which made them financially stable and even profitable. The Serbian clubs could not match the Croatian ones because of a lack of professional organization of financially viable clubs and functional stadiums accommodating large crowds and generating significant income.[19] The soccer grounds at Belgrade's *Trkalište* were not only small and obsolete but had been devastated during the war and occupation.

Because of the hard living conditions and constant famine in occupied Belgrade, the playing fields of the "B.S.K." and "Velika Srbija" stadiums were plowed over for the cultivation of crops.[20] After the Great War the officials of the competitive "B.S.K." and "Velika Srbija," now

renamed "Jugoslavija,"[21] made an enormous effort to repair and upgrade their stadiums.[22] These were only temporary solutions, because by the mid-1920s the Yugoslav Government and the Belgrade City Council relocated both stadiums to a residential suburb of *Topčidersko Brdo* (*"Topčider Hill"*) in order to accommodate post-war Belgrade's population explosion as well as meet the need for the construction of new public buildings such as the National Archives, Technical Faculty and the University Library at *Trkalište.*[23]

The soccer clubs turned a serious predicament into an advantage and opportunity to build modern European stadiums in Belgrade. By the mid-1920s as their players, staff, support and finances improved, Serbian clubs achieved an equivalency of quality with the Croatian teams. "Jugoslavija" was in the ascent, winning two consecutive Yugoslav soccer championships in 1924 and 1925.[24] As soccer got involved in politics, another major aspect of life in the Kingdom of Serbs, Croats and Slovenes, the struggle between the Croatian and Serbian soccer clubs inevitably became political. In order to completely take over the Yugoslav soccer association ("Jugoslovenski nogometni savez" – "J.N.S.") and to move its headquarters and the national soccer team to the capital city, Serbian soccer officials had the ultimate argument when they applied to the government for a permit to build a functional stadium in Belgrade.[25]

Led by the ambitious Janko Šafarik (1882-1949) the "Jugoslavija" soccer club was the first to build a completely new and modern stadium in the course of only two years. The terraces were made of concrete and covered with a roof. The support buildings were modern and comfortable, and the locker rooms were equipped with showers for the players. The estimated seating capacity of the stadium was for about 15,000.[26] The stadium was situated on a plateau between the two Belgrade neighborhoods of Dedinje and Voždovac. There are no records that identify the architect of this clearly modern stadium.

"Jugoslavija" was known as an innovative club, prone to both experiments and eccentricities. On Easter Sunday 1927, the "Jugoslavija" stadium was officially opened to the public. The opening ceremony was a peculiar mixture of traditional and modern elements. At the very beginning of the ceremony, the Serbian Orthodox priest blessed the new stadium, the players, the management and all the visitors. To counterbalance the consecration by the priest, the second act of the ceremony was a parachute jump from an airplane onto the center of the playing field, performed by a certain Popadić, a member of the Yugoslav Royal Air Force. The participants reported that they were witnessing a historic moment, a radical modern turn in Serbian sports. Even the newspapers captured the atmosphere, with a bit of pathos:

> The best full-back in the country, Mr. Ivković, secluded himself in one vacant part of the terraces and for a long time reflectively watched over his playing field, as if he was evoking the past of his club and looking into the future at the same time ...[27]

While "B.S.K." was falling behind "Jugoslavija," the board membership developed plans for its own stadium and obtained permission from the Belgrade City Council to begin the work. A receptive club management, led by physician Svetislav Živković (1895-1978), banker Dušan Radivojević, industrialist Karlo Brener and architect Boško Simonović (1898-1965), secured considerable funding of about 1,000,000 dinars (approximately $17,600) for the construction of a stadium on top of Topčidersko brdo (Topčider Hill), only some 500 meters from the "Jugoslavija" stadium.[28] Renowned Serbian architects Mihailo Radovanović and Branislav Marinković were responsible for the design, and the construction was entrusted to J. Košner, an experienced contractor from Belgrade.[29] The resultant project was novel and innovative. Its salient feature was an imposing 120-meter long terrace with a solid roof, supported by two frontal pillars with fastenings at the corners. Such a modernist structure had not been seen before in Belgrade.[30] The "B.S.K." stadium was officially opened on Easter Sunday 1929 with a friendly soccer tournament in which Yugoslav, Czechoslovakian and Bulgarian soccer clubs competed (Fig. 14.3).[31]

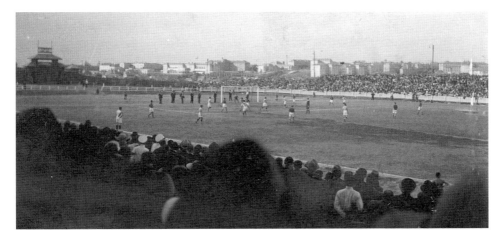

Fig. 14.3 The "BSK" stadium during the soccer match between Yugoslav and Czechoslovakian national teams in 1935.

The construction of two impressive sports venues in such a brief time was a major success for Serbian soccer officials. Both stadiums could accommodate international soccer matches of the highest standards and importance. Hence, the government officials were cooperative with respect to the construction process. The completion of the construction of the stadiums confirmed that all the necessary requirements for relocating the headquarters of the "J.N.S."

from Zagreb to Belgrade had been met. The Yugoslav government's support for moving all national institutions, even the informal ones such as the "J.N.S.", to the state capital was met with resistance, especially by the Croatian soccer clubs and political parties. The soccer forums created the impression that "B.S.K." and "Jugoslavija" enjoyed the special patronage of the State. Those insinuations were not entirely unfounded as the Yugoslav government and the Belgrade soccer clubs shared a commonality of interests.

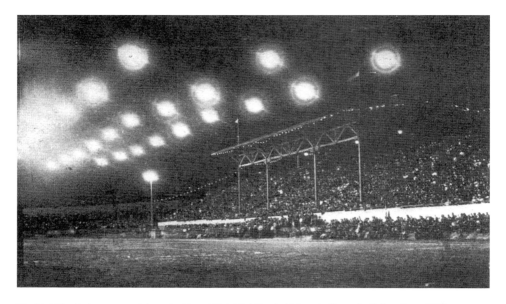

Fig. 14.4 The first soccer match under the artificial lighting in Belgrade, "Jugoslavija" stadium, 1932.

Throughout the 1930s "B.S.K." and "Jugoslavija" continually improved their stadiums. "Jugoslavija" was the first Yugoslav club which had a privilege of holding a soccer match at night, under artificial lighting.[32] On June 22nd 1932, "Jugoslavija" hosted a prominent French soccer club "Racing" from Paris, and for that event the organizers provided a special contrivance with 90 bright lamps that produced in total 90,000 candela of light (Fig. 14.4).[33] The excitement of the public was immense and some Belgradians were so surprised by the intensity of illumination that they thought it was an actual fire. A few years later, both clubs installed permanent and spectacular night lighting. The stadium capacities were also expanded, and by the late 1930s "B.S.K." could accommodate some 35,000 and "Jugoslavija" some 30,000 spectators.[34]

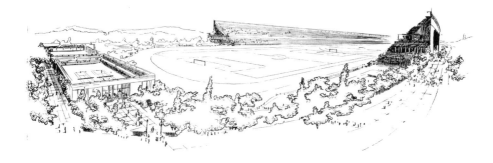

Fig. 14.5 Dragan Gudović, Plan for the new and modern "Jugoslavija" stadium, Belgrade, c. 1938.

In the years before the Second World War the "Jugoslavija" soccer club undertook a major stadium reconstruction project. In 1938, the Belgrade City Council and its chairman Vlada Ilić (1882-1952) granted the club permission to build on an additional 39,180 square meters of land surrounding the "Jugoslavija" stadium. With this addition the "Jugoslavija" soccer club sport complex had an area of 65,429 square meters.[35] A new master plan was produced by the then young architect Dragan Gudović (1904-1989), an employee of the Yugoslav Ministry of Construction, "Jugoslavija" club member, and a protégé and close friend of one of the leading modernist architects, Dragiša Brašovan (1887-1965). Gudović's plan included a detailed, five-year reconstruction schedule. The most important part of the plan was the renovation of the soccer field in keeping with the latest European standards (Fig. 14.5). Accordingly, the drainage system was constructed with a porous mound and the ground covered with a special type of grass. The second most important goal was to build 25 rows of new 17 meter-wide concrete terraces all around the stadium. This addition was to increase the total capacity of the stadium to 6,000 seats and to more than 35,000 standing spots. Also planned were other facilities, most notably new athletic tracks, an indoor hall, swimming pool and tennis court. The final date set for completion was 1943. The "Jugoslavija" management sustained this ambitious plan, and in April 1941, just a few days before the German attack on Yugoslavia, they announced the grand opening of their upgraded stadium. At that moment, the "Jugoslavija" stadium could have accommodated approximately 50,000 spectators; it had state of the art night lighting and an electronic scoreboard. By 1941, the total cost of the improvements was approximately 9,000,000 dinars ($130,000).[36] A cruel twist of fate made all this effort vain when during the Nazi blitzkrieg on April 6th 1941 bombs hit the "Jugoslavija" stadium.[37] The devastation incapacitated the stadium for a full year. Many of the additions and structural improvements that had been made beginning in 1938 were damaged or destroyed.

Dejan N. Zec

Sports Architecture and Yugoslav Nationalism

Although popular and influential, soccer was an activity mainly organized through private initiatives in the 1920s and 1930s. That meant that the Yugoslav government, which was typically actively engaged in sports and thus politicized sporting discourse, was limited in its ability to interfere with soccer.[38] Instead of trying to control the soccer clubs, the government directed its attention to gaining control of the organizations that shared most of the government's political views. The largest and most influential of those organizations was the "Soko" organization or "Jugoslovenski Sokolski Savez" ("Yugoslav Soko Association").[39] The Sokols were enthusiastic gymnasts but they also nurtured an ideology that was appealing to Yugoslavia's King Aleksandar Karađorđević. They promoted the concept of Slavic independence and brotherhood and the even somewhat racist idea of Slavic ethnic superiority over other European nations.[40] Moreover, they became an opposition movement to Austro-Hungarian rule. Following the WWI dissolution of the Austro-Hungarian Empire and the creation of the Kingdom of Serbs, Croats and Slovenes, the Sokols promoted the new country as a promised land for all Slavic patriots, whether they were Serbs, Croats or Slovenes. However, the first decade of the unified state proved that overcoming the divergent and often conflicting interests of Serbs, Croats and Slovenes and creating a new Yugoslav nation would be a difficult task. The internal struggle between the previously separate and independent groups prompted King Aleksandar I to suspend the Constitution and establish a dictatorship in 1929.

When King Aleksandar I proclaimed his dictatorship, the Sokols were put under strict control, and they became a massive tool of state propaganda in promoting the idea of "integral Yugoslavism."[41] The "Soko" manifestations, a mixture of gymnastic exercises, uniformed marches and folkloric spectacle represented national power and strength. Thousands of uniformed performers demonstrated their skills in front of spectators, declaring their loyalty to King and Country, and the State ideology of an integral Yugoslavism.

Massive spectacles demanded a proper stage. In the late 1920s Yugoslav dignitaries began planning for suitable "Soko" stadiums throughout Yugoslavia. All major cities in the country were to receive viable stadiums and training grounds and all "Soko" districts in Yugoslavia were to obtain headquarters buildings for meetings and cultural performances. In 1930, Belgrade, as the nation's capital, was chosen to host the first all-national Yugoslav "Soko" rally under the watchful eye of King Aleksandar I and other government officials. Because the Yugoslav government officially took over the "Soko" organization in December 1929,[42] there was simply not enough time to design and build a permanent stadium in Belgrade for the rally. As a result, the construction of a permanent stadium was postponed.[43]

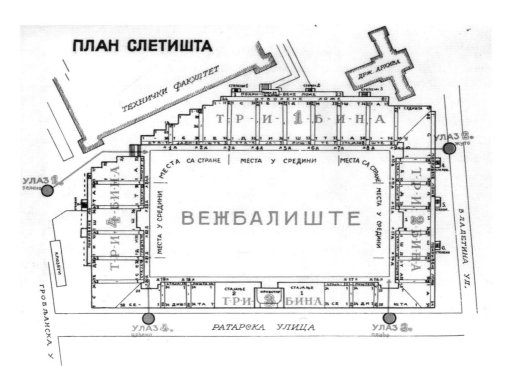

Fig. 14.6 Momir Korunović, Blueprint of the "Soko" stadium at "Trkalište," Belgrade, 1930.

As had been the case twenty years earlier, a large empty plot at *Trkalište* was selected as the site of one-time spectacle in a temporary stadium of massive proportions that would accommodate 100,000 spectators (Fig. 14.6).[44] The chief architect in charge of the project was Momir Korunović. He was experienced in the building of sports venues while his architectural and aesthetic convictions were consistent with the ideology of the "Soko" movement. Korunović, a keen sportsman himself, was familiar with the goals of the movement

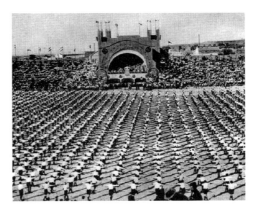

Fig. 14.7 Momir Korunović, "Soko" stadium at "Trkalište" during the Sokol rally of 1930.

because, as a student in Prague, he had embraced the ideas of the Czech "Soko" movement at its peak.[45] On returning to Serbia, he associated himself with the "Soko" and "B.S.K." soccer clubs.[46] His rejection of academism and attempts to develop an original and uniquely national architectural style, also known as the Serbo-Byzantine style, elevated Momir Korunović to the status of the most favorite state architect of the early 1930s.[47]

Korunović's design for the "Soko" stadium in Belgrade was grand and extravagant (Fig. 14.7). His idea was to create an ephemeral stadium construction, easy to assemble and disassemble. The entire stadium was made completely out of wooden pylons and boards. The decorative elements were scarce but prominently displayed. Visually, the most effective was the music pavilion which, situated on the eastern terrace, had an arched niche and was embellished with folkloric ornaments and rugs from Pirot.[48] The pavilion also contained an honorary lodge for distinguished guests such as King Aleksandar I and his wife Queen Maria, their son and heir and Supreme Leader (Starosta) of the Yugoslav Sokols Prince Petar, Prime Minister Petar Živković, Minister of Education Boža Maksimović and Minister Nikola Uzunović.[49]

The rally was held between the 27th and 29th of June with the central event on St. Vitus Day, the Serbian national holiday. Just one day after the "Soko" rally, the workers dismantled the stadium and the timber was reused in other projects. This ubiquitous temporary stadium designed by Korunović revealed not only a singular merging of traditional and modernist features in sports architecture, but also the very notion of modernity and mobility embodied in modular, simple, affordable, temporary architecture. The solution for Belgrade's permanent great capacity stadium remained open.

The Olympic Complex Project Proposal and the German Influence

The period of the 1930s, officially, publicly and privately, was marked by discourse on the idea of holding the Olympic Games in Belgrade. After the visit of the Yugoslav delegation led by Prime Minister Milan Stojadinović to the 1936 summer Olympic Games in Berlin, Yugoslav politicians proposed that Belgrade should host the 14th summer Olympic Games in 1948.[50] The case of the 1936 Olympic Games provides an excellent paradigm of how relations between Yugoslavia and Germany had changed in the second half of the 1930s. The Yugoslav authorities not only accepted financial help from Germany, which made the country almost semi-dependant in many areas, but also adopted certain practices characteristic of fascist societies.[51] They were enchanted with everything they had seen in Berlin, including the organization, the display of power of the German people and their leaders, and the propaganda opportunities provided by the hosting of such a large and, most importantly, international event. This revived unresolved questions of the construction of a central stadium in the

nation's capital city, which had been put on hold by the authorities after the 1930 "Soko" rally.

A number of architects and planners addressed the necessity of building a permanent stadium as part of a large-scale plan, advising the re-thinking and re-arrangement of Belgrade's sports and physical exercise infrastructure. In 1935 Kosta Petrović (1891-1965), an engineer and "Soko" enthusiast, in his efforts to promote a healthy lifestyle published a series of brochures in which he analyzed the needs of Belgrade in the field of sports arenas, exercise grounds and stadiums.[52] His conclusion was that the situation concerning sporting facilities was disastrous and that it was unacceptable for a major urban center and capital city like Belgrade not to have an Olympic style stadium.

The question of the Olympic stadium was both architectural and political. The politicians wanted a German architect to design the stadium because they were amazed at the monumentality of the Berlin Olympic Games and wanted to replicate a similar experience in Belgrade. Such a colossal project would also represent a confirmation of the excellent economic and political relations between Germany and Yugoslavia, and thus it was beneficial for both sides. To the delight of the Yugoslav authorities Werner March (1894-1976), the architect of the Olympic stadium in Berlin, accepted the commission to design the Belgrade stadium (Fig. 14.8).

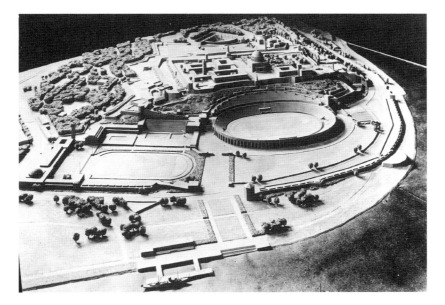

Fig. 14.8 Werner March, Model of the Olympic Park in Belgrade, 1939.

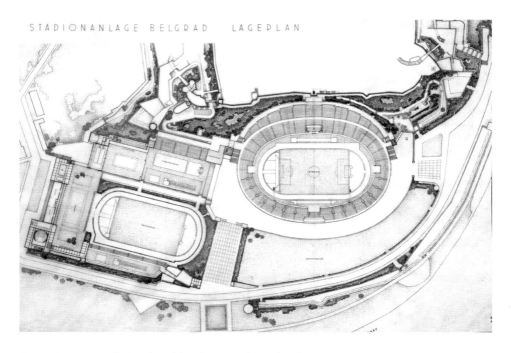

STADIONANLAGE BELGRAD LAGEPLAN

Fig. 14.9 Werner March, Site Plan of the Olympic Park in Belgrade, 1939.

The news that March was the selected architect of the new stadium reverberated throughout Yugoslavia, triggering fierce public debates among citizens and professionals. After the academicism of the 1920s and attempts to create a national architectural style during King Aleksandar's dictatorship, many Yugoslav architects, especially those who were considered modernists, showed significant interest in the work of their German and Italian colleagues and started to implement many of the latter's architectural ideas and solutions in their own work.[53] However, many Yugoslav experts vehemently opposed March's commission because they thought that March would not be able to incorporate the traditions of the Yugoslav peoples into the stadium project.[54]

During his first visit to Belgrade in May 1938, Werner March met with Yugoslav officials and agreed on the project for the Olympic complex. The priority was to build an Olympic stadium that could accommodate between 30,000 and 40,000 spectators, to surround it with additional facilities in the *Donji grad* plateau, and to reconstruct the Kalemegdan fortress by building monuments and museums that would reiterate the monumentality of the stadium.[55] To appease a concerned public, the Yugoslav government appointed a prominent

Yugoslav architect from the Ministry of Construction, Dragiša Brašovan (1887-1965), to work with March. Brašovan's presence and supervision of the project also guaranteed limited reconstruction of historic Kalemegdan.

The project design was completed by October 1940 and presented to the Yugoslav public by Werner March at a special exhibition.[56] The exhibition showcased the achievements of the German architecture and building industry, but the centerpiece of the exhibition was March's Belgrade stadium project. March's design for the Belgrade stadium was a reflection of his work on the Berlin Olympic stadium, a masterpiece of modernist monumentalism of the 1930s, with an impact of neo-classicism, characteristic for German architecture of the Nazi period.[57] Prince Pavle Karađorđević (1893-1976), Prime Minister Dragiša Cvetković (1893-1969) and the Minister of War and Navy, General Milan Nedić (1877-1946), the German Ambassador, Viktor von Heeren (1881-1949), special emissary of Albert Speer Karl Maria Hettlage (1902-1995) and Werner March all expressed their satisfaction with the project, viewing it as a tremendous boost to German-Yugoslav economic cooperation.[58] A project of that size demanded the collaboration of several major institutions: the Ministries of Construction, Physical Education, War and Navy, as well as the Belgrade City Council. The entire project was colossal; dozens of buildings were to be built, and the overall cost of the project exceeded 170,000,000 dinars, equivalent to approximately $2,500,000 at the time (Fig. 14.9).

Yet, controversy over the entire project persisted. A group of Yugoslav architects, engineers and builders voiced their criticism throughout the process. An architect and urban planner, Branko Maksimović (1900-1988), published an article in the daily *Politika* ("Politics") objecting to the opacity of the entire process.[59] He argued that there had been no democratic competition for the project among architects. He also expressed fear that March would design the stadium and the National "Pantheon" in a fashion completely alien to the Yugoslav national spirit. Several prominent architects including Vladimir Potočnjak (1904-1952), Ivan Zdravković, Milorad Macura (1914-1989) and Miša Manojlović (1901-1942), and much of the general public supported Maksimović.[60] Despite the energy and work put into it, the project was never implemented. Because of the sheer number of parties involved in the process and the staggering costs, the planning of the undertaking fell behind schedule. The project was not even close to starting when the war broke out in April 1941 and the Kingdom of Yugoslavia was destroyed. Belgrade never got the stadium it deserved during the interwar period. In the post war years the new communist government built the first multifunctional national stadium, the Stadium of the Yugoslav People's Army ("J.N.A.").

Conclusion

Over the course of only 22 years, the advancement of modernist design and the quality and rate of construction of sports grounds in interwar Belgrade reflect the city's own dramatic transformation from an unassuming capital of a small Balkan state into a modern European city of growing political stature. Population growth and territorial expansion meant that Belgrade was continuously under construction. The city changed dramatically as its citizens acquired new tastes, routines and habits appropriate to life in a metropolis. A new and dominant focus was soccer, a game which became extremely popular in post-war Belgrade.

In the interwar period, the development of sports architecture in Yugoslavia followed a singular path. It encompassed the improvisations of the early 1920s, modern and practical designs of the late 1920s and early 1930s, modeled on Western and Central European venues and the national, Serbo-Byzantine style of "Soko" stadiums and training grounds. The latter was reflective of and closely connected to the era of Yugoslav nationalism and integralism of the early 1930s. By the late 1930s there was also an acceptance of German forms of neoclassicism as exemplified by the joint Yugoslav-German project for the Belgrade Olympic complex. The formidable challenges that sports architecture in Yugoslavia faced were inevitable if viewed against the backdrop of over three decades of national political, economic and societal transformation. This experience was more than that of sports architecture but a larger reflection of the interwar period.

Notes

[1] Kaspar Maase, *Grenzenloses Vergnügen: Der Aufstieg der Massenkultur 1850-1970* (Frankfurt am Main: Fischer-Taschenbuch-Verlag, 1997), 79-115.

[2] Christopher R. Hill, *Olympic Politics* (Manchester: Manchester University Press, 1996), 25-28.

[3] Dubravka Stojanović, *Kaldrma i asfalt: urbanizacija i evropeizacija Beograda 1890 – 1914* [Cobble and Asphalt: Urbanization and Europeanization of Belgrade 1890-1914] (Belgrade: Udruženje za društvenu istoriju, 2009), 328.

[4] Stefan Ilić – Slađana Mijatović, *Istorija fizičke kulture Kneževine i Kraljevine Srbije* [History of Physical Education in Principality and Kingdom of Serbia] (Belgrade: Fakultet fizičke kulture, 1994).

[5] Dejan Zec, "The Origin of Soccer in Serbia," *Serbian Studies* 24 (2010), 140-142.

[6] Jovan Ružić, *Sećanja i uspomene* [Memories] (Belgrade: SOFK, 1973), 145.

[7] Srbislav Todorović, *Fudbal u Srbiji 1896–1918* [Soccer in Serbia 1896–1918] (Belgrade: SOFK Zvezdara, 1996), 18.

[8] Ibid., 13.

[9] At the end of the nineteenth and the beginning of the twentieth centuries, the "Soko" movement spread throughout the Slavic world, including the Kingdom of Serbia. Claire E. Nolte, *The Sokol in the Czech Lands to 1914: Training for the Nation* (New York: Palgrave Macmillan, 2002).

[10] *Enciklopedija fizičke kulture* [The Encyclopedia of Physical Culture]. I (Zagreb: Jugoslavenski leksiko-grafski zavod, 1975), 33-35.

[11] Mihailo Andrejević, *Dugo putovanje kroz fudbal i medicinu* [Long Journey through Soccer and Medi-cine] (Gornji Milanovac: Dečje novine, 1989), 17.

[12] See also chapter by Kadijević and Stefanović in this volume.

[13] *BSK: 1911–1931* (Belgrade: Narodna štamparija, 1931), 18.

[14] Andrejević, *Dugo putovanje*, 27-28.

[15] Ibid., 29.

[16] *Tribuna*, April 5th 1914.

[17] Ružić, *Sećanja*, 198-200.

[18] Peđa J. Marković, *Beograd i Evropa: evropski uticaji na proces modernizacije Beograda* [Belgrade and Eu-rope: European Influences to the Process of Modernization of Belgrade] (Belgrade: Savremena admin-istracija, 1992), 71-76.

[19] Although soccer was still not considered an acceptable type of business enterprise in the 1920s, income from ticket sales was important. It meant that financially stable clubs could attract better soccer players from clubs in other parts of the country and abroad, mostly from Czechoslovakia and at times from as far away as the United Kingdom.

[20] During the occupation the Austro-Hungarian army chamber used the materials from all of the "B.S.K." facilities as firewood. Andrejević, *Dugo putovanje*, 30.

[21] After the First World War and the Unification the club changed its name to "Jugoslavija." It was the second most successful club in Belgrade and Serbia. Ružić, *Sećanja*, 198-200.

[22] Andrejević, *Dugo putovanje*, 29–31; Ružić, *Sećanja*, 303-306.

[23] Ranka Gašić, "Problemi teritorijalnog širenja Beograda između dva svetska rata," *Istorija 20. veka*, vol.3 (2010), 59-61.

[24] Đorđe Smiljanić, *Fudbalska prvenstva Jugoslavije: 1923–1999* [Yugoslav Soccer Championships 1923–1999] (Belgrade: Fudbalski savez Jugoslavije, 1999), 5-6.

[25] Milorad Sijić, *Fudbal u Kraljevini Jugoslaviji* [Soccer in the Kingdom of Yugoslavia] (Belgrade: Milirex, 2009), 9-14.

[26] Ružić, *Sećanja*, 53-54.

[27] V. Rosić, "Свечано отварање игралишта СК Југославије" [Opening Ceremony for the New SK Jugo-slavija Stadium], *Политика* [Politika] (Belgrade, 27 Април 1927), 9-10.

[28] Anonymous, "Свечано отварање игралишта Б.С. Клуба" [Opening Ceremony for the B.S. Club Sta-dium], *Политика* [Politika] (Belgrade, 4 May 1929), 5.

[29] *BSK: 1911–1931* (Belgrade: Narodna štamparija, 1931), 76-78.

[30] Andrejević, *Dugo putovanje*, 31.

[31] Anonymous, "Спортски Ускрс" [Sporting Easter], *Политика* [Politika] (Belgrade, 8 May 1929), 10.

[32] Ružić, *Sećanja*, 53-54.

[33] Anonymous, "Чаробна ноћ на игралишту Југославије" [Magical Evening on Jugoslavija Stadium], *Политика* [Politika] (Belgrade, 22 June 1932), 11.

[34] Ružić, *Sećanja*, 53.

[35] *Četvrt veka S. K. "Jugoslavije": 1913–1938* [Quarter of a Century of "Jugoslavija" Sports Club 1913–1938] (Belgrade: Jugoslovenska sportska revija, 1939), 138-139.

[36] Bora Jovanović, "Свечано отварање новог стадиона Југославије извршиће се 20 овог месеца" [Ope-ning Ceremony for the New Jugoslavija Stadium will be on the 20th of April], *Политика* [Politika] (Belgrade, 5 April 1941), 16.

[37] Dejan Zec, "Oaza normalnosti ili tužna slika stvarnosti? Fudbal u okupiranoj Srbiji (1941-1944)," *Godišnjak za društvenu istoriju* 3 (2011), 55.

[38] The government was able to indirectly help or hinder certain initiatives, but was not able to directly steer the soccer clubs. That was evident in the late 1920s and early 1930s when, following the example of the Croatian Peasants' Party, almost all Croatian soccer clubs positioned themselves in opposition to Belgrade. Sijić, *Fudbal*, 9-18. Some Serbian clubs came into direct confrontation with the authorities who in the 1930s considered "Jugoslavija" to be a liberal and left-wing club.

[39] Certain national Soko organizations had existed since the nineteenth century. With the creation of the Kingdom of Serbs, Croats and Slovenes, all national organizations were united into one, the "Jugoslovenski Sokolski Savez." In 1929 the organization came under the direct control of the Yugoslav government, changing its name to "Soko Kraljevine Jugoslavije." Gabriela Kragujević, "Sokolstvo u Srbiji (1918-1941)," in *Telesno vežbanje i sport u Srbiji: (1857-2007)* (Belgrade: DTA, 2008), 129-166.

[40] Ljubodrag Dimić, *Kulturna politika u Kraljevini Jugoslaviji: 1918-1941, deo 1, Društvo i država* (Belgrade: Stubovi kulture, 1996), 432-438.

[41] The idea that only one nation, the Yugoslav nation, existed in the country, and that Serbs, Croats and Slovenes were merely the tribes of this grand nation, was the ideological pillar of King Aleksandar's reign. "Soko Kraljevine Jugoslavije" was declared as the non-political organization, built on private initiative, but with an important national and state task. The government accepted the Sokols as a national organization and supported them morally, legislatively and materially. But until 1929 the Sokols were independent of the state. See Nikola Žutić, *Sokoli: ideologija u fizičkoj kulturi Kraljevine Jugoslavije: 1929-1941* [Sokols: the Ideology within Physical Education in Kingdom of Yugoslavia 1929-1941] (Belgrade: Angrotrade, 1991).

[42] Žutić, *Sokoli*, 37-42.

[43] Throughout 1929 Belgrade city officials considered the possibility of hosting the all-national Yugoslav "Soko" rally at "Donji grad" ("lower City") plateau, just below Kalemegdan fortress, at the confluence of the Sava and Danube rivers. After adding up the potential costs of removal, conservation and restoration of the medieval buildings from Donji grad, they chose another location. The very idea that a temporary stadium for 100,000 spectators would fit on the Donji grad plateau was challenged by the public.

[44] The *Trkalište* site on the outskirts of the city provided for the stadium's construction without obstructing everyday city life. This location was well connected to the city center, and the broad King Aleksandar Boulevard allowed for the efficient flow of heavy traffic.

[45] Aleksandar Kadijević, *Momir Korunović* (Belgrade: Republički zavod za zaštitu spomenika kulture, 1996), 31.

[46] Todorović, *Fudbal*, 13.

[47] The ideology of Yugoslav nationalism found its visual identity in the art of Ivan Meštrović and the architecture of Momir Korunović. More in: Tanja Damljanović, *Češko–srpske arhitektonske veze: 1918-1941* [Czech–Serbian Architectural Relations 1918-1941] (Belgrade: Zavod za zaštitu spomenika kulture, 2004), 80-88.

[48] See also chapter by Popović in this volume.

[49] Slavoljub Živanović, *Prvi jugoslovenski sportski almanah* [The First Yugoslav Sports Almanac] (Belgrade: Jovan K. Nikolić, 1930), 68.

[50] Čedomir Šoškić ed., *Olimpijski vekovnik 1910–2010* [Olympic Century Yearbook], vol. 2 (Belgrade: Službeni glasnik, 2010), 582-585.

51 After the death of King Aleksandar I Karađorđević in 1934 the Yugoslav authorities searched for a new direction in both foreign and domestic policy, in order to change the negative trends that Yugoslav society faced as a result of King Aleksandar's narrow-minded dictatorship. The political reliance on France and the United Kingdom, as neither of those countries could help Yugoslavia's economy, and periodic low-level confrontation with its neighbors, who had the support of Germany and Italy, proved a failure. Prince Pavle Karađorđević (1893-1976), as a Regent to minor King Petar II (1923-1970) and Milan Stojadinović (1888-1961), who was appointed the new Prime Minister, adopted a pragmatic policy. Their idea was to establish better ties with Italy and Germany. To some extent this policy was successful but had enormous implications. Yugoslavia became largely dependent on Germany. Milan Ristović, *Nemački "novi poredak" i jugoistočna Evropa: 1940/4 –1944/45: planovi o budućnosti i praksa* [The German "New Order" and the Southeastern Europe] (Belgrade: Vojnoizdavački i novinski centar, 1991).

52 Kosta Petrović, *Sokolski stadion u Beogradu: u jugoslovenskom narodnom parku kralja Aleksandra I Ujedinitelja* [Soko" Stadium in Belgrade] (Belgrade: Savez sokola Kraljevine Jugoslavije, 1935).

53 Aleksandar Kadijević, "Uloga ideologije u novijoj arhitekturi i njena shvatanja u istoriografiji," *Naslede* 8 (2007), 232-233.

54 Zoran Manević, "Arhitektura i politika," *Zbornik za likovne umetnosti* 20 (1984), 300-306.

55 Dejan Zec, "Proposed Olympic Complex in Belgrade–Project by Hitler's Architect Werner March," *International Conference Architecture & Ideology CD Proceedings* (2012), 958-966.

56 Ranka Gašić, *Beograd u hodu ka Evropi. Kulturni uticaji Britanije i Nemačke 1918–1941* [Belgrade Walking towards Europe. The Cultural Influence of Great Britain and Germany 1918–1941] (Belgrade: ISI, 2005), 106.

57 Andrej Mitrović, *Angažovano i lepo: umetnost u razdoblju svetskih ratova (1914–1945)* [Engaged and Beautiful: Arts in the Period of World Wars (1914–1945)] (Beograd: Narodna knjiga, 1983), 174-177.

58 Anonymous, "У присуству Њег. Кр. Вис. Кнеза намесника и Кнегиње Олге јуче је свечано отворена изложба нове немачке архитектуре" [In the Presence of HRH Prince Regent and Princess Olga an Exhibition of the New German Architecture was Opened], *Политика* [Politika] (Belgrade, 6 October 1940), 5-6.

59 Branko Maksimović, "Dva urbanistička problema, Pitanje Olimpijskog stadiona i Državne opere u Beogradu" [Two Problems in Urban Planning: The Questions of the Olympic Stadium and the State Opera House in Belgrade], *Politika*, July 15th 1939.

60 Manević, *Arhitektura*, 300-301.

Bibliography

Primary Sources and Archival Material

Aleksić, Dragan. "Tatlin. HP/s + Čovek" [Tatlin. HP/s + Man], *Zenit* (1921), 8-9.

Anonymous. "Novi hram Sv. Marka i palata Glavne pošte" [New Church of St. Mark and the Palace of Main Post Office], *Vreme*, 18.9.1930.

Anonymous. "Stečaj za hram Sv. Save" [Fundraising for the Church of St. Sava], *Политика* [Politika], 3.11.1926.

Anonymous. "Knjige Bauhaus-a" [The Bauhaus Books], *Zenit* VI/40 (April, 1926), n. p.

Anonymous. "Najjadniji i najopasniji deo varoši nosi ime najvećeg srpskog naučnika Jovana Cvijića" [The Poorest and Most Dangerous Part of the Town Carries the Name of the Greatest Serbian Scientist Jovan Cvijić], *Vreme*, 9 July 1927, 6.

Anonymous. "Naselje univerzitetskih profesora" [The University Professors' Colony], *Политика* [Politika], 16 Septembar 1926, 5.

Anonymous. "Beleške, Literatura" [Notes, Literature], *Srpski tehnički list* 21/52 (1910), 400.

Anonymous. "Da li će nestati Jatagan male? Beogradska opština započela je radove na podizanju 118 malih radničkih stanova" [Will Jatagan Neighbourhood Disappear? Belgrade County Started Work on 118 Small Workers' Apartments], *Политика* [Politika], 1937.

Anonymous. "Kuće za državne službenike" [Houses for Civil Servants], *Политика* [Politika], 1931.

Anonymous. "Make the Most of your Face," *Vogue* (April 15 1941), 44-45, 106.

Anonymous. "Na proleće počinje podizanje Činovničke kolonije" [Building of Clerks' Colony Starts in Spring], *Политика* [Politika], 1931.

Anonymous. "Opštinski stanovi za sirotinju" [County Appartments for the Poor], *Политика* [Politika], 20. avg. 1928.

Anonymous. "Razne vesti" [Miscellanea], *Tehnički list* (1925), 30-31.

Anonymous. "Sinoćnje svečano otvorenje izložbe 'Oblika'" [Ceremonial Opening of the 'Oblik' Exhibition Last Night], *Novo doba,* 12 May 1930.

Anonymous. "Vesti iz Udruženja, Rad Sekcije Beograd U.J.I.A. u mesecu martu 1925. Sastanak 26. marta 1925. godine" [Minutes of the Society of Yugoslav Engineers and Architects, March 26, 1925], *Tehnički list* (1925), 343.

Anonymous. "Zidanje činovničkog naselja na Voždovcu počinje 1 aprila" [Building of the Clerks' Colony in Voždovac Starts on April 1st], *Политика* [Politika], 1930.

Anonymous. "Велики успех 'Облика' у Прагу" [Great Success of 'Oblik' in Prague], *Политика* [Politika], 13 October 1934.

Anonymous. "Г-ца Вука Велимировић – дама вајар" [Miss Vuka Velimirović– a lady sculptor], *Реч и слика* 1 (1926), 92.

Anonymous. "Изложба школе за примену декоративне уметности госпође Марије Предић" [Exhibition of Mrs. Marija Predić's School for the Use of Decorative Art], *Недељне илустрације,* 20 October 1929, 6.

Anonymous. "Један угао собе" [A Corner of the Room], *Илустровано Време* (2 August 1930), 3.

Anonymous. "Једна успела изложба" [One Successful Exhibition], *Недељне илустрације* 1 (1930), 7.

Anonymous. "Југословенска уметност у иностранству. Изложба групе 'Облик' у Солуну" [Yugoslav Art Abroad: The Exhibition of 'Oblik' in Thessaloniki], *Политика* [Politika], 11 May 1937.

Anonymous. "Наши нови облакодери" [Our New Skyscrapers], *Политика* [Politika], 9 July 1926, 6.

Anonymous. "Освећење завода за израду новчаница Народне банке" [Consecration of the Institute for Printing Banknotes and Minting Coins of the National Bank], *Политика* [Politika], 27 January 1930, 5.

Anonymous. "Освећење и пуштање у рад нове Државне ковнице металног новца на Топчидеру" [Consecration and Opening of the New Institute for State Minting of Coins at Topčider], *Време,* 8 September 1938, 4.

Anonymous. "Освећење темеља фабрике за израду новчаница" [Consecration of the Foundations of the Factory for Printing Banknotes], *Политика* [Politika], 22 September 1927, 6.

Anonymous. "Свечано отварање игралишта Б.С. Клуба" [Opening Ceremony for the B.S. Club Stadium], *Политика* [Politika], 4 May 1929, 5.

Anonymous. "Спортски Ускрс" [Sporting Easter], *Политика* [Politika], 8 May 1929, 10.

Anonymous. "У женском царству" [In the Realm of Women], *Жена и свет* 11 (1929), 14.

Anonymous. "У присуству Њег. Кр. Вис. Кнеза намесника и Кнегиње Олге јуче је свечано отворена изложба нове немачке архитектуре" [In the presence of HRH Prince Regent and Princess Olga an exhibition of the new German architecture was opened], *Политика* [Politika], 6 October 1940, 5-6.

Anonymous. "Чаробна ноћ на игралишту Југославије" [Magical Evening on Jugoslavija Stadium], *Политика* [Politika], 22 June 1932, 11.

Anonymous. "Школа декоративне уметности г-ђе Маргите Предић" [School of Decorative Arts Mrs. Margarita Predić], *Недељне илустрације* 13 (1929), 21.

Anonymous. *BSK: 1911 – 1931* (Belgrade: Narodna štamparija, 1931).

Anonymous. *Пројекти студената архитектуре* [Studio Design by the Students of Architecture (exhibition catalogue)]. (Београд: Архитектонски факултет, 1928).

Anonymous. *Četvrt veka S. K. "Jugoslavije": 1913 – 1938* [Quarter of a Century of "Jugoslavija" Sports Club 1913 – 1938] (Belgrade: Jugoslovenska sportska revija, 1939).

Anonymous. *Облик. Прва изложба Уметничке групе 'Облик'* 15. XII 1929 – 4. I 1930. [Oblik. First Exhibition of the Art Group 'Oblik' Dec. 12 1920-Jan. 1 1930 (exhibition catalogue)] (Belgrade: Umetnički paviljon "Cvijeta Zuzorić," 1929).

Anonymous. *Шеста југословенска уметничка изложба* [Sixth Yugoslav Art Exhibition (exhibition catalogue)] (Novi Sad: Matica srpska, 1927).

Arhitekt P.T., "Novi sistem gradjenja" [A New Building System], *Zenit* IV/34 (November, 1924), n. p.

Atanasijević, Ksenija. "Pesnikinje i filozofkinje stare Grčke" [Women Poets and Philosophers of Ancient Greece], *Misao* 1.29 (Belgrade, 1924).

B. S. [Babić, Stanojlo]. "Pozorišni trg" [Theater Square], *Srpski tehnički list* 25/9 (1914), 65-67.

Borisavljević, Milutin. "Kotež 'Neimar'" [Kotež 'Neimar'], *Pravda,* November 11, 1932.

Bužančić, Vlado. *Josip Seissel* (Bol: Galerija umjetnina "Branko Dešković," n. d.).

Dimitrijević, Jelena J. *Novi svet ili U Americi godinu dana* [New World or A Year in America] (Belgrade-New York, 1934).

Dimitrijević, Jelena J. *Sedam mora i tri okeana: putem oko sveta* [Seven Seas and Three Oceans: Travel around the World] (Belgrade: Drž. štamp. Kralj. Jugoslavije, [1940?]).

Dj. B. "Изложба Школе за примену декоративне уметности" [Exhibition of the School for the Use of Decorative Art], *Илустровано Време,* 6 December 1930, 7.

Dubovi, Jan. "Budući veliki Beograd" [Future Great Belgrade]. In *Beograd u prošlosti i sadašnjosti* (Belgrade, 1927; Biblioteka "Savremene opštine" 12), 98-103.

Dubovi, Jan. "Vrtarski grad" [Garden City], *Tehnički list* 7/1 (1925), 7-11; 7/2 (1925), 19-24; 7/3 (1925), 42-46.

Fjodorović, K. "Miss Milica Babić," *Недељне илустрације* 7-8 (1932), 3-4.

General Plan of Belgrade: *O uredenju Beograda, Izveštaj komisije, odredene od strane odbora opštine grada Beograda* (Belgrade, 1920).

Grgašević, Jaša. *Umjetni obrt* [Art Crafts] (Zagreb: Naklada Jugoslavenski Lloyd, 1926).

Gropius, Walter. "Internacionalna arhitektura" [International Architecture], *Zenit* VI/40 (April, 1926), n. p.

Hakman, Stevan. "Izložba grupe 'Oblik'" [Exhibition of the 'Oblik' Group], *Jugoslovenska pošta* (Sarajevo), 19 November 1932.

Hakman, Stevan. "Izložba slika, skulpture i arhitekture Umetničke grupe 'Oblik'" [Exhibition of Paintings, Sculptures and Architecture by the Art Group 'Oblik'], *Misao* XXXI/5-8 (1929), 466-469.

Historical Archives of Niš, The GraPo Fund, TO, box 69 – "Plan za izvlaštenje dobara radi otvaranja ulica broj 1 i 13 zapadno od centra parka u Niškoj Banji" [The Plan for the Expropriation of Land for the Purpose of Opening Up Streets Nos. 1 and 13 West of the Center of the Park in Niška Banja] (scale 1:1000), The Municipal Authority of Niška Banja, No. 1255, 9 June 1939.

Howard, Ebenezer. *Garden Cities of To-Morrow* (London: Swan Sonnenschein, 1902 [reprinted by The MIT Press in 1965 and 1989]).

Howard, Ebenezer. *To-Morrow: a Peaceful Path to Real Reform* (London: Swan Sonnenschein, 1898).

J. F. "Képző müvészet. Az Oblik – csoport őszi tarlato," *Napló*, Szabatka 16 November 1932.

J. N. "Десета изложба удружења 'Облик'" [Tenth Art Exhibition of 'Oblik'], *Политика* [Politika], 18 December 1933.

J.T.S. [Jefta Stefanović]. "Regulacija Beograda," *Srpski tehnički list* 21/ 49 (1910), 361-362.

Johnson, Philip and Henry-Russell Hitchcock, *The International Style: Architecture since 1922* (New York: Norton, 1932).

Josephus, Flavius. *Jewish Antiquities* (Cambridge, Mass.: Harvard University Press, 1998).

Josimović, Emilijan. *Objašnjenje predloga za regulisanje onog dela varoši Beograda, što leži u šancu* [Explanation of the Reconstruction of that Part of the City of Belgrade, which Lies Inside the Ramparts] (Belgrade: Državna knjigopečatnja, 1867).

Jovančević, V. "Istorija i umetnost vrta" [History and Art of the Garden], *Savremena opština* 3-4 (1935), 147-166, 248-252, 352-364, 428-439, 513-522.

Jovanović, Bora. "Свечано отварање новог стадиона Југославије извршиће се 20 овог месеца" [Opening ceremony for the new Jugoslavija stadium will be on the 20th of April], *Политика* [Politika], 5 April 1941, 16.

Jovanović, K. "Još nekoliko Ustanova koje će Beograd uskoro dobiti" [Belgrade Will Get Several Additional Institutions]. In *Beograd u prošlosti i sadašnjosti* (Belgrade, 1927; Biblioteka "Savremene opštine" 12), 170-177.

К. "Изложба Ладе у Уметничком павиљону" [Lada Exhibition in Art Pavilion], *Политика* [Politika], 27 March 1932.

Karalić, Predrag. "The Most Beautiful Facade in Belgrade," *Život i rad* 110/18 (Beograd 1934).

Kašanin, Milan [Кашанин, Милан]. "XV изложба 'Облика'" [Fifteenth Art Exhibition 'Oblik'], *Уметнички преглед* 1 (1939), 27-28.

Koen, R. "Модеран намештај" [Modern Furniture], *Недељне илустрације*, 22 October 1933, 5.

Kojić, Branislav. "Arhitektura i dekor" [Architecture and Décor], *Srpski književni glasnik,* Nova serija 43/6 (Nov., 1934), 427-431.

Kostić, L. M. "Stanovništvo Beograda" [Belgrade Population]. In *Beograd u prošlosti i sadašnjosti* (Belgrade, 1927; Biblioteka "Savremene opštine" 12), 59-69.

Kovaljevski, Đorđe. *Professors'* and *Clerks' Colonies.* The report of this commission was completed in July 1923: *Izveštaj o generalnom planu za grad Beograd, koji je izradila komisija sastavljena rešenjem Odbora i Suda Opštine Beogradske od 29. maja 1922. Godine* (Belgrade: Opština grada Beograda, 1923).

Krekić, Bogdan. "Stambeno pitanje kao javna briga" [Housing Question as Public Matter], *Beogradske opštinske novine* 51/3-4 (1933), 456-466.

Krstić, Milica. "Uredjenje Beograda" [Planning Belgrade], *Ženski Pokret* 7/5 (1926), 162-165.

Le Corbusier. *Journey to the East*, edited, annotated and translated by Ivan Žaknić [based on the Journey to the East in 1911] (Cambridge, MA and London: The MIT Press, 2007).

Le Corbusier, Jean-Louis Cohen and John Goodman. *Toward an Architecture* (Los Angeles, CA: Getty Research Institute, 2007 [first published in 1923]).

Leko, D[imitrije]. T. "Radenički stanovi" [Workers' Apartments], *Srpski tehnički list* 22/2 (1911), 19-20.

Leko, D[imitrije]. T.. "Misli o mogućnosti primene srpskog stila" [Notes on Applicability of Serbian Style], *Srpski tehnički list* 19/25 (1908), 233-234.

Lilić, L. "Radnička kolonija u Kragujevcu" [Workers' Colony in Kragujevac], *Политика* [Politika], August 26, 1930.

Macfadyen, Dugald. "Sociological Effects of Garden Cities," *Social Forces* 14/2 (1935), 250-256.

Maksimović, Branko. "Dva urbanistička problema, Pitanje Olimpijskog stadiona i Državne opere u Beogradu" [Two Problems in Urban Planning: The Questions of the Olympic Stadium and the State Opera House in Belgrade], *Politika*, July 15th 1939.

Maksimović, Branko. "Moderni urbanizam u pruskom projektu Zakona o uređenju gradova" [Modern Urbanism in Prussian Law Project for City Planning], *Savremena opština / Savremena općina* 6/3-4 (1931), 204-221.

Maksimović, Branko. "Politika gradskog zelenila i parkovi Beograda" [The Politics of Greenery and Parks of Belgrade]. In *Problemi urbanizma*, Branko Maksimović, ed. (Belgrade: G. Kon, 1932), 53-68.

Maksimović, Branko. *Problemi urbanizma* [Problems in Urbanism] (Belgrade: Geca Kon, 1932).

Manojlović, Todor [Манојловић, Тодор]. "Изложба 'Облика'" [Art Exhibition 'Oblik'], *Српски књижевни гласник* XXXVII 6 (1932), 464-467.

Manojlović, Todor. "Exhibition of the art group 'Oblik'," *The Serbian Literary Gazette* 29 (Belgrade 1930), 59-62.

Manojlović, Todor. "Осма Јесења изложба" [The Eighth Autumn Exhibition], *Београдске општинске новине* 11-12 (Belgrade 1935), 724.

Manojlović, Todor [Манојловић, Тодор.] *Ликовна критика*, Jasna Jovanov, ed. (Zrenjanin: Gradska narodna biblioteka, 2008: phototypical edition of interwar works).

Marinković, Branislav [Маринковић, Бранислав]. "О нашој примењеној уметности. Поводом занатске изложбе" [On Our Applied Arts. On the Occasion of Craft Exhibitions], *Уметнички преглед* 12 (1938), 380-382.

Marinković, Branislav. "Savremena dekorativna umetnost u Francuskoj" [Modern Decorative Arts in France], *Уметнички преглед* 3-4 (1939), 124-126.

Memorandum for the Weissenhofsiedlung in Stuttgart, drafted by the Mayor of Stuttgart, K. Lautenschlager, and the President of Deutscher Werkbund, P. Bruckmann (1925).

Micić, Ljubomir. *Barbarogénie le décivilisateur*. Paris: Aux Arenes de Lutece, 1938; Serbian translation: Micić, Ljubomir. *Barbarogenije Decivilizator*, trans. Radmila Jovanović (Belgrade: Filip Višnjić, 1993).

Micić, Ljubomir. "Beograd bez arhitekture" [Belgrade without Architecture], *Zenit* 37 (Nov. / Dec. 1925), n. p.

Micić, Ljubomir. "Makroskop – Mih. S. Petrov" [Macroscope – Mih. S. Petrov], *Zenit*, I/6 (July, 1921), 14.

Micić, Ljubomir. "Makroskop: Pet kontinenata" [Macroscope: Five Continents], *Zenit* 24 (May, 1923), n.p.

Micić, Ljubomir. "Manifest Srbijanstva" [Manifesto of Serbianism], Dubrovnik 1936, *Srbijanstvo*, Belgrade, 1940; reprinted in *Daj nam Bože municije. Srpska avangarda na braniku otadžbine*, ed. Nikola Marinković (Belgrade: Dinex, 2013), 111-129.

Micić, Ljubomir. "Manifest varvarima duha i misli na svim kontinentima" [The Manifesto to the Barbarians of Spirit and Thought on All Continents], *Zenit* VI/38 (January/February, 1926), n. p.

Micić, Ljubomir. "Nova Umetnost" [Art Nouveau], *Zenit* 34 (Dec. 1924), n.p.

Micić, Ljubomir. "O estetici purizma" [On the Aesthetics of Purism], *Zenit* II/15 (June, 1922), 34-35.

Micić, Ljubomir. *Velika zenitistička večernja* [Big Zenitist Evening], Zagreb, January 31, 1923, poster.

Micić, Ljubomir. "Zenit Manifest," *Zenit* 11 (Feb. 1922), n. p.

Micić, Ljubomir. Cover page with Theo van Doesburg's and Cornelis van Eesteren's Villa Rosenberg (1923), *Zenit* 40 (April 1926).

Micić, Ljubomir, El Lissitzky and Ilya Ehrenburg. "Ruska nova umetnost" [Russian New Art], *Zenit* 17/18 (Sep. / Oct. 1922), n.p.

Mitzitch, Lioubomir. "Avion sans appareil: poème antieuropéen," *Zenit* 37 (Nov. / Dec. 1925), n.p.

Novaković, Stojan. *Istorija srpske književnosti* [History of Serbian Literature] (Belgrade: Državna štamparija, 1867).

Novaković, Stojan. *Srpska bibliografija* [Serbian Bibliography] (Belgrade: Državna štamparija, 1869).

Peković, Slobodanka. "Jelenina pisma." In *Pisma iz Niša. O haremima*. Jelena Dimitrijević (Gornji Milanovac-Beograd: Dečije novine-Narodna biblioteka Srbije: 1986, first published in 1897).

Petrov, Ruža. "Модерне ситнице као неопходни оквир данашњег намештаја. Један сат у атељеу г-ђе Маргарите Кофлер" [Modernist Miscellany as a Necessary Framework for Today's Furniture. One Hour in the Studio of Mrs. Margaret Kofler], *Недељне илустрације,* 1 January 1933, 12-13.

Petrović, Kosta. *Sokolski stadion u Beogradu: u jugoslovenskom narodnom parku kralja Aleksandra I Ujedinitelja* [Soko Stadium in Belgrade] (Belgrade: Savez sokola Kraljevine Jugoslavije, 1935).

Pevsner, Nikolaus. *Pioneers of the Modern Movement* (New Haven and London: Yale University Press, [1936] 2005).

Popović, Djordje [Поповић, Ђорђе]. "Однос излагача 'Облика' и нових прегнућа и тенденција млађих уметника" [The Relationship between 'Oblik' and New Achievements and Trends by Younger Artists], *Правда,* 24 December 1938.

Program stečaja za izradu generalnog plana o uredenju i proširenju Beograda [Program for Master Plan of Organization and Expansion of Belgrade] (Belgrade: Opština grada Beograda, 1921).

Radovanović, Mihailo. *Uvod u urbanizam, Osnovni principi i metode rada* [Introduction to Urbanism, Main Principles and Methods] (Belgrade: Štamparija "Jovanović," 1933).

Rosić, V. "Свечано отварање игралишта СК Југославије" [Opening Ceremony for the New SK Jugoslavija Stadium], *Политика* [Politika], 27 Apr. 1927, 9-10.

Sekulić, Isidora. "Jelena Dimitrijević: Novi svet ili U Americi godinu dana" [Jelena Dimitrijević: New World or A Year in America], *Srpski književni glasnik* 8 (1934), 604-605.

Šijački, M. D. *Niška Banja* (Belgrade: Knjižarnica Radomira D. Đukovića, 1936).

Simić-Milovanović, Zora. *Сликарке у српској историји уметности* [Women Painters in Serbian Art History] (Belgrade: Udruženje univerzitetski obrazovanih žena, 1938).

Stanojević, Milorad. "Finansiska sretstva za podizanje Beograda" [Financials for Building Belgrade], *Beogradske opštinske novine* 53/3 (1935), 141-147.

Stanojević, Veljko. "Изложба Уметничке групе 'Облик'" [Exhibition of the Art Group 'Oblik'], *Политика* [Politika], 16 December 1929.

Ve Poljanski, Banko. "Sumrak." In *Panika pod suncem, Tumbe, Crveni Petao* [Panic under the Sun, Upside Down, the Red Rooster], Aleksandar Petrov, ed. (Belgrade: National Library of Serbia, 1988), 30.

Ve Poljanski, Branko [Micić, Branko]. "'Mi' na Dekorativnoj izložbi u Parizu" ['We' At the Decorative Arts Exhibition in Paris], *Zenit* V/37 (Belgrade, November/December, 1925), n. p.

Ve Poljanski, Branko [Micić, Branko]. "Dialog Marinetti-Poljanski" [Dialogue Marinetti-Poljanski], *Zenit* 37 (November/December, 1925), n.p.

Ve Poljanski, Branko [Micić, Branko]. "Dialogue Marinetti-Poljanski," *New Sound* 34 (February 2009), 1-5 (Goran Kapetanović, trans., Published on the Occasion of the 100th Anniversary of the Futurist Manifesto).

Ve Poljanski, Branko [Micić, Branko]. "Manifesto: A Fragment from a Larger Manifesto to all Nations of the World." In *Panika pod suncem, Tumbe, Crveni Petao* [Panic under the Sun, Upside Down, the Red Rooster], Aleksandar Petrov, ed. (Belgrade: National Library of Serbia, 1988), x.

Ve Poljanski, Branko [Micić, Branko]. "Put u Braziliju" [A Journey to Brazil]. In Branko Ve Poljanski, *Panika pod suncem, Tumbe, Crveni Petao* [Panic under the Sun, Upside Down, the Red Rooster], Aleksandar Petrov, ed. (Belgrade: National Library of Serbia, 1988), 14-15.

Ve Poljanski, Branko [Micić, Branko]. *Crveni Petao – Le Coq Rouge* [The Red Rooster] (Paris/Belgrade: RE, 1927).

Ve Poljanski, Branko [Micić, Branko]. *Panika pod Suncem – Panique sous le Soleil* [Panic under the Sun] (Belgrade: Zenit, 1924).

Ve Poljanski, Branko [Micić, Branko]. *Tumbe* [Upside Down] (Belgrade: Printing Workers' Union, 1926).

Vidaković, Slobodan Ž. "Predlozi za rešenje pitanja malih stanova u Beogradu i rušenje Jatagan-male, Izvod iz službenog referata" [Proposals for the Solution of Small Appartments in Belgrade and the

Destruction of Jatagan-mala, Excerpt from Official Report], *Beogradske opštinske novine* 53/9 (1935), 537-545.

Vidaković, Slobodan Ž. *Naši socijalni problemi* [Our Social Problems] (Belgrade: Geca Kon, 1932).

Yovitchitch, Lena A. *Peeps at Many Lands. Yugoslavia* (London: A. & C. Black Ltd., 1928).

Zenit. Special issue devoted to the New Russian Art, no. 17-18 (Belgrade, 1922).

Živanović, Slavoljub. *Prvi jugoslovenski sportski almanah* [The First Yugoslav Sports Almanac] (Belgrade: Jovan K. Nikolić, 1930).

Secondary Sources

Aleksić, Dragan, and Gojko Tešić. *Dada tank* (Belgrade: Nolit, 1978).

Allan, Scott and Mary Morton. *Reconsidering Gérôme* (Los Angeles: J. Paul Getty Museum, 2010).

Anderson, John. "Wekerle Garden Suburbub Kisapest Budapest," *CAP News* (2004), 18-19.

Anđić, Jovan. "Vrtove je pojeo beton" [Gardens Eaten by Concrete], *Politika* 2007.

Andrejević, Borislav. *Stari zapisi o Nišu, od V do XIX veka* [Old Records on Niš, 5th-19th Centuries] (Niš: Prosveta, 1997).

Andrejević, Mihailo. *Dugo putovanje kroz fudbal i medicinu* [Long Journey trough Soccer and Medicine] (Gornji Milanovac: Dečje novine, 1989).

Armstrong, Carol. *Manet/Manette* (New Haven: Yale University Press, 2002).

Arsić, Branka. "Jelena Dimitrijević." In *Žene, slike, izmišljaji*, Branka Arsić, ed. (Belgrade: Centar za ženske studije, 2000).

Ballantyne, Andrew. *Architectures: Modernism and After* (Malden-Oxford-Carlton: Wiley-Blackwell, 2003).

Barilli, Milena. *Pro futuro. Teme, simboli, značenja* [Milena Pavlović Barilli, Pro futuro. Themes, Symbols, Meanings] (Belgrade: HESPERIAedu, 2010).

Barsac, Jacques. *Charlotte Perriand. Une art d'habiter 1903–1959* (Paris: Standard Editions, 2005).

Barthes, Roland. *Mythologies*, trans. Annette Lavers (New York: Hill and Wang, 1972).

Bassnett, Susan. *Comparative Literature: A Critical Introduction* (Oxford: Blackwell, 1993).

Bataković, Dušan T., ed. *Novija istorija srpskog naroda* [Recent History of Serbian People] (Belgrade: Vojna štamparija, 2000).

Batchelor, Peter. "The Origin of the Garden City Concept of Urban Form," *Journal of the Society of Architectural Historians* (1969), 184-200.

Baxandall, Michael. *Painting and Experience in Fifteenth Century Italy: a Primer in the Social History of Pictorial Style* (Oxford, New York: Oxford University Press, 1988).

Baxter, John. *Von Sternberg* (Lexington, KY: University Press of Kentucky, 2010).

Baylon, Mate. "Stan u Beogradu," *Arhitektura urbanizam* 14/74-77 (1975), 23-42.

Bell, Elizabeth. *Theories of Performance* (Los Angeles: Sage Publications, Inc, 2008).

Benjamin, Walter. *The Arcades Project*, trans. Howard Eiland and Kevin McLaughlin (Cambridge, Mass., London: The Belknap Press of Harvard University Press, 1999).

Benson, Timothy et al. *Expressionist Utopias: Paradise, Metropolis, Architectural Fantasy (Weimar and Now: German Cultural Criticism)* (Los Angeles, CA: University of California Press, 2001).

Benson, Timothy O. and Éva Forgács, eds. *Between Worlds: A Sourcebook of Central European Avant-Gardes, 1910-1930* (Cambridge, MA: MIT Press, 2002).

Benson, Timothy O., ed. *Central European Avant-Gardes: Exchange and Transformation, 1910-1930* (Cambridge, MA: MIT Press, 2002).

Bernik, Stane. "Expressionist Tendencies in Slovene Architecture." In *Slovenska arhitektura dvajstega stoletje* [Slovene Architecture of the Twentieth Century] (Ljubljana, 2008), 51-71.

Bière-Chauvel, Delphine. "La revue Zenit: une avant-garde entre particularisme identitaire et internationalism." In *Europa! Europa? The Avant-Garde, Modernism and the Fate of a Continent*, eds. Sasha Bru et al. (Berlin: De Gruyter, 2009), 138-152.

Biermann, Veronica et al. *Architectural Theory from the Renaissance to the Present* (Köln: Taschen, 2003).

Blagojević, Ljiljana. *Модерна кућа у Београду, 1920-1941* [Modern House in Belgrade, 1920-41] (Belgrade: Andrejević Foundation, 2000).

Blagojević, Ljiljana. *Modernism in Serbia: The Elusive Margins of Belgrade Architecture, 1919-1941* (Cambridge, MA: MIT Press, 2003).

Blagojević, Ljiljana. *Novi Beograd, osporeni modernizam* [New Belgrade, Challenged Modernism] (Belgrade: Zavod za udžbenike / Arhitektonski fakultet Univerziteta u Beogradu / Zavod za zaštitu spomenika kulture grada Beograda, 2007).

Block, Alexander. "Soviet Housing: Some Town Planning Problems," *Soviet Studies* (1954), 1-15.

Bogavac, Tomislav. *Stanovništvo Beograda 1918-1991* [Population of Belgrade 1918-1991] (Belgrade: Beogradski izdavačko-grafički zavod / Srpska književna zadruga / Muzej grada Beograda, 1991).

Bogdanović, Mira. "Modernizacijski procesi u Srbiji u XX veku." In *Srbija u modernizacijskim procesima XX veka,* Latinka Perović, Marija Obradović and Dubravka Stojanović, eds. (Belgrade: Institut za savremenu istoriju Srbije, 1994), 35-58.

Bogunović, Slobodan Giša. *Arhitektonska enciklopedija Beograda XIX i XX veka*, vol. 3 *Arhitektura, arhitekti, pojmovi* (Belgrade: Beogradska knjiga, 2005).

Borić, Tijana [Борић, Тијана]. *Теразије – урбанистички и архитектонски развој* (Belgrade: Zlatousti, 2004).

Borko, Božidar. "O jugoslovenskoj umetnosti i 'Obliku.'" In: Vladimir Rozić, *Umetnička grupa 'Oblik'* (Belgrade: Kancelarija za pridruživanje Srbije i Crne Gore Evropskoj uniji, 2005), 589–594.

Borsi, Franco and Giovanni Klaus König. *Architettura dell'Espressionismo* (Genova: Vitali e Ghianda, 1977).

Bošković, Djurdje. "Modern architecture at the exhibition of 'Oblik'," *The Serbian Literary Gazette* 29 (Belgrade 1930), 214-219.

Boym, Svetlana. *Architecture of the Off-Modern* (New York: Princeton Architectural Press, 2008).

Bozdogan, Sibel and Esra Akcan. *Turkey: Modern Architectures in History* (London: Reaktion Books, 2012).

Božinović, Neda. *Žensko pitanje u Srbiji u XIX i XX veku* (Belgrade: Devedesetčetvrta: Žene u crnom, 1996).

Brdar, Valentina. *Od Parisa do Brašovana* (Novi Sad: The Pavle Beljanski Memorial Collection, 2003).

Brinkman, Bodo. *Cranach* (London: Royal Academy of Arts New York: Distributed in the United States and Canada by Harry N. Abrams, 2007).

Brkić, Aleksej [Бркић, Алексеј]. *Знакови у камену. Српска модерна архитектура 1930-1980* (Београд: Савез Архитеката Србије, 1992).

Brown, Jeffrey. *Dangerous Curves. Action Heroines, Gender, Fetishism, and Popular Culture* (Jackson: University Press of Mississippi, 2011).

Bru, Sasha et al., eds. *Europa! Europa? The Avant-Garde, Modernism and the Fate of a Continent* (Berlin: De Gruyter, 2009).

Buchloh, Benjamin H. D. "Figures of Authority, Ciphers of Regression: Notes on the Return of Representation in European Painting," *October* 102 (1981), 39-68.

Buder, Stanley. "Ebenezer Howard: the Genesis of a Town Planning Movement," *Journal of American Institute of Planning* (1969), 390-398.

Buder, Stanley. *Visionaries & Planners: The Garden City Movement and the Modern Community* (New York: Oxford University Press, 1990).

Calic, Marie-Janine. *Sozialgeschichte Serbiens 1815-1941. Der aufhaltsame Fortschritt während der Industrialisierung* (München: R. Oldenbourg Verlag, 1994) [Čalić, Mari-Žanin. *Socijalna istorija Srbije 1815-1941: usporeni napredak u industrijalizaciji* (Belgrade: Clio, 2004)].

Callen, Anthea. *Techniques of the Impressionists* (Secaucus, NJ: Chartwell Books, 1982).

Campbell, Joan. *The German Werkbund: The Politics of Reform in the Applied Arts* (Princeton, NJ: Princeton Unviersity Press, 1978).

Campbell, Lorne. *Renaissance Portraits* (New Heaven, London: Yale University Press, 1990).

Ceranić, Milica [Церанић, Милица]. "Историја и архитектура палате 'Албанија' у Београду," *Наслеђе* VI (Београд 2005), 147-162.

Chakrabarty, Dipesh. *Provincializing Europe* (Princeton: Princeton University Press, 2000).

Chambers, Iain. *Migrancy, Culture, Identity* (Oxon: Routledge, 1994).

Cherry, Gordon E. "The Town Planning Movement and the Late Victorian City," *Transactions of the Institute of British Geographers,* New Series, *The Victorian City* (1979), 306-319.

Ćirković, Sima M. *The Serbs* (Malden, MA and Oxford: Wiley-Blackwell, 2004).

Clark, T.J. *The Painting of Modern Life* (Princeton: Princeton University Press, 1984).

Code, Lorraine. *What Can She Know? Feminist Theory and Construction of Knowledge* (Ithaca and London: Cornell University Press, 1991).

Cogeval, Guy and Edouard Vuillard. *Edouard Vuillard* (Washington D.C.: National Gallery of Art, 2003).

Cohen, Paula Marantz. *Silent Film and the Triumph of the American Myth* (Oxford: Oxford University Press, 2001).

Ćopić, Nikola. *Beogradska predgrađa između dva svetska rata 1918-1945. god*, text in manuscript (Muzej grada Beograda, 1974).

Čorak, Željka. "The Yugoslav Pavilion in Paris," *The Journal of Decorative and Propaganda Arts* 17 (1990), 37-41.

Čorak, Željka. *U funkciji znaka: Drago Ibler i hrvatska arhitektura između dva rata* [In the Function of Sign: Drago Ibler and Croatian Architecture between Two World Wars] (Zagreb: Matica hrvatska, 1981 [2000]).

Ćorović, Dragana. "The Garden City Concept: from Theory to Implementation – Case Study: Professors' Colony in Belgrade," *Serbian Architectural Journal* 1/1 (2009), 65-80.

Ćorović, Dragana. *Vrtni grad u Beogradu* [A Garden City in Belgrade] (Belgrade: Zadužbina Andrejević, 2009).

Ćorović, Vladimir. *Istorija Srba* [History of Serbs], Vol. 3 (Belgrade: Beogradski izdavačko-grafički zavod, 1989).

Corso, John J. "The Complex Geographies of Sherin Neshat," *Art Papers* (May/June 2013), 26-31.

Creese, Walter L. *The Search for Environment – The Garden City: Before and After* (New Haven and London: Yale University Press, 1966).

Crnjanski, Miloš. "Piza." In Miloš Crnjanski, *Ljubav u Toskani i drugi nežni zapisi*, Aleksandar Jerkov, ed. (Belgrade: Jugoslovenska knjiga, 1997), 37-60.

Crnjanski, Miloš. *Ispunio sam svoju sudbinu* [I Have Fulfilled My Destiny], Zoran Avramović, ed (Belgrade: Beogradski izdavačko-grafički zavod: Srpska književna zadruga: Narodna knjiga, 1992).

Crouch, Christopher. *Modernism in Art, Design and Architecture* (New York: St. Martin's Press, 1999).

Čubrilović, Vasa, ed. *Istorija Beograda* [History of Belgrade]. Vol. 3, *Dvadeseti vek* (Belgrade: Prosveta, 1974).

Čupić, Simona. *Грађански модернизам и популарна култура – епизоде модног, помодног и модерног (1918-1941)* [Bourgeois Modernism and Popular Culture – Episodes of the Fashionable, Faddish and Modern 1918/1941] (Novi Sad: Gallery of Matica srpska, 2011).

Damljanović, Tanja. *Češko-srpske arhitektonske veze: 1918-1941* [Czech-Serbian Architectural Relations 1918-1941] (Belgrade: Zavod za zaštitu spomenika kulture, 2004).

Damljanović, Tanja. *The Question of National Architecture in Interwar Yugoslavia: Belgrade, Zagreb, Ljubljana*, Ph.D. Thesis, Cornell University, 2003.

de Certeau, Michel. *Heterologies: Discourse on the Other* (Minneapolis: University of Minnesota Press, 1986).

de Certeau, Michel. *La culture au pluriel* (Paris, 1974; 2nd edition, Luce Giard, ed. Editions du Seuil, 1994) [*Culture in the Plural.* Conley, T. trans. (Minneapolis, MN: Minnesota University Press, 1997)].

de Certeau, Michel. *The Writing of History* (New York: Columbia University Press, 1992).

de Haan, Francisca, Krassimira Daskalova and Anna Loutfi. *A Biographical Dictionary of Women's Movements and Feminisms: Central, Eastern, and South Eastern Europe, 19th and 20th Century* (Budapest: Central European University Press, 2006).

Dedijer, Vladimir et al., *History of Yugoslavia* (New York: McGraw-Hill Book Co., 1974).

dell'Arco, Maurizio, Paolo Baldacci and Fabrizia Lanza Pietromarchi, trans. Shara Wasserman and Martha A. Davis, *The Dioscuri: Giorgio de Chirico and Alberto Savinio in Paris, 1924-1931* (Milano: A. Mondadori - Edizioni P. Daverio, 1987).

Denegri, Ješa. "Likovni umetnici u časopisu *Zenit*" [Visual Artists in the *Zenit* Journal]. In *Srpska avangarda u periodici* [Serbian Avant-Garde in Magazines], Vidosava Golubović and Staniša Tutnjević, eds. (Novi Sad: Matica srpska / Belgrade: Institut za književnost i umetnost, 1994), 431-442.

Deretić, Jovan. "Književni putnici" [Literature Travelers]. In Jovan Deretić, *Put srpske književnosti: idenitet, granice, težnje* (Belgrade: SKZ, 1996), 213-243.

Deretić, Jovan. *Istorija srpske književnosti* [History of the Serbian Literature] (Belgrade: Prosveta, 2004 [1983]).

Dimić, Ljubodrag. *Kulturna politika u kraljevini Jugoslaviji 1918-1941* [Cultural Politics in the Kingdom of Yugoslavia 1918-1941] vol. 1 *Društvo i država* [Society and State] (Belgrade: Stubovi kulture, 1996).

Dimić, Miroslava. "Profesorska kolonija – izgradnja i njeni osnivači" [The Professors Colony – Construction and its Founders], *Godišnjak grada Beograda* XLV-XLVI (1998-1999), 71-82.

Dimitrijević, Jelena. *Pisma iz Niša. O haremima* (Gornji Milanovac- Belgrade: Dečije novine-Narodna biblioteka Srbije: 1986).

Dobrivojević, Ivana. *Državna represija u doba diktature kralja Aleksandra 1929-1935* [State Repression During the Dictatorship of King Aleksandar 1929-1935] (Belgrade: Institut za savremenu istoriju, 2006).

Domljan, Žarko. *Arhitekt Erlich* (Zagreb: Društvo povjesničara umjetnosti Hrvatske, 1979).

Đorđević, Krista. "Osnivanje i delatnost udruženja prijatelja umetnosti 'Cvijeta Zuzorić.'" In *Beograd u sećanjima 1919-1929* [Belgrade in Memories 1919-1929], Milan Djoković, ed. (Belgrade: Srpska književna zadruga, 1980).

Doroški, Nada. *Отргнуто од заборава. Сећање на људе и догађаје од 1922. до 1996. године* [Snatched from oblivion. In memory of people and events from 1922 to 1996] (Belgrade: Nezavisna izdanja Slobodana Mašića, 1997).

Doy, Gen. *Drapery: Classicism and Barbarism in Visual Culture* (London: I.B. Tauris, 2002).

Doyle, Allan. "The Photographic Harem." In *Lalla Essaydi: Writing Femininity. Writing Pleasure*, John J. Corso, ed. (Rochester: Oakland University Press, 2013), 12-19.

Draškić, Marija, and Olga Popović-Obradović. "Pravni položaj žene prema Srpskom građanskom zakoniku (1844-1946)." In *Srbija u modernizacijskim procesima 19. i 20. veka, knjiga 2, Položaj žene kao merilo modernizacije*, Latinka Perović, ed. (Beograd: Institut za noviju istoriju Srbije, 1998).

Drljević, Marija [Дрљевић, Марија]. "Историја и архитектура Поште 1 у Београду," *Зборник за ликовне уметности Матице српске* 37 (2009), 277-296.

Drljević, Marija [Дрљевић, Марија]. "О архитектури зграде председништва првог дунавског паробродског друштва у Београду," *Архитектура и урбанизам* 20/21 (Београд, 2007), 127-134.

Droste, Magdalena. *Bauhaus 1919–1933* (Cologne: Taschen, 2002).

Dučić, Jovan. "Pismo iz Egipta." In *Najlepši putopisi Jovana Dučića*, Radoslav Bratić, ed. (Belgrade: Prosveta, 2003), 229-249.

Đurđević, Marina [Ђурђевић, Марина]. "Прилог проучавању делатности архитекте Валерија Владимировича Сташевског у Београду," *Godišnjak grada Beograda* 45-46 (1998-1999), 151-171.

Đurđević, Marina [Ђурђевић, Марина]. "Палата Игуманов на Теразијама," *Флогистон* 1 (Београд, 1995), 87-94.

Đurđević, Marina. *Arhitekti Petar i Branko Krstić* [Architects Petar and Branko Krstić] (Belgrade: Republički zavod za zaštitu spomenika kulture, Beograd, Muzej nauke i tehnike – Muzej arhitekture, 1996).

Đurić, Dubravka and Miško Šuvaković, eds. *Impossible Histories: Historical Avant-gardes, Neo-avant-gardes, and Post-avant-gardes in Yugoslavia, 1918-1991* (Cambridge: The MIT Press, 2003).

Đurić, Dubravka. "Radical Poetic Practices: Concrete and Visual Poetry in the Avant-garde and the Neo-avant-garde." In *Impossible Histories: Historical Avant-gardes, Neo-avant-gardes, and Post-avant-gardes in Yugoslavia, 1918-1991*, Dubravka Đurić and Miško Šuvaković, eds. (Cambridge: MIT Press, 2003), 64-95.

Đurić-Zamolo, Divna and Svetlana Nedić. "Stambeni delovi Beograda i njihovi nazivi do 1941. godine," *Godišnjak grada Beograda* 40-41 (1993-94), 65-106.

Đurić-Zamolo, Divna. "Građa za proučavanje dela žena arhitekta sa Beogradskog univerziteta, generacije 1896-1940. godine" [The material for the study of women architects from the Belgrade University, 1896-1940 generation]. In *PINUS Zapisi* 5, Aleksandar Kadijević, ed. (Belgrade: Museum of Science and Technology, 1996), 7-85.

Đurić-Zamolo, Divna. "Jevreji – graditelji Beograda do 1941. godine," *Zbornik Jevrejskog istorijskog muzeja* 6 (Belgrade 1992), 230-231.

Elkins, James. "Review of Steven Mansbach's book *Modern Art in Eastern Europe: From the Baltic to the Balkans, ca. 1890-1939* (1999)," *The Art Bulletin* 82 (2000), 781-785.

Ellingson, Terry. *The Myth of the Noble Savage* (Berkeley: University of California Press, 2001).

Emmert, Thomas. "Ženski pokret: the Feminist Movement in Serbia in 1920s." In *Gender Politics in the Western Balkans: Women and Society in Yugoslavia and the Yugoslav Successor States*, Sabrina P. Ramet, ed. (Pennsylvania: The Pennsylvania State University Press, 1999), 33-50.

Enciklopedija fizičke culture. I [The Encyclopedia of Physical Culture. I] (Zagreb: Jugoslavenski leksikografski zavod, 1975).

Etlin, Richard. *Modernism in Italian Architecture, 1890-1940* (Cambridge, MA: MIT Press, 1991).

Ewing, William A. and Todd Brandow. *Edward Steichen: in High Fashion, the Condé Nast years, 1923-1937* (Minneapolis: Foundation for the Exhibition of Photography; New York: W.W. Norton & Co., 2008).

Feldstein, Richard and Judith Roof, eds. *Feminism and Psychoanalysis* (Ithaca, NY: Cornell University Press, 1989).

Ferkai, András. "Cottage versus Apartment Block – Suburbanisation of Budapest." In *Britain and Hungary, Contacts in architecture and design during the nineteenth and twentieth century, Essays and Studies,* Gyula Ernyey, ed. (Budapest: Hungarian University of Craft and Design, 1999), 151-170.

Forrester, Sibelan. "Isidora Sekulić as an Early Feminist," *Serbian Studies* 5/1 (Spring 1989), 85-94.

Foster, Shirley. *Across New Worlds: Nineteenth-Century Women Travelers and Their Writings* (New York, London: Harvester Wheatsheaf, 1990).

Foucault, Michel. "Of Other Spaces, Heterotopias," *Architecture, Mouvement, Continuité* 5 (1984), 46-49.

Frampton, Kenneth. "Towards a Critical Regionalism: Six Points for an Architecture of Resistance." In Hal Foster, ed. *The Anti-Aesthetic: Essays on Post-Modern Culture* (Seattle: Bay Press, 1983), 16-30.

Frampton, Kenneth. *Modern Architecture: A Critical History* (London: Thames & Hudson, [1980] 1992).

Fried, Michael. *Manet's Modernism or The Face of the Painting in the 1860s* (Chicago, London: The University of Chicago Press, 1996).

Garber, Marjorie and Nancy J. Vickers, eds. *The Medusa Reader* (New York, London: Routledge, 2003).

Garonja-Radovanac, Slavica. "Jelena Dimitrijević: prva priznata srpska književnica." In *Žena u srpskoj književnosti*, Slavica Garonja-Radovanac, ed. 55. Дневник (Novi Sad: Dnevnik, 2010).

Gašić, Ranka. "Problemi teritorijalnog širenja Beograda između dva svetska rata" [Problems of Territorial Expansion of Belgrade between Two World Wars]. *Istorija 20. veka*, vol.3 (2010), 59 – 61.

Gašić, Ranka. *Beograd u hodu ka Evropi. Kulturni uticaji Britanije i Nemačke 1918-1941* [Belgrade Walking towards Europe. The Cultural Influence of Great Britain and Germany 1918-1941] (Belgrade: Institut za savremenu istoriju, 2005).

Gavrilović, Draga. "Devojački roman." In Draga Gavrilović, *Izabrana proza*, Jasmina Ahmetagić, ed. (Belgrade: Multinacionalni fond kulture Kongras, 2007), 19-183.

Gavrilovich, Kosara M. and George Vid Tomashevich. *Songs of Serbia* (Toronto: Serbian Literary Co., 2002).

Giddens, Anthony. *The Consequences of Modernity* (Stanford: Stanford University Press, 1990).

Gifford, Paul. "Defining Others: how inter-perceptions shape identities." In *Europe and its Others: Essays on Interperception and Identity*, Paul Gifford and Tessa Hauswedell, eds. (Oxford, Bern, Berlin, Bruxelles, Frankfurt am Main: Peter Lang, 2010), 13-39.

Golubović, Vid[osav]a "Časopis 'Zenit'" [The 'Zenit' Journal], *Književnost* XXXVI 7/8 (1981), 1477-1482.

Golubović, Vida and Irina Subotić, *Zenit i avantgarda dvadesetih godina* [Zenit and the Avant-garde of the 1920s] (Belgrade: National Museum and the Institute for Literature and the Arts, 1983).

Golubović, Vidosava and Irina Subotić, *Zenit 1921-1926* (Belgrade: National Library of Serbia, Institute for Literature and the Arts, and Serbian Cultural Society Prosvjeta, 2008).

Grčev, Kokan. *From Origins to Style: Macedonian architecture at the end of the 19th century and in the period between the two world wars* (Skopje: Institute of Folklore "Marko Cepenkov," 2004).

Habermas, Jürgen. "Modernity – An Incomplete Project," Seyla Ben-Habib, trans. In *The Anti-Aesthetic, Essays on Postmodern Culture*, Hal Foster, ed. (Port Townsend, Washington: Bay Press, 1983), 3-15.

Hall, Peter. *Cities of Tomorrow: An Intellectual History of Urban Planning and Design in the Twentieth Century* (Malden, MA: Blackwell Publishers, 2002).

Hardy, Alain Rene. *Art Deco Textiles. The French Designers* (London: Thames and Hudson, 2003).

Harlow, Barbara and Laek Alloula. *The Colonial Harem* (Minneapolis: University of Minnesota Press, 1986; Theory and History of Literature, 21).

Hawkesworth, Celia. *Voices in the Shadows: Women and Verbal Art in Serbia and Bosnia* (New York: Central European University Press, 2000).

High Architecture Education in Serbia 1846-1971 (Belgrade: Faculty of Architecture, 1996).

Hill, Christopher R. *Olympic Politics* (Manchester: Manchester University Press, 1996).

Hilton, Timothy. *The Pre-Raphaelites* (London: Thames & Hudson, 1970).

Howe, Patricia. "Appropriation and alienation: women travelers and the construction of identity." In *Europe and its Others: Essays on Interperception and Identity*, Paul Gifford and Tessa Hauswedell, eds. (Oxford, Bern, Berlin, Bruxelles, Frankfurt am Main: Peter Lang, 2010), 77-95.

Ignjatović, Aleksandar [Игњатовић, Александар]. "Дом Удружења југословенских инжењера и архитеката у Београду," *Наслеђе* VII (2006), 87-118.

Ignjatović, Aleksandar. *Jugoslovenstvo u arhitekturi, 1904-1941* [Yugoslavism in Architecture, 1904-1941] (Belgrade: Građevinska knjiga, 2007).

Ilić, Stefan, Slađana Mijatović. *Istorija fizičke kulture Kneževine i Kraljevine Srbije* [History of Physical Education in Principality and Kingdom of Serbia] (Belgrade: Fakultet fizičke kulture, 1994).

IRWIN. "Eastern Modernism." In *Modernologies. Contemporary Artists Researching Modernity and Modernism*, Cornelia Klinger and Bartomeu Mari, eds. (Barcelona: Museu d'Art Contemporani de Barcelona, 2009), 112-115.

Isaković, Svetlana. *Савремена керамика у Србији* [Contemporary Ceramics in Serbia] (Belgrade: Museum of Applied Art, 1988).

Ivanić, Dušan and Dragana Vukićević. *Ka poetici realizma* (Belgrade: Zavod za udžbenike, 2007).

Ivanić, Dušan. "Sabrana dela Drage Gavrilović," *Letopis Matice srpske* 447 (Novi Sad, 1991), 157-159.

Ivić, Pavle, ed. *The History of Serbian Culture* (Edgware, Middlesex: Porthill Publishers, 1999).

Jakasović, Natalija and Slobodan Mijušković, eds. "Sećanja Mihaila S. Petrova" [Memories of Mihailo S. Petrov], *3+4* (1985), 37-41.

James, Kathleen. "Einstein, Finzl – Freundlich, Mendelsohn, and the Einstein Tower in Potsdam." In *Erich Mendelsohn Architect 1887-1953*, R. Stepan, ed. (New York, 1999), 26-37.

Janakova Grujić, Mara [Јанакова Грујић, Мара.] "Београдски опус архитекте Стевана Тоболара (1888-1943)," *Наслеђе* VII (2006), 152-156.

Janković, Olivera. "The Metamorphoses of Milena Pavlović Barilli between 'Pure' and Applied Art." In *Milena Pavlović Barili: Vero verius: vreme, život, delo,* Zorica Stablović Bulajić, ed. (Belgrade: HESPERIAedu, 2010), 123-208.

Jannella, Cecilia. *The Great Italian Painters from the Gothic to the Renaissance* (Florence: Scala, 2003).

Jovanović, Milivoje. "Duhovni prostor u stvaralaštvu Jelene Dimitrijević: Prilozi za biografiju." In *Zbornik referata sa naučnog skupa: Jelena Dimitrijević – život i delo, Niš, 28. i 29. oktobar 2004,* Miroljub Stojanović, ed. (Niš: Centar za naučna istraživanja SANU i Univerzitet u Nišu, 2006), 89-97.

Jovanović, Miodrag [Јовановић, Миодраг]. *Српско црквено градитељство и сликарство новијег доба* (Београд: Завод за уџбенике, 2007).

Jovanović, Miodrag [Јовановић, Миодраг]. *Храм Светог Саве у Београду* (Београд: Задужбина Илије М. Коларца, 2005).

Jovanović, Miodrag. *Srpsko crkveno graditeljstvo i slikarstvo novijeg doba* [Serbian Church Building and Painting of Recent Times] (Belgrade-Kragujevac: Kalenić, 1987).

Jovanović, Miodrag. *Uroš Predić* (Novi Sad: Galerija Matice srpske, 1998).

Jovanović, Zoran M. [Јовановић, Зоран М.]. *Зебрњак: У трагању за порукама једног споменика или о култури сећања код Срба* (Београд-Горњи Милановац: Библиотека "Браћа Настасијевић," 2004).

Kadijević, Aleksandar – Srdjan Marković [Кадијевић, Александар - Срђан Марковић]. *Градитељство Лесковца и околине између два светска рата* (Лесковац: Народни музеј Лесковац, 1996).

Kadijević, Aleksandar – Srdjan Marković [Кадијевић, Александар - Срђан Марковић]. *Милан Минић. Архитект и сликар* (Пријепоље: Музеј у Пријепољу, 2003).

Kadijević, Aleksandar [Кадијевић, Александар]. "Југословенски павиљон у Барселони 1929. Године," *Гласник ДКС* 19 (Београд 1995), 213-216

Kadijević, Aleksandar [Кадијевић, Александар]. "Милан Злоковић и тражења националног стила у српској архитектури," *Годишњак града Београда* XLII-XLIII (2000/2001), 213-224.

Kadijević, Aleksandar [Кадијевић, Александар]. "О архитектури спомен-обележја на Зејтинлику и Виду," *Лесковачки зборник* L (2010), 197-206.

Kadijević, Aleksandar [Кадијевић, Александар]. *Естетика архитектуре академизма (XIX-XX век)* (Београд: Грађевинска књига, 2005).

Kadijević, Aleksandar. "Arhitekt Josif Najman (1894-1951)," *Moment* 18 (1990), 100-106.

Kadijević, Aleksandar. "Ekspresionizam u beogradskoj arhitekturi (1918-1941)," *Nasledje* 13 (2012), 59-77.

Kadijević, Aleksandar. "Elementi ekspresionizma u srpskoj arhitekturi između dva svetska rata," *Moment* 17 (1990), 90-100.

Kadijević, Aleksandar. "Expressionism and Serbian industrial architecture," *Зборник за ликовне уметности Матице српске* 41 (2013), 103-110.

Kadijević, Aleksandar. "Uloga ideologije u novijoj arhitekturi i njena shvatanja u istoriografiji," *Nasleđe* 8 (2007), 232-233.

Kadijević, Aleksandar. *Jedan vek trazenja nacionalnog stila u srpskoj arhitekturi (sredina XIX-XX veka)* [One Century of Search for a National Style in Serbian Architecture (mid-19th-20th centuries)] (Belgrade: Gradjevinska knjiga, 1997, second edition 2007).

Kadijević, Aleksandar. *Momir Korunović* (Belgrade: Republički zavod za zaštitu spomenika kulture, 1996).

Kamilić, Viktorija. "Osvrt na delatnost Grupa arhitekata modernog pravca" [An Overview on the Activity of the Group of Architects of the Modern Movement], *Godišnjak grada Beograda* LV-LVI (2008-2009), 239-264.

Karabacak, Melike. "Osmanli'da Politik Ve Edebi Bir Kadin: Gülistan" [A Political and Literary Woman in the Ottoman Empire: Gülistan İsmet]. In *Perspectives on Ottoman Studies: Papers from the 18th Symposium of the International Committee of Pre-Ottoman and Ottoman Studies (CIEPO)* (Berlin: Lit Verlag, 2011), 955-971.

Kecman, Jovanka. *Žene Jugoslavije u radničkom pokretu i ženskim organizacijama 1918-1941* (Belgrade: Narodna knjiga: Institut za savremenu istoriju, 1978).

Keković, Aleksandar and Zoran Čemerikić. "Moderna u Niškoj Banji – Vile i hoteli" [The Modern Architecture of Niška Banja: Villas and Hotels], *Arhitektura i urbanizam* 8 (2001), 60-71.

Keković, Aleksandar and Zoran Čemerikić. *Moderna Niša 1920-1941* [The Modern Architecture of Niš 1920-1941] (Niš: Društvo arhitekata Niša, 2006).

Klaus, Susan. *A Modern Arcadia: Frederick Law Olmsted. Jr. & the Plan for Forest Hills Gardens* (Amherst & Boston: University of Massachusetts Press / Amherst: Library of American Landscape History, 2004).

Kliemann, Julian and Michael Rohlmann. *Italian Frescoes, High Renaissance and Mannerism, 1510-1600* (New York: Abbeville Press, 2004).

Koch, Magdalena. *...Kiedy dojrzejemy jako kultura... Twórczość pisarek serbskich na początku XX wieku (kanon-genre-gender)* (Wroclaw: Wydawnictwo Universytetu Wrocławskiego, 2007) [Koh, Magdalena. *Kad sazremo kao kultura - stvaralaštvo srpskih spisateljica na početku XX veka (kanon-žanr-rod)*, translated from Polish by Jelena Jović (Belgrade: Službeni glasnik, 2012)].

Kodrnja, Jasna, Svenka Savić and Svetlana Slapšak, eds., *Kultura, drugi, žene* [Culture, Others, Women] (Zagreb: Institut za društvena istraživanja u Zagrebu, Hrvatsko filozofsko društvo, Plejada: 2010).

Kojić, Branislav. *Društveni uslovi razvitka arhitektonske struke u Beogradu 1920-1940. godine* [Social Conditions for the Development of the Architectural Profession in Belgrade 1920-1940] (Belgrade: Srpska akademija nauka i umetnosti, 1978).

Konstantinović, Radomir. "Ko je Barbarogenije?" [Who Is a Barbarogenius?]. In *Treći program* (Proleće, 1969), 11-21.

Konstantinović, Radomir. *Branko Ve Poljanski: Biće i jezik* [Being and Tongue] (Belgrade: Prosveta, 1983).

Kostof, Spiro. *The City Shaped* (Boston, MA: Little, Brown and Co., 1991).

Kragujević, Gabriela. "Sokolstvo u Srbiji (1918-1941)." In *Telesno vežbanje i sport u Srbiji: (1857-2007)*, S. Ilić, ed. (Beograd: DTA, 2008), 129-166.

Krstić, Branko. *Branko Krstić* (Catalogue of works of fine arts, author's edition) (Belgrade 1964).

Ksandr, Karel, ed. *Villa Müller* (Prague: Argo, 2000).

Kuhl, Nancy. *Extravagant Crowd: Carl van Vechten's Portraits of Women* (New Haven, Conn.: Beinecke Rare Book and Manuscript Library, Yale University, 2003).

Kulauzov-Reba, Jovana. *Ženski Istok i Zapad* (Belgrade: Zadužbina Andrejević, 2010).

Kusovac, Nikola. *Pavle Paja Jovanović: (1859-1957)* (Belgrade: "Radionica Duše," 2009).

Kusovac, Nikola. *Slike i crteži Paje Jovanovića* (Novi Sad: Galerija Matice srpske, 1984).

Kuz, R. [Куз, Р.], "Облик ќе ги продолжи своите светли традиции," *Нова Македонија*, 15. октобар, 1957.

Kuzmanovski, Risto. "Razgovori u ateljeima," *Vjesnik u srijedu,* 18 December 1957.

Lacouture, Annette. *Jules Breton, Painter of Peasant Life* (New Haven: Yale University Press in association with The National Gallery of Ireland, 2002).

Lakićević-Pavićević, Vesna. *Илустрована штампа за децу код Срба* [Illustrated Press for Serbian Children] (Belgrade, 1994).

Lampugnani, Vittorio Magnago and Romana Schneider, eds. *Moderne Architektur in Deutschland 1990 bis 1950: Expressionismus und Neue Sachlichkeit* (Stuttgart: G. Hatje, cop., 1994).

Leen Meganck, Linda van Santvoort and Jan de Maeyer, eds. *Regionalism and Modernity, Architecture in Western Europe 1914-1940* (Leuven: Leuven University Press, 2013).

LeGates, Richard T. and Frederic Stout, eds. *The City Reader* (London and New York: Routledge, 2002).

Lesnikowski, Wojciech, ed. *East European Modernism: architecture in Czechoslovakia, Hungary, and Poland between the wars 1919-1939* (London: Thames and Hudson, 1996).

Levinger, Esther. "Ljubomir Micić and the Zenitist Utopia." In *Central European Avant-Gardes: Exchange and Transformation, 1910-1930*, Timothy O. Benson, ed. (Cambridge, MA: MIT Press, 2002), 260-278.

Llewellyn-Jones, Lloyd. *Aphrodite's Tortoise: the Veiled Woman of Ancient Greece* (Swansea, Wales: Classical Press of Wales; Oakville, CT: Distributor in the United States, David Brown, 2003).

Longinović, Tomislav. *Vampire Nation: Violence as Cultural Imaginary* (Durham: Duke University Press, 2011).

M. "Ponovno osnivanje grupe likovnih umjetnika 'Oblik'," *Borba,* 22 October 1957.

Maase, Kaspar. *Grenzenloses Vergnügen: Der Aufstieg der Massenkultur 1850-1970* (Frankfurt am Main: Fischer-Taschenbuch-Verlag, 1997).

Maksimović, Branko. "Urbanistička misao u Srbiji početkom XX veka." In *Knjiga o sintezi,* Boško Rudinčanin, ed. (Vrnjačka Banja: Zamak kulture, 1975), 119-203.

Maksimović, Branko. "Urbanistički razvoj Beograda 1830-1941." In *Oslobodenje gradova u Srbiji od Turaka 1862-1868* (Belgrade: Naučno delo and Srpska akademija nauka i umetnosti, 1970), 627-659.

Maksimović, Branko. *Ideje i stvarnost urbanizma Beograda 1830-1941* [Ideas and Reality of Belgrade Urban Planning 1830-1941] (Belgrade: Zavod za zaštitu spomenika kulture grada Beograda, 1983).

Manević, Zoran [Маневић, Зоран]. "Београдски архитектонски модернизам 1929-1931," *Годишњак града Београда* XXVI (Београд, 1979), 209-226.

Manević, Zoran [Маневић, Зоран]. "Дело архитекте Драгише Брашована," *Зборник за ликовне уметности Матице Српске* 6 (1970), 187-208.

Manević, Zoran, ed. *Leksikon neimara* [Dictionary of Builders] (Belgrade: Gradjevinska knjiga, 2008).

Manević, Zoran. "Arhitektura i politika," *Zbornik za likovne umetnosti* 20 (1984), 300-306.

Manević, Zoran. "The Krstić Brothers." In *Builders* (Belgrade: Cultural Heritage Preservation Institute of Belgrade, 1986), 42-51.

Manević, Zoran. *Arhitektura XX veka* [Architecture of the Twentieth Century] (Belgrade: Prosveta, 1986).

Manević, Zoran. *Pojava moderne arhitekture u Srbiji* [The Emergence of Modern Architecture in Serbia]. PhD diss., Belgrade: Faculty of Philosophy, 1979.

Manević, Zoran. *Serbian Architecture 1900-1970* (Belgrade: Museum of Modern Art, 1972).

Manević, Zoran. *The Krstić Brothers* (Belgrade: Savez Arhitekata Srbije, 1982).

Mann, Nicholas and Luke Syson, eds. *The Image of the Individual. Portraits in the Renaissance* (London: British Museum Press, 1998).

Mansbach, S[teven] A. *Modern Art in Eastern Europe: From the Baltic to the Balkans, ca. 1890-1939* (Cambridge: Cambridge University Press, 1999).

Mansbach, Steven A. "Modernist Architecture and Nationalist Aspiration in the Baltic: Two Case Studies," *Journal of the Society of Architectural Historians* 65/1 (2006), 92-111.

Marković, Jasna. *Muzej Paje Jovanovića* (Belgrade: Muzej grada Beograda, 2009).

Marković, Peđa J. *Beograd i Evropa 1918-1941: evropski uticaji na proces modernizacije Beograda* [Belgrade and Europe 1918-1941: European Influences to the Process of Modernization of Belgrade] (Belgrade: Savremena administracija, 1992).

Marković, Predrag J. "Teorija modernizacije i njena kritička primena na međuratnu Jugoslaviju i druge istočnoevoropske zemlje," *Godišnjak za društvenu istoriju* 1/1 (1994), 11-34.

Markuš, Zoran "Zvezdani tragovi naše avangarde – Zenitove izložbe" [The Starry Reflections of Our Avant-Garde – Zenit Exhibitions], *Delo* XX/3 (Mart, 1974), 360-368.

Markuš, Zoran. "Odlazak Ljubomira Micića" [The Departure of Ljubomir Micić], *Borba,* 11. October 1980.

Markuš, Zoran. *Ljubomir Micić (1895-1971), Zenitistička konstrukcija – Rekonstrukcija-realizacija: Zoran Markuš u saradnji sa Milošem Sarićem i Kostom Ivanovićem* [Ljubomir Micić, 1895-1971: The Zenitist Construction – Reconstruction-Realization: Zoran Markuš in Collaboration with Miloš Sarić and Kosta Ivanović] (Beograd: Muzej savremene umetnosti, 1978).

Martinović, Uroš. *The Belgrade Moderna* (Belgrade: Naučna knjiga, 1971).

Matičević, Vesna *et al.*, *Uslovi zaštite nepokretnih kulturnih dobara, dobara koja uživaju prethodnu zaštitu ambijentalnih vrednosti za potrebe elaborata: Detaljni urbanistički plan blokova između ulica 29. novembra, Mitropolita Petra i Čarli Čaplina* [Terms of Protecting Immovable Cultural Goods, Goods which Enjoy the Protection of Previous Values for the Environmental Study: Detailed Regulation Plan of Blocks Between 29. novembra, Mitropolita Petra and Čarli Čaplina Streets] (Belgrade: Zavod za zaštitu spomenika kulture grada Beograda / Cultural Heritage Preservation Institute of Belgrade, 1992).

McHam, Sarah Blake. "Reflections of Pliny in Giovanni Bellini's Woman with a Mirror," *Artibus et historiae* 58 (2008), 157-171.

Medaković, Dejan. *Srbi u Beču* (Novi Sad: Prometej, 1998).

Medvedev, Mihailo. "Projekti i arhitektura Aleksandra I. Medvedeva" [The Projects and Architecture of Aleksandar I. Medvedev], *Arhitektura i urbanizam* 8 (2001), 79-84.

Medvedev, Mihailo. *Projekti i arhitektura ing. Aleksandra I. Medvedeva, ovl. Arhitekta* [The Projects and Architecture of Ing. Aleksandar I. Medvedev, Authorized Architect] (Niš: Društvo arhitekata Niša, 2012).

Merenik, Lidija. "Ja hoću da sam slikar: žene, umetnost, rod i mit" [I want to be a painter: women, art, gender and myth], *Zbornik. Muzej primenjene umetnosti* 3 (Belgrade, 2007), 43-45.

Merenik, Lidija. "Milena Pavlović-Barilli: The Portrait of a Lady." In *Milena Pavlović Barili: Ex post: kritike, članci, bibliografija*, Zorica Stablović Bulajić, ed. (Belgrade: HESPERIAedu, 2009), 7-63.

Mernissi, Fatima. *Beyond the Veil: Male-female Dynamics in Modern Muslim Society* (London: Sagi Books, 2003).

Mignolo, Walter D. "Coloniality: The Darker Side of Modernity." In *Modernologies: Contemporary Artists Researching Modernity and Modernism*, Cornelia Klinger and Bartomeu Mari, eds. (Barcelona: Museu d'Art Contemporani de Barcelona, 2009), 39-49.

Mihajlov, Saša – Biljana Mišić [Михајлов, Саша - Биљана Мишић]. "Палата Главне поште у Београду," *Наслеђе* IX (2008), 239-264.

Mikić, Peter V. "Вајарка Вука Велимировић" [Sculptress Vuka Velimirović], *Зборник Народног музеја* XIV/2 (Belgrade 1990), 113-121.

Milankov, Vladimir. *Draga Gavrilović – život i delo* (Kikinda: Književna zajednica Kikinde, 1989).

Milanović, Olga. *Живот и дело Милице Бабић* (Belgrade: Museum of Applied Art, 1973).

Milašinović-Marić, Dijana. *Arhitekta Jan Dubovi* [Architect Jan Dubový] (Belgrade: Zadužbina Andrejević, 2001).

Milić, Danica. *Istorija Niša* [History of Niš] (Niš: Gradina; Prosveta, 1984).

Miller, Mervyn. *Letchworth, The First Garden City* (Chichester: Phillimore & Co. Ltd, 2002).

Miller, Mervyn. "Garden Cities and Suburbs: At Home and Abroad," *Journal of Planning History* 1/1 (2002), 6-28.

Milojković, Jelica. *Zvezdanim tragom: Milena Pavlović-Barilli (Požarevac, 1909 - Njujork, 1945), Galerija SANU, Beograd: 17. juli - 25. avgust 2009* (Beograd: Srpska akademija nauka i umetnosti, 2009).

Milojković-Đurić, Jelena. *Tradition and Avant-garde: The Arts in Serbian Culture between the Two World Wars* (Boulder: East European Monographs; New York: Distributed by Columbia University Press, 1984).

Minić, Milan S. "Prva Beograđanka arhitekt – Jelisaveta Načić," *Godišnjak Muzeja grada Beograda* 3 (1956), 451-458.

Minić, Oliver. "Razvoj Beograda i njegova arhitektura između dva rata," *Godišnjak Muzeja grada Beograda* 1 (1954), 177-188.

Mirkov, Andjelka. "Vrtni gradovi Ebenezera Hauarda," *Sociologija* 69/4 (2007), 313-332.

Mitrović, Andrej. *Angažovano i lepo: umetnost u razdoblju svetskih ratova (1914-1945)* [Engaged and Beautiful: Arts in the Period of World Wars 1914-1945] (Belgrade: Narodna knjiga, 1983).

Mitrović, Mihajlo. "Architect Branko Krstić," *Politika,* October 21, 1978.

Mitrović, Mihajlo. "The Golden Circle of Culture," *Politika,* September 7, 1991.

Mitrović, Vladimir. *Arhitektura XX veka u Vojvodini* (Novi Sad: Muzej savremene umetnosti Vojvodine, 2010).

Morawski, Stefan. "On the Avant-Garde, Neo-Avant-Garde and the Case of Postmodernism." In *Literary Studies in Poland*, XXI, Avant-garde. (Wroclaw: Ossolineum, 1988), 81-106.

Morford, Mark P. O. and Robert J. Lenardon. *Classical Mythology* (New York: Oxford University Press, 2003).

Morris, A. E. J. "History of Urban Form – V, Origins of Garden City," *Official Architecture and Planning* 34/10 (1971), 779-781.

Morris, A. E. J. "History of Urban Form – VI, From Garden Cities to New Towns," *Official Architecture and Planning* 34/12 (1971), 922-925.

Naremore, James. *Acting in the Cinema* (Berkeley: University of California Press, 1988).

Nedić, Svetlana V. "Generalni urbanistički plan Beograda iz 1923. Godine," *Godišnjak grada Beograda* 24 (1977), 301-309.

Nedok, Aledsandar and Milisav Sekulović. "Epilog Prvog svetskog rata u brojkama," *Vojnoistorijski pregled* 65 (2008), 98-100.

Nemanjić, Miloš. "Žene Srbije kao deo stvaralačke inteligencije od početka stvaranja samostalne države do 1920. godine" [Women in Serbia as Part of Creative Intelligentsia since the Origins of Independent State until 1920]. In *Srbija u modernizacijskim procesima 19. i 20. veka, Položaj žene kao merilo modernizacije* [Serbia in the 19th and 20th Century Modernizing Processes. Women's Position as the Measure of Modernization], Scientific Symposium, Vol. 2 (Belgrade: Institute for Recent History of Serbia, 1998), 263–277.

Nestorović, Bogdan. "Evolucija Beogradskog stana" [The Evolution of a Belgrade apartment], *Godišnjak Muzeja grada Beograda* 2 (1955), 247-267.

Nestorović, Bogdan. *Arhitektura Srbije u XIX veku* (Belgrade: Art Press, 2006).

Newton, Norman T. *Design on the Land: The Development of Landscape Architecture* (Cambridge, Mass.: The Belknap Press of Harvard University Press, 1971).

Nikolić-Ristanović, Vesna. "Krivičnopravna zaštita žena u Srbiji 19. i 20. Veka." In *Srbija u modernizacijskim procesima 19. i 20. veka, knjiga 2, Položaj žene kao merilo modernizacije*, Latinka Perović, ed. (Belgrade: Institut za noviju istoriju Srbije, 1998), 26-36.

Nikolova, Maja. *Уметничке школе у Београду* (Belgrade: Educational Museum, 2007).

Nolte, Claire E. *The Sokol in the Czech Lands to 1914: Training for the Nation* (New York: Palgrave Macmillan, 2002).

Norman, Geraldine. *Biedermeier Painting, 1815-1848: reality observed in genre, portrait, and landscape* (New York: Thames and Hudson, 1987).

Norris, David A. *Belgrade. A Cultural History* (Oxford: Oxford University Press, 2008).

Norris, David. "Miloš Crnjanski: The Poetics of Exile." In *In the Wake of the Balkan Myth: Questions of Identity and Modernity* (London: Macmillan Press, 1999), 49-59.

Nožinić, Olivera. "Jelisaveta Načić, prva žena arhitekta u Srbiji," *Zbornik za likovne umetnosti Matice srpske* 19 (1983), 275-293.

Oshima, Ken Tadashi. "Denenchōfu, Building the Garden City in Japan," *Journal of the Society of Architectural Historians* 55/3 (1996), 140-151.

Overy, Paul. *Light, Air and Openness: Modern Architecture between the Wars* (New York: Thames and Hudson, 2007).

Palavestra, Predrag. "Od modernizma do avangarde" [From Modernism to the Avant-garde]. In *Srpska avangarda u periodici* [Serbian Avant-garde in Magazines], Vidosava Golubović and Staniša Tutnjević, eds. (Novi Sad: Matica srpska / Belgrade: Institut za književnost i umetnost, 1994), 11-14.

Pavlowitch, Stevan K. *A History of the Balkans, 1804-1945* (London and New York: Longman Publishing Group, 1999).

Pedrocco, Filippo. *Titian. The Complete Paintings* (London: Thames and Hudson, 2001).

Pehnt, Wolfgang. *Expressionist Architecture* (London: Thames and Hudson, 1973).

Pehnt, Wolfgang. *Expressionist Architecture in Drawings* (London: Thames and Hudson, 1985).

Peković, Slobodanka. "Romani i putopisi u stvaralačkom postupku Jelene Dimitrijević." In *Zbornik referata sa naučnog skupa: Jelena Dimitrijević – život i delo, Niš, 28. i 29. oktobar 2004*, Miroljub Stojanović, ed. (Niš: Centar za naučna istraživanja SANU i Univerzitet u Nišu: 2006), 55 – 64.

Perović, Miloš R. *Srpska arhitektura XX veka: Od istoricizma do drugog modernizma* [Serbian Architecture of the 20th century: From Historicism to the Second Modernism] (Belgrade: Arhitektonski fakultet Univerziteta u Beogradu, 2003).

Petersen, William. "The ideological origins of Britain's new towns," *Journal of American Institute of Planning* 34/3 (May, 1968), 160-170.

Petranović, Branko. *Istorija Jugoslavije* [History of Yugoslavia]. Vol. 1 (Belgrade: Nolit, 1988).

Petrov, Aleksandar. "Branko Ve Poljanski and his *Panic under the Sun*." In Branko Ve Poljanski, *Panika pod suncem, Tumbe, Crveni Petao* [Panic under the Sun, Upside Down, the Red Rooster], Aleksandar Petrov, ed. (Belgrade: National Library of Serbia, 1988), viii-ix.

Petrović, Ljiljana. "Milena and the Performing Arts: Measure of Time." In *Milena Pavlović Barili: Pro futuro: teme, simboli, značenja*, Zorica Stablović Bulajić, ed. (Belgrade: HESPERIAedu, 2010), 267-287.

Petrović, Rastko. *Sicilija i drugi putopisi: iz neobjavljenih rukopisa*. Radmila Šuljagić, ed. (Belgrade: Nolit, 1988).

Pevsner, Nikolaus. *Academies of Art, Past and Present* (New York: Da Capo Press, 1973).

Piotrowski, Piotr. "On the Spatial Turn, or Horizontal Art History," *Umeni / Art* 5 (2008), 378-383 [reprinted as shorter version "Towards Horizontal Art History." In *Crossing Cultures. Conflict, Migration, and Convergence*, ed. Jaynie Anderson (Melbourne: The Miegunyah Press, 2009), 82-85].

Piotrowski, Piotr. "Towards a Horizontal History of the European Avant-Garde." In *Europa! Europa? The Avant-Garde, Modernism and the Fate of a Continent*, eds. Sasha Bru et al. (Berlin: De Gruyter, 2009), 49-58.

Piotrowski, Piotr. *Art and Democracy in Post-Communist Europe* (London: Reaktion Books, 2012).

Popović, Bojana. *Primenjena umetnost i Beograd 1918-1941* [*Applied Arts and Belgrade 1918-1941*] (Belgrade: Museum of Applied Art, 2011).

Popović, Bojana. *Мода у Београду 1918-1941* [Fashion in Belgrade 1918-1941] (Belgrade: Museum of Applied Art, 2000).

Premerl, Tomislav. *Hrvatska moderna arhitektura između dva rata* (Zagreb: Nakladni zavod Matice hrvatske, 1990).

Prijatelj, Kruno. *Ivan Galić i njegov salon* (Split: Galerija umetnina, 1961).

Prosen, Milan and Popović, Bojana. "L'Art déco en Serbie" [Art Deco in Serbia]. In *1925 quand l'Art déco séduit le monde*, ed. Emmanuel Bréon and Philippe Rivoirard (Paris: Cité de l'architecture et du patrimoine, Norma édition, 2013), 198-207.

Protić, Miodrag B., ed. *Milena: retrospektivna izložba, 1926-1945* (Belgrade: Muzej savremene umetnosti, 1979).

Protić, Miodrag B. *Milena Pavlović-Barilli. Život i delo* (Belgrade: Prosveta, 1966).

Protić, Miodrag B. *Počeci jugoslovenskog modernog slikarstva 1900-1920* [The Beginnings of Yugoslavian Modern Painting 1900-1920] (Belgrade: Muzej savremene umetnosti, 1972).

Rewald, John, Irene Gordon, and Frances Weitzenhoffer. *Studies in Impressionism* (New York: Harry N. Abrams, 1985).

Rifkind, David, ed. *Architecture's Many Modernisms* (London: Routledge, forthcoming).

Risselada, Max and Beatriz Colomina, eds. *Raumplan Versus Plan Libre: Adolf Loos, Le Corbusier* (Rotterdam: 010 Publishers, 2008).

Ristić, Vera. *Uroš Predić* (Kragujevac: Narodni muzej, 1976).

Ristović, Milan. *Nemački "novi poredak" i jugoistočna Evropa: 1940/41 – 1944/45: planovi o budućnosti i praksa* [The German "New Order" and the Southeastern Europe] (Belgrade: Vojnoizdavački i novinski centar, 1991).

Roter-Blagojević, Mirjana. *Stambena arhitektura Beograda u 19. i početkom 20. veka* [Residential architecture of Belgrade in the 19th and 20th century] (Belgrade: Arhitektonski fakultet Univerziteta u Beogradu, Orion art, 2006).

Rozić, Vladimir. *Likovna kritika u Beogradu izmedju dva svetska rata 1918-1941* [Art Criticism in Belgrade between Two World Wars 1918-1941] (Belgrade: Jugoslavia, 1983).

Rozić, Vladimir. *Umetnička grupa 'Oblik'* (Belgrade: Kancelarija za pridruživanje Srbije i Crne Gore Evropskoj uniji, 2005).

Ruddick, Sara. *Maternal Thinking: Toward a Politics of Peace* (Boston: Beacon Press, 1989).

Rüedi, Katerina. *Bauhaus Dream-house: Modernity and Globalization (Architext Series)* (Oxon: Routledge, 2010).

Ružić, Jovan. *Sećanja i uspomene* [Memories] (Belgrade: SOFK, 1973).

Sabatino, Michelangelo. *Pride in Modesty, Modernist Architecture and the Vernacular Tradition in Italy* (Toronto: University of Toronto Press, 2010).

Sabolči, Mikloš. *Avangarda & Neoavangarda. Jel es kiáltás: Az avantgarde és neoavantgarde kérdéseihez* (Belgrade: Narodna knjiga, 1997).

Šarenac, Darko. *Митови, символи – скулптура на београдским фасадама* (Belgrade: Eksportpres, 1991).

Schorske, Carl. *Thinking with History. Explorations in the Passage to Modernism* (Princeton: Princeton University Press, 1998).

Schubert, Dirk. "Theodor Fritsch and the German (*völkische*) version of the Garden City: the Garden City invented two years before Ebenezer Howard," *Planning Perspectives* 19 (2004), 3-35.

Schwartz, Frederic. *The Werkbund: Design Theory and Mass Culture before the First World War* (New Haven: Yale University Press, 1996).

Sekulić, Isidora. *Pisma iz Norveške i drugi putopisi* (Novi Sad: Stylos, 2001).

Sharp, Dennis. *Modern Architecture and Expressionism* (New York: G Braziller, 1966).

Sijić, Milorad. *Fudbal u Kraljevini Jugoslaviji* [Soccer in the Kingdom of Yugoslavia] (Belgrade: Milirex, 2009).

Sikimić, Đurđica. *Фасадна скулптура у Београду* (Belgrade: Zavod za Zaštitu Spomenika Kulture Grada Beograda, 1965).

Šimčić, Darko. "From Zenit to Mental Space: Avant-garde, Neo-avant-garde, and Post-avant-garde Magazines and Books in Yugoslavia, 1921-1987." In *Impossible Histories: Historical Avant-gardes, Neo-avant-gardes, and Post-avant-gardes in Yugoslavia, 1918-1991,* Dubravka Đurić and Miško Šuvaković, eds. (Cambridge: The MIT Press, 2003), 294-310.

Škalamera, Željko. "Obnova srpskog stila u arhitekturi" [The renewal of the Serbian style in architecture], *Zbornik za likovne umetnosti Matice srpske* 5 (1969), 228-231.

Skerlić, Jovan. *Istorija nove srpske književnosti* (Beograd: Rad, 1953).

Slapšak, Svetlana. "Harem kao prostor roda u balkanskim kulturama." In *Kultura, drugi, žene*, Jasna Kodrnja, Svenka Savić and Svetlana Slapšak, eds. (Zagreb: Institut za društvena istraživanja u Zagrebu, Hrvatsko filozofsko društvo, Plejada: 2010), 39-57.

Smalls, James. *The Homoerotic Photography of Carl Van Vechten: Public Face, Private Thoughts* (Philadelphia, Pa.: Temple University Press, 2006).

Smiljanić, Đorđe. *Fudbalska prvenstva Jugoslavije: 1923 – 1999* [Yugoslav Soccer Championships 1923 – 1999] (Belgrade: Fudbalski savez Jugoslavije, 1999).

Šoškić, Čedomir, ed. *Olimpijski vekovnik 1910 – 2010,* vol. 2 [Olympic Century Yearbook] (Belgrade: Službeni glasnik, 2010).

Srbija u modernizacijskim procesima 19. i 20. veka. Položaj žene kao merilo modernizacije [Serbia in the 19th and 20th century's Modernizing Processes. Women's Position as the Measure of Modernization] Scientific Symposium, Vol. 2 (Belgrade: Institute for Recent History of Serbia, 1998).

Stablović Bulajić, Zorica, ed. *Milena Pavlović Barili: Ex post: kritike, članci, bibliografija* (Belgrade: HESPERIAedu, 2009).

Stablović Bulajić, Zorica, ed. *Milena Pavlović Barili: Pro futuro: teme, simboli, značenja* (Belgrade: HESPERIAedu, 2010).

Stamm, Rainer and Daniel Schreiber, eds. *Bau einer neuen Welt: architektonische Visionen des Expressionismus* (Köln: König, 2003).

Stančić, Donka – Miško Lazović [Станчић, Донка – Мишко Лазовић]. *Бановина* (Нови Сад: Прометеј, 1999).

Stanković, Stevan. M. *Niška Banja* (Belgrade: Turistička štampa; Niš: Turistički savez opštine, 1981).

Steinberg, Leo. *The Sexuality of Christ in Renaissance Art and in Modern Oblivion* (Chicago: University of Chicago Press, 1996).

Steiner, George. "Our Homeland, the Text," *Salmagundi* 66 (1985), 5.

Sternberg, Josef von. *The Scarlet Empress* [videorecording] (a Paramount Picture. Criterion Collection, 2001).

Stoichita, Victor. *The Pygmalion Effect: From Ovid to Hitchcock*. Alison Anderson trans. (Chicago: The University of Chicago Press, 2008).

Stojančević, Vladimir. *Srbija i srpski narod za vreme rata i okupacije 1914-1918. godine* (Leskovac: Narodni muzej u Leskovcu, 1988).

Stojanović, Dubravka. *Kaldrma i asfalt: urbanizacija i evropeizacija Beograda 1890-1914* [Cobble and Asphalt: Urbanization and Europeanization of Belgrade 1890-1914] (Belgrade: Udruženje za društvenu istoriju, 2009).

Stojanović, Miroljub, ed. *Zbornik referata sa naučnog skupa: Jelena Dimitrijević – život i delo, Niš, 28. i 29. oktobar 2004* (Niš: Centar za naučna istraživanja SANU i Univerzitet u Nišu: 2006).

Styan, John Louis. *Modern Drama in Theory and Practice* (Cambridge; New York: Cambridge University Press, 1981).

Subotić, Irina. *Likovni krug revije "Zenit", 1921-1926* [The Visual Arts Circle of the "Zenit" Journal, 1921-1926] (Ljubljana: Znanstveni institut Filozofske fakultete, 1995).

Subotić, Irina. *Od avangarde do Arkadije* (Belgrade: Clio, 2000).

Subotić, Irina. *Zenit i avangarda 20ih godina* [Zenit and the Avant-Garde of the Twenties] (Belgrade: Narodni muzej, 1983).

Susan, Stewart. *On Longing: Narratives of the Miniature, the Gigantic, the Souvenir, the Collection* (Baltimore: Johns Hopkins University Press, 1984).

Susovski, Marijan. *Josip Seissel* (Zagreb: Muzej suvremene umjetnosti, 1997).

Šuvaković, Miško, ed. *Istorija Umetnosti u Srbiji XX vek* [History of Art in Serbia, 20th century]. vol. 1 (Belgrade: Orion, 2010).

Thaler, Wolfgang, Maroje Mrduljaš, and Vladimir Kulić. *Modernism In-between: The Mediatory Architectures of Socialist Yugoslavia* (Berlin: Jovis Verlag GmbH, 2012).

Todorović, Srbislav. *Fudbal u Srbiji 1896 – 1918* [Soccer in Serbia 1896 – 1918] (Belgrade: SOFK Zvezdara, 1996).

Tomić, Svetlana, ed. *Valorizacija razlika. Zbornik radova sa naučnog skupa o Dragi Gavrilović (1854-1917)* (Belgrade: Altera-Multincionalni fond kulture, 2013).

Tomić, Svetlana. "Draga Gavrilović (1854-1917), the First Serbian Female Novelist: Old and New Interpretations," *Serbian Studies* 22 (2008, publication date 2011), 167-189.

Tomić, Svetlana. "Dve vrste Pisama iz Soluna: feminističko istraživačko novinarstvo Jelene J. Dimitrijević naspram nepouzdanog izveštavanja Branislava Nušića o feminizmu," *Zbornik Matice srpske za književnost i jezik* 59/3 (2011), 621-639.

Tomić, Svetlana. "Muške akademske norme i putopisna književnost Jelene J. Dimitrijević." In *Kultura, rod, građanski status*, Gordana Duhaček and Katarina Lončarević, eds. (Belgrade: Fakultet političkih nauka, Centar za studije roda i politike, 2012), 156-175.

Tomić, Svetlana. "Prvo novije temeljno čitanje putopisa Jelene J. Dimitrijević," *Polja* 476 (July-August 2012), 234-237.

Toševa, Snežana [Тошева, Снежана]. *Архитекта Бранислав Којић* (Београд: Грађевинска књига, 1998).

Toševa, Snežana. "Arhitekt Milica Krstić (1887-1964)," *Godišnjak grada Beograda* XLIV (1997), 95-114.

Toševa, Snežana. "Danica Kojić (1899-1975)," *Godišnjak grada Beograda* XLIII (1996), 109-120.

Toševa, Snežana. "Prilog proučavanju rada Branislava Kojića u jugoistočnoj Srbiji" [A Contribution to the Study of Branislav Kojić's Oeuvre in Southeast Serbia], *Leskovački zbornik* 37 (1997), 75-82.

Toševa, Snežana. *Srbija i Britanija, kulturni dodiri pocetkom XX veka* [Serbia and Great Britain, Cultural Contacts at the Beginning of the XX Century] (Belgrade: Muzej tehnike i nauke, 2007).

Tournikiotis, Panayotis. *Adolf Loos* (New York: Princeton Architectural Press, 1994).

Trgovčević, Ljubinka. "Žene kao deo elite u Srbiji u 19. veku. Otvaranje pitanja." In *Srbija u modernizacijskim procesima 19. i 20. veka – položaj žene kao merilo modernizacije* 2, Latinka Perović, ed. (Belgrade: Institut za novu Istoriju Srbije, 1998), 251-268.

311

Trgovčević, Ljubinka. *Planirana Elita: O studentima iz Srbije na Evropskim univerzitetima u 19. veku* (Belgrade: Istorijski Institut, Službeni glasnik, 2003).

Trifunović, Veroljub S. *Urbanizam Kragujevca, 20. vek,* Knjiga prva: period od 1878. do 1974. godine (Kragujevac: Direkcija za urbanizam i izgradnju Kragujevac, 2004).

Tsernianski, Milos. *Migrations* (New York: Harcourt, 1994).

Туцић, Хајна [Туцић, Хајна]. "Дело архитекте Војина Симеоновића између два светска рата," *Наслеђе* IX (2008), 155-178.

Tzonis, Alexandar and Alcestis P. Rodi. *Greece: Modern Architectures in History* (London: Reaktion Books, 2013).

Tzonis, Alexander and Liane Lefaivre. "The Grid and the Pathway. An Introduction to the Work of Dimitris and Susana Antonakakis, With a Prolegomena to the History of the Culture of Modern Greek Architecture," *Architecture in Greece* 15 (1981), 164-178.

Udovički, Jasminka and James Ridgeway, eds. *Burn this House: The Making and Unmaking of Yugoslavia* (Durham: Duke University Press, 1997).

Vasić, Jovica. *Niška Banja* (Niš: Atlantis, 2007).

Vasić, Pavle. *Примењена уметност у Србији1900-1978. Пролегомена за историју примењених уметности код нас* [Applied Arts in Serbia 1900-1978. Prolegomena for the History of Applied Arts] (Belgrade: БИГЗ, Удружење ликовних уметника примењених уметности и дизајнера Србије [*Association of Applied Arts Artists and Designers of Serbia*], 1981).

Vidler, Anthony. *Histories of the Immediate Present: Inventing Architectural Modernism* (Cambridge, MA: The MIT Press, 2008).

Viktorija Kamilić, *Arhitekta Svetozar Jovanović* [Architect Svetozar Jovanović] (Belgrade: Zadužbina Andrejević, 2011).

Vlahović, Gordana. "Aktuelnost putopisa Jelene Dimitrijević o zemlji faraona," *Bdenje*, časopis za književnost, umetnost i baštinu (Kuturni centar Svrljig i književni klub "Branko Miljković" iz Knjaževca) 8-9 (2005), 110-114.

Vogt, Adolf. *Le Corbusier, the Noble Savage: Toward an Archaeology of Modernism* (Cambridge: MIT Press, 1998).

Volait, Mercedes. "Making Cairo Modern (1870-1950), Multiple Models for a 'European-Style' Urbanism." In *Urbanism: Imported or Exported,* Joe Nasr and Mercedes Volait, eds. (Chichester, West Sussex: Wiley-Academy, 2003), 17-50.

Vučetić-Mladenović, Radina [Вучетић Младеновић, Радина]. *Европа на Калемегдану* (Belgrade: INIS, 2003).

Vujović, Branko [Вујовић, Бранко]. *Београд у прошлости и садашњости* (Београд: Драганић, 1994).

Vujović, Branko. *Факултет примењених уметности у Београду 1948-1998* [Faculty of Applied Arts in Belgrade 1948-1998] (Belgrade: Faculty of Applied Arts, 1998).

Vukadinović, Zora. *Родино позориште* (Belgrade: Museum of Theatrical Art, 1996).

Vukotić, Biljana. "Иван Табаковић. Вечито кретање – магија модерне керамике" [Ivan Tabaković. Perpetual motion – the magic of modern ceramics]. In *Ivan Tabaković,* Lidija Merenik, ed. (Novi Sad: Serbian Heritage Gallery, 2004), 65.

Vuković, Radovan and Petar Prelog. *Proljetnji salon* (Zagreb: Umjetnički paviljon, 2007).

Vuksanović-Macura, Zlata. "Plan Emila Holea i Ota Šentala za Kotež Neimar," *Naslede* 13 (2012), 79-91.

Vuksanović-Macura, Zlata. "Socijalni stanovi Beograda u prvoj polovini 20. veka," *Naslede* 12 (2011), 65-89.

Vuksanović-Macura, Zlata. *Život na ivici: stanovanje sirotinje u Beogradu 1919-1941* (Belgrade: Orion art, 2012).

Vuletić, Ljiljana, ed. "Etika feminizma" [Ethics of Feminism], *Ogledi* 11/112 (Belgrade: Helsinki Committee for Human Right in Serbia, 2008).

Ward, Barbara. "Pierre Edouard Frere." In *La Vie Moderne*, Lilien F. Robinson, ed. (Washington D.C.: Corcoran Gallery of Art, 1983), 46-48.

Werner, Elke Anna. "The Veil of Venus: A Metaphor of Seeing in Luca Cranach the Elder." In *Cranach*, Bodo Brinkman, ed. (London: Royal Academy of Arts; New York: Distributed in the United States and Canada by Harry N. Abrams, 2007), 99-109.

Whyte, I. Boyd. "The End of an Avant-Garde: The Example of 'Expressionist' Architecture," *Art History* 3/1 (1980), 102-114.

Whyte, I. Boyd. "The Politics of Expressionist Architecture," *Architectural Association Quarterly* 12/3 (1980), 11-17.

Wilder, Billy, Charles Brackett and D.M. Marshman, Jr. *Sunset Boulevard* (Berkeley, Los Angeles, London: University of California Press, 1999).

Wilder, Billy. *Sunset Boulevard* (videorecording) (Hollywood, Calif.: Paramount Pictures, 2002).

Williams, Richard J. *Brazil: Modern Architectures in History* (London: Reaktion Books, 2009).

Wimmer-Wisgrill. *Yearning for Beauty. The Wiener Werkstätte and Stoclet House* (Vienna: MAK, 2006).

Wood, Christopher S. *Albrecht Altdorfer and the Origins of Landscape* (Chicago: University of Chicago Press, 1993).

Woodward, Susan. "The Rights of Women: Ideology, Policy and Social Change in Yugoslavia." In *Women, State and Party in Eastern Europe,* Sharon L. Wolchik and Alfred G. Meyer, eds. (Durham, NC: Duke University Press, 1985), 234-256.

Wright, Gwendolyn. "Building Global Modernisms," *Grey Room* 7-9/11 (Spring, 2002), 124-134.

Zarecor, Kimberly. *Manufacturing a Socialist Modernity: Housing in Czechoslovakia, 1945-1960* (Pittsburgh: University of Pittsburgh Press, 2011).

Zec, Dejan. "Oaza normalnosti ili tužna slika stvarnosti? Fudbal u okupiranoj Srbiji (1941-1944)," *Godišnjak za društvenu istoriju* 3 (2011), 49-70.

Zec, Dejan. "Proposed Olympic Complex in Belgrade – Project by Hitler's Architect Werner March," *International Conference Architecture & Ideology CD Proceedings* (2012), 958 – 966.

Zec, Dejan. "The Origin of Soccer in Serbia," *Serbian Studies* 24 (2010), 137-159.

Živanović, Dušica [Живановић, Душица]. "Прилог проучавању историје и архитектуре зграде Контролног одељења Министарства пошта, телеграфа и телефона у Београду," *Наслеђе* III (2001), 105-113.

Živković, Stanislav. *Уметничка школа у Београду 1919–1939* (Belgrade: Serbian Academy of Sciences and Arts, 1987).

Zupančić, Dogo. "Plečnikovi studenti pri Le Corbusieru" [Plečnik's Students in Le Corbusier's Atelier], *ab* 185-7 (2010), 22-27.

Žutić, Nikola. *Sokoli: ideologija u fizičkoj kulturi Kraljevine Jugoslavije: 1929-1941* [Sokols: the Ideology within Physical Education in Kingdom of Yugoslavia 1929-1941] (Belgrade: Angrotrade, 1991).

Internet sources

Elkins, James. Chapter 1, "Principal Unresolved Issues" Section 5 On the Terms "Central," "Peripheral," and "Marginal." Draft, October 4, 2013. In *North Atlantic Art History and Worldwide Art* https://docs.google.com/document/d/1uqzIEZXcko3f7AbeVr51Boevbl-_s-7cI_1p72P5-RI/pub https://www.facebook.com/james.elkins1/posts/10201208220819950?comment_id=69331999

Oxford Art Online. "Modernism." accessed July 21, 2011. http://www.oxfordartonline.com.jproxy.lib.ecu.edu/subscriber/article/grove/art/T058785

Živančević, Nina. "Miloš Crnjanski and His Descendents," Electronic Book Review, 01/01/1999, accessed August 6, 2011. URL: http://www.electronicbookreview.com/thread/internetnation/sumatrism

List of Contributors

Jelena Bogdanović (Ph.D. Princeton University), an architect and architectural historian, is an assistant professor at Iowa State University. She specializes in architecture in the Balkans and the Mediterranean.
jelenab@iastate.edu

Dragana Ćorović (M.Sc. Arch. University of Belgrade), an architect and architectural historian, works at the Faculty of Architecture, University of Belgrade. She specializes in the urban development of Belgrade in the 19th and 20th centuries, the Garden City concept and its implementation, and history and theory of garden art.
dcorovic@arh.bg.ac.rs

Marina Djurdjević (M.A. University of Belgrade) is the director of the Architecture Department at the Museum of Science and Technology in Belgrade. She is expert on architects Petar and Branko Krstić, modern and Russian émigré architecture in Serbia.
Marinadjurdjevic@yahoo.com

Jasna Jovanov (Ph.D. University of Novi Sad), an art historian, specializes in art at the threshold of the 19th and 20th centuries with an emphasis on transitional and critical phases in art and art practices. She is the director of the Pavle Beljanski Memorial Collection in Novi Sad and teaches at the Academy of Classical Painting, University EDUCONS, Novi Sad.
uprava@pavle-beljanski.museum

Aleksandar Kadijević (Ph.D. University of Belgrade), professor and chair of art history department at University of Belgrade, is an internationally renowned scholar of early modern Serbian, Russian émigré, and European architecture.
akadijev@f.bg.ac.rs

Viktorija Kamilić (M.A. University of Belgrade) is an architectural historian and curator from Belgrade. Her research focuses on history of Serbian architecture.
viktorijaaa@gmail.com

Igor Marjanović (M.Arch. University of Illinois, Chicago) is an associate professor of architecture at Washington University in St. Louis. His research examines architectural discourses of the twentieth century, in particular on the role of image, text and global displacement in the formulation of architectural ideas.
marjanovic@samfox.wustl.edu

Ljubomir Milanović (Ph.D. Rutgers University) specializes in Late Antique, Early Christian and Medieval art with a focus on Byzantine and post-Byzantine production. He works at the Byzantine Institute at the Serbian Academy of Sciences and Arts.
milanovic.ljubomir@gmail.com

Anna Novakov (Ph.D. New York University) is professor of art history at Saint Mary's College of California. Her research is currently dedicated to the history of the East European avant-garde (from 1920-1940) and its impact on women architects in Serbia.
anovakov@stmarys-ca.edu

Miloš R. Perović (Ph.D. University of Belgrade), an architect, urban planner, and author of internationally recognized projects, was a professor of architectural history at the Faculty of Architecture, University of Belgrade. Currently, he coordinates research on historical avant-garde and development of architectural modernism in the Balkans through the Vuros-Eutaksias foundation.

Bojana Popović (M.A. University of Belgrade) is a curator at the contemporary applied art department of the Museum of Applied Art in Belgrade. Her field of interest is applied art between two World Wars.
bojana.popovic@mpu.rs

Lilien F. Robinson (Ph.D. Johns Hopkins University) is professor of art history at the George Washington University. She is a specialist in nineteenth-century European art with a primary focus on Serbian secular painting.
lfr@email.gwu.edu

Nebojša Stanković (M.A. Princeton University), an architect and architectural historian, is a doctoral candidate at Princeton University. His main interests are Byzantine and medieval art and architecture as well as the romantic and idealistic in modern architecture.
neb.stan@gmail.com

Tadija Stefanović (M.A. University of Belgrade) is a doctoral candidate in architectural history at University of Belgrade. He specializes in architecture of war memorials, modern and Russian émigré architecture in Serbia.
t.stefanovic@yahoo.com

Svetlana Tomić (Ph.D. University of Novi Sad) is an assistant professor at Alfa University in Belgrade. Her fields of research are feminism and gynocriticism of Serbian fiction in the 19th and 20th centuries, and contemporary women's writing in Serbia, Croatia, and Bosnia and Herzegovina. tomic.svetlana@gmail.com

Dejan Zec (M.A. University of Belgrade) is an historian and a researcher at the Institute for Recent History of Serbia. He specializes in social history of Serbia and Yugoslavia, history of the Second World War and the occupation in Yugoslavia, and the history of sports and popular culture in 20th century Yugoslavia.
dejanzec@gmail.com

Illustration Credits

Map 1. Serbia within the Kingdom of Yugoslavia (formerly the Kingdom of Serbs, Croats and Slovenes) with nine administrative units (*banovine*), 1929 (in bold the borders of 1939) (Drawing: Jelena Bogdanović)

Fig. 1.1. Uroš Predić, *Pouting Girl*, 1879. Oil. 31x39.5 cm. (© Matica Srpska Gallery, Novi Sad)

Fig. 1.2. Uroš Predić, *Busy Hands*, 1887. Oil. 15.5x21.1cm. (© National Museum, Belgrade)

Fig. 1.3. Uroš Predić, *The Happy Brothers*, 1887. Oil.122x82cm. (© National Museum, Belgrade)

Fig. 1.4. Uroš Predić, *Flight of the Bosnian Refugees*, 1889. Oil.148.5x114.5cm. (© National Museum, Belgrade)

Fig. 1.5. Uroš Predić, *The Maiden from Kosovo*, 1919. Oil. 115x88cm. (© Museum of the City of Belgrade)

Fig. 1.6. Uroš Predić, *Saint Lazar*, 1893. Oil. Choir Section. (Orthodox Church, Bečej)

Fig. 1.7. Uroš Predić, *Autumnal View from the Artist's Balcony*, 1917. Oil. 50x70cm. (Faculty of the Fine Arts, University of Belgrade)

Fig. 1.8. Uroš Predić, *Panorama of Belgrade from the Artist's Balcony*, 1916. Oil. 390x48cm. (© Museum of the City of Belgrade)

Fig. 1.9. Paja Jovanović, *Wounded Montenegrin*, 1882. Oil. 114x186cm. (© Matica Srpska Gallery, Novi Sad)

Fig. 1.10. Paja Jovanović, *Preparation of the Bride,* 1888. Oil. 1.360x965cm. (© National Museum, Belgrade)

Fig. 1.11. Paja Jovanović, *Rooster Fight*, 1897. Oil. 55x76cm. (© National Museum, Belgrade)

Fig. 1.12. Jean-Léon Gérôme, *Cock Fight*, 1846. Oil. 143x204cm. (© Musée d'Orsay, Paris)

Fig. 1.13. Paja Jovanović, *Coronation of Tsar Dušan*, 1900. Oil. 390x589cm. (© National Museum, Belgrade)

Fig. 1.14. Paja Jovanović, *Migration of the Serbs*, 1896. Oil. 126x190cm. (© National Museum, Pančevo)

Fig. 1.15. Paja Jovanović, *Uprising at Takovo*, 1898. Oil. 125.5x190cm. (© National Museum, Belgrade)

Fig. 1.16. Paja Jovanović, *Vršac Triptych* (*Sowing and Harvesting and Market*), 1895. Oil. 200x200cm (center panel); 200x100cm (side panels). (© City Museum, Vršac)

Fig. 2.1. Ljubomir Micić and Boško Tokin, Zagreb, May 24, 1921. (Unknown photographer. Published in Vidosava Golubović and Irina Subotić, *Zenit 1921-1926*, Belgrade: National Library of Serbia, Institute for Literature and the Arts, and Zagreb: Serbian Cultural Society *Prosvjeta*, 2008, pp. 82-83)

Fig. 2.2. Ljubomir Micić, editor, *Zenit* no. 11, February 1922. (Library of the Museum of Contemporary Art, Belgrade)

Fig. 2.3. Ljubomir Micić, Velika zenitisticka večernja [Big Zenitist Evening], Zagreb, January 31, 1923, poster. (National Museum, Belgrade)

Fig. 2.4. Ljubomir Micić, editor, *Zenit* no. 40, April 1926. (National and University Library, Ljubljana)

Fig. 2.5. Branko Ve Poljanski, *Tumbe* [Upside Down], Belgrade, 1926, front and back covers.

Fig. 2.6. Branko Ve Poljanski, *Crveni Petao – Le Coq Rouge* [The Red Rooster], Paris/Belgrade: 1927, front and back covers.

Fig. 2.7. Branko Ve Poljanski, *Panika pod Suncem – Panique sous le Soleil* [Panic under the Sun], Belgrade, 1924.

Fig. 2.8. Branko Ve Poljanski, *Tumbe* [Upside Down], Belgrade, 1926.

Fig. 2.9. Branko Ve Poljanski, *Crveni Petao – Le Coq Rouge* [The Red Rooster], Paris/Belgrade, 1927.

Fig. 2.10. Ljubomir Micić in Cannes, France, 1934. (Unknown photographer. Published in Vidosava Golubović and Irina Subotić, *Zenit 1921-1926*, Belgrade: National Library of Serbia, Institute for Literature and the Arts, and Zagreb: Serbian Cultural Society *Prosvjeta*, 2008, p. 265)

Fig. 3.1. Cover pages of the first and last issue of *Zenit*: *Zenit*, vol. 1, no. 1, February 1921, published in Zagreb, and *Zenit* vol. 6, no. 43, December 1926, published in Belgrade. (M. R. Perović, *Srpska arhitektura XX veka: Od istoricisma do drugog modernizma* [*Serbian Architecture of the 20th century: From Historicism to the Second Modernism*]. Belgrade: Arhitektonski fakultet Univerziteta u Beogradu, 2003, p. 59)

Fig. 3.2. Jo Klek, Villa Zenit, 1924-25, pencil, india ink and watercolor on paper, 39.3 x 29.4 cm. (National Museum, Belgrade. Also published in *Zenit*, vol. 5, no. 36, October 1925. M. R. Perović, *Srpska arhitektura XX veka: Od istoricisma do drugog modernizma* [*Serbian Architecture of the 20th century: From Historicism to the Second Modernism*]. Belgrade: Arhitektonski fakultet Univerziteta u Beogradu, 2003, p. 71)

Fig. 4.1. Sreten Stojanović: Cover of the catalogue for the seventh exhibition of 'Oblik'.

Fig. 4.2. Photograph of the opening of 'Oblik' exhibition in Sofia.

Fig. 4.3. Marino Tartaglia, *Young Diplomat*, 1923. (© The Pavle Beljanski Memorial Collection, Novi Sad)

Fig. 4.4. Invitation to the opening of 'Oblik' exhibition in Prague.

Fig. 4.5. Photograph of the exhibitors and organizers of the 'Oblik' exhibition in Prague, second row from left to right: Lazar Ličenoski, Svetislav Strala, Pjer Križanić, Nikola Martinoski, Milan Konjović. First row from left to right: Professor Emanuel Purghart, Petar Palavičini, Chairman of the Art Association 'Mánes' Josef Gočár, Zonić (?), Councilor Haloupka.

Fig. 4.6. Opening of the 'Oblik' exhibition in Prague, September 7, 1934.

Fig. 4.7. A page from *The Central European Observer* of September 21, 1934, with the exhibits from the 'Oblik' exhibition in Prague.

Fig. 4.8. Ignjat Job, *Lumbarda*, 1933. (© The Pavle Beljanski Memorial Collection, Novi Sad)

Fig. 4.9. Jovan Bijelić, *Painter*, 1932. (© The Pavle Beljanski Memorial Collection, Novi Sad)

Fig. 4.10. Risto Stijović, *Caryatid*, 1931. (© The Pavle Beljanski Memorial Collection, Novi Sad)

Fig. 5.1. Jelena J. Dimitrijević, Cairo, 1926 (archival photograph taken from Jelena J. Dimitrijević *Sedam mora i tri okeana: Putem oko sveta*, Beograd: Državna štamparija Kraljevine Jugoslavije, 1940)

Fig. 5.2. "The Writer through the Egyptian Desert" (archival photograph taken from Jelena J. Dimitrijević *Sedam mora i tri okeana: Putem oko sveta*, Beograd: Državna štamparija Kraljevine Jugoslavije, 1940, p.121)

Fig. 5.3. "Her Excellency Hoda Hanem Charaoui, Cairo" with the personal dedication in French to "Madame J. Dimitrijevitch" and autograph (archival photograph taken from Jelena J. Dimitrijević *Sedam mora i tri okeana: Putem oko sveta*, Beograd: Državna štamparija Kraljevine Jugoslavije, 1940, p.205)

Fig. 6.1. Milena Pavlović-Barilli, *Dancer with the Veil and the Glove (Pink Pants II)*, oil on canvas, 1939, unknown owner.

Fig. 6.2. Milena Pavlović-Barilli, *Pomona (Landscape with a lamp)*, oil on canvas, 1939, private collection.

Fig. 6.3. Luca Cranach the Elder, *Venus*, oil and tempera on red beechwood, 1532, (Städelsches Kunstinstitut, Frankfurt-am-Main, Germany / The Bridgeman Art Library)

Fig. 6.4. Milena Pavlović-Barilli, *Venus with the Lamp*, oil on canvas, 1938 (The Museum of Contemporary Art, Belgrade, #46)

Fig. 6.5. Milena Pavlović-Barilli, *Girl with a lamp*, oil on canvas, 1935 (The Museum of Contemporary Art, Belgrade, #1519)

Fig. 6.6. Carl van Vechten, photograph of Milena Pavlović-Barilli, 1940, New York (By permission of Van Vechten Trust)

Fig. 6.7. Edward Steichen, Gloria Swanson, New York, 1924, toned silver gelatin print (The Israel Museum, Jerusalem, Israel / The Noel and Harriette Levine Collection / The Bridgeman Art Library)

Fig. 6.8. Milena Pavlović-Barilli, *Mould of Beauty*, illustration, *Vogue* April 15, 1941.

Fig. 7.1. Vukosava Vuka Velimirović, facade sculpture *Industry*, Belgrade, Vračar Holding Bank (at present Turkish Embassy, Krunska Street 1), c. 1924. (Photo: courtesy of Cultural Heritage Preservation Institute of Belgrade)

Fig. 7.2. Margita Gita Predić, book holder, Belgrade, 1920s. (Property of Mr. Ivan Predić)

Fig. 7.3. Margita Gita Predić, bowl, Belgrade, 1920s. (Property of Mr. Ivan Predić)

Fig. 7.4. Margita Gita Predić, cabinet, Belgrade, c. 1929. (Property of Mr. Ivan Predić)

Fig. 7.5. Margita Gita Predić, cabinet for a library, Belgrade, 1930. (Property of Mr. Ivan Predić)

Fig. 7.6. Danica Kojić, interior of the Art Pavilion *Cvijeta Zuzorić*, Belgrade, 1928. (Photograph from the epoch: courtesy of the Museum of Science and Technology)

Fig. 7.7. Danica Kojić, interior of the home of Danica and Branislav Kojić (Zadarska Street 6), Belgrade, 1927-1928. (Photograph from the epoch: courtesy of the Museum of Science and Technology)

Fig. 7.8. Danica Kojić, interior of the villa of engineer Mihajlo Kojić (Žanka Stokić Street 36), Belgrade, 1933-1934. (Photograph from the epoch: courtesy of the Museum of Science and Technology)

Fig. 7.9. Milica Babić, sketch for a costume in the opera *Thaïs* by Jules Massenet, *Pozorište* [Theater] No. 1, Belgrade 1931/1932, p. 6

Fig. 7.10. Beta Vukanović, "Lady Editor-In-Chief" *Žena i svet* [*Woman and World*], January, Belgrade 1929, p. 2

Fig. 8.1. Jelisaveta Načić, Osnovna škola Kralj Petar I, Kralja Petra I Street, No. 7, 1906. Detail of the front entrance. (Photo: Nataša Cvetković)

Fig. 8.2. Jelisaveta Načić, Osnovna škola Kralj Petar I, Kralja Petra I Street, No. 7, 1906. (Photo: Nataša Cvetković)

Fig. 8.3. Milica Krstić, Second High School for Girls, Kraljice Natalije Street, No. 31, 1932. (Collection: Aleksandar Kadijević)

Fig. 8.4. Milica Krstić, Second High School for Girls, Kraljice Natalije Street, No. 31, 1932. Detail. (Photo: Nataša Cvetković)

Fig. 8.5. Milica Krstić, First High School for Boys, Cara Dušana Street, No. 65, 1938. (Photo: Nataša Cvetković)

Fig. 9.1. Momir Korunović, The Memorial (Spomen-obeležje), 1921. Drawing. (Collection: Aleksandar Kadijević)

Fig. 9.2. Momir Korunović, Tower of Saint John Vladimir (Pirg Svetog Jovana Vladimira), The monastery of St. Naum on Lake Ohrid, designed in built in 1929. Demolished after the Second World War. (Collection: Aleksandar Kadijević)

Fig. 9.3. Momir Korunović, The Palace of the Ministry of Post and Telegraph (Palata Ministarstva pošta i telegrafa), Belgrade, 1926-1930. (Collection: Aleksandar Kadijević and Tadija Stefanović)

Fig. 9.4. Momir Korunović, The Post Office No. 2 (Pošta 2), Belgrade, 1927-1929. Collapsed in the bombing of 1941-1944, and after the war inadequately rebuilt by Pavle Krat. (Collection: Aleksandar Kadijević)

Fig. 9.5. Momir Korunović, The Memorial Chapel (Spomen-kapela), Zebrnjak, near Kumanovo, today F.Y.R. of Macedonia, 1934-1937. Destroyed in 1941. (Collection: Aleksandar Kadijević and Tadija Stefanović)

Fig. 9.6. Milan Zloković and Andrey Vasilevich Papkov, The Church of St. Sava, Belgrade, 1926. Competition design – unrealized. (Collection: Aleksandar Kadijević and Tadija Stefanović)

Fig. 9.7. Milan Zloković, The Ossuary (Kosturnica), Zejtinlik, Thessaloniki, Greece, 1926. Competition design – unrealized. (Collection: Aleksandar Kadijević and Tadija Stefanović)

Fig. 9.8. Aleksandar Deroko and Peter Anagnosti, Student Dormitories of the Theological Seminary (Internat studenata Bogoslovskog fakulteta), Belgrade, 1939-1940. (Collection: Aleksandar Kadijević and Tadija Stefanović)

Fig. 9.9. Alexander Popp and Stevan Tobolar, The First Steamers Company of the Danube (Prvo dunavsko parobrodsko društvo), Belgrade, 1924-1926. (Collection: Aleksandar Kadijević and Tadija Stefanović)

Fig. 9.10. Branislav Kojić, House in Zadar Street No. 6, Belgrade, 1926. (Collection: Aleksandar Kadijević and Tadija Stefanović)

Fig. 9.11. Josif Najman, The Institute for Printing Banknotes and Minting Coins of the National Bank (Zavod za izradu novčanica i kovanog novca Narodne banke), Belgrade, 1927-1929. (Collection: Aleksandar Kadijević and Tadija Stefanović)

Fig. 9.12. Dragiša Brašovan, The Yugoslav Pavilion (Jugoslovenski paviljon), the World Exhibition in Barcelona, 1929. Dismantled after the Exhibition. (Collection: Aleksandar Kadijević and Tadija Stefanović)

Fig. 9.13. Dragiša Brašovan, The Workers' Hall (Radnički dom), Novi Sad, 1929-1930. (Collection: Aleksandar Kadijević and Tadija Stefanović)

Fig. 9.14. Dragiša Brašovan, The Air Force Command (Komanda ratnog vazduhoplovstva), Zemun, 1935-1936. (Collection: Aleksandar Kadijević and Tadija Stefanović)

Fig. 10.1. Letchworth, Dwelling Quarters, as in 2007. (Photo: Dragana Ćorović)

Fig. 10.2. J. Dubový, Interpretation of the Garden City concept, Ideal Garden City, 1925. (Jan Dubovi, "Vrtarski grad" *Tehnički list* 1 (1925): 7-11, illustration on p. 7.)

Fig. 10.3. Hampstead garden suburb, contemporary photography. (Jan Dubovi, "Vrtarski grad" *Tehnički list* 1 (1925): 7-11, illustration on p. 10.)

Fig. 10.4. B. Maksimović, *Problems of Urbanism* (1932), cover page (B. Maksimović, *Problems of Urbanism* (1932), cover page)

Fig. 10.5. Đorđe Kovaljevski, et al., General plan of Belgrade, 1:10.000, 1923. (Historical Archives of Belgrade, OGB-490-III-3)

Fig. 10.6. Belgrade, Kotež Neimar, 1935. (Historical Archives of Belgrade, ZF A II 87)

Fig. 10.7. Belgrade, Professors' Colony, c. 1930. (Private collection Miloš Jurišić)

Fig. 11.1. The Professors' Colony, Belgrade, photograph shows the building of the Colony, published in *Politika*, daily newspaper, 16.9.1926 (Private collection Miloš Jurišić)

Fig. 11.2. View of the Professors' Colony from Cvijićeva Street, 1940s (courtesy of the Museum of the City of Belgrade, file Ur. 5866)

Fig. 11.3. Architects Petar and Branko Krstić, house of Stjepo Kobasica, Osmana Djikića Street no 24 (1931), the Professors' Colony, Belgrade (contemporary photograph by Kamilić Viktorija)

Fig. 11.4. Architect Svetozar Jovanović, house of Fehim Barjaktarević, Ljube Stojanovića Street no 19 (1927), Professors' Colony, Belgrade (contemporary photograph by Kamilić Viktorija)

Fig. 12.1. Petar and Branko Krstić, Olga Lazić's Villa, Belgrade, 1931, drawing of the main façade. (Krstić borthers legacy)

Fig. 12.2. Petar and Branko Krstić, Josif Šojat's building, Belgrade, 1934-35, drawing of the main façade. (Krstić borthers legacy)

Fig. 12.3. Petar and Branko Krstić, Project for the Yugoslav Pavilion, Philadelphia, 1925. (Krstić borthers legacy)

Fig. 12.4. Petar and Branko Krstić, Project for St.Sava's Cathedral, Belgrade, 1926. (Private collection Miloš Jurišić)

Fig. 12.5. Petar and Branko Krstić, St. Mark's Church, Belgrade, 1930-39. (Private collection Miloš Jurišić)

Fig. 12.6. Petar and Branko Krstić, The Agrarian Bank Palace, Belgrade, 1931-34. (Private collection Miloš Jurišić)

Fig. 12.7. Petar and Branko Krstić, The Iguman's Palace, Belgrade, 1936-37. (Private collection Miloš Jurišić)

Fig. 12.8. Petar and Branko Krstić, Dušan Tomić's Villa, Belgrade, 1930-31. (Private collection Miloš Jurišić)

Fig. 13.1. Niška Banja, panorama from southwest, a postcard from c. 1937. (© Ćirić Collection, Toronto ON; Courtesy of Goran Ćirić)

Fig. 13.2. Model of the General Plan of Regulation of Niška Banja, 1933. (J. Vasić, *Niška Banja* (Niš: Atlantis, 2007), p. 72)

Fig. 13.3. Villa of Trifun Stefanović, Villa Toplica, Villa Kosovka, Villa Ristić, and Villa Živković, from southeast, a postcard from 1939. (© Stevan Sremac City Library, Niš: The Postcard Collection, RZ 29)

Fig. 13.4. New Bathhouse, Niška Banja, view from west, a postcard from c. 1938. (© Ćirić Collection, Toronto ON; Courtesy of Goran Ćirić)

Fig. 13.5. New Bathhouse, Niška Banja, built c. 1935, interior of the hall with a skylight, as in 2011. (Photo: Nebojša Stanković)

Fig. 13.6. New Bathhouse, bathing pool, c. 1935. (© Historical Archives of Niš: Photo Collection, No. 1786)

Fig. 13.7. Banovinski Hotel and the New Bathouse, Niška Banja, view from southeast, a postcard from c. 1938. (© Ćirić Collection, Toronto ON; Courtesy of Goran Ćirić)

Fig. 13.8. Banovinski Hotel, Niška Banja, interior of a room, from a c. 1940 tourist brochure. (© Historical Archives of Niš: Photo Collection, No. 1504a)

Fig. 13.9. Villa of Trifun Stefanović, Niška Banja, view from east, a postcard from mid-1930s. (© Ćirić Collection, Toronto ON; Courtesy of Goran Ćirić)

Fig. 13.10. Villa Živković, Niška Banja, c. 1935, view from northeast, as in 2011. (Photo: Nebojša Stanković)

Fig. 13.11. Hotel Milenković, Niška Banja, view from northwest, a postcard from c. 1939. (© Ćirić Collection, Toronto ON; Courtesy of Goran Ćirić)

Fig. 13.12. Hotel Dubrovnik, Niška Banja, drawing of the street façade by A. Medvedev, 1940. (A. Keković, Z. Čemerikić, "Moderna u Niškoj Banji – Vile i hoteli" [The Modern architecture of Niška Banja: Villas and Hotels], *Arhitektura i urbanizam* 8 (2001): 60-71, fig. 25)

Fig. 13.13. Villa Erna, Niška Banja, view from west, a postcard from 1940.

Fig. 13.14. Villa Zone (first from left), with villas Teokarević and Čavdarević, Niška Banja, view from east, a postcard from c. 1940. (© Ćirić Collection, Toronto ON; Courtesy of Goran Ćirić)

Fig. 14.1. Momir Korunović, Central lodge of the "Soko" stadium in Košutnjak, Belgrade, built in 1923 (Private collection Miloš Jurišić)

Fig. 14.2. Detail of the terrace of the old "BSK" stadium at "Trkalište", Belgrade, built in 1914 (From *BSK: 1911 – 1931*, Belgrade: Narodna štamparija, 1931).

Fig. 14.3. The "BSK" stadium during the soccer match between Yugoslav and Czechoslovakian national teams in 1935 (Private collection Miloš Jurišić)

Fig. 14.4. The first soccer match under the artificial lighting in Belgrade, "Jugoslavija" stadium in 1932 (From Četvrt *veka s.k. "Jugoslavije:" 1913 – 1938*, Belgrade: Jugoslovenska sportska revija, 1939).

Fig. 14.5. Dragan Gudović, Plan for the new and modern "Jugoslavija" stadium, Belgrade, c. 1938 (From Četvrt *veka s.k. "Jugoslavije:" 1913 – 1938*, Belgrade: Jugoslovenska sportska revija, 1939).

Fig. 14.6. Momir Korunović, Blueprint of the "Soko" stadium at "Trkalište," Belgrade, 1930 (Private collection Miloš Jurišić)

Fig. 14.7. Momir Korunović, "Soko" stadium at "Trkalište" during the Sokol rally of 1930. (Private collection Miloš Jurišić)

Fig. 14.8. Werner March, Model of the Olympic Park in Belgrade, 1939. (Architekturmuseum, Technische Universität Berlin, Inv. Nr. F 5395)

Fig. 14.9. Werner March, Site Plan of the Olympic Park in Belgrade, 1939. (Architekturmuseum, Technische Universität Berlin, Inv. Nr. F 5394)

Index I: General Index

Besides all the *realia*, this index also collects some important abstract concepts. Their list owes much to Prof. Jelena Bogdanović. The entries concerning Belgrade are entered in Index II. - Sever J. Voicu

INDEX II: BELGRADE